THE BLACK

Other books by Brenda Dixon Gottschild

Waltzing in the Dark

Digging the Africanist Presence in American Performance

The History of Dance in Art and Education (co-author, third edition)

THE BLACK DANCING BODY

A GEOGRAPHY FROM COON TO COOL

BRENDA DIXON GOTTSCHILD

First published in hardcover in 2003 by Palgrave Macmillan
First PALGRAVE MACMILLAN™ paperback edition: September 2005
175 Fifth Avenue, New York, N.Y. 10010 and
Houndmills, Basingstoke, Hampshire, England RG21 6XS.
Companies and representatives throughout the world.

PALGRAVE MACMILLAN is the global academic imprint of the Palgrave
Macmillan division of St. Martin's Press, LLC and of Palgrave Macmillan
Ltd. Macmillan® is a registered trademark in the United States, United
Kingdom and other countries. Palgrave is a registered trademark in the
European Union and other countries.

ISBN 1-4039-7121-8 ISBN 978-4039-7121-0

Library of Congress Cataloging-in-Publication Data

Gottschild, Brenda Dixon.
The black dancing body : a geography from coon to cool / Brenda Dixon
Gottschild.
 p. cm.
 Includes bibliographical references and index.
 Hardcover ISBN 0-312-240273
 Paperback ISBN 1-4039-7121-8
 1. African American dance—History. 2. African American dancers.
3. Body image. I. Title.

GB1624.7.A34G68 2003
793'089'96073—dc21

 2003041434

A catalogue record of the book is available from the British Library.

Design by Letra Libre, Inc.

First PALGRAVE MACMILLAN paperback edition: September 2005

10 9 8 7 6 5 4 3 2 1

Printed in the United States of America.

Transferred to Digital Printing 2008

In Celebration of

Sky and Sanji-Rei Larrieux

ᘒᔕᔕᘖ

ᘒᔕᔕᘖ

In Memory of Eliza and George Dixon

ᘒᔕᔕᘖ

In Memory of September 11, 2001:

Shanksville, PA

Washington, D.C.

New York, N.Y.

CONTENTS

ILLUSTRATIONS

ACKNOWLEDGMENTS

As the African proverb tells us, it takes a whole village to raise a child. It takes another whole village to write a book! With deep gratitude I thank the "villagers" who helped make this work possible, beginning with my helpful, encouraging editors at Palgrave—Michael Flamini, Alan Bradshaw, Amanda Johnson—a bridge and buffer. Thanks to those fearless, forthright dance practitioners who agreed to be interviewed (listed with brief bios in the Introduction). And a big "thank you" to my insightful, enthusiastic manuscript readers: Yvonne Daniel, Neil Hornick, Becky Thompson, and Sherrie Tucker (on part 1). Big "props" go to Philadelphia's Dance Advance and Bill Bissell; and to videographers Carmella Vassor and Tina Morton, who offered crucial technical assistance. The staff librarians at the New York Public Library for the Performing Arts' Dance and Theater divisions were enormously helpful, patient, and generous with their time and expertise. And a shout goes out to Lisa Rivero, a champion indexer; and Lawrence Levine, a champion friend.

In addition to those acknowledged in my previous books, thanks to some of the many students from my seventeen years of teaching in the Dance Department at Temple University. With their dancing, thinking bodies they are now cultural workers in their own right, and they form a network of support and exchange that I value highly: Drs. Benita Brown, Ananya Chatterjea, Karen Clemente, Melinda Copel, Donna Davenport, Melanye White Dixon, Indira Etwaroo, James Frazier, Ju-Yeon Ryu, Gaynell Sherrod, and Tamara Xavier; and Robin Wilson and Sagé Blaska from the M.F.A. program.

Inspired by the liner notes from the *Infinite Possibilities* CD, by my daughter, Amel Larrieux, I am stealing (appropriating? ripping off?) her idea and taking this occasion to thank some of those aesthetic influences that helped shape me:

Mary Anthony, who valued my dancing body and invited me into the world of concert dance; Joseph Chaikin, whose improvisational influence from my acting years in The Open Theater remains with me; William Hickey and Uta Hagen, actors and teachers par excellence; Richard Schechner, my scholarly mentor and guide, whose idea it was that I develop a course called "Black Performance from Africa to the Americas," which became my signature written across the years at

Temple; Joann Keali'inohomoku, Toni Morrison, John Szwed, and Robert Farris Thompson—each wrote a work that changed my perspective from white to black (listed in the bibliography); Bernice Johnson Reagon, for her attitude and style in cultural work, combining research and performance; Titos Sompa and Malonga Casquelourde, whom I met soon after their arrival, stateside, from Zaire and who later became my dance teachers; Chuck Davis, whose joy and communal spirit inflected every class he taught at Harlem's Church of the Master many years ago; Nina Fonaroff, for showing me what lay beneath the ballet form; Margot Webb, for showing me a history of black dance that lay hidden for decades; and Alvin Ailey "whose spirit soars above oppression" (Ailey's words, in a 1981 program note about the Czech composer Miloslav Kabelac).

Immense props and praises to my friends who've supported my life and work, through thick and thin: Lois Lowenstein; Helène Aylon; Vèvè Clark; and Ilse Pfeifer. To my siblings—Ted, Ruth, Christine, and George—thank you for being part of me.

To my heart, Amel, and my dear son-in-law, LaRu: your curiosity, support and devotion make the work all the more worthwhile—thanks for inspiring me by being who you are. Hellmut, beloved, I save for you the last word: thank you for allowing me the space, literally and figuratively, to bring this work to completion.

Àshe, Om, and Amen.

INTRODUCTION

With dance as the focus and race the parameter, this work is a personalized cultural study, the third installment in my exploration/excavation of Africanist presences in performance. When Michael Flamini approached me about writing a history of "black" dance, I responded that, instead, I wanted to tell the story as a geography of the body itself. My topic is hot: Race remains dangerous territory, and talking race through the black dancing body is tricky. Nevertheless, I am not pointing the finger or flinging accusations. I interrogate the black dancing body through personal experience, critical analysis of visual and print documentation, and through the eyes of the 24 contemporary dance practitioners interviewed for this book.

About terminology: I chose to use the term "coon" in my title to make a racial point, which I hope will be clear in the text. As a person of African lineage who could conceivably have been subjected to that word, I gave myself the license to use it, not to neutralize it but to undermine it for my special purposes. Like other derogatory epithets, it is not a word that I use casually.

Over the years I have particularized and extended a popular term in contemporary dance parlance, "the dancing body," to read "the black dancing body," here used as title and throughout the text. The terms "thick," "full," "big," and "natural" are utilized separately or in tandem to describe black hair, rather than more common terms such as "frizzy," "nappy," and "kinky," all of which emerged as pejoratives from the dominant culture. "Nappy," like the other "n" word, has gained favor with some elements in the black community in a move to redefine and transform a negative into a positive. I choose, instead, to leave those terms behind as used-up castoffs. (Thanks to my daughter and son-in-law for pointing this out to me.)

The term "Africanist" includes concepts, practices, attitudes, or forms that have roots/origins in Africa and the African diaspora. Others who had used this term include linguist Joseph Holloway and writer Toni Morrison in her essays on literary theory (see the bibliography). I use the term "Europeanist" as its counterpart, denoting concepts, practices, attitudes, or forms rooted in European and European-American traditions.

About the interviews: It was a gift for me to spend such intense, revelatory time with some of the leaders of my dance world. Given the tenuousness of the arts in general and dance in particular—where careers and the awarding of grants are too often predicated on the politics of silence—those who agreed to be interviewed were brave (many others refused). Some opined that my topic was dangerous; others were upset by my segmented analysis of the black body, which, like the African continent, has a history of literal or figurative dissection; and, in spite of candor there was caution—more, I believe, than I would find in other arts professions.

Because this text is neither a survey nor a statistical study, the interviews are representative but not comprehensive. My aim is not to quantify or otherwise arrive at scientific or encyclopedic conclusions. My focus is on cultural image. I attempt to encompass qualitative latitudes by my choice of interviewees: blacks like Ralph Lemon and Gus Solomons jr, who grew up in white, middle-class communities; blacks like Jawole Willa Jo Zollar with a black, middle-class background and Rennie Harris in black, grass-roots culture; blacks like Marlies Yearby and Shelley Washington who, as army brats, grew up in a variety of ethnic and class settings; Latinos Merián Soto and Fernando Bujones, with their particular multicultural perspectives; and whites with dance backgrounds as varied as Doug Elkins's (living largely in black-Latino New York) and Trisha Brown's and Monica Moseley's (raised in all-white communities in the Northwest). I interviewed people who worked together (Seán Curran and Bill T. Jones; Lemon, Moseley, and Meredith Monk; Zane Booker, Ronald Brown, and Joan Myers Brown; Wendy Perron and Trisha Brown) as well as people representing a range of genres (African, ballet, tap, hip hop, modern-postmodern, Broadway, and, with Meredith Monk, a movement-music-theater idiom) and generations (extending in age from early thirties to early seventies). They represent choreographers, dancers, artistic directors, dance writers, and an archival librarian. The unifying factor is that they were all dancers at one time. There are other kinds of dance practitioners not represented: body therapists, producers, presenters; nor did I extend the range to people in other disciplines. These are fertile areas for future work.

Occasionally interviewees expressed opinions that run counter to the book's basic premises. In a few cases I've added alternative comments; in others I let the information stand, leaving it up to the reader to draw conclusions. It was not my intention to put opinions on trial, but to provide a forum for expressing (daring) views on a volatile topic. I appreciated the willingness to go this far. In other instances the interview process stimulated the interviewee to think in new ways. In using ellipses I have never altered content or the speaker's meaning but tried only to keep the narrative moving.

I've always known that dancers and dance makers are some of the most intelligent, philosophical, and articulate people in society. These interviews confirm that belief.

About the photographs: Because of the topic I wanted to feature the subjects in renderings that showed their dancing bodies. Approximate dates (decades) have been supplied for photographs taken before the 1990s. Frequently dancers are so totally "in" and "into" their body that focus (theirs, ours, the photographer's) is deflected away from the face: Thus, in some reproductions facial features are obscured, with the body assuming the expressive priority. In almost all cases the photos used were chosen by the performers. Two shots are of non-interviewee subjects and two people I interviewed did not submit photographs. No depictions are included of dancers whose work is discussed but who weren't interviewed; their representations can be seen in other published works (listed in the bibliography) and/or library collections, films, and videos.

About the biographies: All individuals interviewed are outstanding, award-winning figures who perform, choreograph, and teach internationally and are active forces in their field. Their credits are impressive (and include several MacArthur fellowships). Details can be found on their websites and in dance encyclopedias. What follows, then, are thumbnail biographies to help context their interviews:

ZANE BOOKER—b. 1968. Earliest dance classes at Philadelphia School of Dance Arts. Performance credits include Philadanco (1982–86), the North Carolina Dance Theater (1987–88), Netherlands Dance Theater II (1989–91), Netherlands Dance Theater (1991–95), Ballets Monte Carlo (1995–99), and Baryshnikov's White Oak Project (2002).

JOAN MYERS BROWN—b. 1931. Influences: Anthony Tudor (ballet training), Katherine Dunham (teaching philosophy). Founded Philadelphia School of Dance Arts, 1960, and Philadanco (Philadelphia Dance Company), 1970.

RONALD BROWN—b. 1966. Influences: Mary Anthony, Jennifer Muller (as student of, then company member with both). Formed his ensemble, Evidence, 1985.

TRISHA BROWN—b. 1936. Studied with Ruth Beckford, Louis Horst, Anna Halprin, Robert Dunn. Founding member, Judson Dance Theater and Grand Union. Formed Trisha Brown Company, 1970.

BRENDA BUFALINO—b. 1937. Major influences: Sevilla Fort, Honi Coles, Stanley Brown (danced with his jazz ensemble, mid-1950s). Founded the American Tap Dance Orchestra, 1986.

FERNANDO BUJONES—b. 1955. Studied at the School of Ballet Nacional de Cuba and School of American Ballet. Performed with American Ballet Theatre (1972–85). Artistic Director, Southern Ballet Theater (Orlando, FL.).

SEÁN CURRAN—b. 1961. Studied with Lawrence Rhodes, Stuart Hodes. Performed with Bill T. Jones/Arnie Zane Company (1984–94) and in *Stomp* (1994–99). Formed Seán Curran Company, 1997.

CHUCK DAVIS—b. 1937. Dancer, Olatunji (1962–66) and Eleo Pomare (1966–68) companies. Founded Chuck Davis Dance Company (1967–83) and the annual Dance Africa Festival (beginning 1977). Founded African American Dance Ensemble (1994).

DOUG ELKINS—b. 1960. Performed (early 1980s) with Magnificent Force, New York Dance Express, Royal Rockers (hip hop ensembles). Founded Doug Elkins Dance Company, 1987.

GARTH FAGAN—b. 1940 (Jamaica). Performed as a teenager with Jamaican National Dance Company. Influences: Pearl Primus, Lavinia Williams, Martha Graham, José Limón. Formed Bucket Dance Theater (now Garth Fagan Dance), 1970. Choreographed Broadway musical hit *The Lion King*.

RENNIE HARRIS—b. 1964. Danced, choreographed, and taught hip hop genres since he was fifteen. Performed with Philadelphia-based Scanner Boys (1979–92). Formed Rennie Harris PureMovement, 1992.

FRANCESCA HARPER—b. 1969. Studied with Barbara Walczak and at the Joffrey Ballet School, School of American Ballet, and Alvin Ailey School. Directs the Francesca Harper Project. Freelance choreographer. Performance credits include Dance Theatre of Harlem (1987–91), Frankfurt Ballet (1991–98), Complexions (beginning 2002).

BILL T. JONES—b. 1952. Studied with Kei Takei, Lois Welk, Percival Borde. Founded, with Welk and Arnie Zane, the American Dance Asylum (mid-1970s–1981). Jones and Zane formed the Bill T. Jones/Arnie Zane Dance Company, 1982. Jones's memoir, *Last Night on Earth*, was published 1995.

RALPH LEMON—b. 1952. Studied with Zena Rommett, Viola Farber, Nancy Hauser. Founding member, Mixed Blood Theatre Company (Minneapolis). Performed with Meredith Monk/The House, 1979–81. Founded the Ralph Lemon Dance Company (1985–95). Wrote *Geography* (2000) and *Tree* (2003).

SUSANNE LINKE—b. 1944 (Germany). Studied with Mary Wigman (1964–67) and at Folkwang Schule (1967–70). Director of Folkwang Tanzstudio (1975–85). Co-directed Bremer Tanztheater (beginning 1994).

BEBE MILLER—b. 1950. Studied at Henry Street Settlement Playhouse as a child with Alwin Nikolais and Murray Louis, and later with Louis, Phyllis Lamhut, Nina Wiener (1976–82). Performed with Dana Reitz (1983). Founded Bebe Miller Company (1985).

MEREDITH MONK—b. 1942. Composer, vocalist, mover in an innovative movement-music-theater performance genre. Briefly associated with the Judson

Dance Theater where she performed her solo *16 Millimeter Earrings* (1966). Formed The House (1968) and Meredith Monk Vocal Ensemble (1978).

MONICA MOSELEY—b. 1942. Studied with Joyce Trisler, Joffrey Ballet, Merce Cunningham. Founding member of Meredith Monk/The House (1968–80, with occasional guest appearances thereafter). Associate Curator, Dance Division, New York Public Library for the Performing Arts.

WENDY PERRON—b. 1947. Studied with Irine Fokine, American School of Ballet, Martha Graham, Joffrey Ballet. Danced with Jeff Duncan, Rudy Perez, Twyla Tharp's Farm Club. Member, Trisha Brown Dance Company (1975–78). Formed Wendy Perron Dance Company (1983–94). New York editor, *Dance Magazine* (beginning 2000).

GUS SOLOMONS JR—b. 1940. Studied at Martha Graham School (1961–66). Dancer, Donald McKayle (1961–64), Martha Graham (1964–65), and Merce Cunningham (1965–68) companies. Founded Solomons Company/Dance (1972–97); co-founded PARADIGM (beginning 1998). Writes for *Dance Magazine* and other publications.

MERIÁN SOTO—b. 1954 (Puerto Rico). Studied Salsa (and other popular forms) in Puerto Rico and New York. Apprenticed with Elaine Summers (1978–85). Founded Pepatián (multidisciplinary Latino arts ensemble) with visual artist Pepón Osorio (1983).

SHELLEY WASHINGTON—b. 1954. Studied with Helen McGehee, Walter Nicks, Clay Taliaferro, Maggie Black. Danced with Martha Graham (1974–75), Twyla Tharp (1975–2001), American Ballet Theatre (in association with Tharp, 1988–91). Stages Tharp ballets worldwide; teaches ashtanga yoga with David Swenson.

MARLIES YEARBY—b. 1960. Mentors/teachers: choreographer Bobbie Wynn, directors-writers Laurie Carlos and Robbie McCauley, Aaron Osborne. Performed with Bobbie Wynn and Company (CA, 1979–85), Urban Bush Women (1987–90). Formed Movin' Spirits Dance Theater, 1989. Choreographed *Rent,* Broadway musical hit.

JAWOLE WILLA JO ZOLLAR—b. 1950. Studied as a child with Joseph Stevenson in the Katherine Dunham tradition. Worked with Dianne McIntyre (early 1980s). Established Urban Bush Women, 1984, a total-theater, dance-drama-music ensemble.

TOPOGRAPHY OF THINGS TO COME: RUMINATIONS ON DANCING IN A BLACK DANCING BODY

LATITUDE 1

LOOKING BACK

On 12 September 1968 the renowned dance photographer Jack Mitchell took what would become a historic photo. It originally appeared in the Sunday *New York Times* on October 20 of the same year; it came to my attention when it was republished in the December 2000 issue of *Dance Magazine,* in the Dancescape section. The photo shows a group of the old giants, middle forces, and young lions of American concert dance. Martha Graham, the doyenne, is seated in the center. She is encircled by Merce Cunningham, Erick Hawkins, and Paul Taylor on her right; the young and bony Yvonne Rainer diagonally behind her; Don Redlich and José Limón (who is clasping Graham's left hand) to her left; and the young, chubby-faced Twyla Tharp diagonally in front of her. Anna Sokolow was the only invited choreographer who didn't show up. The composition is a solemn, lovely study and, indeed, it is historically significant. This august tribe was heralded as part of the first full season of "modern dance" funded by one of the first big Ford Foundation grants. It's a photograph of firsts, and these folks look as though they knew they were making history.

But the question is, where is Alvin Ailey? Why was he absent from the photo shoot? Perhaps he was on tour at the time, but his omission is striking in hindsight. At the moment when the Civil Rights Movement was in full flower, and when the New York concert dance community liked to think of itself as color-blind, Ailey was the giant whose presence is sorely missed. He belonged there, in the mix. Besides Martha Graham's company, the Alvin Ailey American Dance Theatre was the most popular American dance ensemble worldwide. I use this photo as my starting point for a discussion of the black dancing body that has shaped itself by means of experience and, for everyone who knows, insinuated its presence even by its absence. The black dancing body was the negative space around which the white dancing body was configured. I include myself in that number. Let me explain.

I am considered tall—nearly 5 feet 8 inches. Without giving more measurements, let's just say that my torso takes up much less body space than my legs, with my waist interestingly close to my armpits: "short-waisted" or "stilt-legged" were

terms directed at me as a child. In proportion to my legs, my long arms look fine. Slim hips—none, really—and a markedly arched spine that accounts for and ends in distinct buttocks are other defining characteristics in this picture. Odd? Well, even more extreme contours and variations of this frame can be seen not only in fashion magazines but also on stages across the globe in the post-Balanchinian, postmodern era of dance. But that part comes later. Let me begin in 1957.

As a relatively young dancer (formal studies did not begin until I was 15, but I had always danced, always wanted to be a dancer), this body got me in trouble. Shorter, rounder, less muscular, more conventionally proportioned "feminine" dancers were chosen for starring roles in the high school musicals. When I was 18 and studying on scholarship at the legendary New Dance Group Studio in midtown Manhattan, one of my teachers there, Donya Feuer (now a longtime resident of Sweden, where she was a choreographer and filmmaker), offered me a scholarship to come and study with her and her then-partner, Paul Sanasardo, at their Chelsea studio. After a year of daily classes with them I was brought into their dance company as a sort of supernumerary, along with three other long-limbed dancers whose body types were nothing like Feuer's nor her two leading ladies (Chifra Holt and Milagro Llauger; all were approximately 5 feet 2 inches tall). Certainly, questions of talent, training, and technique may have figured in artistic decisions to exclude me from those star turns that I lusted after. But an unspoken, deciding factor was this body that, in the 1950s and early 1960s, was seen as an anomaly. Still—above and beyond the reality of my anatomical dimensions—the first and final factor was race: I was a black dancing body housed in chocolate-brown skin, with a full head of generously big, natural hair (at that time manually straightened and pulled back into a bun), and a full African nose.

When I was in my early twenties and making the rounds in the Big Apple, my friends and I made a point of auditioning for Broadway musicals for which we knew that even the best African American dancers would not be hired. But we were young, brash, aspiring dancers. In hindsight I realize our actions were a response to the civil rights sit-ins that were going on across the nation. We still submitted ourselves to these trials on a regular basis so that our black presence couldn't be totally ignored. Years later, at the beginning of a new millennium, most American musicals and dance companies were still either white or black. A typical example was *Swing!*, a dance-based Broadway hit of 2000, that had a token black in the cast: quite an irony, since swing originated in the African American community in the 1920s and 1930s and was a black music (and dance) form until white practitioners (like Benny Goodman and the Dorsey Brothers) jumped on the bandwagon and disseminated the form to the white mainstream audience. Reviewing the Berlin 1999 "Tanz Im August" (Dance in

August) festival for *Dance Magazine*'s November 1999 issue, I observed a degree of ethnic diversity within this selection of European dance companies that underscores its absence in the United States. Ensembles based in Munich (Rui Horta Stage Works), Prague (Déjà Donné), and Brussels (Rosas) all included a wider ethnic diversity than the concert dance ensembles in a city like Philadelphia, where I now reside. How can this situation be justified? Choreographers and directors pull out the old argument that such politicized issues as affirmative action and diversity would restrict their artistic freedom of choice. And, yes, the dance world still likes to think of itself as beyond politics—as though any human system of expression could exist outside that realm. (Steve Paxton, one of the originators of a dance style known as contact improvisation, in the Dance in America 1980 film, *Beyond the Mainstream*, talks about the contact improviser's state of mind as receptive, open, and—to use his word—"apolitical.")

In 1962 I began to study with Mary Anthony, who was a major influence on my early development as a dancer. Indeed, my time with her (through 1967) coincided with the Civil Rights era. I remember when she was offered a booking at the Virginia Fine Arts Museum in Richmond. Such institutions were still segregated at that time. Anthony made it a point to inform the presenters that she would not perform unless she was allowed to have an integrated company. Soon after, she invited me to dance with her ensemble. We played in Richmond and may very well have been the first "integrated" group on that stage. I put the word in quotes because I was the sole member of color in this small ensemble, and the audience was still segregated. But Anthony's voice had been heard, and her/our point was made.

Still auditioning and still a neophyte dancer, I had an unsettling experience with choreographer Pearl Lang. I responded to her call, not for a featured role but to work as a pick-up in a small chorus of four dancers. I was informed, after auditioning, that I could not be used because my skin color would "destroy the unity of the corps." (In all fairness, Lang had used African American dancers in cameo solo roles, including Loretta Abbott and Paula Kelly, who later had major careers dancing with Alvin Ailey and in Hollywood, respectively.) Lang used my complexion as the hook for her rejection, the same argument used by the Rockettes for so many years. I guess if I could have "passed," it wouldn't have mattered. I discussed this incident in an essay I wrote in 1990. It struck me as ironic and frustrating that dancers could live in fantasy worlds, be Wilis or princesses, goddesses or witches, but black-skinned dancers in a dance based on a Greek-inspired theme would be detrimental to some principle of unity.

So there I was, early on in my career, aware of the barriers and boundaries that the black dancing body represented to the white dance hierarchy. But even then I

saw ample evidence that those same qualities that were repulsed were also desired. Why else would black forms of music and dance that took their shape, rhythm, and accent—color, if you will—from black initiatives be the reigning soul and spirit in American culture? Why else would Elvis Presley imitate, to the letter, the sound of Big Mama Thornton, an African American rhythm and blues singer, to create his early hit "Hound Dog" and then go on the *Ed Sullivan Show* dancing (or, as the press of the era would say, "gyrating his pelvis") and singing as though he were the white answer to Jackie Wilson? Why else would the revered George Balanchine have used significant markers of African American dance in creating *The Four Temperaments* (1946), *Agon* (1957), *Jewels* (1967), and a host of other modern ballet masterpieces? And why would modern dancers turn to bare feet, use of the floor, grounded energy, and articulation of the torso—elements that were Africanist in nature—as basic components in their revolutionary movement strategy?

Why was it that the white world loved the culture but disdained its creators—loved black dance but oppressed/repressed the black dancer, the black dancing body?

The only answer I have found to this question is the ongoing power of racism and its perpetual grip on world consciousness. The sobering reality is that racism today is rearing its head in new and more complex ways at the same time that theories of race are facing extinction at the hands of academic scholarship. Cultural scholar Kwame Anthony Appiah "has called for an abandonment of the very concept of race, arguing that it is a biologically meaningless term that confuses socially constructed descent systems and prejudice with biological heredity."[1] There is enough variation *within* any ethnic group to make the theory worthless. Likewise, there are enough examples of similarities *across* ethnic groups to further debunk any racialized genetic theory. Why? Because there are no "pure" types—no races, as such. Europeans, Africans, Asians—we are all mixed bloods, mixed "races."[2] Race is not a biological imperative but a social construct convenient for purposes of classification and differentiation. The variations that gene theory is finding in humankind do not fall within the old racial divisions; clearly, we need to address peoples in terms of context, culture, and attitudes, not race. We need to apply genetic theory from a different perspective, to utilize it from a non-racialized starting point.

In spite of scientific findings, many people still buy into the old ways of thinking. But so goes the world: now over a century after Einstein's groundbreaking discoveries, we still perceive the world in Newtonian terms. On the one hand, some African Americans, proud to be who they are and sick and tired of *racism*, ascribe to the concept of *race* but *revise the canon* and use this label to affirm that black is beautiful. For example, an African American doctoral candidate at Harvard states

that she doesn't buy the new thinking about race as a nonentity. She is black: Others are not, and that means something positive, not negative. From her perspective, as soon as blacks became ready to constructively utilize the idea of separate races, white scholars decided that race was outdated. On the other hand, the *New Yorker* dance critic (white), in a review of the Alvin Ailey American Dance Theatre, praises the Ailey (black) dancers to high heaven after dismissing Ailey's choreography as second rate (which shows that, in some cases, it's the black dancer who is admired and the dance that is seen as not up to par). Near the end she first asserts, "In my experience, black dancers, on average, are better than white dancers." Then she inserts the "nature or nurture" question as an afterthought. Both claims give renewed credence and fresh energy to the old race theories. It seems significant that the piece was run in the 27 December 1999–3 January 2000 issue of the magazine, smack on the millennial threshold. Here we are, living in the twenty-first century, talking about black dance and black dancers! What are we really talking about? A prejudice? A stereotype? An ideal? A limitation? And if I speak of black dance and a black dancing body, then is there also a white dancing body, an Asian dancing body, and so on? How and what differentiates these separate bodies? Who has the final word on what it is they do? Who is studying them? Where? And to what end? How is the information being gathered? If we let go of the concept of race, then where would we hang our racism?

Because of the persistence of global racism we are stuck with talking about a social construct in jejeune biological terms. But that predicament is a righteous indication of who we are and where we are as people on this planet at this point in time, entrenched in the thrall of our own skewed constructs. We inherit the language we deserve, and that language shapes our perceptions. As jazz music scholar Sherrie Tucker says, "Racists need race to justify their racism, but nonracists also need race to be able to analyze racism."[3] In the end race, like gender, is about power and where we are positioned in the hierarchy of a racialized society. Biology and genes are really not the question, but act as a convenient, habit-ridden path of explanation: Newton over Einstein, if you will. And in the end, beyond our hierarchies and hegemonies, there is no "black race" or "white race," "black dance" or "white dance." It's simply that the habit of racism has rendered us unable to put the fusion of American cultural creations into words from the vocabulary at our disposal. Our traditions and cultures are so thoroughly mixed (and have been for ages, beginning with the intimacy and depth of contact between blacks and whites during the centuries of American slavery) that our language reflects old assumptions and categorical errors. Nevertheless, if one speaks of "black dance," that term predicates the existence of "white dance," its unacknowledged counterpart. Even the term "African dance," although it is more specific than "black dance," is a misnomer. The Sabar dance styles of Sene-

gal are as different from the Watusi dances of Rwanda or the Masai dances of Kenya as a Greek folk dance is from Russian ballet. European forms are not randomly grouped together in this way.

What I find amazing about this predicament is how the paradigm of the black dancing body has shifted over the course of the twentieth century into mainstream white acceptability. And this body—elusive, fantasized, imagined, loved, hated—is my subject and object. Although the black dancer remains Other, the black body has, through dance, sports, fashion, and everyday lifestyle, become the last word in white desirability. Going back to my description of my own body, those characteristics—long limbs, short torso, arched spine, noteworthy buttocks, narrow hips—scream out at us from print, video, and film media and from stages and sports arenas across the globe. And just look how this mythical quotient has changed the shape of the ballet body. As Arthur Mitchell—founder and artistic director of the Dance Theater of Harlem—pointed out in the 28 December 1987 issue of the *New Yorker*, George Balanchine "described his ideal ballerina as having a short torso, long arms, long legs, and a small head. If that's ideal, then we [black folk] are perfect." No wonder the Harvard graduate student wants to stake her claim! And so do I! Finally my awkward goose is the graceful swan. The black body is no longer the black sheep. The black swan preempts the white one! That is why this book is subtitled "From Coon to Cool": although its shape has changed with the times, this black body is basically the same bundle of traits and variables that was looked upon as "coonish" a mere century ago. Only, now, there's a different spin on it. Cool.

Nevertheless, black bodies, like all bodies, come in many shapes, sizes, and colors, not only the body "type" described above. That profile, like my own and seen as typical, is really *stereotypical* and, like all stereotypes, draws its strength from an ounce of fact buried in a ton of fable.

If, as claimed by Stephen Holmes, race is America's "low-grade fever"—an illness so constantly present that you lose awareness of it—then the following blurb, televised on BBC World News on 9 March 2001, is all the more interesting. It was a report regarding an Italian genetic researcher, a Professor Antinori, and his American counterpart. To justify their work on human cloning they said, "We don't intend to clone the Michael Jacksons or Michael Jordans of the world." [4] This was their way of assuring a review board that their experiments were not designed to create a super "race." So we have apparently arrived at a point when black performing bodies may actually be the ideal, rather than an anomaly; yet that low-grade fever—attraction/repulsion, love/hate—rages on. It's a malady of epidemic proportions, and blacks and browns are as likely to catch it as whites—to internalize its premises and buy into its negative stereotypes.

At the modern/postmodern crossroads, when the times were mightily a-changin', the composer/musician Ornette Coleman was carrying out in sound his own revolutionary civil rights activism. He released an album called *Tomorrow Is the Question!*, followed by one titled *The Shape of Jazz to Come*. Like its musical counterparts, the black dancing body signaled the stamp and shape of minstrelsy, vaudeville, jazz, pop, rock-funk-soul, of nineteenth-century entertainments and twentieth-century modernism and postmodernism. Now—in the new millennium, with tomorrow still the question, and African American–based hip hop culture and black bodies a glamorized global phenomenon—can we bet on that body to sustain its role as the shape of things to come?

THE VOYAGE AHEAD

When Monica Moseley—assistant curator for the Oral History Archives of the New York Public Library for the Performing Arts Dance Division and one of the dance field practitioners interviewed for this book—interviewed me for the archives, she characterized me as a translator between black and white communities and between the worlds of performance and academia. This book is the latest effort in my border-crossing pursuit to shed light on the role of African Americans in shaping American consciousness/culture and to investigate the role of racism in this equation. It is the final entry in the trilogy that began with *Digging the Africanist Presence in American Performance: Dance and Other Contexts* (Greenwood, 1996) and continued with *Waltzing in the Dark: African American Vaudeville and Race Politics in the Swing Era* (St. Martin's Press, 2000). The titles give some indication of the territory covered in those works. Now I aim to present a nonlinear, unorthodox "history" of this elusive, paradoxical black dancing body (always present, but always on the move, always shifting, but still the same) as geography, rather than chronology. Geography as a metaphor for the sites, states, routes, and milestones of the black dancing body. The body as both body politic and individual signature.

We have created constructs that subliminally or consciously reflect the fallacy of race and drive our actions and reactions along racialized pathways. Black dance is one of these constructs. Taking this line of thinking a step further, the black dancing body exists as a social construct, not a scientific fact. However, this phantom body, just like the phantom concept of a black or white race, has been effective in shaking and moving, shaping and reshaping, American (and now global) cultural production for centuries. It has been courted and scorned—an object of criticism and ridicule as well as a subject of praise and envy.

This work is a cartogram of American history as told through the black dancing body, a map that predicates black history and dance history—two mar-

ginalized stories—as central to the formation of American cultural history. Like all maps this one is a social construct created by one individual whose values, needs, and criteria represent a particular culture and politic at a particular time. Just as the map of Africa was changed in the twentieth century to represent more accurately its actual size in relation to Europe (maps from earlier centuries depicted Europe as equal to or larger than Africa), so it is time for the remapping of the black dancing body. Black bodies are as same or as different as any other bodies: What changes is our perception.

As Ralph Ellison long ago pointed out in his masterpiece *Invisible Man*, the black American is both highly visible and invisibilized, ensnared in a complex dance with the white world at large—a dance of wit, will, body, and soul—that can be deadly if the wrong move is made. Although the "steps" have changed considerably since Ellison's time, the underlying rules are the same. Metaphorically, blacks are compelled to "dance" correctly or risk annihilation. This double bind of being seen and unseen, each position fraught with danger, is the crux of the American contradiction regarding its black populace. Out of its convolutions arises the love-hate relationship that characterizes black-white interactions, part of which is the appropriation of black culture (music, dance, lifestyles) by the white world.

My geography-history travels back and forth in time from minstrelsy to present-day practices. Although I conducted 24 interviews with contemporary practitioners to complete this work, the book is not a compendium of conversations but, rather, my description, analysis, and reflections on the black dancing body, with material from the interviews supporting every chapter. Furthermore, it is neither a comprehensive overview nor a statistical, quantitative, or comparative study. It is "the story of human beings (not abstract 'forces') making choices . . . and coping with the consequences."[5] In the forthcoming chapters I survey this black body and map its most contested parts (feet, buttocks, skin, hair) in order to revise and reconstitute its history. In the final chapter I try to get a hold on the ineffable by interrogating soul and spirit as parts of the body, or embodied attributes. Taking to heart the Bauhaus adage, "form follows function," I have allowed chapters to be shaped by (my perspectives on) the subject matter. I hope this work will help bring dance and performance to prominence in the current discourse on cultural studies and identity politics. These relatively new interdisciplinary areas of study do not shy away from the tough issues and place the interrogation of race, gender, and class at their center.

Using race as a marker for dance endeavour has been interpreted as a defensive stance. One person interviewed for the present work made clear that he felt "troubled" by the direction of my questions. Some people may feel that even though race is an issue at large, it doesn't really exist any longer in the dance

world, where "we" have made a "safe haven" from such politicized issues: "Why bring up old stereotypes and pains of the past? And maybe blacks aren't as important to dance as she makes them out to be. In addition, she's black, she's biased; she's polemical."

The Buddhist saying, "the only way out is through," is a beacon guiding me through this endangered territory. I aim to refute habit-ridden cultural biases and contribute to the incipient canon on American cultural formation and performance history. I hope to deconstruct racial mythology and stereotypes in order to break through those assumptions and prescriptions that we all grew up with, blacks, browns, and whites alike. Asians and Latinos have their own colonial and post-colonial crosses to bear; yet all peoples subjected to Europeanist influences grew up with comparable myths surrounding black inferiority and white superiority. I speak in this book of a black/white axis of difference because that is the line across which all peoples of color must choose sides: are you light enough to pass for white? Are you a white Latino? As an Asian, can you assimilate and become white? If you are of mixed ethnicity (well, aren't we all?), will you list yourself as white or black? As an antidote to the centuries-old presumption of white supremacy, a wonderfully vital, new field of study has opened up in academia—whiteness studies. In camaraderie with African American studies and led by scholars like Ruth Frankenberg, Noel Ignatiev, and George Lipsitz, this area of expertise asks us to examine basic assumptions about whiteness—its power and privilege, its assumed beauty and refinement. The rightness of whiteness, so to speak. Whiteness studies adds fuel to my fire and reinforces my perception that the only way out is through.

For those readers who are not in the dance field or have never studied at a dance studio it may be helpful, in light of the forthcoming chapters, to understand the workings of the dance technique class. This institution is the integer that is most fundamental and basic to the field. Professional dancers of all ethnicities and dance genres (hip hop and African dance included) continue to take class for the duration of their performing careers—even those who themselves are teachers or choreographers. The way dance instruction and practice are handled in the dance class remains pretty much the same as it always was. Although there is always the possibility for some variation (for example, the teacher or coach may move through the space or direct a section of the class from behind the dancers' backs, instead of facing them), the following outline is the usual modus operandi:

A teacher, coach, or choreographer sits, stands, or moves in front of the individual dancer or group of dancers ("front" is, by custom and tradition, wherever

the authority figure is positioned). The class or individual learns movement from the leader and performs it for her. The performer and/or her performance (of a particular phrase, step, routine, or exercise) is sometimes praised, sometimes corrected, or both, but in the end the issue is how to get it right. The object is to correct one's body and one's performance to the aesthetic value that the leader knows but that you, as student or dance company member, aspire to and must be taught. Structurally inherent in this relationship is the inferiority of the dancer, in the sense that the approval of the authority and one's willingness to acquiesce to the authority are essential to success. The natural body may be praised for having "good" feet, energy, jump, turnout, sense of rhythm, or whatever else fits the leader's aesthetic preference; but, still, it must be brought under control, must conform to an ideal. Sometimes the ideal is embodied in the leader's prized students (or favored members of the ensemble) who may be placed at the front of the class or rehearsal space and used as models to demonstrate movements.

Although this description may sound harsh, the process works. Either it weeds out those who can't put up with it or it strengthens, develops, and creates dancers by practice, repetition, and pointed criticism. On the one hand, there is the wonderful chemistry between mentor and muse that allows creative seeds to bear fruit. On the other hand, there is the possibility of abuse, either physical or mental, and sometimes both. Dancers suffer physical injuries as they reach for the ideal, and mental anguish if and as they are advised that they aren't there yet (or, worse, will never "get it"). Figuratively speaking, dancers as a group are a subjugated "race"—destabilized as a matter of course, as a prerequisite inherent to the field. Unlike music, visual art, or scripted theater where process and product are completed by utilizing the implements of the medium (musical instrument, canvas and equipment, or scripted words), for the dancer *the body itself* is the medium, with no intervention or go-between separating the artist from the art, the dancer from the dance. It is the actual body that must be styled.

It may be this most intimate, inseparable relationship between process and product that accounts for dancers' obsession with their bodies, the (often scathing) criticism coming from some of their mentors (this fact was echoed in accounts from most of the dancers), and the struggle to reach a potentially unattainable ideal—since striving is an integral part of keeping one's career alive. It is this exquisite, intimate tyranny to which one accedes in becoming a dancer. Although this "tyranny of the ideal" is not as strong in African-based dance forms (traditional African, tap, or hip hop) where a more generous ideological range may be operative, nevertheless, the dancers' job is to aim for the ideal set by the leader. It is a battle with the body to make it something other than what it is. If this is true for all dancers, then what is it that sets black dancers apart?

BLACK WHITE DANCE DANCERS

WHAT IT IS

I find it curious about the mythology that we've grown up with, the idea of the black body versus the white body and, yeah, there is a difference . . . between being black and being white, and I wonder how much of that has to do with the moving. . . . Physical experience is extremely political, and I've seen this culturally. . . . Even to say black dance, there is a choice being made there in reference to something else.

—*Ralph Lemon*

A black dance is any dance that a person who is black happens to make. . . . There was a time when I never wanted to be called a black company or a black choreographer. . . . I've spent a life trying to not look at it that way. . . . The whole premise of your book, dissecting the black body, is a troubling one. I remember being with Bernice Reagon Johnson in Paris and I was invited to do something with Max Roach and somebody was talking about taking photos of her head, and she said, "No, no, no: Don't photograph parts of me." You know? Don't take parts of me.

—*Bill T. Jones*

Because of my own historical understanding of the dance, on some level all of it is black dance because you know, when you look at the history of ballet, its rhythms were drawn from Africa, and when you look at the history of modern [dance], it's very evident that folks of color, particularly the

*African diaspora, very much influenced what that form is. So for me, on
some level, all of it is interconnected and mixed up just as much as the
blood is.*

—*Marlies Yearby*

What is black dance? This issue has been the subject of controversy and unease in
the American concert dance world since the 1960s and has resurfaced every decade
or so since then. In 2000, it again came to the forefront, spearheaded by a new ini-
tiative in the form of an annual project presented by the 651 Arts Center in Brook-
lyn, New York, titled "Black Dance: Tradition and Transformation." This time
around the term "black dance" was taken up as a badge of honor by a new genera-
tion of African diasporan dancers and choreographers (that is, artists of African de-
scent working in communities across the globe) who may have been unaware of the
historical pitfalls of categorization or have decided to repossess a term of limitation
by redefining it (as is the case with the use of the "n" word by young people of
African lineage). This adoption of the term measures the degree of separation be-
tween blacks and whites, blacks and blacks, old-timers and newcomers.

The history and ideology surrounding the term are unique and stand apart
from a similar usage in music. Apparently, the phrase was not coined by the
black community or choreographers of African descent but was a means of dis-
tinguishing them from the white concert dance mainstream, as dance writer Zita
Allen explains in her signature essay, "The Great American Black Dance Mys-
tery," written in 1980. It is a media phrase developed most probably by white
dance writers of the 1960s who, for the first time, recognized distinct strains of
development amongst the African American concert dance choreographers who
came to prominence after the rise of Alvin Ailey, including Rod Rodgers, Eleo
Pomare, and Dianne McIntyre. But this recognition of particular styles during a
specific era does not mean that black people had only just begun to choreograph.
Rather, it means that the white mainstream press had only just begun to notice.
Because of civil rights advances in other sectors of society and the desegregation
of centralized dance venues, these writers suddenly became aware of choreogra-
phy created by black practitioners. Therein lies the main contention around the
term for African American dance practitioners: It is not their name for their
work. Furthermore, it begs the question: Is separate equal? African American
scholars and practitioners alike disparaged the terminology as pigeonholing.

At the other end of the spectrum and in accord with the zeitgeist, African
American musicians of the 1960s chose to hold up their banner of "black music"
as an affirmation of cultural nationalism. According to Sherrie Tucker, this senti-
ment continues today: "Even among academics who do race theory it is, and has

been, more often certain white academics that I see wanting to stop using the term 'black music' and more often certain African American academics who have argued that it is too dangerous to stop using that term, due to histories of appropriation and erasure of cultural history."[1] The dance world equivalent of Tucker's description was the movement that saw the advent of black American companies (like the Chuck Davis Company and the Dinizulu Dance Ensemble) working in traditional West African dance vocabularies sometimes directly in conjunction with continental Africans (like Babatunde Olatunji). "African dance" was the name these artists chose to define and describe their work—not "black dance." Most concert dancers of the era shunned the "black dance" moniker, seeing that it limited the ways and places in which they were funded, produced, and presented. These artists were on a trajectory with black orchestral musicians or opera artists; their protest was to demand recognition through integration. Artists like Bill T. Jones and Garth Fagan are still of the same mind, as shown in their comments in this chapter.

Seán Curran defined black dance as "dance that is made by, performed by a black person, or a white person doing a black person's dancing or choreography. I think I did black dance when I did Bill's [Bill T. Jones's] dance. It's not just about who's making it, if they're black, or who's doing it, if they're black. I think it goes deeper than that.... I think Twyla [Tharp] has made black dance." Maurine Knighton, executive director of 651 Arts, defines black dance simply as "contemporary dance created or danced by people of African descent." It is important for presenters like Knighton to have a working definition since grants, commissions, and performances are negotiated on the strength of targeted names and aims.

This section examines the constellation of issues, ideas, aims and assumptions around the terms "black dance" and, to a lesser extent, "white dance." Again, I do not believe there is such a phenomenon as black or white dance—or even a black or white dancing body. *They are cultural milestones, not racial markers.* However, as a person of my times, I cannot ignore or escape these terms. My strategy for going beyond them is to move through them. Furthermore, I recognize, with love and gratitude, the vast riches that peoples of African descent have brought to American dance, culture, and life. The black dancing body (a fiction based on reality, a fact based upon illusion) has infiltrated and informed the shapes and changes of the American dancing body. Until racism and white-skin privilege are no longer an everyday issue in American life, I believe that there is good reason to use a terminology of difference (black dance; black dancing body) that allows us to honor these contributions.

In part nine of Ken Burns's superb television series on jazz music (unfortunately, the documentary pretty much neglected jazz dance as well as women in-

strumentalists), Wynton Marsalis characterized jazz as "existence music: It does-
n't take you *out* of the world; it puts you *in* the world. It makes you deal with it."
Likewise, the black dancing body is the existential body. At its most mundane
level it is perceived as the working, field hand body, the muscles that laid the rail-
road, bore the children, endured physical hardship. In its enslavement history
this body experienced extreme forms of torture to which no animal, wild or do-
mesticated, was subjected. Yet, it prevailed. The perpetrators, both fearful of and
fascinated by the black body, were locked in the love-hate syndrome that charac-
terizes oppression. It is also the body that is perceived as most extraordinary: the
highest jumping, most rhythmically complex, improvisationally creative, longest
enduring—and with the smoothest, wrinkle-resistant skin! By dint of its worldli-
ness it can take us to otherworldly realms. That is why traditional African reli-
gions are danced religions: It makes good sense that we use our ordinary
physical bodies as a means to transport us to extraordinary flights of the spirit. In
order to understand what the term "black dance" might mean, we need to briefly
trace it back to the reality to which it refers—namely, its African roots.

Contrary to conclusions reached by outsider critics, most forms of tradi-
tional African dance are neither linear nor narrative. More likely it is the sung or
spoken word that carries a story line. Like the ordinary/extraordinary of the
black dancing body, traditional African dance utilizes the ordinary imagery of
home and community (whether mortar, pestle, scythe, animal imagery, or moral
tenets of good and evil) to reach for the extraordinary—those ineffable flights
that can be expressed only in the medium of the dancing body and are not neces-
sarily translatable into words or the verbal telling of a story. The real story in
African dance is the manifestation and presence of the dancing body. It doesn't
mean something else: It is what it is!

Bare feet in solid contact with the earth; the ground as a medium to caress,
stomp, or to make contact with the whole body (whether with serpentine, suppli-
catory, or somersaulting movements); a grounded, "get-down" quality to the
movement characterized by body asymmetry (knees bent, torso slightly pitched
forward so that, in its quintessence, the dancing body looks like Yale art histo-
rian Robert Farris Thompson's concept of "African art in motion"); an overall
polyphonic feel to the dance/dancing body (encompassing a democratic equality
of body parts, with the center of energy, focus, and gravity shifting through dif-
ferent body parts—polycentric; as well as different body parts moving to two or
more meters or rhythms—polymetric and polyrhythmic); articulation of the sep-
arate units of the torso (pelvis, chest, rib cage, buttocks); and a primary value
placed on both individual and group improvisation: All these are elements drawn
from the Africanist aesthetic and perspective.

The traditional and classical Europeanist aesthetic perspective for the dancing body is dominated and ruled by the erect spine. Verticality is a prime value, with the torso held erect, knees straight, body in vertical alignment; a diatonic feel to the dance, with a primary rhythm dominating and resolving the dancer and the dance. The torso is held still (and sometimes purposefully rigid), the limbs moving away from and returning to the vertical center, with a privileging of energy and gestures that reach upward and outward.

These differences in aesthetic languages account for a good deal of the misunderstanding that exists, to this day, between peoples of African and European lineage. They point to deep-structure differences in cultural and social mores: "In the classical Europeanist view, the movement exists to produce the (finished) work; in the Africanist view, the work exists to produce the movement. As assessed by Africanist aesthetic criteria, the Europeanist dancing body is rigid, aloof, cold, and one-dimensional. By Europeanist standards, the Africanist dancing body is vulgar, comic, uncontrolled, undisciplined, and, most of all, promiscuous."[2] However, these differences are not so marked, once we leave behind the traditional, classical African and European forms and look at the products of contemporary dance. In the dances created in the United States and Europe by blacks and whites during the previous century, these aesthetic strains are no longer separate but are, as Marlies Yearby points out, "interconnected and mixed up just as much as the blood is." A *New York Times* Sunday Arts and Leisure article by Christopher Reardon during Black History Month 2001 boldly set forth the same idea in its title, "What Is 'Black Dance'? A Cultural Melting Pot."

If black dance is a cultural melting pot, then so is white dance: It's a two-way street. But "black dance" is the only term we hear about. Once identified by mainstream critics, it had to be categorized. Many African American choreographers regarded this label as a constrictive lens that made so-called black dance the designated alien or outsider that was obliged to contrast with and measure up to the unnamed, "normal" standard—white dance. And this is why, to this day, a crop of vintage African American choreographers detest this term. Therein lies one pitfall of institutionalized racism: the belief that whites, white endeavors, and white institutions are the norm and that white American culture is not, in itself, an ethnic category. What this perspective does is to circumscribe variations from the norm as Other, under rubrics like black dance. Once the category has been established, there is little room for free movement and self-definition. Years ago Alvin Ailey asked, "Is a work I do to Bach black just because I do it? . . . I don't think *Blues Suite* [1958] is a black dance. . . . Four bars of it will be black, but what about the Cecchetti arms, all in the same phrase? I want very much not to be pegged."[3]

Here are some reactions from interviewees when asked what the phrase "black dance" actually means:

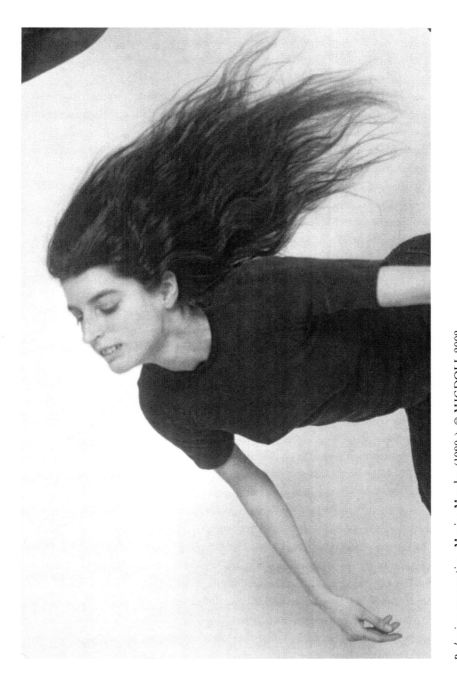

Packaging our perceptions. Monica Moseley (1980s). © MIGDOLL 2002.

Monica Moseley: "It becomes a kind of intellectualization for me—presenters' language. . . . One of the things that comes up is the presentations that have been done at BAM [the Brooklyn Academy of Music] and 651 Arts, where they have kind of packaged the performances to attract audiences based on that. And it's a strength and it's also a limitation."

Joan Myers Brown: "That term, black dance, I think it comes from the media more so than the field. . . . [Some major presenters] still only present one black company and then that is the flavor of the month. And I always say that Philadanco [the Philadelphia Dance Company, founded by Brown in 1970] is the afterthought: after you can't get Ailey and after you can't get the Dance Theater of Harlem, and then after you can't get the flavor of the month, you say, 'Oh, but there's Philadanco.' Keeps us working, but still we're the afterthought."

And, according to Marlies Yearby: "More as a choreographer have I experienced what it is to be black in terms of how we get presented. There's that kind of dynamic that . . . [implies] 'we already have our black,' or 'we have our slots, and our slots are filled.' They don't say it that way, but that's what it amounts to . . . basically that's what the codified language means: what money exists out there for us."

Besides the voices that address the black dance issue from the standpoint of funding and presenting, others focus on the philosophical questions behind the terminology. From his perspective as a ballet-trained African American male who danced in Europe for most of the 1990s, Zane Booker has this to say: "If you change the music and the color of the people, is it still black dance? Are we talking about just the way the movement is done? And maybe the answer is yes or maybe the answer is no. I am sure that jazz and hip hop and the like are definite forms. But I think that we become so defensive about it because it has been separated from everything else. . . . Whereas if we had called it 'postmodern contemporary'—I don't know, made up some term—it could have been more acceptable and palatable. But because we always get singled out and then shoved over to the side and put in a box we don't want to accept the term."

Garth Fagan is forceful about the limitations and selective discrimination inherent in the use of the term "black dance": "I get in trouble because I don't use it because it limits. And whose definition is this? And are you talking about African dance? Are you talking about Caribbean dance . . . New Orleans jazz? You know, what are you talking about? [Is it that] . . . the choreographer happens to be a person of color, or happens to be an African American, or happens to be an Asian, or whatever? But the first thing is that they are a choreographer who happens to do that [namely, to choreograph]. Because in the white world, I don't hear those distinctions. . . . When I use my cultural background, which is Caribbean and African, and when I get rid of the African adornment and the straw and the fabric—which is nothing wrong with that, I love that—but when I choose to just

take the movement and blend it into the modern ballet vocabulary, then people can't see it [as the category that is labeled and recognized as black dance], and they get upset. But if it were another culture [that is, white culture] done that way, it would be wonderful, hello and hosannas, you know."

Such ideas are present and strong not only in the dance world but also in the realm of visual arts. What Holland Cotter points out in a review of a 2001 exhibition of African, Oceanic, and ancient American art at New York's Metropolitan Museum of Art is relevant here: "There is no small art and there are no small cultures; there are only constrictive or expansive lenses to see them through."[4]

The terminology/nomenclature issues arise again and again. Language shapes our perceptions. Innocent-sounding terminology can have the effect of a slur, an epithet, a major insult, or an aesthetic limitation. In "To Have and Have Not," an article in *American Theatre* about the need for artists to empower themselves, arts advocate and activist Jaan Whitehead warns: "The relationship of language to identity is one of our least appreciated issues. Language is always more powerful than it seems in everyday life. It expresses our view of ourselves, but it also constitutes that view. We can only talk about ourselves in the language we have available. If that language is rich, it illuminates us. But if it is narrow or restricted, it represses and conceals us. If we do not have language that describes what we believe ourselves to be or what we want to be, we risk being defined in someone else's terms."[5]

With the body as the medium and the (tyranny of the) ideal dancing body as the message, dancers are particularly vulnerable. Black dancers—or, more clearly, dancers of African and African diasporan lineage—and dancers like Doug Elkins, who openly embrace Africanist dance forms, face the added jeopardy of a language that basically states that one form is normative and others inferior and/or auxiliary. Things may have changed since his undergraduate days in the dance department at the State University of New York at Purchase; however, here's what Elkins recalls about the general attitude of the dance faculty in the early 1980s toward his dance preferences:

"When were talking about white [dance] identity, it used to be presented like 'This is right. The other things are interesting games and experiments, but if you really want to dance, they are apparitions, they are bastardizations of the real thing.' . . . I remember constantly being told by the ballet teachers, 'This is ballet. This has a four hundred year history. It is right.' . . . Mel Wong was my mentor and a person for me to talk with: 'They're telling me I should stop break dancing so I can focus on becoming a real dancer.' And he said, 'you *are* a real dancer. . . . Don't let someone fool you by thinking that they're going to make you real.' That was helpful. There's an Yvonne Rainer quote, and I'm paraphrasing it: One of the hardest things to learn to ignore is other people's explanations of who we are."

Marlies Yearby sums it up neatly: "I'm ready for the language to be changed—it's sort of like that 'downtown' and 'uptown' dance—I'm ready for all of this language to just go away and be changed, because we're never going to deal with the real historical content of how the music is the way it is, how the dance is the way it is. We're going to constantly feel like we have to edit ourselves and not vision ourselves in the way that we completely are. . . . And at the roots of all of what is considered American art sits our voice, so completely strong. So, how do we claim our place in that if we're still trying to make it 'black dance' and 'white dance'?"

(In dance jargon, "uptown dance" designates formal, traditional modern dance and is frequently the code signifying black dance. "Downtown dance"— also known as postmodern dance—is the loose, less structured, experimental form(s) that emerged from downtown Manhattan venues like Judson Church [in its 1960s heyday as a venue for alternative dance]; it is the code for white dance. These terms parallel the use of "rock and roll" to mean "white" black music, if you will, and "soul," or "rhythm and blues," to designate "black" black music.)

APPROPRIATION AND EXCHANGE

There are some b-boys [dancers who perform to the break beats created by hip hop DJs; break dancers] who find the shit I do, it's not "true school," and I understand. It's become something else. It's become part of something that has shaped me. I don't have a claim to being "ghetto original," but I have a loving respect, and not just for the thing itself, because the thing itself is made up of the people. You know, you can collect African art, but, "well, I don't know any black people, I just collect African art."

—Doug Elkins

My ignorance was such that I grew up thinking jazz [dance] was a white form. I mean, I thought jazz was something that you saw on TV. It was the June Taylor dancers or whatever. It was like shoulders and hips and cute looks and stuff like that. And even when I was studying with Matt Mattox I didn't know it was a form that came from black culture, or that Katherine Dunham had anything to do with jazz . . . and I always thought of jazz as very slick—you know, Juliet Prowse on TV or spangled costumes and all of that. So I didn't know until maybe 15 or 20 years ago.

—Wendy Perron

Doug Elkins and Wendy Perron are talking about the way black cultural proper-
ties wend their way into white realms. What differentiates appropriation (or, less
politely, rip-off) from exchange? As I have said in earlier books and articles, I
believe that it's a question of who's got the power, be it the power of the purse or
the power of persuasion. Because white-skin privilege confers a degree of power
upon the most well-intentioned of its carriers, a benign act of cultural borrowing
can have the effect of a calculated theft. On the one hand, we can look at the ir-
refutable fusion of cultures and peoples—black, white, and brown; Native Amer-
ican, European, African, Asian—in the United States and say that it's irrelevant
to talk about appropriation: Everything is up for grabs, and everybody does it,
on all sides. On the other hand, given that racism and white-skin privilege make
the playing field a grossly uneven ground, it is important to acknowledge and ex-
amine the issue, should we ever hope to get through it and transcend it.

Without belaboring this question, some explanation is in order. First of all, it
is clear that cultural exchange is a two-way street, with many side roads and al-
leyways shooting off from the central avenues that house the keys to the cultures.
To understand this complex process more clearly, I've begun to think about it in
the following way:

APPROPRIATION leads to APPROXIMATION leads to ASSIMILATION. This
applies not only to performance, but to other sectors of society as well. What it
means is that manners, behaviors, styles, trends, phrases, motifs—*tropes*—from a
given cultural realm are appropriated by another culture but are obliged to go
through a transformation in the process. They must be made to approximate a
look and texture, feel and shape, that will meet with the aesthetic approval of the
appropriating culture before they can be assimilated. This is a natural process.
Cultural arenas manage to keep themselves alive and well by frequent injections
of new blood from Other cultural arenas. However, those outsider injections
must measure up to the reigning aesthetic in the host culture in order to be rec-
ognized as "one of us"; they must tally with the host comfort zone, if even at its
outer limits.

Whether it is Alvin Ailey or George Balanchine, the model applies. Thus,
when a Balanchine ballet like *The Four Temperaments* utilizes Africanist dance
characteristics—kicking, rather than placing the leg extensions; allowing the
pelvis to be pulled off center; flexing the hands and feet; letting the energy deter-
mine the form, rather than the traditional ballet convention of letting form, and
the vertically aligned spine, dictate the outlay of energy—it doesn't come out
looking like an African dance but like European ballet with a "jazz" accent. And
when Alvin Ailey fuses ballet, modern dance, and African American social dance
characteristics, we don't think that this is the New York City Ballet performing

Revelations. That's why Doug Elkins says that his b-boy style may be character-
ized as "not 'true school.'" He has melded it with his own "school" as a Jewish-
Chinese, Brooklyn-bred American male who has lived and trained equally in
so-called white and black milieus. That is also why dancer-writer Wendy Perron
could have lived through a significant portion of her adult life without realizing
the black roots of jazz: the version she encountered, as a person moving in white
circles, had been finessed and distilled to a form that could be assimilated into the
white aesthetic because it approximated what was already there. In other words,
the "new-unknown" is obliged to take on characteristics of the "familiar-and-
known" in order for assimilation to occur. Many of us would characterize this
process as a watering down of the appropriated culture's aesthetic.

For example, the original African American swing music developed by
the likes of Louis Armstrong and Duke Ellington ended up as the music
played by the Dorsey brothers and Lawrence Welk; and the Lindy Hop, as
developed in African American ballrooms by dancers like Norma Miller, Leon
James, and Frank Manning in the swing era (1930s–1940s), became the Jit-
terbug, a social dance of white American teenagers. On the black side of the
equation, the assumption by the dominant, white culture has been (through
custom and tradition) that, in order to gain legitimacy, black forms (and black
folks, in all walks of life) need to take on white characteristics. Thus, it is not
looked upon as appropriation that Alvin Ailey melds African American forms
with ballet and modern dance, or that Arthur Mitchell founds a company of
black dancers performing white-based ballet: The more the culture that is re-
garded as inferior/auxiliary takes on the characteristics of the dominant cul-
ture, the more the dominant culture takes this move as proof of its superiority.
It is right, it is the normative standard, and all others should measure up to it
and buy into it. It is in this context that the term "black dance" takes on a par-
ticularly demeaning connotation.

When asked what images came to the mind's eye when I used the term "white
dance," several interviewees named Trisha Brown, the renowned postmodern
dancer-choreographer, as the object of their gaze. But a dancing body like
Brown's could not have come about without the influence of a jazz (read, black)
aesthetic working on her, albeit subliminally. Her first dance teacher, Marion
Hageage (with whom she studied from 1946 to 1954 in Aberdeen, Washington,
where she was raised) was a jazzy type who "played the piano, drank coffee,
smoked cigarettes, then would get up and dance across the small studio floor, and
I would follow, learning the moves." These "moves" were Broadway-type jazz
routines finessed to a white, small-town acceptability, as described by my appro-
priation-approximation-assimilation model. Brown also learned the Jitterbug and

studied Dunham technique with Ruth Beckford (African American) while major-
ing in dance at Mills College. (This movement vocabulary, developed by and
named after anthropologist, choreographer, and dancer Katherine Dunham, is a
fusion of African, modern, and ballet; both Dunham and Ailey were masters of
fusing Africanist and Europeanist genres to come up with something altogether
fresh and new.) Nevertheless, Brown freely and forthrightly admits that it was
only recently that she became aware of black influences as a major force in her
artistic development. In a February 2000 *Dance Magazine* article, written to pre-
cede the premiere of her work *Rapture to Leon James* (an homage to the late, great
Lindy Hop artist), she commented to reporter Elizabeth Kendall "that all the so-
cial dance in America comes from Africa, and therefore, that her own dancing has
been African all along."[6] On the following page, in a very telling quote that closes
the article, Brown declared, "We're all African-American when we're doing this,"
a very deep bow to the extent of her indebtedness to this heritage. So what is a
white dancing body or a black dancing body, given a statement like this?

Elkins echoes Brown's sentiments, taking in an even bigger bite of black cul-
ture: "I remember when I was watching Spike Lee's *Crooklyn* a few years ago and
going 'I know this.' I recognized parts of this, things like watching *Soul Train* and
everyone wanting to be [a basketball legend like] Walt Frazier or Earl 'The
Pearl' Monroe—like a small subtext of cool." Yes: black culture brought to the
white avant-garde "a small subtext of cool," a phrase that bears repetition.

Meredith Monk adds an interesting contribution to the discourse: "At a cer-
tain point I felt that I couldn't go to ballet class anymore because I needed to
spend the same energy really exploring my own vocabulary. I had done that
when I was in school, at Sarah Lawrence, but I felt that if I was going to take
ballet class every day, then that was the energy of the day. At a certain point, I
started exploring more the internal articulations of my body. And I felt that that
came from that social dance thing, of really exploring the internal, little, tiny gra-
dations and little, tiny articulations of the body. And then suddenly all kinds of
revelations started happening about how you really needed to have a 'released'
body . . . [that] that linear kind of idea of the body would get in the way of those
little articulations. I think that that was very inspired by black [social]
dancing. . . . So I think once you experience that, you can't really go back to just
form and shape anymore."

What is important in Monk's development is the fact that she was able to expe-
rience the world of African American social dancing at a time (the 1960s and 1970s)
when blacks and whites freely socialized in downtown Manhattan. During that pe-
riod, New York City's Greenwich Village and, more important, the Lower East Side
(part of which was later given the more fashionable "East Village" moniker) were

convergence centers for a covey of radical people and movements that rubbed shoulders (and other parts) with one another: hippies; free-form jazz innovators like Albert Ayler, Archie Shepp, and Ornette Coleman; poets like LeRoi Jones (who, at the early end of this spectrum, was married to Hettie Jones, a Jewish woman, and had not yet transformed into the charismatic Imamu Amiri Baraka); visual artists, black and white; Civil Rights organizers, black and white, some of whom would later become martyrs or university professors; African nationalists who helped all of us understand that black is beautiful and taught us West African (largely Yoruban and Asante) music and dance forms; and a slew of modern and postmodern dancers, black and white, including people like Meredith Monk, Deborah Hay, Gus Solomons jr, Judy Dearing, Elaine Shipman, Barbara Ensley, Yvonne Rainer, and Dianne McIntyre, amongst many others. Parties that began "round midnight" and lasted until dawn were commonplace and were marked as much by free form, improvisational dancing as they were by the boundary-blurring social drugs that were so popular at the time. Unlike the white middle-class kids in America's heartland who lived in segregated enclaves and learned the Jitterbug (or, later, the Twist, Frug, and Monkey) through television and white imitations, Meredith Monk and this avant-garde crowd met, moved with and learned from the black dancing bodies whose culture had spawned these dances. An in-the-flesh experience goes a long way in solidifying a muscle memory.

Exchange is at one end of the spectrum; appropriation is at the other end. Here is what Seán Curran, Irish American, says about a common practice in contemporary dance studios and, by extension, in other walks of contemporary life:

"It's sort of trendy to be in hip hop class or to learn how to break dance or to be in an African class. And I think it's great—you know, spread the word—but I've taught at studios where after my class it's an African class, and there are people there treating it like an aerobics class. And to me all dance is more sacred than that. And there's something icky about—or inauthentic, I don't know—white women in do-rags and sarongs. I don't know how else to describe it, but it's a need, a want, a desire, to be the Other. I'm guilty of it, too. You know, I'll go into my snap-queen thing and try that, or I sing along to the radio and try to sound like Destiny's Child or Peabo Bryson."

(Turban-like head wraps are commonly worn by females in various African cultures and have been adopted by African Americans. "Do-rag" refers to a head wrap intended to maintain one's hairdo. In many African dance classes, even those held in ethnically mixed dance studios, a sarong-like "lapa" or wrap skirt is traditionally worn by the women.)

Curran's description is true not only in the United States but also in Europe and around the globe. It is *black* American culture that in many ways distin-

guishes American culture from European culture. White Americans differ from white Europeans by having easier access. So it was refreshing to speak with contemporary dancers who could openly address their indebtedness to black dance—whatever the term means—and the cultures from which it arises.

Brenda Bufalino graphically depicts the "need, want, desire" described by Curran. She was raised in a white suburb of Boston and attended dance classes since she was a toddler, but she never studied with a black teacher until she went to Boston as a teenager:

"It was such a dramatic difference when I went to Stanley Brown's [classes] and I saw a contraction. I almost fainted from ecstasy! I will never forget that moment as long as I live. . . . [In his classes I learned] this wonderful animal-like quality because of the gestures of the dance and what the gestures called for that I continue to use in my work to this day. And I definitely do associate it with black dance. . . . Not European. . . . When I saw that, I didn't see it separate from my white body. I saw it as something that held promise for *me* in my white body. So it wasn't this separate thing. It was as soon as I saw it, there was more of a symbiosis of 'Oh! That's also me!'"

A "contraction" is an Africanist means of articulating the torso by simultaneously rotating the pelvis and/or rib cage backward, rounding the spine, and folding—contracting—the abdominals; it is also the movement principle that, with an altered aesthetic emphasis, constitutes the major force in the modern dance technique of Martha Graham. It is interesting that Bufalino associates Brown's dance style with an "animal-like quality." The Africanist, articulated torso and bent-kneed, get-down postures draw attention to the pelvis, abdominals, breasts, and buttocks, which, by Europeanist custom and tradition (if not stereotyping), suggest our animal nature. The verticality of Europeanist ballet and folk dance suggests moral uprightness and a moving away from animal nature toward a more ethereal imperative.

A little later in her career Bufalino was surprised to find commonalities between what she was doing in an Afro-Cuban dance setting and what was choreographed in a neo-classical ballet:

"When I was with the Bobby Clark Dancers [an integrated dance company, led by an African American and based in Boston] in the early fifties, I did Afro-Cuban [dance styles] on point. . . . And when I saw *The Firebird*, I said, 'I'll be a son of a gun: a contraction!' So, watching the bodies go, watching us all perhaps . . . having more of our body parts become more available to us through the African influence, I think it has just influenced all of the dance, [just] as the white abstraction and line have influenced black movements and black companies. . . . I just kept seeing the gradual integration of more accessibility of body parts in the dancing, even from [Martha] Graham."

When I commented that Graham could not have utilized a European model for her signature contraction, Bufalino responded: "No, no: she did not. And conversely, Bill T. Jones would not have gotten those lines, the drama of those lines, from Africa." In talking about "having more of our body parts become more available to us through the African influence," Bufalino echoes Monk's sentiments about exploring subtle gradations and articulations of the body through African American social dance. She was careful to contextualize my comment on Graham with her response about Jones, cautioning me to remember that all exchange is not appropriation and that cultural borrowing is a two-way street.

Bill T. Jones extends this train of thought: "just like I say that there's some sort of a machine out there that turns out hundreds of singers of every race who sound like Aretha Franklin. It has to do with exposure, repeated exposure. It has become 'the inflections, the colorations.' I dare say the 'mannerisms' of black dance are fed into children at a very early age through the medium of television and the movies. So I don't know if the words [black dance, white dance] mean the same thing to a generation right now."

Indeed, black cultural sources infuse white forms, and white cultural artifacts have been assimilated and transformed by black culture to meet its own needs and priorities. Just look at how, after their enforced conversion, black peoples' prerogatives changed the face, shape and rhythm of Christianity; and then those changes were reabsorbed by white Christians in a recursive cultural pattern that produced charismatic white speakers like Billy Graham and his ilk, as well as Pentecostal forms of white worship—and myriads of Aretha Franklins! We know that black and white cultures have interfaced ever since we met on these shores centuries ago. We also know that the past century witnessed fusions, exchanges, appropriations, and recursions at a level as accelerated as the century itself. Elkins, Curran, and Bufalino lucidly affirm that what they saw black bodies doing represented something that they recognized as themselves. So what are the forces that perpetuate a black/white dichotomy? What about the bodies?

BODIES

I think it's a cop-out to say that our bodies aren't made for anything. It's just a cop-out. And I think the culture of the whole thing comes through: who you are, what you've experienced, and how much you want it.

—Zane Booker

The kids today . . . their technical skills are proficient, so they're able to do whatever it is that they have to do because they know how to do it, and it isn't about the body, I think it's about the training.

—Joan Myers Brown

I'm sure the new generation of black dancers admire their own looks, because they know they function well.

—Gus Solomons jr

Whatever the constellation of traits, habits, preferences, and variables that make up the black dancing body, it is clear that white dance culture has been fascinated by this construct. In general, the black dancing body has been scrutinized by the dominant culture through the lens and theory of difference. Naturally, the point of origin of any theory largely determines its outcome: differences in the dancing body of an oppressed people were occasionally valued but frequently scrutinized for signs of inferiority. In the white world, dancing bodies were measured against white ideals that ran counter to the aesthetic criteria of "inferior" Africanist cultures, even though the dances performed by white dancing bodies were either solely or partly based on Africanist elements. Thus, social and ballroom styles, Broadway and cabaret forms, as well as concert dance forms (modern dance and ballet) dealt with blackness in the "appropriation-approximation-assimilation" manner already described. The result was that, in the 1900s and 1910s, Vernon and Irene Castle "corrected" popular African American animal dances of the era (Turkey Trot, Possum Trot, Fox Trot) to white aesthetic criteria.

Social dance schools, including the legendary Arthur and Katherine Murray academies, and white Broadway and Hollywood choreographers performed similar corrective surgery on the popular African American dances of the swing era and beyond. As an adolescent in the 1950s I recall watching the Murrays' weekly television show. With not a body of color in sight, this middle-aged couple taught the socially sanctioned, white way to do the latest dances. Models like this made a kid like me feel that black dancing was dirty and white dancing was dull. Still, I wanted to dance. I dreamed of being both correct and sensual. My models were Bambi Lynn and Rod Alexander (the dance team from TV's *Your Show of Shows*): squeaky clean but, at least, romantic; and Hollywood's cool but always sexy Cyd Charisse.

Recently, with the advent of body therapies, the dance world has found a language and means of dealing with difference in the dancing body. What these therapies (such as Alexander, Pilates, Klein, Trager, and other techniques) have revealed is that the issue to be faced is not inferior or superior anatomies, but

alignment, cultural movement choices, and habits. One can align the buttocks, rather than stick it out; and work the feet to point, rather than articulating them in a get-down, earthy, flexible position. In other words, the question is not about biological difference but, rather, "Can you work it?" The black dancing body has proven that, given equal opportunity, it can "work it," whether the "it" is ballet or booty dancing. With social and political obstacles removed, it can do any so-called white form, and, inversely, white dancing bodies, if acculturated and schooled in a black way, can execute so-called black forms. As Zane Booker insinuates in his quote above, it is only bias, ethnocentricity, or racism that blinds us to these facts.

Many of the people I talked to echo these opinions. Yet, in the same breath, a few also express the paradox: namely, that there is and there isn't a black dancing body, or that white and black bodies are and are not the same. I attribute the differentiation to cultural factors—familial, social, communal and aesthetic values, preferences, proclivities, and habits (physical and mental) absorbed in utero and reinforced thereafter during each period of development from infancy through childhood, adolescence, and maturity. Nobody disputed this contention, although they addressed the fact that differences were apparent.

According to Gus Solomons jr, "The important differences between black and white bodies [are] from the waist down: the leg, the proportions of the leg, the overly long shin, that very functional calcaneous [heel] which makes the gastrocs [calf muscles] work more efficiently, and that's why they [the calves] don't have to be big, you know, and that's why we [black people] have that jump. They're the very thing [the long, slim shin and calf muscles] that visually . . . [I] don't like—well, that's me, because I'm neurotic!"

Following the conversation with Solomons, I came upon exceptions to his claim. At a Brooklyn flea market, from a dealer in vintage magazines, I purchased the November 1944 issue of *Strength and Health* ("Published Monthly by the Strength and Health Publishing Company . . . York, Penna"). The cover photograph shows an example of the ideal (white) male physique of the World War II era. The model is identified as a co-owner of and instructor at a California gym. His lower legs—gracefully developed calves and elongated, slim shins— match Solomons's description of a supposedly characteristic black body trait. A more up-to-date example that comes immediately to mind is the long, skinny shins of Matt Geiger, a white, former 76ers basketball player. For every trait that we connect with a particular ethnic group, there is enough variation from the norm inside the group and examples of the norm outside the group to make us reconsider our assumptions. Whether black, white, or brown, when one is tall, lanky, and slender one is likely to have long, slender shins.

Garth Fagan qualified his comments by asserting that the very qualities attributed to black bodies are in fact cultural proclivities that can be acquired by whites:

I see the black dancing bodies — and this might be cultural, not genetic — they're more in touch with their backs, especially their lower backs, for undulations for doing your contraction from the back, as opposed to just isolating your upper body for contraction in a white dancing body. And again, *I underline that a white dancing body can do that if trained* . . . and quick, rhythmic, dynamic shifts, a liking for that; and a kind of volume or mass in movement, which harkens back ancestrally to primal-earth-stomping ways. I see broader shoulders, narrower hips, more gluteus maximus in the back [translation: more buttocks], more heel on the foot, a more earthy way of moving and a sense of passion in the movement. And that goes even for ballet, you know. And with the white dancing ones again, I see the four square rhythms, constant four square rhythms, but that goes back to the early folk dancing, you know — and the erect back, the isolated head and neck. When I tell my dancers, you know, "Just relax the head, let it carry its weight, I want to see the weightedness of it," they're trained not to do that. *And again I underscore, these are generalities. I know too many people of either race who break the stereotypes and plan to do it.* [Emphases mine.]

Fagan's observations, particularly his final point, are significant: By and large, we move the way we choose to move; we learn, practice, train in, and absorb what we like. (And, to quote Brenda Bufalino, "it is the movement that pronounces the shape.") The perception that blacks have "more heel" is a tricky one that is partially based on the assumption that blacks, in general, have less lateral arch in the foot, causing the heel to protrude; and more directly based on skin color differentiation between soles of feet (and palms of hands) and the rest of the black body. Thus, the whiteness of the black heel stands out in contrast to the ankle and leg. Some things, including heels, palms, and perspiration, are simply more visible on black bodies than on white.

On the other hand, ballerina Francesca Harper addresses the ounce of truth in the stereotype of the African American dancing body: "I don't think white bodies are as muscular as blacks, and I say that proudly. It is still wild to see how amazed they are at how our bodies are so defined and strong. . . . And I think that it's harder for black women. . . . You have a double-edged sword: to be a strong woman is not necessarily what people want all the time."

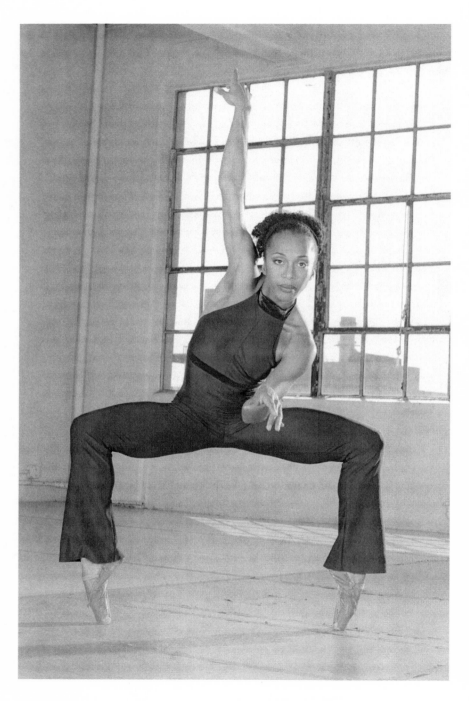

Bodies "defined and strong." Francesca Harper. Photo by Richard Termine.

Solomons slightly shifts Harper's paradigm, addressing strength in terms of energy:

> Joan Acocella [dance critic for the *New Yorker*] said it: "They dance like their lives depended on it," and that's really true.[7] It's a kind of hyper energy. Black bodies tend to be put together strongly—you know, the connections are good and strong. For instance, I often compare the difference between Balanchine's women in *The Four Temperaments*, coming in [Solomons refers to the female quartet in the ballet's "Melancholic" variation]. . . . Those legs were just not connected at the hip whatsoever, and they just went up. When I saw DTH [Dance Theater of Harlem] do it, those legs had power behind them! You know, it was really different. They went just as high, but they weren't loose. So when black dancers move, my image is that they take advantage of those strong connections in their bodies so they can be reckless in a way that white dancers can't be.

Choreographer-dancer Hellmut Gottschild (my husband) insists that this difference is due to "the ballet ideal of effortlessness . . . not the difference of musculature." He contends that the differences Solomons points out should be attributed to "white ballet-trained dancers," not simply "white dancers."[8] However, the DTH dancers that Solomons alludes to are superbly trained in ballet's ideals and techniques, and that is where Solomons saw difference. What is the difference? Is it in the dancers or in the culturally conditioned eye(s) of the perceiver(s)? Is it a question of different styles, ballet or otherwise?

Pursuing Solomons's line of thought, I asked whether this energy varied or changed in terms of different dance techniques. He responded: "Does it? Let's see. . . . The first black man in Trisha's [Trisha Brown's] company . . . his dancing seemed much more presentational than the rest of the dancers in the company. And there was nothing he could do about it. He was doing the movement all the way it was supposed to be done—just right—but it looked more powerful. I thought in a way that he looked out of place, because he wasn't completely liquid. Or maybe they were tea, and he was black coffee."

As we continued our conversation, Solomons's comments further illustrated the fact that, in spite of difference, black and white dancing bodies are equal in potential. Perhaps the paradox—and the lesson to be learned—is that "equal" does not mean "same," a realization that suggests we might consider revising our aesthetic canons (or, at least, making them less rigid) so as to honor that insight. Here follows a portion of our dialogue:

GS: I think, in general, dancers—the homogeneity of dancers is increasing so that if there aren't political reasons for separating races the availability of all colors of dancers is there to do all styles: For instance, in Europe, where black dancers get to do all those things. I must say, to their credit, [New York] City Ballet has, what, three black women?

BDG: But if, as you say, bodies are becoming more universal or the same, then what about what you mentioned a little earlier, about this black energy?

GS: That's still different. I think it has a lot to do with context because, for instance, I saw ABT [American Ballet Theater] do a Ulysses Dove work a few years ago. He had those women dancing just like Ailey's people; he gave them the imagery that made them fiery. I was astonished. I mean, people like Julie Kent and Susan Jaffee were just slashing their legs! They were lookin' good!

BDG: It can be trained, then?

GS: Absolutely, absolutely.

Brenda Bufalino addresses some changes in the black dancing body that are eradicating the differences and offers more evidence that, through training, body shapes can change to conform to a given aesthetic code: "You certainly see bone now with Arthur Mitchell's company [the Dance Theater of Harlem]. . . . I also think you see what you would call more of a white body on blacks now who aren't doing ethnic dance. I mean, I think that *it is the movement that pronounces the shape,* you know, so that's a very big part of it. I mean, in ballet you tuck [the pelvis and buttocks] under. In Afro-Cuban you pull [the same area] out. Even on Broadway, I can remember how I really didn't like [Bob] Fosse, shame on me, because he started putting the pelvis to the front all the time: I didn't like it." (Emphasis mine.)

Joan Myers Brown's thoughts reinforce the comments made by Solomons and Bufalino, suggesting that dancers' bodies are shaped by training, not biological imperatives: "The training for dancers has improved so that black dancers are being trained equally as well as white dancers in this generation. Early on, the training that most of us got was in black schools, and that was limited. So I think the comparison to, maybe, the 1950s and 1940s is different from what the comparison is now, because of the training. Maybe [back then] we didn't know how to do fouetté turns [a particularly challenging ballet turn that is a mark of showmanship and is performed in place with as many as 32 repetitions by the most accomplished ballet dancers]. We saw it and we emulated it, but we weren't taught how to do it."

One could draw the wrong conclusion from these statements and assume that the black dancing body is the black sheep, the poor cousin, in need of loans from the rich, white relative. This is not the case, nor was that the spirit in which Solomons, Bufalino, and Myers Brown offered their comments. Portions of nearly every interview drove home the fact that cultural exchange is a two-way street, with cultural enrichment standing at every corner. Similar to Meredith Monk's comments on her experiences gained from black social dance, Seán Curran touched on the challenges offered to the white dancer moving in black milieus: "For Bill [T. Jones], his abilities are so far-ranging, it's almost like his movement vocabulary is just so full that there's more capabilities, and I think in a way it has to do maybe with the black dancing body. There is—in terms of joints, like shoulder joints and hip joints—there's more movement possibility. The whole idea of "back space"—something Ron Brown is really playing with—is an African thing. My body, I don't know if it's the white body, it just doesn't do that. And also a looseness, a freedom. I think it had to do with a lower sense of center [in black dancers]."

Idealized shape and size, so significant in Europeanist forms of concert dance, black or white, take a back seat in traditional Africanist forms such as African dance and hip hop. According to Chuck Davis: "In traditional dance, size is the last thing you worry about. If you can dance, then you can dance. And coming from the tradition, those of us who travel back and forth to Africa know that, in the compound when the drums begin, the person jumping out in the center of the floor does not look down and say, 'Oh, am I skinny enough to be out there today? Do I have a dancer's body?' No! There is a rhythm, and I have to interpret it, and I am interpreting it according to my ethnic heritage, and here I go. Welcome to the real world!"

Ron Brown reiterates Davis's observations, from both performer and audience perspectives: "I think there is still a kind of marvel at people [dancing] who are 'people size,' like normal bodies. There's still this 'oh, wow!'—this fascination." Brown recalls meeting someone who wanted to take a master class that he was teaching during a residency but was afraid because she thought she was too big. "And I said, 'Oh, no! You're not too big! You'd be surprised—even in my classes in New York, people are all different sizes.' So there's a happiness about it, that we can do it—people your grandmother's size can dance. . . . From black people I hear how nice it is to see people of all sizes on stage. White people don't really mention that about my work specifically. I think white people probably just see that exotica that we're talking about." (Critics of all persuasions have raved about Brown's transformation and fusion of the Senegalese Sabar dance style into a postmodern concert dance form.)

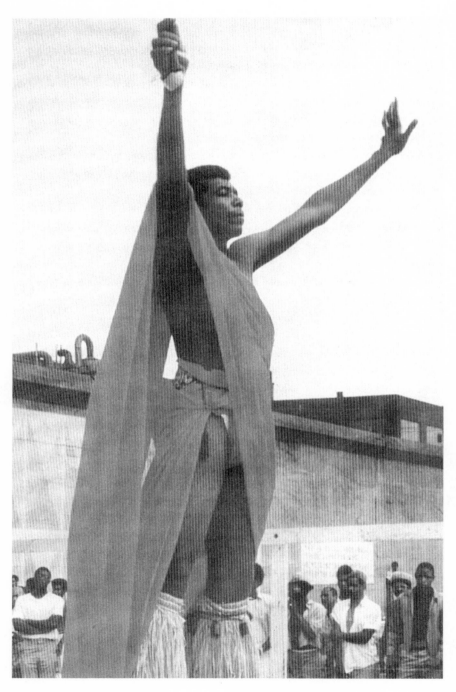

"Welcome to the real world!" Chuck Davis (1970s). Private collection—Chuck Davis's African American Dance Ensemble, Inc.

This section concludes with an extended anecdote related by Brenda Bu-
falino at the very end of her interview, augmented by a thought-provoking re-
flection from Bill T. Jones. The two statements complement each other and
eloquently address what needs to be said about bodies and cultures, black and
white:

Bufalino: Well you know, from my experience, we are such creatures of
our environment, and our environment is what shapes us. I went to
Africa, to Togo, in 1978, with my mother because she went very often.
Her husband was in the Peace Corps. And he and she made many
friends there. . . . And there was never a funeral. I kept saying, "I want
to see a dance," but nobody died.

So then they gave me a funeral.[i] This whole village came out to cel-
ebrate my death. . . . I guess they didn't think I looked like I was going
to get married, so they decided I was closer to death, and they gave me
a funeral! So I'll never forget dancing at my funeral on the beach, and
here I had done all this work with Sevilla [Fort], and I was still doing
that kind of dancing even then, you know . . . what they call "modern
primitive," and they kept coming over and saying, "We recommend
you," or "We give you a one hundred percent!"

They were so shocked to see me do that stuff, and we were all on
the sand. And I thought I was going to die, but I wouldn't stop. . . . I
must have danced for hours, but I was so impressed about how my
body took the shape of the environment I was in: the pull of the gravity,
this sense of the moisture—the whole environment. That's what creates
these body types, and that's what creates the movement in that it also
helped to form the body type. You are responding to gravity, ultimately.
Or resisting it. . . . It's not only the body type. And then the body type is
created by the generations of gestures. It absolutely fascinates me. So,
from feeling it in my own body, I felt like I understood something, in a
much deeper and more powerful way, of all the years I have trained, of

i. Life passages—births, deaths, weddings—are prime times for extended ceremonies in
many traditional African cultures, involving music, dance, poetry, and song. Most African
cultural traditions are not rigid but fluid aesthetic concepts that embrace improvisation
and spontaneity as first principles. Even rituals are flexible in form and content. Humor
and irony are also valued, so the idea of a funeral for a living Other would be an extension
of a worldview that venerates ancestors and regards life before birth, on earth, and after
death as a continuum.

what "the black body" was about. And it was a great honor for me to understand that. And something in my history, genetically or even by response to gravity, had something to do with that "simpatico."

Jones: See, I find that there is an impulse in my dancing that is to find the heroic shape or the grand path, which I would call "white dance." And then along the way it is diverted and there are rivulets of this current, this shimmying, this lasciviousness, this undulation or this warrior dance that is what I call the "black dance." What is the edifice? The edifice I always think is a mental construct or an idea, and I would say that is the white dance, which I have learned to make my dance. My edifice is a white edifice. And then inside of it is populated with—how to say it in the least sentimental way?—black spirits. And they are sometimes male and sometimes female: how the hips are used, how the arms are used.

In a nutshell, body "type" is not fixed and static, but fluid and mutable.

ATTITUDES, RECEPTIVITY

How much are attitude, spirit, soul, and other ineffable attributes of character and energy significant in shaping and defining dance and, for our purposes, the black dancing body? Gus Solomons jr arrives at important and revealing observations about an attitude—one of risk and daring, emotionally and/or physically—that seems to him a definitive characteristic of black dance and dancers, and even black audiences. Here is a portion of our dialogue:

> GS: I've watched black audiences watching black performances, and missing the turns is less important than having gone for them, to the audience. It's not the accomplishments; it's the magnitude of the attempt that impresses them. In fact, if you fall off it they're much more likely to think you did a better job because you went for it.
> BDG: Now, would that be the same with the dominant culture?
> GS: Not at all. The white dominant culture sees the perfection in every accomplishment: You'd better not fall off that turn! As a matter of fact someone fell last night [Solomons had attended a performance by the American Ballet Theatre]. She was doing a flip over [her partner's] back, and she just went splat! I mean, there was no way to save her. She jumped back up and went on, but the whole audience went "'gasp!" And then, when the lights went out on the sec-

tion, there was this silence, too. Then the audience . . . [applauded
as if to say], "It's all right, it's okay, we love what you did."

BDG: Well, doesn't that sound like the black audience?

GS: No: That was an *accident,* that was sympathy; that wasn't admira-
tion, you see? In other words, it wasn't because she went for it and
didn't [make it], it was because . . . it wasn't her fault; it was out of
her control. It's about control, [which] is a big issue in white cul-
ture, and that's what you see, in spades, in a ballet company. People
have infinite control over what they do. The more control they ex-
ercise, the more the performance is esteemed. A dancer does five
turns; you think, now four, okay, four is good: He did five. But if he
went for five and fell off, you wouldn't say [applauding], "Oh, he
went for five but he didn't make it." You'd say, "Oops."

In some sense, we can say that dance of all kinds is about the literal and/or
metaphorical play and balance between freedom and control, improvisation and
set sequences, technique and inspiration, tension and release. Solomons's obser-
vations highlight a basic difference between Europeanist and Africanist perspec-
tives with regard to these paired opposites. The place in the body where they are
most clearly located and easily observed is in the torso. The vertically aligned
torso is the center of the Europeanist ballet body and stands in contrast to the ar-
ticulated Africanist torso, where chest, ribs, belly, pelvis, buttocks can move in-
dependently, each sometimes "dancing to a different drum" in the kind of
specificity of articulation addressed by Meredith Monk and Brenda Bufalino.
Generically speaking, the Europeanist dancing body ideal is the icon of control
and order; the Africanist of improvisation and release. Every dance form main-
tains its integrity by negotiating both sides of these paired opposites; different
quantities in each equation (freedom/control, improvisation/set sequencing, and
so on) are the shifts in balance that distinguish one dance form from another.

Extending this paradigm, we see that the dominant body attitudes repre-
sented in a given dance form not only designate it as a specific form but also in-
fluence and have an impact upon audience attitudes. Accordingly the ballet
audience, attuned and habituated to view control as a prime value, applaud its
display and are embarrassed when it isn't fulfilled (as in the Solomons example).
The dance audience (black and white) at a performance of an Africanist dance
form (by Rennie Harris, Chuck Davis, or even the fusion style of Alvin Ailey) is
acclimatized to the "go for broke," and "give your all" aesthetic that is such a
strong cultural value in African and African diasporan communities. So their ex-
pectations and reactions change accordingly. Again, the example of traditional

white Christianity—a "book" religion, where the liturgy is fixed in the literature, and people remain in their seats—represents a level of control that sets the tone for a particular kind of audience response; likewise, with black-styled Christianity, free-form sermons and singing result in a concomitant level of free-form, participatory congregational response. In the traditional Europeanist purview this assumed lack of control is seen as indecent, low-class, and primitive. Control is a defining quality of being "civilized."

When an interethnic dance company performs, issues may arise that stem from the cultural confusion of the audience whose set patterns of response may be boggled by the mix. Garth Fagan had white dancers performing an African dance in his first dance company, back in the 1970s. He was criticized "from both sides, you know. From the black side, for the reasons like 'we're giving away our culture,' and all of that stuff; and more so from the white side, because 'they just don't blend in, and those beautiful black brothers and then this white skin—it's just distracting.' . . . But I had them doing African dance because they could do it!" Then again, issues can arise from inside the integrated ensemble. After all, a dance company lives together like a family and must negotiate a mutually acceptable comfort zone for the overall health of the group. According to Joan Myers Brown,

> Sometimes people are uncomfortable dancing with people who are not like them. . . . I'm thinking about the people who form the [dance] companies, and they feel that other people may be uncomfortable having more black folk than they now have: I mean, [the mentality that says] "one is okay." . . . Even in my group, which is the reverse, it takes a certain type of white person to be able to come in my company and not only dance well but be a part of the family . . . to live with them on a daily basis. . . . And I don't know if this is true or not, but I find that most of the black dancers who go into white companies, they start being white.

As Fagan and Myers Brown point out, the race issues that pervade our society are reflected in our cultural institutions. Indeed, engaging in a discourse about race and racism in dance could pose a professional risk for working choreographers and dancers, as may be evidenced by the practitioners who declined to be interviewed for this book. Yet, for most people I interviewed and in spite of its racial problems, the dance world seems to offer a "safe haven" from the racism encountered in daily life. As they revealed in their separate interviews (here quoted together), Shelley Washington and Wendy Perron found this profession more accepting of their body types than the world at large:

Washington: See, strangely enough, in all of my early dance experiences, dance didn't have the racial issues for me. . . . Those were people I trusted. I trusted my teachers. If I had issues it wouldn't be about my race. It was school. It was walking down the street. There was no singling out—not in dance. Looking for an apartment, yeah.

Perron: I felt lucky in terms of my body. And I auditioned for Juilliard while I was in high school, and there were so many girls whose bodies they didn't like that they didn't accept, you know. . . . Vicky Shick and Risa Jaroslow both became professional dancers, and they were both rejected by Juilliard. . . . Vicky was told she was too voluptuous. So I was tall and thin and had pretty good proportions and was accepted. In the dance world I felt more comfortable with my body than I did in the high school world, in the dating world.

Washington: I've just been going back and looking at old pictures and when I was fourteen and away at Interlocken Arts Academy I'd be in a picture posing with all the other girls, and I'd be the only black girl in point shoes in the photo, and I would notice that I was like a stick, and everybody else was already growing hips and waists and stuff and I was always that drop of water, they used to say: straight — shoulders, chest, waist, hips, thighs—all one long line [all of which were appreciated and praised by her dance teachers]. . . . And I went to a school where I was the only dancer in my whole school, and all my friends were getting breasts and filling out and starting to wear bras, and I didn't. And I had very muscular calves, and the boys were teasing me and coming behind me and pulling my knee socks down and saying "Shelley The Man."

Perron: Maybe I'm naïve, but I think in our field there's not that much prejudice as there is in other fields.

Marlies Yearby holds a similar point of view: "My experience as myself as a black person and what that meant was more amplified outside of the dance space than inside it."

These perspectives are one way of interpreting the data through the lens of individual experience and specific background. Each of us, in this most intimate of professions, has her own spin on "what it is," or what defines our dancing bodies and our dance communities. The tale that Chuck Davis, Garth Fagan, or Joan Myers Brown has to tell is very different from Perron's, while that of Shelley Washington, Ralph Lemon, or Gus Solomons jr (African Americans who grew up in white communities and danced in white companies) runs along lines

similar to Perron's. Many who turned to dance did not fit in with their social set during the terribly cruel years we call adolescence. Yet others became leaders because of their dance prowess. Race was a contributing factor in these dance lives, whether it was outright or subtle, whether the dancers realized it or denied it, accepted it or just didn't know.

Having explored some of the landscape of black and white dance and dancers, we now have some compass settings to help guide us deeper into the geography of the black dancing body.

THE PHYSICAL TERRAIN

THE SEAT OF SENSUALITY

*Merián Soto: I think I wanted to be black. I was really attracted to black-
ness—I wanted to be black. . . . There was a sense of just loving blackness.*
BDG: Why?
Merián Soto: Black is beautiful.

White gaze, black gaze; female gaze, male gaze; rich or poor gaze: black is ugly or
black is beautiful. Each of us makes our world: Who we are, how we feel, react, and
think shapes our reality, our preferences, and our criteria. We make reality—not the
other way around. For centuries whites have seen the black body as a sexualized ter-
rain—not because black people are sexually different from whites, innately or bio-
logically, but because that is how whites chose to perceive blacks. Be it seductive or
repulsive (or both, as was the case with the rash of "Hottentot Venuses" who were
paraded around Europe in the early nineteenth century and exploited as sexual ob-
jects), the black body has served as the screen upon which white fears and fantasies
have been projected. It is the Self-versus-Other syndrome of colonialist discourse at
work. Attract. Repel. Attract. Repel. Underneath white critique of the black body
lurks sexual innuendo and physical danger. The geography of these desires and ha-
treds has been charted as one dimension of the long history of violence against black
people: slavery, lynchings, chain gangs, rape, and more. The flip side of the coin re-
veals the exotic-erotic syndrome. The black body is loved for its blackness, above

and beyond its accomplishments. Shelley Washington gives a prime example that
returns us to the black dancing body:

> We did a piece a few years ago. I can't remember where it was, it might
> have been Germany. . . . We did the *Sinatra* [Songs], and they didn't like
> it because it was too sweet. . . . They love the *Fugue*, and Keith Young
> and I did the first duet, and we were black, and we didn't get booed, and
> everybody else got booed. Stuff like that I remember. And I remember
> things like taking a bow in Paris and maybe, I don't know how it goes,
> but we would come out and take bows individually. And I had very little
> to do, and I got the most applause. . . . You know, people saying things
> like "Oh, the French love the black woman. So exotic." If anything I re-
> member that, and being in Finland and just having people follow you
> around and go "Ahhh." Or when I was in Saigon with Martha [Graham]
> in 1974–75, buses, people would just stop, really, the roads would just
> screech and stop if I walked down the street. People would come out of
> the shops, and they weren't even shy [about ogling me].

Washington's recollections of being treated as a black body object centered
on isolated incidents while touring abroad. Dancing in the States and in the com-
pany of other Americans, she felt in her element. Although he felt that he had
more opportunities as a lead dancer in Europe than stateside, Zane Booker expe-
rienced the exotic-erotic as an expatriate in the Netherlands. He talks about his
experiences as a black male dancing with the Netherlands Dance Theater under
the artistic direction of choreographer Jirí Kylián. At first, Booker was haunted
by the fear that he was cast in particular roles because he was black rather than
for reasons of talent. After a couple of years in the company, he broached the
topic with Kylián, who "said he didn't think it was a problem to use a person for
their 'natural costume.' That's the way he put it. . . . And a lot of company mem-
bers don't really help in those types of situations, because they harp on it as well,
like 'oh, that's the black role' . . . out of jealousy and out of them seeing some-
thing that was real about it, too."

The idea that skin — black skin — can be a costume is an extension of the idea
that white skin is the norm and other skins are deviations. For some white peo-
ple, having a tan is the equivalent of putting on a costume. Petra Kugel, a Ger-
man dancer/colleague with whom I discussed this work, revealed that when she
is tanned she feels dressed, even when she is nude. This sentiment is echoed by
choreographer Hellmut Gottschild. In a monologue from a performance work of
his titled *Tongue Smell Color* (1999) he states:

"A little later [in his childhood, in Germany], I encountered pictures of black bodies in travel books and magazines. They usually came adorned with drums, spears, and bare breasts. . . . However . . . their blackness made them distant, Other. My eye experienced it [black skin] as a kind of neutralizing coating . . . as if not naked at all. White women's bodies, on the other hand, felt so bare in their whiteness, as if robbed of a protective cover—really, really naked."

Perhaps this is one reason why Europeans sunbathe nude on public beaches: they actually sense their acquired dark skin as a costume, as did Kylián of Booker's natural color. Through the lens of our cultural conditioning we choose how we see the black (or white) body. What may be an innocent cause on the part of a white person may reach its black object as a deadly effect. It is also significant that the dark-skinned black male dancer may be more easily acceptable in the white dance company than a black female of comparable hue.

Ralph Lemon addresses a similar condition when describing his position in the first dance company with which he performed (in Minneapolis, his native city): "Perhaps I was exoticized because I was male and I was black, and I did have what they described as a good body. So, you know, it was a very easy, privileged situation for me." One can utilize to one's advantage the double-edged sword of the erotic-exotic, but it can also leave the black dancer even more destabilized than most other dancers: Do I really "have it," or is it just a matter of color? Still, this condition may be preferable over the one I described earlier, with Pearl Lang excluding me because of skin color.

Complexion is not the only zone of black body geography to be exoticized. Monica Moseley mentioned another obvious site: "When West African companies started coming to Paris and to New York, the women who had their breasts [bared] were a featured reason for why people were interested in going, and there was a kind of leering thing about that. And yet I also think about Josephine Baker, who didn't at all mind showing her breasts, and one of the real pleasures about seeing her films for me is to see how much pleasure she took in her body and how beautiful it was."

However, Baker's career begged the exploitation-or-advantage question. Surely, Baker made circumstantial advantage of her unique beauty and manifested a sense of self-possession and aplomb that was part of her special charm: She was her own woman, even though she was someone else's creation. But, just as certainly, she was a prime example of black body exploitation. Her unique, even spectacular dancing and singing talent were secondary to the display of her lusted-after black body. Her breasts and buttocks were eulogized, mythologized, exoticized. The body was the drawing card, and she was the embodiment of "the primitive trope" (the constellation of ideas, images, and associations that constructed black

peoples as savage). In addition, she was extremely insecure about her naturally brown complexion and used skin-lightening makeup throughout her career.[1]

By emphasizing the black body as sexualized, the black intellect could, accordingly, be demoted in the white imagination. That is, whites left the body to blacks and kept the (thinking) head as their exclusive terrain. I surmise that one of the white underlying fears, in this case, was the incipient sense that bodies are *not* ignorant—that black bodies were, indeed, thinking bodies that could express a world of views in the turn of a shoulder, could parody and demean their white detractors with the switch of a hip. Black bodies weren't dumb; they were extensions of black minds—intelligent minds—in a physical landscape where the Cartesian mind/body split refused to take hold. Black bodies were mind/bodies, full of intelligence, humor, and cutting commentary. Such a body didn't respect traditional (white) boundaries, could be dangerous, needed to be contained by ridicule, if not the whip. Susan Cook, professor of music and women's studies at the University of Wisconsin (Madison), came up with a wonderful phrase to describe this white fear: *enculturated somatophobia.* In other words, fear of the body that is entrenched and reinforced through cultural mores and institutions. Yvonne Daniel, professor of dance and anthropology at Smith College, has written about the wisdom and intelligence found in the danced religions of the African diaspora, which she calls *embodied knowledge.* Using their initiatives, one can describe the conflict between the traditions of white and black dancing bodies as the clash between enculturated somatophobia and embodied knowledge.

Blacks live in both worlds—black and white. Zane Booker worries about whether he is in a world-class dance company because of his talent or his color; Shelley Washington remembers times when Europeans cheered her complexion, not necessarily her dancing. But there is solace to be found in the world of core black culture that still holds on (for identity; for dear life) to its own aesthetic criteria. Representing this side, choreographers Chuck Davis and Ron Brown spread the message to blacks and whites that big is no less beautiful than skinny. On the other side, if they hope to make good in white dance milieus, black dancers are obliged to adhere to a white dancing body norm. Thus, Brenda Bufalino can speak of "more bone" in African American dancers. Slimming down is essential in all but a few havens of the international concert dance community. Anorexia, though somewhat silenced, is still a big issue. As one dancer said to me, "How can they consider Jennifer Lopez big?!" (Lopez came on the scene as a dancer.)

In the traditional black world, black bodies are comfortable "as is," according to Joan Myers Brown: "I think that being uncomfortable with your body is something that we learned here in this country. . . . But I think, again, we love our bodies because we are comfortable with them." Bill T. Jones and

Garth Fagan echo Brown's assertions. "There is an eroticism and sensuality in dance," Jones said, "and I think that it's a redeeming life-force. Now, is that black dance? I dare say when I see great African dancers, it is effortlessly integrated into what they do." In that worldview, size can be an asset. Responding to my question about what black people (not necessarily dancers) say to other black people about black bodies, Fagan quipped, "In my friends and acquaintances, it's complimentary, always 'girl, look at that booty: whew!' . . . It's celebratory and . . . self-affirming. And the other side of the coin is 'If you're going to go through that door, you truly need to lose some weight.' You know, just talking straight."

Trisha Brown addressed this sense of ease: "I see a richness and a warmth and a sexuality in the black body that I gravitate towards. . . . [For instance, seeing Dance Brazil] being in their body from head to foot, and right side up and upside down with fierce exactness and, you know, the organic process so well understood. I'm avoiding saying 'animal.' I'm not going to say it! And just a real love of dancing, a love of your body, and it's just so palpable and so delicious."

It is a noteworthy point that Brown wanted to say "animal" but also wanted to avoid saying it so as to not confuse her use of the word with pejorative usages that attempt to demean the black dancing body or suggest that blacks are "closer to nature" by such a reference. It should be obvious from her account that what she describes as the black dancing body is the thinking, intelligent, deeply intuitive body, the quintessence of the human "animal," so to speak. But racism and social Darwinism have attached sticky, negative connotations to this reverse anthropomorphism. There is almost no way to avoid that stickiness except by avoiding the comparison.

Trisha Brown also recalled her stint as a dance major at Mills College in California in the 1950s. A forceful conditioning experience during this time was exerted by her African American roommate who, though not a dance major, joined Brown in "entertain[ing] our classmates with 'cool,' madcap dancing, usually after lunch and before next class." Brown stated that this roommate was "a tonic against academia," suggesting that, even though this young black woman was not majoring in dance, she possessed a somatic intelligence and comfort level that resonated with Brown and her peers and challenged the mind/body separation of the academy.

Ease and comfort with one's sensuality and sexuality are key attributes of black body geography and culture. Doug Elkins addressed the means by which he was educated and initiated into this zone by hanging out with African American youth and dancing in a fashion that encompassed sexuality in an organic, non-threatening way: "Here's an example; dancing with friends who are black,

hanging out at their house, and learning to social dance. Like if you look at *Crooklyn* [the Spike Lee film] again, and you watch the kids dancing, watching *Soul Train,* playing basketball, and somebody has a sister or somebody to make you dance with: 'Show him how. . . . It's like that. . . . No, no, no: get loose! Come on!'—So being encouraged, being laughed at and encouraged too."[i]

From across the Atlantic the same message is echoed by Susanne Linke, who worked with choreographer Pina Bausch before becoming a freelance dancer and choreographer. Linke talked about the first black person in Bausch's company of German expressionist dancers and the exhilarating effect of his presence. In her own halting English, she captivatingly recalled the influence of his embodied knowledge on her somatic (re)education:

> Carlos Orta, who came in 1970 to the Folkwang School was, for me, the first connection, a closer meeting with a black person. . . . He comes from Venezuela. . . . He is completely mixed. It is not Africa black. But, still, at that time . . . we would say "Neger." [That] is not an insult, but, wow, that is very exotic, and he is a wonderful dancer. . . . He was absolutely *in* the dance movement; whatever he did was so strong and so musical, and so we went a lot on a party with him [that is, out social dancing at parties]. He could improvise so well. From him, we learned a lot: how to improvise; how to move the hips; the Venezuelan, the Caribbean movement; the hips and the pleasure. . . . For many of us at the time of this company, Carlos Orta was very important. Even for Pina Bausch. He brought something of the natural connection to the body.

Linke's comments are important. White dance practitioners have used the black dancing body as the territory for accessing the inherent and potential sensuality of their own dancing bodies. This syndrome has occurred across decades and dance genres, ranging from white artists like minstrelsy's Thomas "Daddy" Rice and Dan Emmett; the swing era's Fred Astaire and Eleanor Powell; American ballet's George Balanchine and Agnes de Mille; Broadway's Bob Fosse and Michael Bennett; hip hop's Doug Elkins and Bill Shannon; contemporary tap experts Lynn Dally and Brenda Bufalino; European concert

i. Elkins's description of learning to dance in the protected environment of home, sibling, family, and friends actually illustrates an ancient ritual of adolescence that has historical precedents. Across eras and cultures, and whether it's the Waltz, the Yankadi (a dance from Sierra Leone), or the Freak, dance can serve as a socially sanctioned way of teaching the etiquette of courtship.

dancers Susanne Linke and Pina Bausch; to the likes of postmodernists Meredith Monk and Trisha Brown—to name an exemplary pair from sundry eras and styles.

One of the most prevalent and pernicious myths attached to the black dancing body is that the movement is not learned but inborn. This misconception is assumed as fact both inside and beyond the dance world. Without doubt, Carlos Orta's body ease owed more to nurture than to nature. It behooves us to question what is "natural."

TRAVELOGUE IMPRESSIONS

Based on the premise that there's a world of culturally relevant information to be found in our spontaneous reactions and subjective responses, this section presents the dancers' replies to questions that called for their uncensored feedback. They were encouraged to leave reasoning aside and let associations flow. Both interviewer and interviewee had come to an understanding that this line of questioning is dangerous (but not reckless) and challenging (but not confrontative), and we entered into a realm of trust in the process and its outcome. Implicit was an understanding that "no judgment, no blame" was my modus operandi, and that the politics of race is not a dead issue. These candid, insightful, sometimes provocative responses represent a range of eras, styles, ages, ethnicities, and perspectives. Urged to access images arising from memory, fantasy, dreams, mythologies, stereotypes (although stereotypes will be dealt with separately in the following section) the dancers responded to four related questions: first, what images come to the mind's eye when the term "black dance" is said; next, slightly shifting the paradigm, what images arise when the term "black dancing body" is said. The final two questions pose the same task with regard to white dance and the white dancing body. Responses are grouped in three subcategories.

Why enter the realm of impressions and associations? The way to break the code is to examine it. The way to understand the image is to acknowledge it. The only way out is through. There is an intimate connection between these somewhat subconscious images and the conscious, daily tropes that we know so well: We play out in real life a sublimated, state-of-the-art, politically correct version of those inner workings and cultural assumptions. We make reality.

Like a travelogue, this section chronicles "entries" by voyagers traversing black and white topographies, with commentary from me when I felt explanation was warranted. Although the comments are stacked together, all come from one-on-one interviews.

Black Dance/Black Dancing Bodies

People/Works/Genres

Brenda Bufalino: "Being in Africa, seeing dancing, the first dancing I saw and felt so incredibly attracted to, which was the Afro-Cuban primitive. . . . I see a certain caricature of Juba. Elegance came to my mind, but I think of that because that is a very strong attraction for me all the way back to John Bubbles, as with Fred Astaire. . . . I remember seeing Arthur Mitchell . . . and he wasn't particularly brilliant. . . . But it was just 'wow'! Now, I don't know if it was my state of mind at that particular time or whether that was [because] he kind of dominated the stage."

Seán Curran: "I'm thinking of Trisha Brown now really connected to a blackness, especially in sort of the more recent work—that freedom. She owes something to that; I think she readily admits it, too. Twyla [Tharp] too. I'm thinking of other favorites. . . . DTH [Dance Theater of Harlem] and them doing white dance in a way but doing it their black way. And I think of that *Creole Giselle* and that Stephanie woman [Stephanie Dabney] in *Firebird*. It's funny, I see more when I see black than I do when I see white. . . . Elegant—that's another thing, I think, when I think of black dance: the elegance of the Nicholas Brothers."

Ron Brown: "Pearl Primus; Alvin Ailey; Talley Beatty; Philadanco. . . . Bebe Miller—I told her that once! Loretta Abbott. I'm looking at their hips. Alastair Butler—his face and the size of him, the 'no nonsense' something about his body. I'm kind of seeing this rhythm; I'm seeing faces smiling, shoulders bare."

Merián Soto: "My first thought was Katherine Dunham. Then I see Bomba and Plena [Afro-Latino traditional forms of music and dance, indigenous to Puerto Rico, Soto's birthplace]. I see Bill T. Jones and Donald Byrd, and Bebe Miller. I see Reggie Wilson and his spirituality. Jawole Willa Jo Zollar. Then I'm back to Nigeria. Kariamu [Asante]. Now I'm in Cuba, with all the Santería dancers and the beautiful dark bodies. There was this woman when I was there [Cuba], Rosario Cárdenas, who does very way-out work. She did a performance, and there was a black woman who has the most beautiful, sculptural body I've ever seen, who danced stark naked, with sweat just streaming down her constantly. . . . It was so hot, I don't know how they could dance. It was like 104 degrees. She kept sweating and dancing in the nude—so that's a black dancing image."

Doug Elkins: "The Nicholas Brothers, the *Soul Train* dance line, things just pop up. I just saw an image of Shorty George Snowden. A range of dynamics. . . . Speed. . . . And I just had a picture of Earl 'Snake Hips' Tucker."

Wendy Perron: "Well, I was just thinking of Donny [Donald] McKayle's *Games*. . . . I think of Ailey. *Revelations*. I don't think of Gus Solomons. . . . [I think

of] Rod Rodgers [and] dance companies going back to the 60s or 70s where there were mostly blacks in the company."

Francesca Harper: "I see bare feet. I see [Katherine] Dunham. I see white: *Cry*—Judith Jamison with her skirts. I see white skirts and these beautiful brown feet . . . top hats . . . tap shoes and tuxedos. I see a minstrel. . . . I also see the Nicholas Brothers . . . on the stairs jumping down in the splits. . . . Bill Robinson . . . and [Savion] Glover and that lovely piece he did with the Shirley Temple doll [in Glover's Broadway hit, *Bring in Da Noise, Bring in Da Funk*]. . . . I see Josephine Baker and this beautiful naked dancing body. What else do I see? These really beautiful, statuesque men like Geoffrey Holder . . . and bodies dancing *Dougla* [a work that Holder choreographed for Dance Theater of Harlem that illustrates the fusion of African diasporan cultures and celebrates the black dancing body].

Qualities

Bebe Miller: "There's that muscularity thing, but also a particular fierceness—technical, but more of a force behind them that is defining, that is sort of proving itself."

Gus Solomons jr: "It implies to me emotion, rather than motion, as the primary [means of] expression. . . . I just had a picture of African women, with rounded forms."

Doug Elkins: "A very open, free pelvis. Again a center is something that one does not hold, but that one moves in and through. Strangely enough, to quote [Merce] Cunningham, there is more than one center. There is not a center, there is a choice of centers contextually, and I think about that in black dance. Some of the games I like in it are the paradoxes of it. . . . Wit. I think wit is an aesthetic. Whether in voguing, which is black Latino, gay, African American—the thing of 'throwing shade,' the thing of 'dissing' someone. . . . That would be another thing in the aesthetic of black: the sense of play. And that appeals to me. The trickster character, whether for me it's the Monkey King or Br'er Rabbit, and then when one is given a difficult task, one will invent; one will use one's imagination to find a way through, in, out, over."

Susanne Linke: "Long legs. I see the beauty of the harmony. It's a harmony. Elasticity. Arms. For me it is not the shape, it is the energy. This is important. And the white dance is more shape."

Meredith Monk: "A fluid spine. I see very very complicated shapes. And I see passion. And I see no bones. That's what Blondell's [Blondell Cummings] dancing was like—where are the bones?! And Carolyn Adams was also like that.

At Sarah Lawrence she'd go up in the air and then she'd come down, but how she got there—she'd just hover, and then she'd land, and it would be like a feather, and it was as if she didn't have any bones. Everything was just so fluid that you didn't feel like there was any skeleton. Like a mystery. There's a loose thing about the black body in movement that I think of right away . . . very fluid spine, very fluid joints, very complex, particularly very complicated in the torso and pelvis. All of this, these inner diagonals, and so much articulation within the torso—all this stuff going on. Kind of a release—not held. A kind of freedom. Ecstasy. See, that's something that's very inspiring. Transformation I think is something that is very top on the list. And that comes from the ancient belief of taking in a spirit and then becoming that spirit. Embodying it. . . .

"A lot of stretching and tension. Sort of, again that kind of stretching beyond yourself : the kind of thing of not working within the axis, but working to get beyond and larger than one is. . . . So it's pushed a little bit. . . . And bright light. And big. Very big. Not always so subtle. I think that's part of a whole sensibility. It's different. It's very extroverted. As opposed to, say, Asian dance, which is very subtle."

Zane Booker: "Beauty. I love the black body. I think black bodies are beautiful. There are so many [variations]. I see clear definition of muscles; I see brown bums; I see deep chocolates; I see light cocoa; I see extension; I see power. Long arms. Gazelles. Cougars and lions. Mostly I think I see power."

Shelley Washington: "It's the simplest thing. I see beautiful bodies. I see glistening. I see shine. I see sweat. I see white teeth. I see long arms and hands. I see arched backs. I see communication with other people. I see lots of bodies. I hear music. . . . I see fabric moving. I see bodies touching. I feel rhythm. I sometimes see exorcism or whatever, you know, stuff that comes out. Free fall, or free form. I see lips. I see smiles. I see all sizes and shapes. I see no particular form of dance. Somehow in my head there's Jitterbug, and there's people in church, and there's classic, and there's everything from chain gang, dancing and moving. . . . It's just a flurry."

Bill T. Jones: "Round upper arms—definitely arms. Firm, muscled, and I suspect female. A line of the spine that has a deep curve and pronounced buttocks. Head thrown back, and mouth open. . . . *I'm not sure if I begin to feed the image or if the image is being revealed.* [Emphasis mine.] Because I do see a particular type of black woman dancing. And she's barefoot, and the dance is never slow and legato, and it's always energetic and verging on violent, but more about an ecstasy and pounding the floor."

[It is noteworthy that Jones's quintessential image is the black *female* body. In the final chapter I discuss Ailey's *Cry*, which assigns a similar transcendence to

the female dancing body as in Jones's description. Both Jones and Ailey had a special bond with their mothers. *Cry* is emblematic of the high status of woman as mother, mate, and carrier of the culture in Africanist traditions. It also illustrates a gender and sexual equality in certain sectors of the dance field that allows interchangeable character attributes—power, ferocity, and anger, as well as tenderness and vulnerability—in males and females, as reflected in Francesca Harper's observation.]

Harper: "I see muscles, I see strong bodies, you know: women as well as men."

Brenda Bufalino: "I guess I always think of tremendous strength for the black body, really overpowering the stage with a strength."

Ralph Lemon: "Muscles. Not cold. Not cool, which I think is an interesting terminology for black people. I don't know if I've ever known a cool black person. Smooth. . . . There's a subtlety, I think, to it. . . . I've experienced this in watching black bodies move, but a lot of it is mythology also, you know. And I have to say that because, you know, *I'm not sure where these perceptions really come from. It's coded.* [Emphasis mine.] Bent bodies. . . . Africans, you know, they dance from a very different place, so the bodies aren't straight."

Seán Curran: "Not just how African American people move, but the African American experience and survivors. A musicality and a profound understanding of complex rhythms and stuff that is desirable and you get a hunger for. . . . Articulate, automatic, fluent, free, sexual (that I think has been imposed a bit). Feet that don't stretch (I have the same kind of feet . . .). Sweat, I love seeing—you see sweat on black skin better than [on] white. An ability to channel negative emotions. A love of dancing. That comes back to the automatic-ness: It's not work—freedom, you know, a flow, a spirit. I think of the whiteness of the soles of the feet, and the darkness or the blackness of the tops. The palms too. It's not a fetish thing, but I always sort of loved looking at the black dancer's bare feet."

Bebe Miller: "Body striving. Not living easily in the skin. Narrative. More conservative. Less experimental."

Contexts

Chuck Davis: "I see dealing with traditions and images definitely associated with the African and African American aesthetic. I see the Nubians of East Africa dancing with all the different patterns they use. And, in that area, they are black. They are so black they have a purplish tint to their skin."

Francesca Harper: "I had the powerful image of dancing for your supper."

Wendy Perron: "Plantation dances: the black dancing body and maybe some sort of sense of desperation."

Rennie Harris: "Block party. That's all. Block party. Clubs. Actually, before the clubs, the dances, the disco, social dance. Going to the dance."

Bebe Miller: "Black dance is somehow seen as a way of articulating the politics of a situation as opposed to the aesthetics of a sensibility."

White Dance/White Dancing Bodies

People/Works/Genres

Bebe Miller: "Merce Cunningham. Trisha Brown. Formalisms that are more taken for granted. Conservative is not the right word, but the more established companies, rather than either the black or white nittier-grittier people who are my contemporaries."

Ron Brown: "I think of Steve Petronio, Trisha Brown, Paul Taylor, ballet, David Dorfman. . . . Something interesting: I was just about to say David Rousseve. That's funny. It's just the aesthetic of the movement."

[Both Bebe Miller's and Ron Brown's comments are interesting in illustrating how ethnic categories have burst their borders in the postmodern, post-Cunningham era. Trisha Brown and Merce Cunningham, erstwhile radical mavericks of concert dance, are now among the dance establishment's recognized pioneers of experimental dance. As of 2003 he is in his eighties; she is in her sixties. Miller and Ron Brown, no longer mavericks, are hitting their stride. Their dance community differs so keenly from Trisha Brown's and Cunningham's that the black-white fusion choreography of African American David Rousseve can be identified by Ron Brown as white; and, conversely, Miller can claim that her dance milieu is inhabited by people who do not represent any established dance worlds, black or white.]

Merián Soto: "More ballet. . . . I feel like I'm surrounded by white dance. It's interesting, I didn't say Alvin Ailey for the black dance. White dance, oh my: I just think of Trisha. She seems so totally white to me."

[The comments regarding Trisha Brown and whiteness are notable. In the previous section Seán Curran gave the nod to both Trisha Brown's and Twyla Tharp's Africanist heritage. I see Brown's dancing body as a "reverse oreo"—white outside, black within—not by intention or deception, but by acculturation. Africanist components in her development have been "invisibilized" (the term I use to mean the subtle ways that Africanist resonances are subsumed, submerged, and suppressed in our culture). Most of us, black, white, and brown, have not been acculturated to "see" or "read" these forces, so they go largely unrecognized in white forms and performers, whether it is Trisha

Brown or American ballet. In *Digging the Africanist Presence in American Performance,* I explored invisibilized Africanisms in supposedly white culture.]

Zane Booker: "I see beauty, length . . . you have the 180 degree turnout . . . Sylvie Guillem's body, I would look at it and say that is physical perfection."

Wendy Perron: "Baroque dance. I don't know why, but that stuff seems whiter to me than ballet. Whereas I've done ballet, so I don't think of ballet as white dance. *Swan Lake* — I mean with just that phrase, white dancing body, I'd sooner see that than I would see Martha Graham. Because to me, that's not a white dancing body; that's an individual artist. But I would see women."

[It is interesting that Perron resists identifying herself with such a category as white dance and even resists having to put ballet in that category. Acculturation makes the term seem uncomfortable, abnormal, restrictive. Her reaction to the term may help some readers understand the African American reaction to its opposite, black dance. It is also notable that she sees women for the white dancing body while Jones, for quite different reasons, sees women for the black dancing body image.]

Brenda Bufalino: "Well, I guess the thing that comes [to mind] is Irish and Scotch dancing where the body is somehow superfluous. Even more than ballet, I think of the ethnic dances of certain regions. . . . I think [also] of the ballet body. The typical ballet body before Arthur Mitchell."

Qualities

Seán Curran: "Upright. I was thinking of round arms, port de bras. For some reason, "proper," stuck in the head a bit, something that is built and made and constructed rather than is free or flows, something imposed in a way. I think of virtuosity. I'm thinking of tricks, double air turns to the knee, and multiple pirouettes [a basic ballet turn on one leg], and high legs — the Rockettes — how we value that. How a whiteness values precision and unison. Broadway dancers. I feel less of a freedom than when I think of a black person dancing. Shoes. I'm thinking again of the feet. (I guess I have a foot thing!) Dancing in shoes as opposed to bare feet. I see people in costumes, and I don't when I see black people dancing — it's more about the movement. I'm seeing clothed white people in my mind's eye. Makeup. You know, the African American people didn't necessarily wear the makeup that the white people did in Bill and Arnie's company."

Shelley Washington: "It's almost not so much what I see; it's what I don't see. I don't see sweat. . . . I see conformity. I see lines. I see perfection. I see rows. I see pink. I see shoes."

[Washington's comment regarding sweat offers an interesting correspondence with Curran's earlier statement about being able to see sweat more readily on black skin. Traditionally sweat has been associated with sex, athleticism, and hard manual labor, if not lack of grace and inferior status. Both Curran and Washington seem to elevate it to a position of honor.]

Susanne Linke: "Intellectual . . . porcelain . . . more formal. And regulated. Maybe they have nice feet. Nice arms. The torso is maybe not so strong."

Doug Elkins: "Upright. Very upright. The spine pretty much stayed in one place like it was on a tray and being brought to you."

Ralph Lemon: "Vertical. I want to say frail. They're not frail. . . . A body perhaps more about the skeleton . . . just in the sense of perceiving that body and . . . there's something . . . transparent. You know, I want to say thin, but it's more than that. It's not just a thinner physicality."

Brenda Bufalino: "I see more of a turnout. I just see more bone."

[Bufalino's and Lemon's reflections can be contrasted with Meredith Monk's earlier comment about the black dancing body as having no skeleton, no bones, all fluidity.]

Meredith Monk: "Mental constructs. Rules. And expectation of certain bodies: looks. I think in white dance, too, I see a lot of stretching beyond, not really dealing with the axis, kind of like not dealing with the globe that's just around the body, but dealing with points beyond it [which was also part of Monk's earlier comments on so-called black dance]. This yearning thing . . . I think white dance has a lot to do with denying gravity and black dance, to me, very much uses gravity. . . . And awkwardness. Musically awkward. . . . Bluntness would be the way that I'd express that the rhythms are not happening in a kind of internal counterpoint. . . . And you know, the white body, a more tightness and stiffness naturally. *But I'm not saying that one is better than the other.*" [Emphasis mine.]

[Monk's final sentence applies to her personal perspective, as well as to my own and those of the other people interviewed. These imagined characteristics and attributes are offered as unqualified, unranked perceptions, not as value judgments.]

Joan Myers Brown: "Running in a circle, breathing deep, huffing and puffing. Most of the time [it's] when I see things that [make me feel like saying], 'This is so white,' that has no relevance to me, to the audience. It seems self-centered and involved internally, but it doesn't seem to be for us as observers, it seems to be more for the participants. And it's very hard for me to sometimes assimilate what it's about."

[Although Myers Brown's statement may strike the reader as harsh, this image of the "downtown, experimental" postmodern white dancer is one that frequently

surfaces when "uptown" modern dancers, black or white, talk amongst themselves. Myers Brown is honest in making it clear that this is her personal response, based on how she receives certain performances. The issue is one of technique and aesthetic preference. The postmodern style of dance Myers Brown bemoans is based on New Age body therapies generically known as "release technique," which developed in opposition to the pulled-up verticality of traditional—or "uptown"—modern dance and ballet, black and white. Release techniques as applied to performance stand in contrast to—and sometimes defiance of—traditional virtuoso techniques and sometimes emphasize the experience and *process* of dancing over and above the dance product, which accounts for Myers Brown's statement about self-centeredness. The inception of this new attitude can be traced back to the beginning of the postmodern dance movement, centered at Greenwich Village's Judson Church in the 1960s. The comments that follow and conclude this subsection echo Myers Brown's thoughts in greater or lesser degrees.]

Ron Brown: "Ballet shoes. Baryshnikov. People skipping in Paul Taylor's choreography. Skirts. I guess it's this flipping feeling, the release floor work, you know: putting your hand on the floor and hopping over, the kind of sequential follow-through in the movement."

Zane Booker: "I guess the first thing I would think of is something classical. And then I would think of the downtown scene, which is not strictly white anymore, but I guess from my history it was usually white dancers who participated in that field. We used to always call it 'stop, drop, and breathe.' So that term comes up."

Gus Solomons jr: "The first thing that came to mind was ABT [the American Ballet Theatre], which I just saw last night, and the second thing is "downtown." People in shirts that fall off one shoulder and sweatpants falling to the ground and not being able to get up. "Release dancers," that whole ethos, that whole non-presentational performance thing. That's "white dance."

Contexts

Francesca Harper: "I see long tutus, long hair—long, shiny hair . . . gloves, long gloves . . . court dances . . . couples in long gowns. It's very funny: I realize that it doesn't associate with me as deeply [as black dance and dancers]. I fish more, really, to get images. . . . I see paintings of naked bodies sitting with grapes . . . chiffon dresses . . . dancing, with someone who is playing a lyre, in medieval festivals. "

Gus Solomons jr: "[I see] the white dancing bodies downtown, in the postmodern release genre, that are, I want to say, stubby. And that's just a generalization. This goes along with the image that hit me first in the head: short hair—out

of the way, maintenance-free. Very low-maintenance bodies that are concerned with motion. It's really energy again, it's another kind of energy. . . . The black dancer to me is explosive energy, and the white energy is sustained, like stamina, the ability to do contact improv all day long.

[Contact improvisation is a basic tenet and building block of downtown dance styles. Contactors invent/improvise movement by supporting each other's weight in a vocabulary of rolling, suspending, lurching, balancing, and falling.

[It is noteworthy that the images of white dance and white dancing bodies were not as readily forthcoming as those for black dance and dancers and, further, that the idea of context was the least accessible of the three subdivisions in both black and white categories. To repeat, the paucity of white images stems from the fact that white is the norm, and normal defies categorization. The black dancing body comes along with the context of a contested history; the white dancing body is the figure of a ballerina, or a downtown postmodern dancer, alone in the studio.]

STEREOTYPES

Oh, I wanted calves. I still do. I still work on that damn machine thinking, "O.K., I'm going to change my genes. If I do this enough times I will change my genetics, and I will have Erik Bruhn's legs": that's what I wanted. . . . Finally, as of about 1997, I thought, "O.K., I believe it now, I have a really spectacular body for the stage." But until then I wanted to look like somebody else. I wanted to look like a white ballet dancer.

—Gus Solomons jr

. . . there's the dual consciousness. You're still trying to prove that you can do this other thing: "I'm wanting the approval because I know how you're looking at me."

—Ron Brown

I think a lot of it is upbringing. We grew up in this starched world.

—Trisha Brown

The difference between this section and the travelogue section approximates the distance that separates aesthetic preference from institutionalized racism. To begin thinking about this section I looked up the word "stereotype" in a dictionary, a thesaurus, and a synonym finder. What the definitions have in common is the reductive nature of the term. Perhaps in particularized contexts,

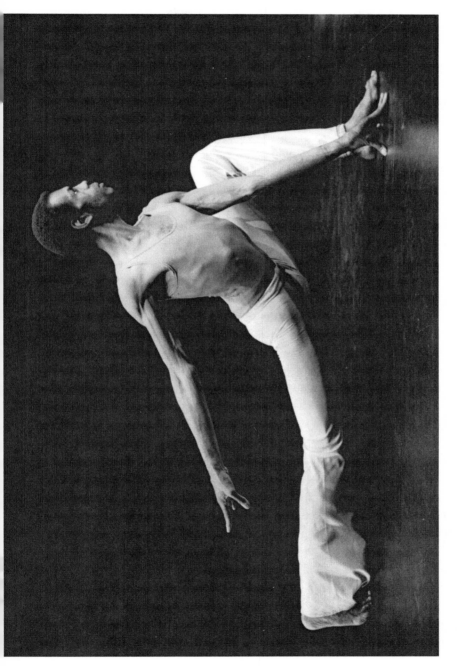

Beyond the stereotype is the spectacular: Gus Solomons jr (1980s). Private collection of Gus Solomons jr.

standardization could be interpreted as aiming for the universal, but these def-initions clearly point to a person or thing that simply conforms to a generic mold. A universal is inclusive; a stereotype, exclusive (that is, the stereotyped person or thing is set apart, excluded). An ideal is a culturally specific, vener-ated generalization. In setting the "type," the individuality of an artist—a per-forming artist and, specifically, a dancing-body artist—is forfeited. Whether it's an "attract" or "repel" stereotype—say, black buttocks as gorgeous or out-rageous—the effect is the same, in the sense that the individual is subsumed in the generalization. "Stereotype" is a word that usually carries negative conno-tations, so the idea of a positive stereotype is an oxymoron.

The stereotyping of people of African lineage runs uncannily parallel to that of Jewish people. Nowadays it may be hard to believe that in the 1930s basket-ball was regarded as a Jewish sport. In Jon Entine's *Taboo—Why Black Athletes Dominate Sports and Why We Are Afraid to Talk About It*, we learn that the captain of the original New York Celtics and four of St. John University's "wonder five" were Jewish. Back then, when the "new" genetic science made "Eugene" a choice given name, it was a "fact" that Jews were genetically superior to whites in balance, speed, and acuity of eyesight. One sportswriter embellished these racial "attributes" with more familiar ones, citing the Jews' "scheming mind" and "flashy trickiness." So why didn't Jewish athletes continue to dominate sports? Did their genes change? No. Environmental factors changed and mainstream perspectives changed. As white-skin privilege was accorded to Jews, Jewish-ness mattered less. American anti-Semitism began a long-overdue retreat after World War II as Jews were allowed to assimilate into white culture. Sports had served as a rung on the ladder of upward mobility. It is important to point out that, at earlier times in American and European history, Jews, Italians, Irish, and even Germans were not always considered white (a fact that is detailed in the Szwed, Ignatiev, and Malcomson entries listed in the bibliography). Once African Americans were allowed to play on integrated sports teams and Jews moved up the socioeconomic ladder, blacks replaced Jews as the genetic heroes of American sports. This information is particularly interesting, since today's more popular stereotype of Jewish men is all head, all intellect, and no body. Their bodies did not change: just our perceptions.

Entine's book is a scientifically weak and flawed attempt to prove that, un-like Jews or any other group before them, African Americans are genetically superior in sports. Ignoring environmental evidence, he attributes to genetic differences elements that seem clearly to be environmentally influenced. Also not taken into account is the competitive nature of sports, which magnifies, by hundredths of seconds, the smallest measurable physical differences. With race

a shifting landscape of cultural stereotypes (rather than a scientific measure of proof), it is untenable to discuss racial superiorities or inferiorities, black, white, or brown, at this time. More reliable data is supplied in the new literature that deals with race as a non-entity, such as Paul Gilroy's *Against Race: Imagining Political Culture Beyond the Color Line* (the British title was more exact: *Race, Identity and Nationalism at the End of the Colour Line*) and the works by the authors mentioned above.

African Americans have also been stereotyped as genetically best suited for *certain* types of dance that exhibit what is supposedly our innate sense of rhythm, but innately ill-equipped for other "white" dance forms. As was the case with sports and with professional, academic, white-collar, and blue-collar jobs — that is, the full spectrum of professional and vocational possibilities beyond the most menial — so also is the world of concert dance opening up to peoples of African lineage as they slowly chip away the barriers that had kept them out. But to enter that world means to go through and beyond several attract-repel, love-hate stereotypes that are grouped around specific body zones, particularly the feet and the buttocks: the finessed feet that blacks supposedly do not have, but need; and the bawdy buttocks that supposedly they have, but do not need. The black buttocks are alternately loved and hated by both blacks and whites. Bebe Miller gives a pithy rationale for why these two areas are stereotyped, implying that, through stereotypical lenses, blacks want white class, and whites crave black sexuality: "Oh, well, the feet: it's like the height of refinement. It's ballet. It's class, I think. And the butt is sexuality. They are tangents to each other, and it's striving."

Stereotype threat is an important concept that is useful in this discussion. This theory, developed by Claude Steele and his psychology research team at Stanford University, goes to the heart of what is destructive about stereotypes: Too often they obstruct individual achievement and act as self-fulfilling prophesies. (Ironically, Steele is the twin brother of Shelby Steele, author of *The Content of Our Character — A New Vision of Race In America*, a work that has become a conservative bible and standard rebuttal to affirmative action — the antithesis of his brother's liberal theories.) According to a Malcolm Gladwell article in the *New Yorker* about Steele's research (aptly titled "The Art of Failure"): "When black students are put into a situation where they are directly confronted with a stereotype about their group — in this case, one having to do with [a dearth of] intelligence — the resulting pressure causes their performance to suffer. Steele and others have found stereotype threat at work in any situation where groups are depicted in negative ways."[2] Thus, the article reports that women failed math tests when they were told that their quantitative skills were being assessed, but

performed as well as men when told, instead, that the same test was a research tool. Similar results occurred when white male athletes trying to improve their leaps were trained first by a white athletic instructor and then a black. The group improved when taught by the white instructor but did poorly under the black one. Why? Because they were responding to the stereotype that we all know — that white men can't jump (at least, in sports).

Why go on about stereotype threat, and why bother to examine stereotypes at all? Because we live with them, we are all subject to them, and there is something to be learned from them. I believe we can use information gleaned from examining our stereotypes in a deconstructive, critical fashion. They tell us about our construction of Self and our fear of Other. And, in the end, stereotypes are internalized so that they form an intimate bond with personal responses such as those detailed in the previous section. As Gladwell says, "We have to learn that sometimes a poor performance reflects not the innate ability of the performer but the complexion of the audience."[3]

Returning to the discussion of the black dancing body: Essie Marie Dorsey, an African American dance legend in the Philadelphia elite black community of the 1920s and 1930s, once told her student and disciple Marion Cuyjet that the worst black (dance) school is better for a black child than the best white school would be. (Cuyjet carried on Dorsey's legacy at her own dance academy, the Judimar School, and trained dancers like Judith Jamison, Artistic Director of the Alvin Ailey American Dance Theater, when Philadelphia dance schools were still segregated. Desegregation came finally in the 1960s.) When Cuyjet related this opinion to me while I interviewed her in 1986, I was taken aback. What had Dorsey meant, and how could she hold such a view even back then? Didn't she realize that integration and diversity were the best solutions? Now it is clear to me that long before the concept of stereotype threat was given a name and pedigree, African Americans like Dorsey were aware of its dire consequences on young minds and bodies. Joan Myers Brown, Dorsey's aesthetic granddaughter (Cuyjet was one of Brown's mentors) harbors some of the same fears Dorsey had: "I have a student who got a scholarship to Joffrey. I told her mother, 'Don't send her there, send her to DTH [the Dance Theater of Harlem]. She's been at the Pennsylvania Ballet, and she needs to stop competing with white girls and feel good about herself. Send her to DTH where she'll be . . . comfortable and she can grow. . . . ' At DTH her training is going to be excellent, so that when she goes into a white environment she won't feel she's not good enough."

This section is subdivided to represent, first, white stereotypes about black bodies, followed by black body self-stereotypes. The stereotypes held by whites as imagined by the dancers interviewed far outnumber black projections. These

groupings indicate that—in spite of civil, social, political, cultural, intellectual, and economic changes in the dance world and the world at large—contemporary perceptions are not all that different from the ethnocentric assumptions that reigned during the mid-nineteenth-century minstrel era. Airing them may help us begin to see these old patterns for what they are and find a way to let go of them.

These stereotypes run the gamut of images and associations that, in some instances and milieus, have solidified into established stances. Some were what the dancers imagined they would hear—what they felt pulsing in the culture when asked to act as a channel; others had been overheard in comments or conversation not directly involving the dancers; and others had actually been said to them.

My question was blunt: "When they are alone, what do you imagine white people [black people] say about black [white] bodies? About black [white] dancing bodies? Any distinctions?" The dancers interviewed were encouraged to allow lore, mythology, and stereotypes a full airing.

White on Black

Rennie Harris: "They kind of stereotype our thighs and, on another level, the warmup. I can always hear someone say, 'Well, you're not made up for this,' or 'You don't really warm up,' or 'You're too muscular to do this,' or 'You need to do this, do that.' . . . My sense is they think that it is very aggressive, the [black] dancing bodies . . . aren't made for modern dance or ballet. And the other [end of the] spectrum—wishing the whole time that their bodies were like that. You know what I mean? And a lot of that [stereotyping] coming from that [repressed desire to be the Other]. And I think that's why black culture is so appropriated in that way. So they think of a very physical, aggressive, athletic [body], and not necessarily made for [their kind of dancing]."

Brenda Bufalino: "Exaggerated. Lips are exaggerated. Hips are exaggerated. Long arms are exaggerated. Nose is exaggerated."

Ralph Lemon: "It's an interesting story with Meredith, and I mention this in *Geography,* the book I wrote. It was right after I left the Nancy Hauser Company. I was in *Recent Ruins* [a Monk performance work], and someone commented to Meredith . . . that I looked like an Ailey dancer. . . . I didn't look like an Ailey dancer; I looked like a black dancer who was probably dancing with a certain amount of 'technique,' in this Monk genre which is more about a kind of pedestrian, ordinary, physical quality."

Lemon's movement approach was based on Hauser's experience in German expressionist modern dance, which originated in Germany with Rudolf Laban and Mary Wigman, as practiced in the United States by Hanya Holm. In this case

he was incorrectly characterized as Aileyesque simply because he was an African American dancer whose medium was a defined modern dance technique that differed considerably from Monk's quotidian movement style. Well into the 1970s Ailey was, for many white dancegoers, the only frame of reference for judging black dancers, and all too often they assessed black dancers not by the work they were dancing but by the Ailey standard. Bill T. Jones recalled that in about 1971 people "were always telling you to go to Alvin Ailey," although that was not the kind of dance technique that Jones was practicing or seeking. On the other hand, several dancers I interviewed stated that the white stereotype of the black dancer is, as Ron Brown put it, "that the black dancing body does not have technique. That it's going to be limited. That you'll never have the facility, the turnout, the feet; that the structure will not allow for this ideal technical specimen."

Mention of the buttocks came up in almost every interview as a stereotyped black body zone. Merián Soto and Chuck Davis rattled off a hatful of additional clichés.

Soto: "Their butts. Powerful muscles. Oh, God: smell. Something about 'that person smells like a black person,' whatever that is. 'They sweat more, for some reason.'"

Davis: "'The feet too big. The butt's too big. They say they all got rhythm, but they ain't. Too loose: they don't have that ballet strength.' . . . These are all things I've heard."

Weight and bulk are frequent sites of stereotypes, Ron Brown said. "I've heard [white] people say, 'Oh, your male dancers look like football players.' Massive. Just big. Whereas a black young lady, she sent this email to the booking manager saying, 'I love the concert, and your men are fine specimens.'" As mentioned earlier by Garth Fagan, Ron Brown, and Joan Myers Brown, the black world, inside and outside of dance, has generally been willing to embrace big bodies.

Wendy Perron and Bill T. Jones cited myths around the African American male chest. Perron: "Actually someone showed me a picture the other day and said, 'This young dancer'—he was a ballet dancer—'has the Ailey chest.' But, you know, there are a lot of different chests on the stage and as many different in Ailey as there are in Paul Taylor or whatever."

Jones: "What is that about the big chest of a black man? These plates, the way that the chest is described, you know, the weight in the upper arms. Now, all men have that, but there is something about the way that a black man carries his chest, and coupled with the fact that black men have the use of their lower body maybe in a way that white men don't. None of these things are true anymore, but . . ."

It is significant that Jones qualified his remarks by stating that these differences are no longer true. It points to the fact that the environment shifted in the post–World War II eras. The kind of backbreaking physical work that produced such chests (in white or black men, depending on who was relegated society's most menial tasks) is no longer commonplace except in areas such as the Delta, Appalachia, and Amish settlements. Nowadays, exaggerated proportions are cultivated in the artificial world of bodybuilding and weight lifting, which is certainly not dominated by black men.

Still, the myth of black musculature is alive and well. According to Gus Solomons jr: "White men envy the definition of most black people's muscles. At least half the trainers at my gym are black men. They look gorgeous and people want to look like that, so they run to those trainers. Black men's bodies are very much admired by white men and women. . . . [But] I'm not sure what white dancers would say visually about the way black dancers look. [They might say] 'I wish I could jump like that.' That's functionally, not visually. I'm sure they envy the way the Ailey dancers can put it out, that projection, that presence, that riskiness, that bravery. Physically, they may say, 'I'm glad my thighs aren't that muscular,' those kind of things."

Solomons's comments neatly address the attract-repel nature of the stereotype: the black body envied and demeaned for virtually the same attributes.

Wendy Perron's musings bring us back to an age-old argument: "I think really the stereotype is not about the body parts but about the sense of rhythm, about a kind of dance sense that a lot of people think of as innate. And Katherine Dunham would say, 'No, it's learned, too,' but you know, I don't know what's nature and nurture."

The "inborn-sense-of-rhythm" stereotype is so entrenched in the Euro-American imagination that it still holds sway in the most learned of settings. Perron was not repeating her personal perspective but recounting the debate and voicing her insecurity about even addressing it. An example like Doug Elkins's explanation of how he was taught by black adolescents to dance and feel rhythmic subtleties the way they had been taught to do helps explain the "nurture" part of the debate: Whites can be nurtured to dance black. The example of Molefi Asante—developer of the postmodern theory of Afrocentrism who was raised in core African and African American culture but, according to close associates, cannot dance a step and has little sense of rhythm (except for appreciating it in others)—helps debunk the "nature" fallacy. And it is a fallacy: Not all blacks have rhythm. Like other "either-or" arguments, the nature or nurture debate is a generalization, a stereotype in and of itself, with so many exceptions that the rule demands revision. Perron's continuation, as she tries to make sense of her confusion, is helpful:

"My friend Harry [Sheppard] said to me, 'I learned how to dance in my mother's arms.' Well, I learned how to dance in my mother's basement! [Perron's mom taught modern dance in the basement of the family home.] But he learned how to dance in his mother's arms. And it was like, well, maybe it's more part of the culture. . . . It's valued early on. Whereas in my family, we did it in the basement. It was part of the professional thing and all that. But I could never dance in front of my father and brothers. That was nothing that was valued. . . . Anyway, when Harry said that, that's what made me realize that this stereotype is part of the culture. It's part of what you do with babies and all of that stuff."

In other words it's nurture, from culture and family. In spite of substantial evidence to the contrary, the "nature" fallacy lives on.

Meredith Monk: "Well, I think the lore has a lot to do with 'all body, no mind.' You know, kind of simpleminded, too—not sophisticated enough—the work, not intellectual enough. . . . Too exaggerated. . . . Not refined enough. Coarse, or something like that, yes? . . . Black people are too emotional."

Bebe Miller: "In touch with spirituality. More animal. More in touch with the bizarre. The good bizarre: they're not bizarre, but they are more in touch with the altered state. Funky, and what all that might mean. Attitudinal performers. It's kind of Josephine Baker but, you know, different: moved forward."

Miller's final comment acknowledges that some things haven't changed very much: we have different terminology and different frames of reference (for example, we don't talk about hip hop dancers as "savage" or "primitive"), but much remains the same. And the characterization of the black male dancing body as animal—not in the highly intelligent, super sensitive way described earlier by Trisha Brown, but in the pejorative way—is still alive.

Marlies Yearby: "Particularly with black men, I've noticed again that whole sensation of power and animal in how they're used." Her observation was echoed by Ron Brown in the following anecdote: "I remember—ooooh!—I remember doing a duet with a woman, and the choreographer came over to me, and she said, 'You need to grab her like an animal, like you want to rape her,' and I was like, 'What are you talking about?!' And I always got these parts where I was running around trying to get someone. And I talked to my [dance] partner about it: 'Is it because I'm 20, or is it because I'm black?' My partner was white. And she ended up thinking it was because I was 20. But it didn't really feel that way."

The animal equation, expressed or imagined, continues as a white construct for framing black endeavor. Ron Brown was reacting to the naïve, if not sensationalist, picture of sexuality imagined by the choreographer, a frame that played upon race tropes about the "savage" black man's lust for white women. No wonder he questioned the casting.

In a way that simultaneously exploited race and sexual orientation the media worked the stereotypes to the hilt in their coverage of Bill T. Jones and Arnie Zane. As Jones recalled: "When Arnie Zane and I were dancing together, they would always preface all of the reviews with 'Bill T. Jones is tall and black with an animal quality of movement, and Arnie Zane is short and white with a pugnacious demeanor,' you know. Or, 'the two of them are like oil and water on stage, and Bill T. Jones is all unctuous and ingratiating desire and Zane seems to be wound tight like a grenade,' or something like that. They were reading our personas, and they were attributing, unabashedly attributing it to race as well as — well, what else would they attribute it to at that time? They didn't know anything about our personalities."

But, of course, sexuality is part of the frame as well, with the media capitalizing on the play of black and white, male and male, and the physical contrasts and sexual energy around the attraction of opposites with, again, the animal frame of reference projected on the black dancing body. Jones's point reinforces the idea that the stereotype erases individuality for the sake of generalization. The following anecdote by Seán Curran, who danced with Jones, says a mouthful about the power of the stereotype to actually cancel out — if not annihilate — the individual: "In that documentary, I think it's in the *I'll Make Me a World* [three-part video on African American arts made in 1999], I talk about Bill making a phrase called 'warming up in Dixie' for *Last Supper at Uncle Tom's Cabin.* . . . He would say, 'No! You've got to do it more like a "darky" dancing in the South.' Everyone could do that. Even Larry Goldhuber, 300-pound Larry, so there was an idea that 'Oh, this is how it's done,' from seeing minstrelsy or those black-and-white films and stuff. . . . And I remember thinking, 'Isn't it interesting that we all can do this, but we can't do what Bill is asking in that other [more subtle, more sophisticated] way.'" What was also cancelled out, sadly enough, is the uniquely individual ways of dancing of the great African American minstrel men of the era, subsumed in the stereotype. Curran continued to outline the black body stereotype: "It's improper, it's impolite, it's vulgar, it's too much — and that, for me, would be the biggest stereotype. And I think today it's the snap queen, it's the banshee, it's the loud, obnoxious girl: it's changed; there's been transformation. . . . Attitude. You know, like a big attitude thing."

Yet the more it has changed, the more it has remained the same. The issue of attitude brings up the question of who is allowed to do what. The stance that is classified as black attitude is a kind of arrogance or bravado that says many different things. One of them roughly translates as, "Don't anybody (white or black) tell me how to act or what to do: I make my own rules!" With so many racialized

restrictions imposed on the black body, dancing or otherwise, this disposition is a
more calculated and effective response than outsider opinion might presume. Just
in order to take classes, to gain the techniques that would put one in the right po-
sition to succeed at an audition, the black dancer frequently had (and still must
have) a mantle of defense. Garth Fagan is intimately acquainted with the need for
and emergence of "attitude": "I know the times when I took classes and people
looked down their noses at me before I [even] did a second-position plié. It wasn't
about what I could do: It was just 'why are you here?!'"

Ron Brown cites a case in which white-skin privilege allowed for a leniency
that is frequently disallowed for blacks: "I was in Arizona [at a dance concert],
and I don't know what piece of classical music this was, and they're doing mod-
ern dance with their modern dance ballet costumes, and this guy comes out, and
he's dancing to modern dance and then all of a sudden he starts break dancing to
this classical music, and the audience loves it. And I'm sitting there finding it cu-
rious, knowing that in anyone's comp class [dance composition course: regular
fare for aspiring choreographers], if a black person had done anything like that,
it would not have gone over."

How are the boundaries pointed out to the black choreographer, either di-
rectly or indirectly suggesting that she "stay in her place"? Garth Fagan ad-
dressed the same issue in chapter 1: "When I choose to just take the
[Afro-Caribbean] movement and blend it into the modern ballet vocabulary . . .
they get upset. But if it were another [a white] culture . . . it would be wonderful,
hello, and hosannas."

Black on Black

How have entrenched views of black dancing bodies been internalized? African
Americans are living in two dominant spheres, black and white, and are obliged
to juggle identities and switch codes in order to succeed in these very different
worlds. In a documentary film about his life, linguistic philosopher and radical
theorist Noam Chomsky speaks of internalizing alien values and then convinc-
ing oneself that one is acting freely. He then made an equation: Propaganda is to
democracy as violence is to dictatorship. That is, democracy has a price on the
ticket. This comparison parallels the circumstance facing black dancers.
Africanist body aesthetics (bent knees, grounded feet, bodies pitched forward,
and so on) had to be subordinated to Other principles for black dancing bodies
to gain entry in the white dance world, be it Broadway, cabaret, or concert
work. Figuratively speaking, the social, cultural black dancing body had to be
violated—deconstructed and dismembered—in order to conform to democ-
racy's propaganda. However, since Africans are also Americans, and what are

considered white dance forms are rife with black dance tropes, one could easily believe that one was acting freely by internalizing the "bad" stereotypes—that is, the propaganda—about the black dancing body, and by looking upon that body as needing fundamental correction. With a little chauvinistic brainwashing, one could be convinced that a ballet standard of "good" feet or a Broadway definition of jazz dance was neither white nor black—just American, and just "good dancing." Black stereotypes about black dancing bodies are, after all, internalizations of white stereotypes, and it is here that stereotype threat casts its shadow, long and low. But as dance anthropologist Yvonne Daniel pointed out, the other side of the coin is that black people "become bi-, tri-, or poly-lingual," adopting white standards as they move in the white world and returning to Africanist criteria in diasporan situations. Social code switching is a sophisticated defense mechanism and becomes a means of cultural survival.[4]

Although the dancers I spoke with characterized it as more accepting of anatomical variations, the black world, inside and outside dance, is critical, cutting, parodic, witty, and often cruel. We are all human, and no ethnic group is angelic. On the one hand, Monica Moseley states "There has been less stereotyping of body types in black dance. There is more range about roundness and different kinds of proportions." In the next breath, speaking about a level of standardization that now infuses white concert dance, and the lack of latitude about difference, she acknowledges the contradiction: "And yet, as I say that, I think that the same kind of standardization has come into companies like the Ailey company, where they are all tremendously sleek. . . . There is not a tolerance for different body shapes there, you know."

Marlies Yearby echoes this reservation: "Dancers in general, I think, are always complaining about weight. But I notice around my black dancers that that is always a discussion—their weight . . . and the discussion of 'yeah, but for dance it's not good to be big-figured or voluptuous.'"

Chuck Davis: "The black classical dancers look with disdain upon the African dancers, and vice versa. And the modern dancers are caught in the middle."

Particularly for female dancers the buttocks is the "seat" of positive or negative commentary inside the African American community, depending upon the dance genre. Bufalino's tap world responds quite differently from Solomons's postmodern milieu, as is shown by their comments:

Brenda Bufalino: "For myself, black dancers or black people would say to me, 'Well, you've got buns, and that's good.' Like not having any buns is a terrible thing."

Gus Solomons jr: "Unfortunately, I think black female dancers probably envy white female dancers' bodies. . . . 'I wish my butt wasn't so big, I wish my feet pointed like that.'"

Doug Elkins introduced another level of stereotyping that is as lethal as the physical: "A lot of [black] dancers have internalized it: 'I'm physical, but I'm not intelligent. . . . I hear a lot, sometimes, the talk of the emotional power, the cultural connection, but not that—you talk about the intellectual genius of Balanchine, of Cunningham. . . . There's a John Henry thing: 'I go to work.' That's even a black body stereotype—the John Henry idea. That's what I mean—Superman, Superfly, representing, representing for the whole culture [is] a heavy burden."

In his associative style Elkins is addressing two sobering issues. First, that the black dancing body is seen as a headless, non-intellectual phenomenon; and secondly, that that individual body must represent the black body politic by its every move. To be perceived as an individual, not a stand-in for every black male or female, and to be regarded as an intelligent artist, the black dancer must work twice as hard as her white counterpart. Merián Soto describes how she played into this stereotype on immigrating to the United States from Puerto Rico. Soto's case is interesting, since she does not see herself as white nor describe herself as black: "When I first went to the States . . . I always felt like I wasn't as smart or as good as the white people. Or the Americans, period, even the black people. I didn't have the ideas, and I didn't have the technique, and I didn't have this, that, and the other. I remember reading about Judson and seeing Judson and thinking, 'God, they're so smart, they're so great,' and on and on."

To further examine self-stereotyping Soto comes out with a different spin than Noam Chomsky's. Does she manage to go beyond the stereotype? Here follows a portion of our interview:

MS: [Some of my works contained] a lot of this kind of exaggerated sexuality. There was a piece called "You and I" [*Tú y Yo*], and it's an improv piece where the dancer faces the audience and the house lights come up on the audience so the dancer can make eye contact with the audience. She does that, and then lets her body respond to that, and retreats and does a dance. Then comes forward again, and each time she comes forward she strips, so she ends up—but when I performed it, when I was in my underwear, I would go into very sensual things. I was a go-go dancer for a while, so a lot of it referred to that: the idea of owning my sensuality. It still becomes an issue. Now I'm working with Salsa, and it's very sensual, the work that I do. . . . I have a friend, Awilda Sterling, who's a wonderful Puerto Rican dancer/artist, also black Puerto Rican. She told me, "I don't like that work," and I said, "Why? How can you not like

that work?" And she said, "because it reaffirms stereotypes of sexuality in Puerto Ricans."

BDG: That's interesting, because I was going to say that the images that you just showed me [Soto had demonstrated movements], what they seem to do is to refute stereotypes by going so far that you come out on the other side. It's like when certain black people say the "n" word in such a way that it's totally re-empowered.

MS: I think in this Salsa work there is a little of that, but . . . I think that the stereotypes, we also assume them. We kind of digest them, and they become a little something else, but they're there. . . . Why should I deny my . . . celebration of my sensuality just because there's a stereotype out there about Latinos? I don't care! I want to make this dance about pleasure. . . .

BDG: The question always is how to negotiate the fiery territory of racism which has set up these pictures of you that are foreign to you but that you've grown up with.

MS: Yeah, except that I think stereotypes contain a history. They contain a lot of stuff. In popular culture there's this constant meeting the stereotype and re-appropriating it, taking it away from the market economy. . . .

BDG: —and re-owning, most definitely. In my opinion you can do some of the stuff that you were talking about, but if Wendy Perron or Trisha Brown did it, it would be totally unacceptable. The same thing, with the same dancers, it would be unacceptable if it had been choreographed by a white person. That's what re-owning is about, that there are certain things you can do with your culture or I can do with my culture [for example, the subtitle of this book] that nobody else is allowed to do . . . that no one is allowed to use the word "nigger" unless they're black and they can figure out a way to use it.

The following quote from Shelley Washington takes us to a different level of what the stereotype means and how it is played out. Unlike Soto, who grew up in Puerto Rico and now has her own company of people of color based in New York and Philadelphia, Washington spent her dancing career in an internationally famous dance company populated by whites, with choreography and leadership by a white woman. Accordingly, Washington's aims and needs were different:

I was the only black female dancer in Twyla's company and for many years Keith Young was in the company, a black man. But you know,

things would happen, like I would go to the theater, and I would hear
somebody say, in the tech rehearsal, "Put the spot on the black girl."
And sometimes it would bother me . . . and sometimes I would say,
"Excuse me, isn't there any other way to describe me? The girl with
the curly hair, the girl in the red leotard?" Here was my thing, and
also even growing up: I wanted to succeed; I wanted to be good. . . . I
didn't want people to say "the black girl who fell last night. . . . Who
fell off the balance beam? The black girl." Just so identifiable, and yet
I tried to turn that around and make it work for me. I remember my
mother being in the audience once, and my mother was not big on
tooting her horn or anything, I mean my mom was very quiet, very
proud but never said, "Oh, this is my daughter." Someone in front of
her said "That black woman has the most beautiful arms, I love the
way she moves, la-la-la." My mom tapped the woman on the shoulder
and said [proudly, if somewhat ironically], "Excuse me, that black
woman is my daughter." And there you go, so it turned around and
worked the other way.

Bill T. Jones offered insightful commentary about what is to be gained by a
black person performing for a black audience. His comments show also how
clearly sexuality and race are linked frames in the discourse on the black dancing
body. Performing for one's own can offer the possibility of going beyond the
white stereotype and a particular black one, which Jones calls "that kind of in-
fantile racial profiling that I was doing and that others were doing on me and I
was doing on them; [it] was stuff that carried through into this dancing persona.
This kind of 'I've got superiority, I've got an understanding of sex and freedom in
my body that you don't have.' And that was possibly part of the posturing and
belligerence as well. You know, 'you [white people] can't be spontaneous and
show real emotion. I can do a real emotion right here.' . . . I only wish that when
I was that young, that I had had all-black audiences, so that I would have known
what not to fall back on. . . . Because it was always speaking to the Other. I was
the Other speaking to the Other, and yet I had learned how to impersonate so as
to pass in some way."

And that is the issue with stereotyping, whether it is white on black, or black
on white. The object of the stereotype is falsely identified and is required, or
sometimes chooses, to pass for something other than who she is. Passing—
whether impersonating another personality or another ethnicity or using sexual-
ity as a "pass-port"—becomes important for the dancer who hopes to be invited
into certain ensembles or cast in certain roles.

RACIALIZED CASTING

When I was 12 or 13 and I was living in Michigan, I was the shadow to Peter Pan. . . . The girl who was Peter Pan was the most beautiful girl, with the pretty hair, the cheerleader, the perfect blond, la-la-la. I wore all black; she wore all green. I did everything she did, behind her. We got to the performance, and Peter Pan forgot her steps. And the shadow did not—did the whole thing . . . the shadow kept going. And it was then that my mother addressed the teacher and said, "You know, I think that Shelley has real talent, and she really loves what she's doing here. Where do you recommend I send her?" And that's when I started going to the National Music Camp, and after that I went to Interlocken Arts Academy for three years and did my schooling and my dancing there. But I do remember being the shadow, which was sort of interesting also because I was the only black in my dance school, the only black in my town, and I was the shadow. . . . And you know what else I was: I was also Pocahontas. Yes, I was the Indian. . . . I think they're funny [examples] because I am who I am because of those things. I don't take them as negative; I just think they're kind of funny.

—*Shelley Washington*

Although this memory from Shelley Washington is pre-professional, it helps to set the tone for this section. There are stereotypes; there is biased casting; and, then, there is the way in which the object of bias receives and processes these realities. Washington's assertion that she doesn't dwell on the negative was reiterated by several other dancers; yet, others expressed anger about the injustices. The attitude of those black artists who have succeeded in white venues reflects a strength of character and positive outlook that we generally associate with heroism. Washington's middle school experiences date back to the 1960s, a time when racialized casting was a more blatant practice than the subtle variations that we find today.

Joan Myers Brown began her career when these practices were standard: "Most black dancers prior to the late 1960s were the exotics. Harold [Pierson] was [usually cast as] this big black guy with this barrel chest and this booming voice . . . so he was there. Harold . . . was with Bob Fosse before Ben Vereen. Harold was Fosse's 'little black dancing boy.' . . . He was in the original *Sweet Charity*. And even today in ballet companies, especially in European ballet companies, it's always, for lack of a better term, it's always *freaky* stuff that they do,

you know. It's never—have you talked to Desmond [Richardson]? If he can't be Othello, they can't use him. Well, he wants to be Romeo!"

Part of the game is to know when and how to make the stereotyped casting work in one's favor. Apparently, it opened the doors to steady work for Pierson in his chosen profession. The dance field is highly competitive, with the supply of dancing bodies far exceeding the demand, regardless of the dance genre. Dancers are not federal workers or tenured faculty members. Job security doesn't exist. Even if the role one is cast in is a stereotype, a job is a job. And one job may always turn out to be the stepping-stone to a better opportunity. The race factor can be a plus, provided it doesn't become a rut. As ballerina Francesca Harper put it, "There have been times when someone will be doing a project where they'll need ethnicities."

Referring to a time that—we hope—is over and done with, Garth Fagan proclaimed his commitments as a choreographer and artistic director: "As all artists do in any art form, you bring to the art form what you know, what has been your experience. You illuminate what are your desires. You erase what you don't want to see. Which is why, on my stage, you'll never see the pimp or the whore. I just have no interest in that, because there are enough people doing it. And I know that there are a very small percentage of us that are pimps and whores."

Gus Solomons jr detected more discrimination when auditioning for Broadway shows than in the modern dance world: "I noticed when I first came to New York [1961] . . . I would audition for Broadway, and I never got the job, but I always got kept to the end. The choreographer wanted me, but the producer didn't—couldn't mix the show." He worked with concert dance groups by invitation. Although, as men of color, black males had to be better than their white counterparts to be hired, they had a certain edge in the dance market, since males were and remain the privileged, sought-after minority in this female-dominated field. Even so, the black male dancer faced unique challenges. Fagan offers a biting perspective:

"I just know that I always had to work harder. I had to jump higher, turn faster. . . . I don't know why, because people who were clearly less talented than me—that a blind man could see—got the parts and got the jobs, you know, and I had to really blow them out of the room to do it. . . . In college [Wayne State University], it was rampant. But there was a shortage of male dancers, as there is today. And I could boogie! . . . And there were always instructors who didn't see that [way]—who were supportive and open-minded and open-eyed—but there were the racist sons of bitches too. So I moved towards the ones who were supportive and open. Pat Welling—what a brilliant teacher she was. White as snow,

but she supported me, my first solo, and race never came into it, or not that I was aware of. And that's all I can ask."

Still, there are issues in the concert dance world that cannot be ignored. On the one hand, I interpreted my personal experience with Pearl Lang as a not-so-sublimated racial issue (why else would she cite the color of my skin as the rationale for not using me?); and Ron Brown interprets his experiences with white female modern dance choreographers as racialized. On the other hand, Ralph Lemon sees race—or the absence of racial diversity—as noteworthy but not necessarily an issue:

> I still love going to Cunningham's dance company, and you know there are no black bodies there. [Over the course of several decades Cunningham has worked with, one at a time, black male dancers, including Solomons and Ulysses Dove. Never has he hired a black female, and the presence of black males in the troupe has been noteworthy for its infrequency.] So, you know, nothing against that. It's just that, what does that really say? It says a lot, and it's very complicated. It doesn't say one thing, but it does say something, I think, that is very racially powerful and, yes, for me, is ultimately a little disturbing. . . . I adore the work of Steve Petronio, and there are no black dancers in his company. And for me, when I dance the more pure traditional modern dance, when I was in a more modern dance genre, I had no black dancers—I had one. That was it. So, you know, it's not about racism, it's just about a sense of class, perhaps. Not in the way of the haves and have-nots, but just—or not class but a kind of self-selected or self-induced segregation.

Lemon's layered reflections bring up the issue of aesthetic preference and, as he said, a different sense of class—aesthetic, rather than social. The problem and issue is where preference leaves off and prejudice begins. When does a penchant for a certain body color, size, shape, style help advance one's creative ideas, and when does it reflect narrow-mindedness? When Cunningham decided to use Solomons and Dove, did it allow his aesthetic vista to expand to accommodate their unique presence, or did these two extraordinary dancers (in what is always an extraordinary dance ensemble: to be a Cunningham dancer is to be unique) fit the picture of what the choreographer wanted at that particular time? Or both? What Lemon characterizes as "class" may simply reflect the world one grew up in. Solomons has already stated that he wanted to look like a white ballet dancer. And we know that he grew up in a practically all-white neighborhood and attended white academic and professional schools, as did Lemon, Bebe Miller, and

Shelley Washington. These black artists cut their eyeteeth on white aesthetics. In some sense, they already fit the picture, and color was less important than aesthetic class (just as Jewishness meant less when anti-Semitism's hold on America eased up after World War II).

In her own way, and from her Jewish New York background and vantage point, Wendy Perron echoes both Solomons's and Lemon's perspectives: "I never did a lot of auditioning. I can count the number of auditions I did on one hand. I auditioned once for Pearl Lang. I didn't get in. I auditioned once for a company that they were doing at ADF [the American Dance Festival, a prestigious annual summer institution], but I didn't get in. Everything I've done, I've done through non-audition. I didn't audition for Trisha [Brown, with whom Perron danced from 1975 to 1978]. We just sort of met, and that's how we did it. In a way, I think things are more self-selecting. . . . If I had been black, would I have been interested in Trisha at that time in the early 70s? I don't know. And I never auditioned for Alvin Ailey. . . . I think those interests get sort of segregated out even before the auditioning happens, maybe."

However, the Ailey company since the 1960s has aimed for ethnic diversity as a basic premise in its mission. It is also significant that, in her interview, Bebe Miller recalled that she wanted to dance with Trisha Brown in the 1970s, auditioned for her company, and was eliminated with the first cut. Miller had already been inside the downtown dance scene and its aesthetic criteria for some time. The argument about self-selection can be one-sided. Who is ultimately doing the selecting? Generally, it is up to the choreographer, director, or producer—not the dancer, who awaits selection or rejection by other parties: That is simply the way auditions work. The Bebe Miller audition scenario is a case in point. In many ways what seems to be a "safe haven" actually conforms more to the rules of the dominant culture than many in the field are willing to admit.

Still on the topic of the black male dancing body and racialized casting, the ballet world has had more issues with blacks than either Broadway or the modern-postmodern concert stage. In his tenure with the Netherlands Dance Theater and the Ballets Monte Carlo, Zane Booker bore the brunt of this issue, first, by being cast in roles that Joan Myers Brown characterizes as "the black boy," and, secondly, by being underutilized. Black males in white ballet companies are seldom cast in leading roles in the classical repertory. As Booker so cogently put it: "People's ideas, their images of what they want to see on stage in certain roles, overpower the casting process. . . . What's frustrating is that sometimes you want to do something that is totally, totally within reach, but because they don't see you in it, because you're black, you just don't get it [the role]. You don't get it. . . . And that's one of the things that I was thinking about the other day, where

race comes in with classical ballet. *If you have someone who looks the part and their technique might be a little shaky, they'll work with them and fix it and put them into it. Where if you don't look the part or if you don't fit into their perception of the part, you never get a chance. You never get a chance."* [Emphasis mine.]

This is such a potent statement. If the choreographer's artistic vision sees only blond Erik Bruhn look-alikes in the role of Romeo or Count Albrecht (the hero of *Giselle,* a staple in the classical ballet repertory), then tough luck for the talent and potential of a fine soloist like Zane Booker. I saw Booker perform with Philadanco in 2001. This young man looked like a fine ballet soloist taking a cameo turn with a modern dance company. His line, technique, and persona are balletic and classical. He has trained in ballet since he was eight years old. Yet he admits, "I never felt like I fitted into either world—a purely classical world or a purely modern world. You say you see me with Philadanco, and you see me in a classical company. Somebody [else] will see me in a classical company and say that they see me more with the Ailey group. And that's the honest truth. . . . Like *Sarabande*—I got put in a soloist role because I was black. Now today, I believe I have enough talent to have done that role, but then I really questioned myself because I didn't get put [in a lead role] in anything else from him."

Sarabande was choreographed by Jiří Kylían, who invited Booker to be a member of his ensemble, the Netherlands Dance Theater, where Booker worked with the junior company (1989–91) and the premier ensemble (1991–95). Again, the Ailey reference reared its ubiquitous head as the only home for the black dancer, regardless of the genre in which he is trained. And, again, the dancer is at the mercy of the choreographer for how he is cast and whether he dances or not. In all walks of life, but even more so in the arts, the choreographer, director, or boss wants to work with people who agree with him, cooperate with him, and share his vision. The dancer who balks at not getting a role or, worse, brings up the taboo topic of race may risk losing his job. How many white dancers are subject to the kinds of self-questioning and identity risks that black dancers are exposed to as a matter of course? Booker and others like him do not follow in the footsteps of the playwright August Wilson, who stirred up great controversy in the mid-1990s by declaring that blacks should not be cast as Romeo, Ophelia, or Willy Loman, nor even desire to play white roles, because color-blind casting disesteems their ethnic heritage. They want to be cast in as many and as varied roles as whites. This does not mean that to do so would reject their blackness; but what it could mean is that we all could begin to understand our traditions—classical and contemporary, black and white—as more generous, more engaging, and more embracing than the racial limits we impose upon them.

Joan Myers Brown bristles as the conversation turns to type casting. In *Standing at the Edge, We Dance,* a video about Philadanco made by Carmella Vassor in 2001, Myers Brown mentions that someone asked her, "What makes your company different from Alvin Ailey?" Her response: "What makes my company different from Eliot Feld or Paul Taylor?!" Again the dance world seems not so much to democratically self-select but to dictatorially segregate by continuing to categorize along racial lines.

Like Booker, but several decades earlier (1940s) Brown was trained in ballet in Philadelphia. Anthony Tudor, world-renowned choreographer and ballet master, came on weekends from New York to teach Sunday classes at the Ballet Guild. He refused to discriminate, which was the standard practice in Philadelphia dance schools at the time. So a number of talented African Americans studied with him. Myers Brown recalls a painful episode: "The forerunner of the Pennsylvania Ballet was the Ballet Guild, and I was one of the first two blacks in it. It was Geraldine White and myself. And we did *La Sylphide,* and that's when that comment was made—something like 'the ballet would have been fine except for the two flies in the buttermilk.' . . . It was in the paper or it was quoted, or it was something, but it was a big joke at the guild next morning. I was 17 years old. I don't remember whether it was the *Daily News* or the *Inquirer,* or it had to be the *Bulletin* or one of those papers because we were talking about the review. Mr. Tudor was very offended. So that was my last escapade as a ballet dancer. . . . I never fit in. I never did. I always felt that I was outside of everything."

Booker, Myers Brown, and Francesca Harper all indicated that the ballet-oriented black dancer faces even more of a challenge than others in finding a dance home. In his interview Booker offered a final story that capped his frustrations with casting. After dancing with the North Carolina Dance Theater for a year, he gave notice to Salvatore Aiello, then the director (who has since passed away). When Aiello asked what he hoped to do, the young dancer replied that he wanted to go to New York to work with the American Ballet Theater or the New York City Ballet. "And then he said . . . 'I want you to stay because I have a ballet I want you to do the lead in next year, and it's about a slave,'" Booker recounted. "I was just so baffled and I couldn't believe that what he was trying to use to entice me to stay was a ballet about a slave!"

Harper, who danced with the Dance Theater of Harlem from 1988 to 1991 and with the Frankfurt Ballet (Germany) from 1991 to 1999, voiced many of Booker's frustrations and then concluded: "I am constantly trying to look past the racial thing, but you can't at a certain point. It's like . . . they just don't see you fitting into the Flower Festival Town Scene, where they see Mary Jo, if you know what I mean." Picking up on her train of thought, we had the following exchange:

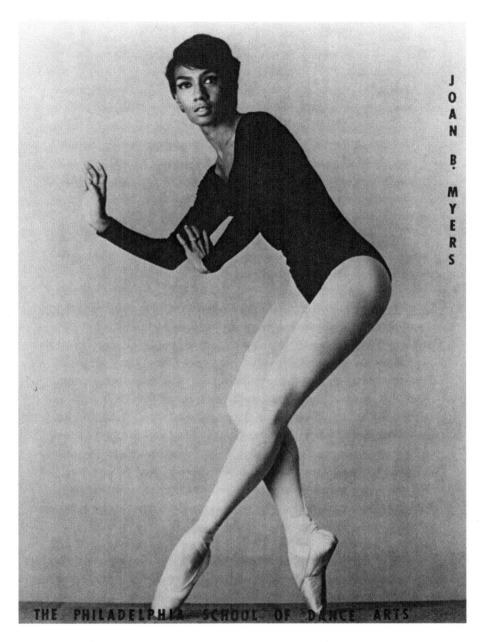

"A Dream Deferred." Joan Myers Brown (1950s). Permission of artist.

BDG: Who the hell "fits" into the Flower Festival Town Scene, any-
way? Who is living that life? It's all fantasy, and that is what the-
ater is about.

FH: I know, right.

BDG: And we know that, once a black ballerina is put in the cast, audi-
ences adjust.

FH: It's so true. Acting . . . you see at the Public Theater, when they
have Angela Bassett and Alec Baldwin playing *Macbeth,* and it is
fabulous. . . . But I find that it's so funny. It's more [racism] here [in
the States]. I come back, and it makes me angrier here in America.
And I feel a little more oppressed, pushed down. I think I also was
really lucky to have worked for somebody [William Forsythe,
American-born artistic director of the Frankfurt Ballet] who was
very liberal and progressive.

Clearly, not all European experiences are free of racial bias, as shown by this
bizarre incident recounted by Doug Elkins:

I just came back [spring, 2001] from a project which ended up being
like a variety show, choreographing at the New Luxor Theater in Hol-
land, and I [was about to] cast. I said, "Should we get dancers, every-
one blond, the same height?" And they said, "No: this is about the
city—Rotterdam—and so a multiracial cast." So I was really happy
about that. I cast it with dancers of different abilities and different
heights, shapes, some were from Surinam, some were North African.
But it became a problem when they [the producer and director] wanted
to do pure unison, and [they'd say], "She's shortened the steps, she's
Bolivian, her body looks wrong for the dances." And [I'd respond],
"No, those are called breasts and hips, and they're supposed to be
there." . . . And what they ended up doing, which frustrated me, was
putting them all in blond wigs.

Brenda Bufalino's story of passing for "colored" is a gem and points up the
irony and inanity of racialized casting. From 1955 to 1960 she performed as a
soloist in a Calypso act. At that time, she recalls, "I was just so angry at
whites . . . that any viewing of a white anything brought distaste to me. . . . I
dyed my hair black and—hey, I can pass for a lot of things, I can pass even for
Chinese! I've looked so many different ways in my life. You'll get a kick out of
this: I actually used to work the Black Debutante's Cotillion Ball, and on 125th

Street with Ray Barretto [renowned Latino percussionist and bandleader]. . . . People were all doing Calypso then. . . . There was no problem [in passing for black]. It wasn't like I walked in and said, 'I'm a Negro.' I just looked strange enough to be anything." Later, when she ran up against the problem of being a female tap artist in a man's world, she again played a modified passing game: "I went into a man's suit [in order to be] . . . looked at seriously," she said.

Like Bufalino, Merián Soto also introduced the subject of gender, relating the story of a project in which she was involved: "I was part of the advisory board of this national study on choreographers . . . it was in '91 or something. The results were appalling. The best-paid choreographers in the States at that time, and I think it continues to be, were white males. The worst-paid were Latinas." [Recent gender studies show that, in spite of their majority representation in the dance field, women in general receive comparatively fewer grants and commissions than their male counterparts.] Soto also addressed the casting issue from the perspective of racial bias in funding:

"Another one of my battles a few years ago was with the New York Foundation for the Arts. Year after year I would look at the fellowship recipients, and there would be nine white people, one black person, no Latinos—something like that. The ratios were really [unconscionable], and in a state like New York." Although Soto received regular funding from other organizations, including the National Endowment for the Arts, she decided that if she were turned down once more by NYFA, she'd appeal. She was turned down.

I said, "I've got to do this, someone's got to do this." I lifted up that dirty carpet. Man, people were freaking out. Even the black people and the Latinos on the artist advisory board were freaking out. Everybody got freaked out, because I sent copies to a lot of people. I even got a letter from NYFA where one of the officers there had gotten two of the people of color on the artists' board to sign off. I called one of them and I said, "How dare you!" The beauty of it was that he promised me they were going to take it up. They did a series of meetings with artists of color and the community and the staff. I went to the first one. . . . There were all these artists in different disciplines, all shades, all different cultures, and they're saying, "Why don't you have panels that are all people of color? Because as people of color we have to negotiate at least two cultures, so we are much more prepared to judge a variety of work." Or somebody from New Mexico saying, "When I came here I thought, with the demographics, that there would be all this [diversity] thing, and look: Look at the percentages, it doesn't read." Truly, I want

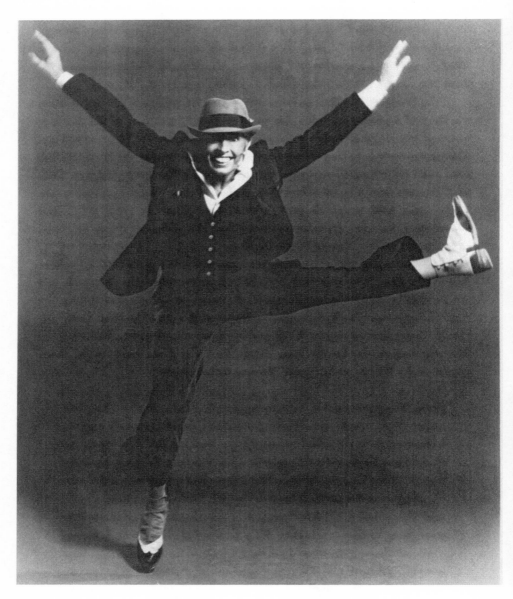

Fighting sexism in male apparel. Brenda Bufalino (1970s). Tom Caravaglia © 2002.

to just say that at least now they've responded. I have to give them credit for that.

Soto's final two sentences are of utmost importance: concerted agitation elicited a positive institutional response and a successful outcome. Change is possible.

The politics of art is an incendiary issue, especially when questions of stereotyping and racialized casting are on the table. Whose frame of reference is to be used to judge who is hired or what choreography is worthy of funding; and when and how is it possible to question, contest, or reverse those decisions? Where aesthetics leaves off and politics begins—or, better, how the two are bed partners that influence and counterbalance each other—is an area that must be continually negotiated.

POSITION:
FERNANDO BUJONES AND
JAWOLE WILLA JO ZOLLAR
(INTERVIEW EXCERPTS)

On his birthday (9 March 2001) I interviewed ballet legend Fernando Bujones, illustrious principal dancer with the American Ballet Theater (ABT) from 1972, when he was 17, until 1985. A Cuban-American, Bujones's performance style was the quintessence of the heroic, radiant approach associated with Alicia Alonso and her National Ballet of Cuba. He is currently artistic director of the Southern Ballet Theatre (Orlando, Florida).

The interview with postmodern innovator Jawole Willa Jo Zollar was conducted on 19 May 2001. Having danced since childhood in both Africanist and Europeanist styles, Zollar founded the Urban Bush Women (UBW) performance ensemble in 1984. The company has performed worldwide and organically links professional concert performance with community activism, showing that all people are dancers and that dance, by its nature, is political.

My excerpts are intended to give a feel for the general way things transpired in the course of two sample interviews as well as the specific turns of conversation dictated by the details of individual careers. As indicated by ellipses, I have done some editing to compress my commentary and minimize the back-and-forth of these hourlong-plus conversations.

Although Bujones's opinions are his own, they are a gauge and mirror of the ballet perspective/aesthetic in which he was nurtured. Just as Bujones represents his milieu, so Zollar's outlook is inflected by her standing as a driving female force in the postmodern, post-colonialist, multicultural dance arena.

BUJONES

Dance in itself would not be so powerful, so enriched, if it wasn't for black dance.

BDG: Please talk about the presence of African American dancers in the American Ballet Theater and whether you were aware of the "mandate" by its co-founder and longtime director, Lucia Chase, not to use black dancers.

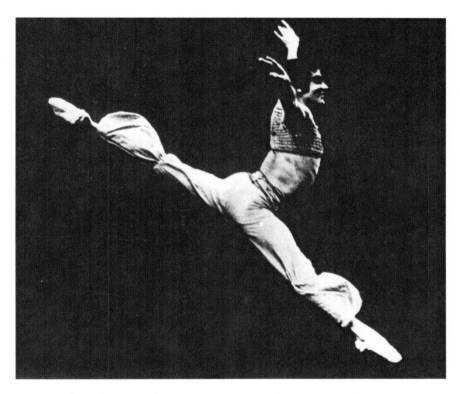

A Cuban-inflected élan. Fernando Bujones (1970s). Martha Swope/Timepix.

FB: Yes. I knew about that. I felt that in the '70s the company still had a . . . cautious way of using an Afro-American dancer. We had a dancer, Keith Lee, who was with us—tall, handsome, and pretty strong. And he was used in specific roles, like the *Moor's Pavane* [a choreography by modern dancer José Limón based on Shakespeare's *Othello*] . . . or to do the barrel turns in Harald Lander's *Études* [the best-known ballet by this Danish-born international choreographer] because of his athletic prowess . . . because of his strength, because of his skin color too.

BDG: Any comments about Alvin Ailey's works choreographed for ABT [*The River,* 1970, and *Sea Change,* 1972]?

FB: Ailey was very admired by ABT. *The River* was a huge success . . . and he did the next work for us. . . . [Somehow] the search for more Ailey works kind of dissolved. The artistic direction went into other choreographers and they went more into . . . bringing back . . . beginning roots again [meaning the "Americana" ballet styles of Eugene Loring, choreographer of *Billy the Kid,* and Jerome Robbins].

BDG: What was the overall feeling in ABT about blacks in the company?

FB: We didn't have so many Afro-American dancers in the '70s. . . . We were like a family. . . . There was no real racial problem. And Keith Lee, for example, was very popular with the company, so I don't think there was a problem between us. If there was anything with the artistic direction . . . we couldn't feel it, they kept it very secluded. . . .

Lucia Chase was artistic director until 1979. . . . I have a feeling that Lucia in the '60s and '70s was a different Lucia from the '40s. In the '40s she was . . . kind of [into] Americana, bringing the roots of the pilgrim—you know, she's a New Englander—the pioneer kind of spirit. Then later on she was very open-minded into bringing a very international look to ABT. . . .

In the '60s we still saw the aura of Tony Lander, Erik Bruhn [light-haired, pale-skinned Danes], and she [Chase] loved blond hair. . . . She was always in love with Irina Baronova and Natalia Makarova later on. . . . One of the things that she said to me when we first met was, "I thought you were blond!"—she had seen me perform in the School of American Ballet work-shop performance—and I said, "No, and I hope that's not a problem!" She had this idea I was blond because . . . she loved this kind of blond look very much! . . . She later eased on that, but she always still had favorites that were blond.

[*Note: Bujones is Cuban and decidedly brunet in skin and hair color, so Chase's slip seems all the more remarkable. One is reminded of Zane Booker's comment about getting parts because one appears to look a certain way.*]

BDG: What images come to mind when I say the phrase "black dance"?

FB: Exotic. Exciting. Sensuous movements. Voluptuous. I think that some of the most captivating, energetic dances come from Afro-American groups. I love to see an Alvin Ailey performance. I love to see Peru Negro, in Peru, a group that performs exciting folklore styles of dance. I really think that dance in itself would not be so powerful, so enriched, if it wasn't for black dance. And I remember someone like Arthur Mitchell, just doing *Slaughter on Tenth Avenue* [ballet choreographed by George Balanchine], what he did with that piece in terms of charisma, charm, and energy! It was captivating. I think that when Susanne Farrell and Arthur Mitchell did it, it was magic. And if you change that cast, it didn't work the same. It changes the whole perspective of that ballet. And that's what sometimes it [the presence of the black dancing body] can do.

BDG: What specific body attributes did Mitchell bring to the role?

FB: The looseness of his limbs. The flexibility was incredible. The smile. It was radiant. The moment he smiled, you just fell in love with him because there was a charm there that conveyed the interpretation of his role and conveyed the naiveté and the exciting aspect of the work and also the sensuality of it. We were excited to see him on the stage, and he was also beautiful looking physically when he did a piece like *Agon*, which was so abstract and so just physical and there was, like, black and white [in the 1957 premier of the ballet, Balanchine cast Mitchell to partner white ballerina Diana Adams, a first in American ballet]. . . . Long-limbed body. There was an elegance to his body.

BDG: Then, what images come to mind when I say "white dance"?

FB: A certain elegance to a style. . . . In some cases, lyricism and purity. . . . There's an imperial quality to Cynthia Gregory's dancing [former ABT principal dancer]. . . . I see a naiveté in Suzanne Farrell. . . . In the case of [Rudolf] Nureyev you could consider him white and Asiatic. . . . And this mix creates a very exotic [brew]. . . . Also, like black dance, powerful . . . because I see a connection there between white, Asiatic, and Afro. . . . I don't see a break; I see a connection.

BDG: What images arise when I say "black dancing bodies" and "white dancing bodies"?

FB: I see curves. I see double-take moves and sharp, forceful moves. I see a charm that comes across through those movements and also an inner strength that just comes out. Very charismatic. On the white, I see very linear movements. An elegance. A sort of lyrical, poetic: I see a white dancer, and I see an arabesque [a basic ballet leg lift, with the raised leg extended to the back high enough to make it parallel with the floor]. I see a black dancer, and I see a forceful contraction movement that all of a sudden leaps in the air.

[*Note: Bujones's reflections here align with those expressed by most others interviewed. The black dancing body is defined by energy and movement; the white dancing body by line and shape.*]

BDG: Do you perceive any changes for your generation, from earlier generations of dance practitioners, with regard to these black/white categories?

FB: I think they [black dance and dancers] bring, and they have brought through the ages, an inner strength which is mesmerizing, captivating. And for as beautiful and as elegant as ballet has been for all these years and for as beautiful an arabesque that we admire, we need that inner strength. We need that looseness too. . . . I think it [ballet] has been enriched [by black

influences], by all means. . . . The looseness, primarily in the middle torso
and hips . . . is very much needed. Otherwise ballet would be too rigid. . . .
So I think the combination of the square or the rigidness that portrays lin-
ear dance and elegance . . . [with the] looseness . . . rounds out the com-
plete movement of dance.

BDG: Are you saying that black influences have made for a different kind of
choreography in twentieth-century ballets?
FB: Absolutely. . . . And not only . . . for America, I think in Europe [as well].

BDG: How would you characterize your particular gift in ballet, owing to your
Latino training?
FB: They [his teachers at the School of American Ballet] . . . were caught on
something that I had that they felt was special, something that I brought
with me from Cuba. And that was posture, elegance. There was a cer-
tain . . . way that we were taught to stand in fifth position [the basic,
turned-out, closed-legged starting position for many ballet phrases: legs ro-
tated outward from hips to toes, with one leg immediately in front of but
touching the other] that already we had to project that we were like a
poseable dancer. Having that kind of feeling already inside of me as a
young student captivated them. . . . It was part of my training, that we were
given a sense of importance.

BDG: What was the racial breakdown of your ballet classes in Havana, as a boy?
FB: We were handpicked and chosen through an audition . . . of, let's say, 100.
Twenty of us were chosen as an elite class, but we had a mixed crowd, skin
color and everything.

BDG: Let's jump to stereotypes, myths: when they are alone together, what do
white people say about black [dancing] bodies—not your personal views,
but the fables, the "words in the air"?
FB: I've heard that they say they have an incredible looseness to them . . . that
they can move their gluteus, their butts, better than anybody else; that they
just have an incredible sense of rhythm to music, a natural way of moving
that is just captivating. Sometimes I've heard that they are not the ideal bod-
ies for classicism, which I don't quite agree with, because I think that in the
case, for example, of Arthur Mitchell . . . I think that if you have the right
proportions to be able to perform the classical roles, and you have the right
body and you have the right body lines to interpret a prince, why not? And,

you know, one of the most exciting male dancers right now in the world is Carlos Acosta. He's Afro-Cuban.[i]

BDG: Has a black dancer ever had the edge over you for a role or commission?

FB: I don't think so, and if he would have been and he deserved it, I would have been supportive of it, by all means . . . because . . . I'm the kind of person that totally, really supports talent where there is talent.

BDG: What do you perceive as the largest, most prevalent area of stereotyping with regard to the black dancing body?

FB: Probably still the area that is the toughest to accept, all around, is seeing a black dancer do a specific classical ballet that for years has had a tradition of being performed by white dancers. . . . Like maybe *Romeo and Juliet*. It's not that it hasn't happened . . . but it's probably the kind of thing that is still hard to accept—a black dancer doing Romeo or a Prince Siegfried [the hero of *Swan Lake*], or maybe a Count Albrecht. People still, for whatever reason, envision a *Romeo and Juliet* cast mainly with white dancers. And why not a whole cast of blacks doing *Romeo and Juliet?* . . . I think that there's still a bit of stereotyping feeling out there. . . . And . . . there's also still a bit of technical limitations that exist. Not all the dancers, black or white, have the technical means or facilities, the looks, to be able to technically or artistically dance or portray these demanding roles in the classics. . . . In the case, for example, of a white dancer, not everybody has the right style or feeling to be able to perform *Coppélia* [a comedy that is another staple in classical ballet]. They may be too elegant for that role, or too tall. The same thing can happen with an Afro-American dancer. Not everybody has the artistic means or the technical means to interpret or dance these roles yet. But those that do should be given the opportunity, and sometimes they are not given enough opportunity.

BDG: Is there anything you'd like to add to wrap up the interview?

FB: One of my favorite T-shirts was one that [Maurice] Béjart [founder-director of the Brussels-based ensemble Ballet of the 20th Century] used to wear. . . . It says "Dance Is Universal" and then underneath it says

[handwritten margin note: more acceptable for whites to do hip hop but stigma for black to do ballet]

i. In her year-end assessment of dance for 2001, *New York Times* critic Anna Kisselgoff characterized Acosta (and his partner, Tamara Rolo) as "symbols of perfection in *Swan Lake* with the Royal Ballet [of London] in Boston."

something like "the planets are always revolving, aren't we, too?" And I think dance is so global, universal, and constantly revolving. And we cannot stereotype or limit ourselves from this revolving and growing aspect of dance. That's what's made dance a very exciting art form in this past century.

ZOLLAR

The diversity is so big in what we call black —and, really, what we call white.

BDG: Please talk about childhood body images, black or white, negative or positive, that shaped your development.

JWJZ: I don't really remember very many negative body images as a kid. I do remember being teased because I was bowlegged. I developed breasts early, so I think I was a little self-conscious about that . . . they were probably the same size they are now. But, in terms of dance, I don't remember having images of my body as negative until I went to college. . . . The fact that I had a butt—they [buttocks] were honored, were good values.

BDG: Any memorable media images?

JWJZ: The images were white: blond hair, you know. The villain was usually dark haired. Even if you look at the Betty and Archie comic books—Betty and Veronica—the good one was blond, the bad one brunette. . . . I certainly wasn't conscious of it as a kid, of what the greater thing that it might be saying, but I know that I took it in. I always thought as a kid that I wanted to be one extreme or the other . . . either very, very black—blue-black—or very light. I didn't like being brown, in between. [Zollar's complexion is chocolate brown.]

BDG: Why?

JWJZ: You would always hear the expression, "She's so black, but she's pretty," and I just thought it was such beauty in the people who were very black. And then on the other side of it was the very light-skinned person, but I didn't want to be so light you didn't know I was black.

BDG: How have size, shape, or color affected your choreography?

JWJZ: I'll start with size. What I became aware of is that because I am short and muscular . . . I could move very fast, and so speed was something that interested me. Speed, quick jumping, a quick athletic burst, which probably

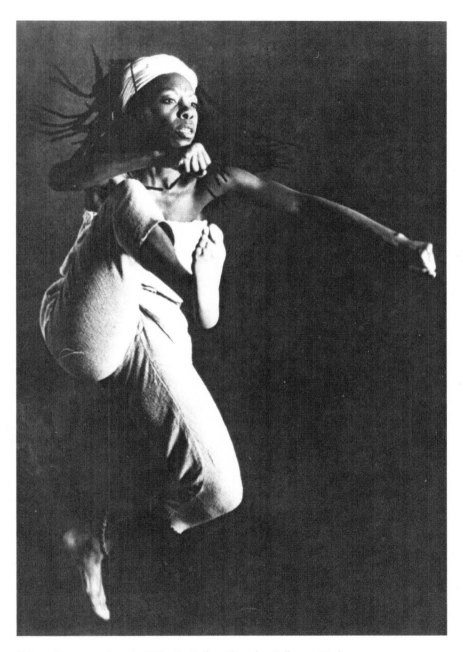

Defying Stereotypes. Jawole Willa Jo Zollar. Photo by Cylla von Tiedemann.

if I had a tall, very long back, that wouldn't have been my movement inclination. . . . I think I used it to define the [UBW] aesthetic. I was interested in moving . . . as fast as I could. And like bebop, it was like how much information can I get in this short space of time, and the dancers would always say, "It's too fast" . . . and I'd always say, "I bet you Charlie Parker's musicians told him that, too. Just push for it."

And what I like about a certain kind of speed is that the dancer also has to let go of formal training because you can't hold onto it once you get to a certain kind of athletic speed, and that was a point often of resistance. . . . I spend a lot of time with the dancers saying, "I don't want to see your formal training. I don't want to see a certain kind of line. I want to see a raw physical movement that from the audience point of view, it looks like they [the audience] could do it." And I think that has sometimes translated to people as the dancers didn't have any technique.

BDG: . . . when it's just a different aesthetic.

JWJZ: It is another aesthetic. So it was often a point of stripping away what you know. That's a hard place for dancers. They spend all these years training, and then I'm saying, "No, I'm not interested." But they needed the training in order to have a certain kind of command of their bodies . . . So I think that being aware that I was short and had a certain kind of physical power really kind of defined the aesthetic.

BDG: How about shape and color?

JWJZ: I had always joked in college that when I graduated I was going to form a group called Thunder Buns . . . because I just got so sick of hearing somebody's rear end was too big. . . . So certainly with other dancers [who hoped to work with UBW] it wasn't ever an issue for me. I wanted muscle tone. . . . In terms of color I was aware that if the company ever became too light, that meant something to other people. And you know, one time I looked up and the company was four women who were light skinned. . . . When I'm looking at casting and auditioning I'm not thinking about those things, and I don't like that I have to think about it. . . . And now I look up and realize that there are no light-skinned women. It's the first time the company has been all dark. . . . And surely somebody will say, "Oh, she doesn't hire light-skinned women," just like people would say she doesn't hire women with straight hair, which has never been true. So you get all of these things.

BDG: These are some of the issues that inspired this book!

JWJZ: Whether it is in your head or not, people are going to see it in that way because race has meant so many things and people have cast [performers] on those bases. So there is a history to that thinking . . . but it certainly is not in my mind.

BDG: What images come to mind when I say "black dance"?

JWJZ: A rainbow. . . . I see a rainbow because I think black dance is really like who we are in the society. We are absolutely everything and everyone and as the black experience it means that you could be culturally white, raised in the middle-class white suburbs, and that is your orientation, or it could mean that you were raised in the inner city but you love classical music and the opera. So to me, it absolutely is, it really is the full spectrum of, I would say, the American experience.

BDG: And what about the term "white dance"?

JWJZ: I think the first thing that came up was Lucinda Childs and Merce Cunningham. [Cunningham has created "abstract" dances on his New York–based ensemble since 1952; Childs, one of his many students who moved abstraction to a minimalist postmodern standard, was one of the original members of the Judson Dance Theater of the 1960s.] Because it is, if I think of a white dance aesthetic—and I won't say white dance, but a white cultural aesthetic—it's highly abstract. Emotion is not the driving force, or externalized emotion is not the driving force behind what you experience as the audience. The hip movement is fairly reserved, if there at all. It's a fairly straight upper body, and it's very much an aesthetic of privilege, the privilege of not having to worry about if the audience understands what you are doing or not.

BDG: Shifting the paradigm slightly, what images surface when I say "black dancing bodies"?

JWJZ: Again I get a rainbow. Because I see all kinds of shapes and sizes. . . . I see women with butts, I see women with tall, model-like bodies. I see breasts. I see dark skin, light skin, straight hair, no hair. . . . the diversity is so big in what we call black—and, really, what we call white.

BDG: What about white dancing bodies?

JWJZ: In terms of white people, there is the same diversity as black people. However, when I think of the white dancing body I think ballet has defined that aesthetic, so I think of the Balanchine body, and I think of a flat butt and no breasts—and that's not really true of white people, but that's what

comes to my mind in terms of what the predominant idea is . . . and also what is thought of as having a good body for a dancer, which is the very thin, no butt, with those hipbones [at the front of the pelvis] that just jut out.

BDG: What changes have developed for your generation, as compared to earlier generations of dance practitioners, regarding these black/white categories?

JWJZ: Arthur Mitchell proved that black people could do ballet. I don't think we have to prove that now, but I think that for earlier generations that had to be proven . . . that a black body was capable of the kind of extreme turnout that you use in ballet. . . . I don't think those things are issues [anymore]. Or maybe . . . they are still issues, but . . . it's more "we know it, and if you don't understand it, well that's your loss." . . . I think . . . there was never an answer to what white dance was. That question wasn't even asked in the earlier generation. . . . I guess 15 years ago, as I began asking the question, it was a shock to people. . . . And I keep saying that I'm waiting for a white dance festival to happen—where you sit on a panel and talk about whiteness and what it means to be a white choreographer.

BDG: What current issues exist for blacks in ballet?

JWJZ: There are lots of young black girls who go into ballet, and it's hard for them to stay there.

BDG: Are there differences for males and females?

JWJZ: Yes, absolutely. Because for black women . . . if you're in a school, everybody says Dance Theater of Harlem—go there. I mean, it's great, but there's no other options. To a white dancer they'll say, "Oh, have you looked at this place and this place and this place?" But to a black dancer it's the Dance Theater of Harlem, and definitely more for females . . . because of the shortage of men. . . . People are willing to become colorblind when it comes to that shortage of good men dancers.

BDG: Any other areas of change between your generation and earlier generations?

JWJZ: My mother was a dancer, and she wanted to do stuff like the Cotton Club, but she was too dark. She always talked about being too dark. And that was something that was always in my head: that she wasn't able to live out her dream because of her skin color. She was one of those children who grew up, and everybody said, "She's dark, but she's pretty." So I was aware of that, through wondering what would have opened up for my mother had the color thing not been there.

BDG: What was your earliest, first dance school experience involving black/white dancing bodies?

JWJZ: The first dance school that I went to was the Conservatory of Music, in Kansas City, Missouri [where Zollar grew up], that had a ballet program. My mother called to see—she heard they had a new Russian teacher—she called to see if they accepted black children, because this was in the '50s: segregation. And the teacher being Russian was like, "Sure, of course." . . .

We went, and she would say, "You look like a little monkey," or something like that—you know, she was talking to the whole class. But we as these [black] children . . . are very aware that we are in this environment. First, the strictness of the form, because she was very strict . . . I was maybe six. . . . And, in our minds we internalized it as "little black monkey." Now, more than likely she didn't say that, but I think that's how we heard it and how we experienced it, so we told my mother we didn't want to go back there. . . .

So then she took us to a community dance school [run by] Joseph Stevenson that was all black, in the heart of the black community. He had studied with Katherine Dunham. . . . He and his partner were ballroom dancers. As well as staging revues, he would choreograph cotillions for the black social clubs . . . and sometimes we were part of the entertainment for those. So that's where most of my training took place. . . . I don't remember anything about [ideal] body type, because it wasn't a technique. . . . It was what people call traditional jazz dance. . . . That's what I grew up doing. . . . You put your individuality in your style; you had to develop a style. . . . And so, if you were the big fat woman, you did the big fat woman dance, so it wasn't about a body type at all. . . .

I remember feeling superior, even as a little kid. I remember saying to someone [who studied at another children's dance school] that they did that white jazz . . . but we felt like we were doing [the real thing], and we weren't trying to imitate white people. . . . And that aesthetic stayed with me.

BDG: What was your experience of black/white dancing bodies in college?

JWJZ: I first became aware that my butt was a problem [in college] because I would have teachers who would say that it was too big. And I was hyperextended [that is, the lower back was over-arched], so I had teachers that didn't know how to talk about that. For them it was my butt rather than my alignment. . . . This was the University of Missouri, Kansas City, early '70s. . . . The whole idea of [body] semantics was just really coming into our . . . vocabulary, so the teachers still didn't know how to [change the

frame of] reference, so we were still told to tuck [our buttocks] under. . . . Pull up, tuck under, lock your knees: it was just a different way of approaching teaching. . . . They didn't know how to give me the language, so the way they referenced it was my butt. So I became neurotic about my weight. Now I weighed maybe 98 pounds, but I went on a diet to try to lose my butt.

[*Note: See similar reflections by Meredith Monk in chapter 3.*]

And the aesthetic . . . across the country, it wasn't just there . . . was very, very thin. . . . I went to [graduate school at] Florida State in '75, and I went on this 500-calorie-a-day diet. . . . And I was running in the mornings. . . . Fortunately I never went the route of anorexia or bulimia. . . . And at the same time I was researching African dance for my MFA paper, and my focus was on minstrelsy, which took me back to the plantation. . . . That's when I started to become aware of [the fact] that, "I don't have to buy into this." And that's when I started talking about Thunder Buns and Company, and I started getting very resentful every time somebody would make a remark about my butt. . . . Because what they were talking about was my hyperextended back and the lack of stretch in my lower spine and psoas [a set of muscles used in flexing the hip] and the need to strengthen the abdominals, but nobody knew how to talk about it in that form. . . . It has nothing to do with the look of it, it has to do with the alignment, the physical alignment of it, and I think that that [vocabulary] shift really made a lot of sense to me.

BDG: Now, please talk about black/white dancing bodies as issues have arisen in your professional milieu.

JWJZ: There is prejudice toward the very thin body . . . however, I think that there is more diversity [nowadays]. . . . I remember Johanna Boyce and her group, Cat Women . . . they were larger women, and I think that Mark Morris has a reputation for having dancers that are not bone thin . . . and even now we're seeing in the modeling and even in the actress thing, we're seeing large women stepping forward, from Camryn Manheim [of the ABC-TV series *The Practice*] to other large women. And maybe Oprah [Winfrey] has accepted who she is.

BDG: Moving to stereotypes, myths: What do white people say about black [dancing] bodies—not your personal views, but the fables, the "word on the street"?

JWJZ: Well, there's the stereotype of black people being able to jump higher. And I do think that when you have a larger butt you have more power to jump. . . . I think that when you have a combination of things—a larger butt, powerful thighs and Achilles tendon, that's a combination of elements that

make you more able to jump, and I think that black people tend to have those combinations more.

BDG: Then what about Mikhail Baryshinikov, Russian dancer and a fabulous jumper?

JWJZ: With Baryshinikov, I would say look at his butt: It's not flat, and he's got those powerful thighs!

BDG: Have you anything else to add regarding white stereotypes about black bodies?

JWJZ: I'd be willing to guess that white people don't talk about black people in terms of their bodies as much as we think they do. My guess is it's a different kind of conversation, not about the black body but about aesthetics and style. It's much more subtle. Things like, "She should go to Ailey" . . . not that she doesn't have the body [for performing with a major white company], but "Wow, she's great, she should go to Ailey." . . . I don't think it would even occur to them to send someone of my color to ABT. . . . My technique wouldn't matter . . . they would say "Dance Theater of Harlem." Pacific Northwest Ballet — it just wouldn't occur [to them].

BDG: Have you any example of when you had the edge over a white dancer or choreographer, for a role or commission?

JWJZ: No. I think that's a myth. . . . I mean, look at how many black companies there are [and how little work there is for us]. . . . like this year [2001] we had not one booking for Black History Month and none last year, and next year's very spotty for February.

BDG: Have you any example of when a white dancer or choreographer had the edge over you?

JWJZ: I can't ever really prove that, but I certainly suspect that. . . . Is a mainstream presenter going to have an all-black season? No. Are they going to have one, maybe two, black companies? Probably. Do they think about . . . the way it creates an advantage for the white companies? Is it malicious? No. They're just not going to have an all-black season. Could they have an all-white season? Absolutely, but more than likely there will be one or two "special interest" companies.

BDG: What do you perceive as the largest, most prevalent area of stereotyping with regard to the black dancing body in white culture?

JWJZ: I think it has to do with what I would call the experimental dance. In other words, if a white choreographer uses dancers that don't have a certain technical facility . . . and it's within the experimental milieu, I don't think there's ever a thought that the dancers can't [demonstrate proficiency in technique]. . . . It's thought of as an aesthetic choice. If as a black choreographer you don't use dancers from the Ailey model, and you use a different model, it is absolutely always [assumed] that the dancers can't. . . . I would say that is the big one.

[*Note: This is the same opinion expressed by Garth Fagan in the "What It Is" opening section of chapter 1. If whites are experimental, it is deemed innovative by mainstream pundits. Should blacks do the same, it is for lack of correct dance technique and training.*]

BDG: What's the largest, most prevalent area of stereotyping with regard to the black dancing body by black culture?

JWJZ: Ailey has been so wonderful and so successful that I think it has set up one expectation of the dancer. And if you don't fit into that expectation . . . I remember when I first started black people would say, "She's doing that downtown experimental stuff." . . . I think it's changing, [but] there was a very narrow line for black dancers to walk in and if you were outside of that line then you were into the white stuff.

BDG: Knowing that this work is about perception and reception of the black dancing body, have you anything to add to wrap up the interview?

JWJZ: Well, I guess it's wrong, but it's a sort of stereotype that black people didn't have the type of feet that white people had, which of course isn't true, but I remember I was doing a concert with some colleagues from Florida State University when they moved to New York. . . . After the performance this young white woman came up to me and said, "I love your line," and I said, "Wait a minute: me?!" And she said, "Yeah, I loved your feet. . . . Everybody else's feet were all curved over, but yours were nice and straight!"

LOCATION:
WHO'S THERE?

SUBJECT: CENSUS 2000—CHECK BLACK

*By this time most of you should have already received your Census 2000 forms. There
are several ethnicities listed on the form. The black race needs to be counted. It is of the
utmost importance. Just in case you are not sure which category you belong in, here
are a few helpful suggestions:*

. . . If you can name all of the characters on the show, "Good Times," check black;

If you are a white woman and only date black men[i], check black . . .

If you know what fat back and hog maws are, check black . . .

If you can name three Al Green songs, check black . . .

If somebody in your family is called Big Mama, check black . . .

If you eat greens more than three times a year, check black . . .

If you have more than two piercings in your ear or wear a nose ring, check black . . .

If you know how to do the Hucklebuck, Tootsie Roll, or Electric Slide, check black . . .

*If you have ever used the phrase "nah looka heyah," "wachout there nah," or "sho
 nuff," check black . . .*

If you refer to anyone (family or friend) as Pookey or Boo, check black . . .

If your name is or rhymes with Shaniqua, check black . . .

If you understand ebonics or use it, check black . . .

If you have tape recorded music on your answering machine, check black. . . .

 —Anonymous email circulated winter-spring 2000

i. " . . . or black women" needs to be added. Even this witty exercise perpetuates the invisibiliza-
tion thrust upon gays and lesbians, as feminist sociologist Becky Thompson pointed out to me.

I was one of many who received and forwarded this email at the beginning of the new millennium. (Was it circulated only to people of color?) This hilarious send-up actually serves as both a bonding device (some of the references, all of which weren't quoted here, were very in-group) and an ironic statement about how difficult it is, in our day and age, to sort out who is or isn't black. A particularly sarcastic comment, "check black if you're white and date only blacks," says a lot about this blurring of identity. I can only guess the intentions of the author of this message; for me, it points up the absurdity of race categories and the anachronistic character of the Census. Still, race is always an issue of power, and "checking black" is one of the few means for a historically oppressed people to have the agency and power to mobilize against racism.

Like the sections that will follow, part I interrogated the black dancing body and its relationship to racialized constructs. And what of the generic "black" or "white" body? One summer morning as my husband and I sat in the outpatient admissions office at Temple University Hospital, we passed the time by "body watching" with a vengeance: As serious fun related to the work on this book, we observed the buttocks of every passer-by. In this half-hour or so we witnessed a world of variety proceed before our eyes, represented in many ethnicities. Finally, we zeroed in on black women's buttocks: big butt, small butt, no butt, low butt, high butt—describing them as they sauntered or hurried by. The variety *within* an ethnicity at a given moment in a given locale is profuse. Scientists and other scholars have acknowledged this fact for generations, but the public domain doesn't get it or doesn't want to get it. There is no black body type, but lots and lots of variations and combinations—no average, no "mean." We simply cannot quantify or control human diversity by our constructs. Blacks come in all sizes, shapes, and colors. The black (dancing) body is a sociocultural concept, not a biological imperative, and the term "black dance" is really a misnomer. As Jawole Willa Jo Zollar pointed out in her interview, we could more appropriately speak of "black dance aesthetics." The black dancing body—be it black, white, or brown—is the body that is shaped by black culture, by growing up listening to Al Green, doing the Electric Slide or the Freak in the living room, dancing with sisters and cousins while grown-ups sit in armchairs and on sofas, egging you on while protecting your space. It is as close to home as maestro George Balanchine sending his ballerinas to study with Katherine Dunham and asking Arthur Mitchell to show them how to do "old-fashioned jazz"[1]; and as far afield as a Taliban soldier in Afghanistan asking a relief worker to demonstrate rapping and confirm that there are people who are black living in the United States. Black people's culture, black people's bodies, are everywhere—a constellation of attitudes-habits-predilections, the sum of which are

reduced to the least common denominator by using the terms "black dance" and "black dancing body."

"Who's there?" is the opening line of Shakespeare's *Hamlet,* spoken by palace guard Bernardo, to which guard Francisco replies, "Nay, answer me: stand, and unfold yourself." Who is there when we name a person by her so-called race or even ethnicity? Who and what do we see when one stands and un-folds — reveals — oneself? In the 2000–2001 theater season director Peter Brook's production of this classic played in Seattle, Chicago, London, and New York. Brook cast Adrian Lester, a young, dreadlocked Afro-British actor, in the lead. In a symbolic way, Brook's choice was an in-your-face response to the two open-ing lines of the play, an updating that brought the immediacy of contemporary life into a centuries-old text. Who is Hamlet, or Sundiata? Who is King Arthur, or Hannibal? Who's there when we speak of black or white? Who's there, when the black body has been interrogated, tried, and convicted on the basis of a white aesthetic? Who's there, when Adrian Lester can play Hamlet but Zane Booker cannot play Romeo?

At the equator of our race consciousness, who's there?

MAPPING THE TERRITORIES

LATITUDE II

A woman's face, dominated by a frightened, wide-eyed stare: Male hands reach out and pry her lips away from her teeth so that she seems to sneer beneath her petrified gaze. She is naked. The doctor begins describing her, as he continues to manipulate her body: "Rounded gums. [Clasping her jaw, turning her head from side to side:] Slight Prognathism. [Measuring nose with small ruler:] Nostrils arched. Nasio-labial space normal. [Simultaneously spreading her nostrils and flattening them against her face:] Septum slightly flattened. [More manipulations of her body parts continue, with accompanying comments:] Lower lip fleshy. Prognathous jaw typical of non-European races. Forehead narrow. Scalp low. Hair thick, oily, shiny. Ears normal—lobes not fixed, slanted. Upper eyelids drooping. Skin swarthy. Hips naturally large and flaccid. Soles of the feet flat—arch totally absent."

This "examination" was not performed on a black body, but on a woman suspected of being Semitic (defined in the film as Jewish, Armenian, or Arab) during World War II. It is the opening scene from Joseph Losey's chilling movie about Nazi-occupied France, *Mr. Klein* (1977), demonstrating that when we want to identify someone as Other, we go to the body. But it could have been Georges Cuvier examining Sara Baartman, the so-called Hottentot Venus, in the Paris of 1820. Whether Africans or Jews are the targets, the mythology runs along parallel tracks in the Aryan-colonialist imaginary. Nevertheless, there is no universally ideal body type. Bodies are idealized for specific political, economic, and social purposes of inclusion/exclusion, for purposes of figuring out where the Self ends and the Other begins. As far as dance is concerned, the high lateral arch in the feet that is valued in ballet is, in its own way and in other aesthetic perspectives, ugly and inflexible. For certain techniques (such as Bharata Natyam, a form of southern Indian dance) a flat foot slapping the floor is the best carrier of the aesthetic. Likewise, all bodies can be trained to fit a given dance ideal, provided that there is no medical dysfunction and the dancer begins early enough in childhood for the body to shape itself around the demands of that particular technique. And that is what ballet, Bharata Natyam, tap, and every other form of dance across the planet and across the eras have set out to do: to train bodies to move in their preferred manner and in accord with their aesthetic ideal.

There is no inherent value in having highly arched feet or an unarched spine: both, in the extreme, portend imminent anatomical problems (arthritis of the feet; an inflexible upper back). Likewise, there is nothing inherently wrong about unarched feet and an arched spine, although both, like their opposites, can lead to muscular-skeletal problems (poor alignment; lower back pain). And let us remember that there are "white people" with flat feet and swaybacks and "black people" with military backs and arched feet.[1] Race theory based on body types stands on shaky ground. On one hand, white dancers have developed the "position Négroïde"—namely, arched spine, buttocks stuck out—after training in African dance and practicing that carriage as part of the package. This stance (so named and utilized as part of the mime techniques taught to my husband during his training at the Mary Wigman studio in 1950s Berlin) is unwittingly valued and practiced by high-fashion models as a sexually alluring posture.

On the other hand, black dancers have developed ballet bodies. Surely, no dancing body—black, brown, or white—is inherently unfit for any kind of dance. Instead, cultural preferences by the established pundits of taste set and shape the exclusive criteria that distinguish one culture's values from another, one dance form from another. It's really more about what we like to *see* than what the dancing body can be taught to *do*. And no dance form or technique is based upon "the natural body," whatever that might be. Each form carries its own human-made (usually man-made) aesthetic criteria that represent a particular culture's needs, aspirations, preferences, and dislikes in a particular era. And each form, even those that we call classical or traditional, has changed over time. Thus, the twentieth-century ballet body looked very little like its nineteenth-century counterpart. Visual renderings and written accounts of Marie Taglioni or Fanny Elssler in the European ballet world of the 1830s–1840s give a different impression than what is communicated by ballerinas like Suzanne Farrell or Darci Kistler, late-twentieth-century American ballerinas trained in the Balanchine tradition, or even by mid-twentieth-century stars like the Bolshoi Ballet's Maya Plisetskaya or the Royal Ballet's Margot Fonteyn. Even more interesting changes can be seen in the Chinese style of ballet that held sway during the Communist reign there. Twentieth-century dancing bodies reflected twentieth-century values. They became taller, longer limbed, and more muscular, acrobatic, speedy, and technically sensational than their nineteenth-century forerunners. We may still recognize it as the same aesthetic *form* in both centuries, but the *shapes* were different. Change in technical training and overall lifestyle led to different body profiles. In the twenty-first century there will be a central role for black and brown bodies in ballet: Classical forms either accommodate or perish.

No one assumed that whites couldn't perform traditionally black dances. Black forms have held sway in defining white popular entertainment since the nineteenth-century minstrel era and the twentieth-century Broadway and night-club periods through millennial entertainments such as MTV and the live mega-shows of pop recording artists. Stars like Madonna (who, early on, studied dance at the Alvin Ailey American Dance Center) not only surrounded them-selves with dancers of color, but also incorporated the latest black-derived dance forms in their shows. This current trend parallels the white Virginia Minstrels of the 1840s incorporating their versions of black plantation dances in their staged routines. In the popular arena, black dances, separated from black bodies, be-come the means of production for distilled white versions—modesty-modified imitations—that meet an acceptable white standard before they can be inte-grated into the white mainstream. (Again, the appropriation-approximation-assimilation model at work.) It is the difference between a one-step performed by Vernon and Irene Castle—the white, turn-of-the-century ballroom team adored by high society, and the same dance done by its Turkey-Trotting origina-tors in black America. Whites have the privilege of appropriating black cultural goods and tailoring them to their culture-specific needs. Up until the 1960s this change predicated modification of Africanist torso articulation (namely, isolating and playing the body parts one against the other so that chest, rib cage, back, belly, pelvis, and buttocks have the option of working independently or sepa-rately). In the Protestant Christian underpinnings of mainstream white culture, overt use of the separate parts of the torso reads as sexually suggestive. In black diasporan culture, using the torso is not mainly or necessarily a sexual come-on, but an aesthetic value based on whole-body dancing. This helps explain why black children are encouraged to learn the latest fad dances. They are not being trained by their elders to lead a life of promiscuity, but to carry on a tradition of polycentric, polyrhythmic body fluency.

George Lipsitz in *The Possessive Investment in Whiteness* talks about a remark-able retention phenomenon amongst plantation-era Africans: "Even when slaves and free blacks found themselves dependent upon European or American tools and artifacts, they put them to use in distinctly African fashion."[2] Let us make a figurative inversion of this theory and look upon the black dancing body parts— particularly the buttocks-pelvic region—as a "tool" used in "distinctly African fashion" in social and grass-roots dances. Problems arise when in the white arena blacks are required to deploy that body in Europeanist fashion. In the subse-quent paragraph Lipsitz states that many (white) Americans "still don't want an African hut in their country. They understand that the unity forged through the possessive investment in whiteness depends upon the erasure—or at least the

eclipse—of the African . . . pasts." Likewise, the unity of the Europeanist danc-
ing body ideal—verticality—needs to erase or, at least, subdue the Africanist
body. So inferiority is the tool. Africanist ways of moving body parts (feet, but-
tocks, belly) and Africanist characteristics (skin color, hair texture, facial fea-
tures) are deemed "bad." But these features and attributes have shaped black
survival and black cultures, compelling black peoples to transform the bad into
"the baaaaad," to revise the negative into a positive.

How hard black dancers have had to work to disprove the assumptions
about black bodies as unfit for "white" dance forms! With regard to what it can
or cannot do, the black dancing body has been victimized by "the soft bigotry of
low expectations" (to borrow one of the education slogans of President George
W. Bush) as well as by outright racism. And even now there are those inside and
outside the dance world who still pose the question: Are black bodies fit for bal-
let? Yet statements by experts, including the Merce Cunningham dance
archivist, David Vaughan, and revered Manhattan ballet coach Richard Thomas,
reinforce the main premises of this book. According to Vaughan, "Ballet tech-
nique has always accommodated itself to human bodies in all their variety."[3]
Thomas states, "Anybody can do ballet. It's not a matter of how you're built but
of whether you have a brain."[4] His comment is telling and puts the issue of the
dancing body into another realm by insinuating that it may be more important to
be a thinking body, an intelligent body, than a perfect body. As Shelley Washing-
ton said, "I've never seen anyone who had everything who was as good as some-
body who was missing something . . . white or black. . . . The perfect body
doesn't work. . . . You have to have something that you have to overcome . . .
something that you have to work on, something that makes you vulnerable."
These statements remind us that dance is a process, not only a product, and that
a dancer evolves. Washington talks about the work she did to develop her lateral
arch in such a way that she looks rather astounding on point. She also addresses
the fact that, having taken up yoga at age 40, she has gained flexibility in her
limbs and spine that she never had as an active performer with the Twyla Tharp
ensemble. Had she studied yoga as a child her dancing body might have devel-
oped quite differently. Then, again, the fact that she didn't—and waged a battle
against tight, narrow hips—may have had a lot to do with the extraordinary
dancer she turned out to be. I discovered yoga in my twenties, and for me, too, it
opened up a world of flexibility that I had been unable to achieve in my ballet
and modern dance training. With many contemporary dancers of various ethnic-
ities looking to yoga as an auxiliary movement technique (which, unfortunately,
is a reductive approach to this holistic practice), others who deemed themselves
inflexible may be in for rewarding surprises.

The geography of the black dancing body: I began this section in the fall of 2001, not long after the September 11 attacks on New York's World Trade Center. The day that marked the second month after the tragedy was a Sunday as well as Veterans day—a holiday that, this time around, was not simply an excuse for another long weekend. Significantly and symbolically this was also the day that the United States began bombing Afghanistan. The line from an old ballad that declares autumn in New York is "often mingled with pain" kept flashing in my mind. Practically the entire, fat, November 11 *New York Times* read like a memorial. One article resonates with the topic of this book. "New Yorkers Lose Their Inner Rand McNally; Sept. 11 Rips Up Mental Maps That Guide City Dwellers' Lives," by Kirk Johnson, contended that without the navigational guide of the Twin Towers as their pilot, people in my home town were disoriented, their mental maps of security destroyed: "The human sense of order, predictability and stability is linked directly to the shape and texture of the physical world, and particularly to the landmarks that define it and in turn, define us."[5] Indeed, external landmarks can be milestones, borders, boundaries, or beacons. With familiar landmarks gone, that which was known becomes suspect, if not feared, and disorientation may set in.

This landmark concept can be applied to what it means to be black in the United States. For many African Americans, numerous urban and rural areas across the nation have functioned as symbolic land mines posted with invisible "No Trespassing" signs. Lying beyond topographical markers are the physiological landmarks that have defined the black (dancing) body as an embattled territory. Feet: black feet programmed to accommodate the enslaved black body that was forced to work like a beast of burden; feet that were obliged to dance for one's supper or that dared steal away to freedom. Feet shackled to other feet, having to negotiate a common *rhythm* for their shuffle steps so that the chains didn't cut into the ankles as the "gang" lumbered forward. Skin color that made one both visible and invisible, seen too much and noticed too little. Skin that, for Bible-toting southern fundamentalists, was "the mark of Ham," the darker Old Testament brother who was destined to a life of trials and tribulations. (And what better way to self-righteously justify slavery than to dehumanize the enslaved.) Hair that could get you in trouble: Oh, what a landmark it is! Unruly, wiry hair; rough hair, tough hair; reviled, revolutionary hair undermined by slave owners who could force an African to refer to his hair as "wool," rather than hair—their way of wiping him off the map of humankind. Some female slave owners punished enslaved females by personally shaving their heads.[6] The loss of this "natural" landmark equates with navigating minus one's pilot. And then there are the buttocks and the rampant sexual mythology accruing around

this endangered site: the female buttocks—defiled by night against woman's will, defamed by day by the mockery of dominant culture females.

Sometimes, when there is nothing else to lean on, these physiological landmarks act like geographical beacons that highlight and fix our sense of human order, provided that we are strong enough to see them in a positive light and resist the trap of self-hatred. Accordingly, in the Africanist worldview big butts, arched spines, and feet making full contact with the ground are valued. In the Europeanist perspective black bodies represent an Other order, both desired and detested. This map of difference was the starting point for white minstrelsy. The quest to apprehend and appropriate what was distinctive about blacks—and to demystify the difference by labeling it inferior—focused on the black body.

Each chapter in part II opens with a memoir on my own dancing body. We start at the bottom of the map—down there, at the feet, the demonized yet envied black dancing feet—and work our way up through chapters on buttocks, skin, and hair. Where do gender and sexuality fit into the picture? Everywhere—since the fables that surround the black (dancing) body are landscaped in gendered sexual tropes. "Feet" focuses on three male dancers in celebration and affirmation of the righteousness of their glorious grounding, beginning with minstrelsy's William Henry Lane, better known as Master Juba. The buttocks chapter zooms in on mythologies around the black female behind, beginning with the Khoikhoi woman who was abducted and paraded around nineteenth-century Europe as the Hottentot Venus. It moves on to a discussion of two women who used the stereotype with wit and irony in order to transcend it. These choices do not mean that black male rear ends or black female feet were let off the hook of historical calumny or, alternately, were lacking in talent. Rather, they show that black males and females each had their own crosses to bear, with ethnocentric issues in daily life (such as the sexual attraction-repulsion around the black female buttocks) replicated in the dance arena—illustrating my contention that dance is a measure of society, not something apart from it. Furthermore, there have been fabulous female dancing feet in every era and genre since the post-minstrel period (1890s) when women were first introduced to the early vaudeville stage. This is another invisibilized story that deserves its own telling. Pre–World War I talents like Ida Forsyne and swing era dancers like the Whitman Sisters and Jeni Le Gon are the tip of this crop of unsung maestros. Contemporary performers like Ayodele Casel (who has worked with Savion Glover) and Germaine Ingram (the Philadelphia-based muse, inspiration, and partner to master tapper LaVaughan Robinson) continue the tradition.

Whether a ballerina or a "booty" dancer, you start with your feet on the ground.

FEET

My feet: long and bony, like my hands. Strangely, my big toes were angled inward at birth — maybe proto-dancer's toes, since so many of us wind up with bunions anyway. (It was my parents' choice not to have them broken and reset while I was a baby.) I have what is termed a high instep (that is, the lateral arch is situated closer to the ankle than the toes), which makes the dancing foot look nicely pointed, even though I don't have a high arch. My toes and ankles, like all my joints, are very flexible: good for plasticity in movement, bad with regard to making me prone to injury. (The downside of flexibility is lack of strength.) Early on I was made aware of the stereotypes around black feet: Big, flat, and inarticulate were frequent descriptors. Growing up I was too black, too tall, and my feet were too big — and, ooooh, those crooked toes!

Dance saved me! At Mary Anthony's studio in lower Manhattan my body was valued for its elongated, lyrical line, and my feet were used as exemplars. They were neither perfect nor beautiful, but my use of them showed how ordinary feet could be put to excellent use. Anthony pointed this out to a couple of (Jewish) friends of mine who were dancing with her at that time (mid-1960s: back then I was the only dancer of color in the ensemble). These feet were fast and flexible. They did the job, after all. And me? I was in the thrall of the white dancing body — an oreo wanting to succeed as a white modern dancer in black skin.

∽∾

I know my feet, all about them. It's like my feet are the drums, and my shoes are the sticks. . . . My left heel is . . . my bass drum. My right heel is like the floor tom-tom. I can get a snare out of my right toe, a whip sound, not putting it down on the floor hard, but kind of whipping the floor with it. I get the sounds of a top tom-tom from the balls of my feet. . . . [I get the hi-hat sound] with a slight toe lift, either foot. . . . And if I want cymbals, crash crash, that's landing flat, both feet, full strength on the floor.

—Savion Glover, My Life in Tap

Feet are so important to dancers because they ground us, and we need to know where we stand. They give us security and are our launching pad for fast and furious or light and airborne movement. Whether black, brown, or white, on Broadway, the ballet stage, or the street corner, dancers spend a lot of time working—and working on—their feet.

Before Jews were considered white they, too, were characterized as people with flat feet, "bad" feet. It is remarkable how, once white skin privilege is bestowed upon an ethnic group, the stigmas attached to their bodies are miraculously erased. No one complains about the Jewish foot in the contemporary dance world. So what has changed? The feet? The perception? The acceptance? And why should this issue still be discussed with regard to black dancers? Although subjected to calumny in comic routines, these black feet were admired in minstrelsy and vaudeville for their speed and articulate clarity. Charles Dickens, commenting on the dancing of Master Juba in 1840s London, stretches to find the words to adequately express his enthusiasm for what he has seen.[1] The style initiated by Juba would ultimately be refined and finessed into what we now call tap dance, a form practiced as frequently and wholeheartedly by whites as by blacks; for, like all things American, no one ethnic group can keep exclusive claim on a cultural skill for long. As Le Roc, a 20-something British R&B singer put it: "White singers get more credit for being able to sing and dance black than black singers do."[2] A dancer like James Brown, largely self-taught, brought footwork to new heights of achievement in his fast-paced, raw execution. But these pop styles of dance, even though appropriated by white practitioners, were looked upon as the rightful place for black dancers to hang out. The real problems arose whenever blacks moved toward mastery of "white" forms.

To draw this map of black feet I begin with a sketch of William Henry Lane and minstrelsy, fast forward to James Brown, stop by for a visit with Gregory Hines en route to the world of Savion Glover, and wind up at the feet of ballet and some roving myths.

FEET, DON'T FAIL ME—MASTER JUBA

William Henry Lane was a youth who spent his entire life dancing, frequently in competition against white soloists in jigging matches. Lane died in 1852 when he was about 27 years old. Yet, a rendering of him from a poster for his appearance at London's Vauxhall Gardens (in the Harvard Theatre Collection) looks like the portrait of a middle-aged man. Part of the aging appearance is due to the black, burnt cork and exaggerated lips in the depiction: He is made up and disguised in the minstrel mask. In the mid-nineteenth century, Lane would not

have been allowed to perform except in blackface. This artist was the link be-
tween black and white dance and dancers and black and white minstrelsy, a
crosser of borders who was hired by the entrepreneur P. T. Barnum (later of cir-
cus fame) when Barnum's white minstrel, John Diamond, quit.[3]

Lane's sobriquet, Master Juba, conjures up images of an older African step
dance, Giouba, brought to the Americas in Middle Passage, which, according to
dance historian Marian Hannah Winter, "somewhat resembled a jig with elabo-
rate variations, and occurs wherever the Negro settled, whether in the West In-
dies or South Carolina."[4] "Juba" was a common name for enslaved Africans that
was associated particularly with dancers and musicians. Stearns and Stearns de-
scribe the Juba step as a "sort of eccentric shuffle," which, in its Cuban form,
fused "steps and figures of the court of Versailles . . . with the hip movements of
the Congo."[5] Another step, "Pattin' Juba," consisted of "foot tapping, hand clap-
ping, and thigh slapping, all in precise rhythm."[6] This variation was the forerun-
ner of the Hambone, a percussive song-movement form popularized in
twentieth-century rural African American communities. Thus, it was a tribute to
black history and traditions that Lane was dubbed Master Juba.

Although he has been all but forgotten, Lane was characterized by Winter as
the "most influential single performer of nineteenth-century American dance."[7]
There is little documentation of his work beyond a smattering of newspaper and
journal accounts from the era, including a famous one by Charles Dickens from his
American Notes (published in 1842) and several reviews from Lane's extended stay
in London (1848 until his death there in 1852). By these accounts (and by studying
the few extant renderings of him) we can surmise that Lane's contribution was in
forging an original, innovative merger of Africanist-based torso articulations, foot-
work, and rhythmic syncopation with Europeanist steps characteristic of the Irish
Jig and perhaps even the "steps and figures of the court of Versailles." This is why
Winter characterized him as an artist of utmost importance: In merging these two
streams Lane laid the groundwork for twentieth-century pop culture and its seam-
less fusion of black and white forms that is so definitively American.

Let us jump cut to Lane's feet and their significance. We can surmise that he
utilized his feet as percussion instruments and introduced the speed, syncopa-
tion, and sophisticated complexity of African rhythms to the white popular stage,
challenging the hegemony of white dancers who, themselves, imitated black
street and plantation steps and movements in an attempt to enliven their rou-
tines. But Lane was the real thing, "the genuine article." As speedily and intri-
cately as his most famous competitor, John Diamond, could dance, apparently
Lane could outdo him. The *Illustrated London News* of 8 May 1848 asked, "How
could he . . . make his feet twinkle until you lose sight of them altogether in his

energy?" Another critic commented that he had never before witnessed "such flexibility of joints, such boundings, such slidings, such gyrations, such toes and heelings, such backwardings and forwardings, such posturings, such firmness of foot." Still another clipping from that 1848 London season gushed, "The manner in which he beats time with his feet, and the extraordinary command he possesses over them, can only be believed by those who have been present at his exhibition," while another characterized his work as "an ideality . . . that makes his efforts at once grotesque and poetical."[8] So these feet were amazing in bringing to bear elements that left his critics speechless and grasping to create neologisms ("backwardings and forwardings") that could replicate his innovations. Dickens wrote of Lane's "single shuffle, double shuffle, cut and cross-cut . . . presenting the backs of his legs in front, spinning about on his toes and heels like nothing but the man's fingers on the tambourine."[9] As an earlier, American handbill read, "No conception can be formed of the variety of beautiful and intricate steps exhibited by him with ease."[10]

The best living analogy I can think of for "twinkling" one's feet until they become a blur is the fantastic tap artistry of Savion Glover. I project Glover's feet onto the descriptions of Lane and realize that Lane is Glover's aesthetic ancestor. (Of course, there are huge differences, since each artist represents the culture, styles, and mores of his era.) The repetition of the word "such" in one review gives a sense of the rhythm, repetitive but syncopated, of Lane's offerings. And still the writer observes and comments that Lane is firm on his feet, a basic requisite for dancing excellence. Obviously the young man is technically accomplished, knows what he's doing, and is in control. Lane's energy is also cited. Recall that, in the chapter on definitions of black dance, an ineffable quality of energy was one of the characteristics given by several dancers. Juba's energy and ease add up to charisma. The man had "soul," and all indicators point to the genius that lived in his feet. A steady stream of white and black imitators followed on the minstrel stage and Lane's innovations were carried over into early vaudeville, which is how and why his legacy was transmitted down through the ages and can be tasted even today in the work of Savion Glover.

Dickens's comment about Lane's use of toes and heels like the fingers of a tambourine player are particularly telling. This observation is consistent with what we now call tap dancing, wherein toes and heels are played alternately, sometimes contrapuntally, like percussion instruments, and are as specific and sensitive as fingers playing an instrument. Clearly Lane had traveled beyond the conventions of the nineteenth-century Irish Jig and even beyond the complexities of the Africanist Jig as performed on southern plantations. As the Stearnses explain, Lane came on the scene at the moment when the specific meaning of the term "jig" as an Irish folk

dance was being amended to mean black dancing in general.[11] By then both
Africans and Irish were performing step dances that were generically called jigs.
The term later becomes pejoratively associated with African Americans as in "jig
piano," an early form of ragtime music, "jig top," the segregated section of white
rural carnivals and circuses, and "jigaboo," one of many white epithets for African
Americans. Cutting his eyeteeth in New York City's notoriously raucous Five
Points ghetto of poor Irish immigrants and free Africans, Lane absorbed, embodied,
and re-created both traditions in his own ingenious dancing image. The observer
who characterized his work as both grotesque and poetical is pointing out that Lane
established an aesthetic that differs radically from the Irish Jig. He offered to white
audiences a black aesthetic by deconstructing the ramrod straight torso of the Irish
jiggers and replacing it, first, with a torso that bends, torques, and leans asymmetri-
cally pitched off-center (as in the Vauxhall Gardens rendering) in a decidedly
Africanist posture; second, with legwork that in the swing era (1920s–1940s) would
be characterized as "legomania" and entailed exaggerations in bending the knees
and twisting and spreading the legs in ways that were unheard of in the Irish Jig;
and, third, with his fabulous ball-toe-heel syncopated footwork. These characteris-
tics were considered ignoble postures until Lane, through his charismatic presenta-
tion, transformed the ugly into the beautiful, astounding audiences by presenting
the grotesque as poetic—a metamorphosis that is achieved only through consum-
mate artistry and a total engagement between the performer and the form, the
dancer and the dance. Lane brokered contradictions through the force and power
of his black dancing body.

Returning to the Vauxhall Gardens rendering, Lane's feet are the most beau-
tiful, delicate, and detailed part of the picture.[12] He is wearing shiny black, low-
heeled boots that end just below his knees. His feet are almost balletically turned
out. His torso is asymmetrically poised in a jazzy position, one hip jutting out.
His hands are coolly tucked in his pockets. The toes of his boots are finely ta-
pered finials for his long, narrow feet. The boots, the feet, are the center of focus,
attention, and energy. They look as though they were built for speed. Indeed,
these are toes that look ready to twinkle and feet that look considerably younger
and more plastic than the rest of the body, with the face the least expressive of all
(which is the price paid for blacking up). Is this likeness an idealization on the
artist's part? If so, that would be a radical way of portraying a black minstrel:
Most nineteenth-century renderings were demeaning. Perhaps the visual artist
was confronted with a classic dilemma of representation—namely, that it is most
difficult to depict something unfamiliar. In this case, artists tend to resort to a fa-
miliar conception or idea, rather than what they see (namely, the new, strange
phenomenon).[13] That's why many early Enlightenment renderings of Africans

were Europeanized to fit the ideal of the noble savage. In terms of facial features and bodily postures, sixteenth- and seventeenth-century portraits of Africans look like Europeans in modified blackface. The Vauxhall Gardens artist may have unwittingly neutralized some of Lane's distinctiveness—and blackness—through the fact of inadvertent ethnocentrism. Nevertheless, there is a force and energy in the depiction that attests to Lane's uniqueness.

If the Vauxhall sketch is an idealization, then by coincidence it runs parallel to the norms of traditional African art which is never realistic but always conceptual. The classical African artist works with what is *known*, rather than what is seen. Accordingly, there is no continental African standard of representational, naturalistic portraiture or landscape art. Instead, a sculptor may exaggerate the size of the human head in relation to other body parts to show that the person is a head of state; or the breasts to show that the individual is a nurturer. Thus, ironically, one might "read" the Vauxhall picture in an Africanist context: Since Lane's feet are the center of his gravitational pull, as well as the center of our attention, they are represented here symbolically, not naturalistically. Beyond these speculations what we can say, conclusively, is that this representation of Lane's feet reinforces their power.

Before leaving Lane, let us take a step backward for a brief glimpse at some of the Africanist forces that shaped him. We must look to the plantation era to theorize Lane's development as proto tap dancer.

Rhythm: African rhythm is the signature that separates Lane's style from the white styles of his era. The centrality of multiple rhythms (polycentrism) and multiple meters (polymetrics) is characteristic of almost all forms of continental African performance and is exhibited in song, dance, and music styles. In addition, these expressive forms were interconnected: African musicians also danced and sang. Lane himself was an expert tambourine player.[14] He was also the sum of all the African pasts that preceded him. His feet had a reason to be brilliant. Generations earlier, immediately after Middle Passage, African drums were outlawed in the United States (although not as definitively in the Caribbean and South America). The feet—as well as hands clapped together or patted on various body parts and "found" instruments such as spoons, buckets, or brooms—had to carry out the function of the drums. In addition, enslaved Africans were forced to give up their religious practices and become Christians. The Protestant denominations frowned upon dance, particularly fancy footwork. But African religions were danced religions. Practitioners embodied their deities through codified dance movements that involved not only footwork but also the articulate Africanist torso, which was alien to a Europeanist dance aesthetic based upon the vertical alignment seen in forms such as ballet, the Irish Jig, and English Clog dancing.

Fortunately, plantation-era African American Christian ceremony was seg-
regated from white practice, enabling Africans to develop their own style and
criteria that modified yet retained a host of African characteristics. Out of these
restrictions enslaved Africans created a religious practice known as the Ring
Shout (which will be discussed again in the final chapter). Instead of sitting still
on upright wooden pews and facing a proscenium altar to listen quietly to a
preacher, they preserved the African centrality of the circle, communal worship,
and improvisation. In the Ring Shout practitioners moved in a counterclockwise
direction (an African tradition) while singing, chanting, and improvising a cap-
pella versions of Christian hymns that were embellished by African techniques of
repetition and polyphony and accompanied by body percussion and rhythms on
buckets, brooms, and other found objects. Improvised variations were their cre-
ative ways of moving to these rhythms and traveling in the circle.

There was a particular Protestant taboo about crossing the feet while moving
(since foot patterns could be construed as dancing), sometimes expressed in
rhymes to remind errant feet to watch their manners. (One such ditty warns,
"Watch out, Sister, how you step on the cross, your foot might slip, and your soul
get lost.") Honoring both African and European needs, enslaved Africans found
ways to shift weight from heels to toes, to insides and outer edges of the feet, mov-
ing the feet in various directions, turning toes and knees in and out, sliding, glid-
ing, shuffling, stomping the feet—without ever crossing them or lifting them from
the ground. On top of this they articulated the torso and limbs in counter rhythms
and different directions, adding syncopations and improvised movements
throughout the body. Thus, they were not breaking white Protestant rules—not
dancing, in a European sense! What they were doing, in an exquisite example of
acculturation, was inventing a new dance form! What I have described would
look like an early form of pre-tap dance called buck dancing. This is the form that
Lane inherited, along with African and Irish forms of the jig. So the shuffling syn-
copation of the Ring Shout and buck dance and Lane's ingenious innovations
were Africanist ancestors in the evolution and development of tap dance.

DANCING AGAINST THE GRAIN—JAMES BROWN'S BODY

*Most of the entertainers out there, I taught them most of the things
they know. But I didn't teach them all the things I know.*
 —*James Brown, quoted In Selby,* Everybody Dance Now

Everything about James Brown's body personifies the full map of this book and
the chapters in this section: His skin color, hair texture (and aesthetic adjustments

of same), facial features, and body build (filling the stereotypes of a muscular physicality, with a definitely prominent rear end) are the embattled territories where the black dancing body has fought to make a place for itself in mainstream culture. He deserves serious praise—"props"—for utilizing physical attributes which, when he started out in the 1950s, were seen as negative in the world of white pop culture. But Brown brought them—himself, that is—to the mainstream table and began the initial thrust that four decades later would result in appropriation of the hip hop body by white mainstream youth. He even managed to redefine old gestures that had been tainted by slavery. Thus he could bend, bow, fall to his knees (oh, please, baby, please!) in humility. An important point: Brown humbled himself in the name of love, and the love he calls for seems to beg for response from a black woman. I mention this point because, for whites as well as blacks, one of the most compelling aspects of Brown's work (and, later of hip hop culture—meaning graffiti artists, b-boys and break dancers, deejays and rappers) is that nothing "white" is implied in it. He lures white seekers with a grass-roots, unflinchingly black aesthetic that celebrates and reaffirms blackness for blacks: "Say it loud," he shouts, "I'm black and I'm proud!" Like Master Juba, Brown is the genuine article, and he extends an "equal opportunity, affirmative action" invitation to all comers to embrace blackness.

Brown is a wellspring of inspiration for artists and amateurs, not only on the dance floor and the popular stage but also in the clubs of the hip hop generation and the concert performance venues of postmodern dance. In *The Blues Brothers*, the 1980 Dan Aykroyd–John Belushi movie, he appears briefly as a singing, dancing preacher, the perfect role for him as a man then in his forties. He is at the center of a crucial dance scene in the film, not so much as the dancer but the reason for the dance, a function he has amply filled in real life. The wild, sexy, "in-your-face" performance style of white and black rock, punk, and hip hop artists would not be with us today were it not for Brown's radical, nitty-gritty innovations. By the late 1960s he had become a major factor in the invention of "funk," a raw, sweaty, gutsy, blatantly rhythmic style of music, song, and dance. His dancing style is as thoroughly extraordinary and influential as Lane's, and his work has been imitated by artists for decades, some of the most influential including Mick Jagger, Michael Jackson, MC Hammer, and Prince, all of whom are expert movers in their own right.

With Brown, as is the case with Lane and Glover, our attention gravitates to the feet. Tap artists call them "legs": If you tap well, you have "legs." And "legs," as well as the whole body, are important in Brown's dancing. Indeed, his body is an orchestra: Head, neck, little rounded belly, butt, legs, knees, feet—all are separate instruments in his somatic symphony. He is an integrative artist, and his

dancing is almost inextricable from his singing. As Brown quips in the video *Everybody Dance Now:* "I started dancing as a necessity back in 1941. [Brown was born 3 May 1933.] I was living in Augusta, Georgia. Times were very bad. I started dancing for the soldiers, and they got excited and started throwing quarters, nickels, and dimes. And pretty soon I had a lot of money on the ground. I realized that dancing was going to be a way of life for me." Using his feet as percussion instruments to keep the beat (the same means used by Lane and by rhythm tap dancers, but for a different end), Brown understood that rhythm was his basic strength. A self-taught mover, he danced faster and harder than anybody anyone had ever seen before.

Brown was almost a staple on the 1960s white teenage television dance program circuit, making numerous appearances on shows like *Where the Action Is*, and *Shindig!* (both on ABC-TV). On some of these programs (now available on video) he is the lone person of color to be seen amidst a sea of starched, well-behaved white adolescents. His presentation of self starkly contrasts with these spectators, and he is used as an exotic, often actually teaching them his moves in the way that Hawaiians teach tourists the Hula. (And, in a sense, these kids are tourists observing Brown's black planet.) In several numbers on *Where the Action Is*, filmed on 14 October 1966, he lip-syncs over his songs for only a few seconds and, instead of pretending to sing, concentrates his energy and focus on his fast and furious dancing. Thus, "Night Train," "Papa's Got A Brand New Bag," and "I Got You [I Feel Good]" become background music for his dancing skills.

Early on Brown trained as a boxer, which is apparent in his dance style. Frequently he uses his arms as though he were sparring his way over, around, and between the popular dances of the 1960s (Monkey, Frug, Boogaloo) that provide the body movement atop his flying feet. This trait is especially evident when the videos are run at fast-forward speed: He looks like he's in the ring. His famous cape routine was stolen from the antics of "Gorgeous George," the wrestler. (This act was developed for the hit song "Please, Please," Near the song's end, Brown falls to his knees, bent forward, begging his lover for forgiveness; his master of ceremonies, Danny Ray, comes over to throw a cape around his shoulders and usher him off the stage, but his "grief" is so deep that he shakes off the cape, rises, and continues to sing this slow, moaning ballad. Again he falls to his knees; again the cape is thrown around him. Finally he allows himself to be led out, usually to a wildly cheering audience.) The stage is Brown's boxing ring; his performing ensemble, the audience, and his own dancing body are his sparring partners. As he asserts in *Everybody Dance Now:* "When you're dancing against the grain, it makes it more dynamic, but if you flow, then you're not doing anything."

"The James Brown" is a dance step named after the master. To a continuous pulse set up by his feet, with legs close together, knees slightly bent and parallel, weight on the toes as the heels remain slightly lifted off the floor, the toes continuously grind or gyrate into the floor, while the heels and knees work in and out. Maintaining this perpetual motion, the feet are crossed and opened to accomplish forward, sideward, or even backward locomotion. It is like a speeded-up version of a fad dance known as the Skate (thus, the sliding movements) combined with the Mashed Potatoes, but faster, tighter, and figuratively even smoother than mashed potatoes. To accomplish this step Brown's ankles must remain incredibly mobile. Turning his toes in and out, he works all parts of his feet. This multifaceted use of the feet is similar to the way that Glover works on taps, often using even the inner lengthwise side of the foot for movement. Brown can turn while continuing the movement by crossing one foot in front of the other and swiveling for one or more full revolutions. There are two other embellishments that can be added to this basic step: Half-splits to the floor that, like a yo-yo, rebound back to a standing position; and a "super-bad" step—with one leg lifted forward and knee bent, Brown pulses the knee of the standing leg in a repetitive motion. He can do this in place or use this one-legged exclamation point to write his dance sentence across the stage.

In his London concert recorded at the Hammersmith Odeon in 1985, Brown at age 52 dances all the while he is singing, at times in place, at times across the floor, either keeping half- or double-time rhythm with one or both legs pulsating to the beat. Sometimes his tight, muscular buttocks are called into play and pulse backward on a back-back-back-back, "on-the-one" beat; or, adeptly maneuvering the microphone, he glides across the stage in a Skate—a step that hearkens back to Juba and minstrelsy and looks ahead to the slides and moonwalks of the hip hop nation. Of course, at this age, his dancing is more sedate, and he bides his energy to take him through these hours-long shows. With age he dances more with his torso and there is less fabulous footwork. Instead of breaking out into his skating, sliding variations on the band's solos, he is more likely to stand at the side of the stage with his back-up singer (here the wonderful Martha High, who worked with him for years) and in half-time they dance popular social dance steps in unison. When his lead alto saxophonist, Maceo Parker Jr., plays a beautiful, jazz-inspired solo, Brown dances, alone and in place, using his head and shoulders as a conductor's wand for leading his band as they back up Parker. This brings up an important point: Everyone dances in the James Brown ensemble—musicians, back-up singers, female lead singer. While standing in front of the bandstand, his horn section frequently move together in Motown-style unison steps as did his back-up male singing group, the Flames, before Brown went solo. There is a

sense of movement even from his seated musicians. This practice reflects Brown's indebtedness to the swing bands and dancing bandleaders—like Louis Jordan and Dizzy Gillespie—who were major influences on his early development.

Brown is a forerunner of the hip hoppers who made braids and cornrows— formerly female attributes—a badge of masculinity. In his whole-body dancing of the mid-1980s period—his face heavily made up (foundation as well as eye makeup), long, coiffed hair, and tight unisex suits in bright colors—he blurs the divisions between male and female, allowing his anima full expression. In "Cold Sweat" (the London 1985 version) he hypnotically repeats the phrase "rock your body," which he embellishes with a continuous salvo of hip, shoulder, and belly rolls undulating sequentially through his torso. His legs are spread, knees bent, feet planted in one spot. As in his 1960s concerts, he is not afraid to fall down on his knees, to scream "like a woman." He makes these actions the male domain; he owns them and allows them to empower him as though they are the gospel truth. And there is something almost religious about his performance.

On some songs (like "Sex Machine") he is practically tap-dancing in place, shifting his weight from foot to foot, keeping his toes planted and lifting his heels and bringing them down to the floor in fast, rhythmic claps. Like "the James Brown," this posture is another Brown staple. It's a sexy, wide-legged stance on top of which he layers contrapuntal rhythms through subtle torso responses in his pelvis, belly, rib cage, and that powerful backward-pulsing rear end—all playing tag with the rhythm established by his heel drops. As erotic as Brown's body (and sometimes his lyrics) may be, it is always a matter of innuendo, as opposed to the outright displays of the hip hop generation. For example, Brown's left hand often hovers near his genitals but there is never any crotch-grabbing or overt focus on the penis.

Now, to backpedal to his prime, two Brown performances out of many possible choices are my focus: his rendition of "I Got You," the hit song that was his signature for years and was introduced in his film debut (1965) in Frankie Avalon's teen movie *Ski Party;* and his singular performance (even for Brown) in Boston the day after Dr. Martin Luther King Jr. was assassinated.

Accompanied by the Flames performing "vocal choreography" (tap artist/choreographer Cholly Atkins's name for the unison movement created for vocal groups) while they sing back-up, his performance in this film is another example of Brown's exotic-erotic pull with mainstream white audiences. The setting is a ski lodge. The guests, all white, are cozily seated on couches and pillows. Brown and his black ensemble are dressed in Nordic-patterned sweaters, a concession to the theme. His routine seems a bit toned down for this scene, but the signature moves are all there. Brown's body weight seems to have fluctuated at

various times in his career. Sometimes he's quite slim; at other times he is chunkier and more compact, although he never seems to be overweight. In this film he is at a thin point. His legs, clad in simple black, straight-legged pants, look particularly slim, allowing us to see his moves with extra clarity. His foot- and legwork are exquisite examples of improvised skill tempered by technical command and control. Light and lithe like a featherweight champ, his heels barely touch the floor as he swivels and slides on his toes, articulates the ankles to swing heels and knees in and out, and once or twice vibrates the legs in a quiver—so fast that his legs "twinkle"—as he covers ground in the small circle carved out for the performance. On top of this work his upper body spars, fists clenched, arms pedaling, while he allows his torso to respond with subtle hip and pelvic movements. He breaks with the break in the song after the first four bars by slipping in a fast turn and stopping short for a suspended moment, his arms frozen, mid-movement, in air. He takes a little jump to start up the footwork anew. As fast as his feet are moving (they are visualizations of the song's rhythms) he has enough control to speed up the movement to double time for a few seconds. He concludes by using his eponymous step to back himself upstage, descend into a half-split, pop up again, and bow.

In the televised Boston concert on 5 April 1968, the day after the King as- sassination, Brown was brokered as a political tool, part of a bread-and-circuses move to offset potential racial unrest following the murder. (He gave a similar concert in Washington, D.C.) Brown had already been a visible and vocal sup- porter of the Civil Rights Movement and had subscribed to lifetime membership in the National Association for the Advancement of Colored People. At this ap- pearance, about halfway through the concert, the mayor of Boston (Kevin White, whom Brown calls "a hip cat") appears onstage and makes a short speech. Boston's finest (that is, the police) were out in full force. That night Brown danced and sang up a storm. At 35 he was at his zenith, still light and lithe but a mature, secure performer who knew how to get the audience in the palm of his hand and keep them there—which is the reason why he was given this civic performance task. It is one of the most intense performances imagina- ble, and this comes through in spite of poor video technical quality. Of course, the gravity of the occasion filled everything he said and did with special meaning. His performance of the song, "Got That Feelin' (Feelin' Good)" was particularly poignant. Like many of his songs, it sounds like a gospel shout, and "feelin' good" takes on soulful, spiritual connotations. "We'll all get together, in any kind of weather," he sings, repeating the line about four times. Then he screams that fa- mous "like a woman" yowl, bursts away from the standing microphone in skate- slides that catapult him into the James Brown step at what seems like

triple-time, punctuated by a turn or two. Now he is on the side of the stage. As the music breaks, he does, too. He stops short, lifts bent arms shoulder height in a "stick-'em-up" Hallelujah pose and begins to pulse his torso in full-body contractions while standing in place, arms frozen in air. The audience goes wild, screaming in ecstasy, for these moments are ecstatic. The break—when music and movement break from one rhythm and suspend for a nanosecond before shifting into another gear—is the stuff of magic, the kind of magic that makes people "get happy," whether the moment is sacred or secular. Next, he Camel Walks back to the mike at center stage and resumes singing. He dances with his saxophone players, with his go-go dancer (a feature of the ensemble in the 1960s). He is riding high. He is preaching the gospel of James Brown with every part of his being. He is the essence of "soul." Indeed, he has earned his nicknames, "The Godfather of Soul," "Soul Brother Number One," and "The Hardest Working Man in Show Business."

He also has earned another title: "The Keeper of the Dance."

IMAGES PAINTED WITH HEART AND FEET[15]—SAVION GLOVER

I can almost see what I hear. Any sound that you hear in the city, it can be done to dance.

—*Savion Glover,* Savion Glover's Nu York

Tap dancing: an act of black beauty and power (even when white dancers do it, it's a black form). A hoofers' competition is an *agon* of bonding. "*Ba*-de-ah, *ba*-de-ah, doo-bop-de-*ah*-de-ah": The contest is the motional equivalent of verbal signifying— "bustin" on your buddy through the force of your feet instead of the power of the word. Its improvisational base is key to the aesthetic. Thinking on one's feet—the mind/body split healed through tapping feet. At one point in the television special *Savion Glover's Nu York,* his 1997 tap dancing ode to the Big Apple, Glover performs at the Church of the Master in Harlem with Kirk Franklin, the charismatic gospel artist, and Franklin's ensemble. As Glover concludes, Franklin throws a "cape" over the shoulders of the kneeling dancer. It is a precious moment: a direct reference and tribute to James Brown as one of Glover's aesthetic parents. Brown's work was landscaped by the R&B style; Glover's belongs to the hip hop nation. His tap artistry runs parallel to the rat-a-tat speed and syncopation of that speak-song style known as rapping. Glover actually gets more taps to the beat than a rapper can rap. In the swing era, Lindy Hoppers talked about packing their routines with as many steps as possible so their stuff would be too difficult to steal. How very difficult it must be to steal Glover's taps; they are so fast, so original, always changing.

At age 17 he was accorded the following "props" from the *New Yorker* maga-zine: "A tall drink of water bounded up from the front row and made his way to the stage. It was Mr. Glover, wearing slacks, a Bart Simpson T-shirt, and a neck-lace of golden links. He began to slouch and saunter around, casually pigeon-toed, just ambling. The only difference between him and any other ambling teen was that he somehow managed to produce so many tap rhythms so nonchalantly that even eyewitnesses couldn't quite believe it. Within a couple of minutes, he had shaken out a boatload of tarantulas."[16] Glover's boyish charm is infectious. Between 1991 and 1996 his frequent appearances on *Sesame Street* introduced and popularized tap for a new, very young generation. He appeared as a regular guy, one of "the people in the neighborhood."

Glover follows the fantastic lead set by Gregory Hines in popularizing tap dance for postmodern generations. In 1978, dancing as Hines and Hines with his brother Maurice, Gregory Hines appeared in *Eubie!*, the black Broadway musi-cal. (*Eubie!*, the musical *Black and Blue*, and the film *Tap* are among the many choreographic credits of Henry Le Tang, master dancer-teacher-choreographer.) By 1985, at age 39, Hines was paying tribute to his swing-era mentors (Chuck Green, Jimmy Slyde, and Steve Condos) in the George T. Nierenberg film *About Tap*. He co-starred with Mikhail Baryshnikov in the film *White Nights* (also 1985, wherein he initiated a revolution by tapping to contemporary pop music).

In 1989 Hines starred in *Tap*, an incredible all-black film in which he both taps and acts up a storm. The film displayed a hip and street savvy dance aes-thetic, using to great effect a powerful tap style in scenes that are contemporary challenges to Gene Kelly's classic sidewalk romp with the kids in *An American in Paris*. The stunning ending is set in a cabaret. While Hines's taps are amplified through the club's sound system, he first dances to a rock score and for his cli-max performs West African steps, *on taps*, accompanied by African conga drum-ming. This ending and the opening scene cleared the way for further re-visioning of tap. Had the cast been all white, this movie probably would have been mar-keted as the flavor of the month, and Hines as the next Astaire. But that kind of fame for a black artist is still not possible in Hollywood (and even Denzel Wash-ington does not make it as a romantic hero with a love interest).

There is as little possibility of Glover becoming a Hollywood star as it was for Hines; however, in Hines's wake Glover has given tap dance a new pedigree. Like Hines, Glover pays glowing tribute to his mentors, acknowledging that he is building on their superb lead. These hoofers and troupers developed tap cul-ture and spirit. Glover considers himself lucky to have had the opportunity, as a youngster, to hang out with them. They passed the legacy on to him and encour-aged him to build upon it.[17] "The best," as Glover describes them, include Honi

Coles, Jimmy Slyde, and Hines. Coles's and Slyde's work was linked to bebop, the post–swing era jazz style; Hines experimented with updating tap by using pop-rock accompaniment; Glover dances to hip hop, New Age gospel, reggae, and more. Each change in musical partnership heralds changes in the dance technique. Hines's tapping to rock music is the bridge between the swing and bebop tappers of yore and what Glover does. In Glover's words, "I dance to jazz and old stuff and whatever, but mostly it's going to be hip hop, something with a funky bass line."[18] Hines says of Glover, "He can tap dance faster and harder and cleaner than anyone I've ever seen or heard of. He hits the floor harder than anybody, and to do it, he lifts his foot up the least. It doesn't make any sense. There must be some explanation, you tell me what it is."[19] Tap artist Lon Chaney—another revered Glover mentor and the reason why Glover began dancing—played drums before he became a dancer. So had Glover: From the age of three until he stopped drumming at age seven to begin tap classes, Glover had been a child prodigy.[20] This beginning may help explain the brilliant use of his feet as percussion instruments.

Glover has one short dance scene in *Tap*. As the adolescent son of the dancer with whom Hines is in love (played by Suzanne Douglas), the boy is left on his own at Mom's dance studio to teach a class of his tapping peers while Hines and Douglas go out on a big date. First he corrects the class by telling them their dancing is "good, but it's raggedy. When you dance, you want to dance clean, always clean, like this." He proceeds to demonstrate. Moving to a "smooth jazz" selection (that is, where the big-band sound ended up after the swing era), his performance is a demonstration in more ways than one. It is a compendium, a primer of what his mentors taught him (and most of them, along with Sammy Davis Jr., appear in the movie). He shows how he has mastered elements culled from the proficient footwork of Coles, Bunny Briggs, and Buster Brown, the acrobatics of Harold and Fayard Nicholas, the smooth, sliding grace of Jimmy Slyde, as well as Hines's youthful immediacy. This snippet represents the time before Glover developed his own style. His taps are clean, clear, strong, and intelligent beyond his years. Like all good tap artists, he accomplishes his work with an air of ease and nonchalance.

Later, Glover and Hines worked together in the George C. Wolfe Broadway hit *Jelly's Last Jam*, as the young and older Jelly Roll Morton, respectively.

Before taking a closer look at Glover's performance, I'll offer a word about rhythm tap, the tradition in which he was schooled. What defines this form is the use of the feet as complex percussion instruments that enunciate and articulate musical rhythms, allowing dance to function as music and music to serve as dance. This essence is captured in the opening scene of the stage musical *Black and Blue*

(1988). An ensemble of tap dancers is spread across the stage, facing the audience. Making a bass rhythm by their improvised vocal sounds, they create a voice orchestra to accompany individual dancers who come forward and dance solos, making counter-rhythms with their tapping footwork. What the torso does is secondary and an afterthought. The focus is the feet. What we are seeing is the community, the competition, and the democracy of tap—an African legacy evidenced in dance and other performance modes across the African diaspora. The group bears witness to its dancing members, egging them on, cheering or laughing or offering friendly but sometimes cutting put-downs. There also exists in tap a refreshing democracy of body image, as compared to ballet and modern dance. The fat, the tall, the slim, the small, young and old, even the physically challenged—all are welcome on the floor as long as they have "legs," and something original to contribute. (Dancers like the one-armed, one-legged Crip Heard and "Peg Leg" Bates, who danced with one wooden leg, plied their disabilities as novelties during the swing era.) As mentioned in the section on William Henry Lane, tap has roots in the African-inspired plantation dances of the enslaved. Another African tradition, competition dances, is one of the basic teaching tools in rhythm tap. Skills are honed and new steps learned in the process of competing. And, most important, the technique of improvisation (if one can call it a technique) is called upon each time a dancer attempts to outdo his peers.

Black and Blue is a loving re-creation of the "good old days" of African American vaudeville. We are fortunate to have this video documentation of the work of tap dance legends like Lon Chaney, Ralph Brown, Bunny Briggs, and Jimmy Slyde as recorded for the Dance Division, New York Public Library, Lincoln Center. Slyde gives a luminescent dance rendition of the Benny Goodman/Chick Webb/Edgar Sampson song, "Stompin' at the Savoy." Briggs performs the softest, lightest, slowest-yet-fastest (to each beat) dance to the beautiful Duke Ellington ballad "In a Sentimental Mood." He taps all the rhythms, the terpsichorean equivalent of John Coltrane on saxophone, not sliding *over* any moment but processing *through*, touching every idea before moving on. When Slyde and Briggs dance the title song, everything they do contradicts and nullifies the oppressive images in the words ("What did I do, to be so black and blue? I'm white inside . . ."), which is typical of black popular and vernacular forms: They contradict and transcend negativity by filling a stereotype with their individuality and *soul*. The 14-year-old Glover was part of the opening lineup of hoofers as the maverick—a coltish, long-limbed adolescent feeling his oats and obviously elated to be allowed to dance with the elders. When it's his turn to solo, he does cutesy things: a little bit of Charleston on taps and some toe tapping too. Later he performs a stairway dance with Dormeshia Sumbry and Cyd Glover (not related to

Savion Glover). In one of the large group numbers he is part of the ensemble, doing the very Hollywood-type number that he would later critique in his soliloquy from *Bring in Da Noise, Bring in Da Funk* (1995).

Savion Glover's Nu York allows us to see the artist dancing the ordinary-extraordinary of his hip hop urban reality—transcendent events in quotidian settings: at a street festival in Spanish Harlem; a church and boulevard in central Harlem; a midtown dance studio; Battery Park; and under the Brooklyn Bridge (where the Twin Towers backgrounded his performance, giving the scene a special poignancy). Energy is spilling over the top as Glover taps to Wyclef Jean's rap version of "Guantanemara." Jean laces the song with clever, ironic references to today's issues in English and Spanish, thereby preserving the social relevance of this protest song. Call-and-response: Glover begins as a spectator, singing and swaying as he stands in the youthful crowd until he is called to the stage by the rapper. Call-and-response is going on in about five different directions. Glover, Jean, the spectators, the back-up musicians, the cameras—all are given the opportunity to both initiate (call) and react (respond) in this form of repartee that is characteristic of all Africanist performing arts—from traditional West African drumming to African American sanctified church services to hoofers participating in a jam session. (When one dancer comes out to offer a challenge, he is responding to the call of the previous dancer as well as making a call to which the next dancer will respond.)

Later, when we see Glover and Kirk Franklin at the Church of the Master concert, Franklin describes Glover's feet as the biblical "good and perfect gifts." Franklin has popularized and commodified hip hop gospel music, which is right up Glover's alley. With young people as performers and spectators, the reason for the concert at the Harlem church is to celebrate Christianity through generation-friendly art forms. As they enter the sanctuary, Glover says, in voiceover, "You don't 'have church' on the outside; you have it on the inside." One can see the truth of this adage in the way he performs. He rejoices. His stance: shoulders hunched forward, head tilted down, legs spread, knees bent. He is "workin' it," "hittin'," "rockin',"—in other words, dancing righteously and truthfully: "When you're straight layin' it down, communicating, saying something, expressing yourself, getting on the floor the rhythm you live by, that's hittin'."[21] His arms and torso follow through as responses to the call of his feet. James Brown personified *soul.* Glover is a manifestation of *spirit:* Paradoxically, by the intensity of his inner focus and almost meditative concentration, he reaches out, out, out. At times he looks like an old man, as though he is the conduit for releasing the muscle memory of his cultural/spiritual history, the vessel and medium for bringing it all to bear in the danced moment.

Perhaps the most clairvoyant example of Glover-as-spirit is near the end of the film when he teams up with Stevie Wonder, the superman of sung spirituality. The song they have chosen to work with is Wonder's *Ribbon in the Sky*. Their combined performance brings us up short in the face of the power of art to transcend and transform. Glover taps ribbons of sound around Wonder's transported singing. The message is one of faith: that we cannot lose with God on our side; that there is strength to be gained from our pain; that we'll survive through the power of love. Their rendition offers the catharsis that is associated with great art. Both men reach out by the power of their interior focus: Glover's gaze, inward and concentrated; Wonder wondrously ensconced in his dark glasses. With feet and voice they each personify the inner life of the spirit as it reaches out and flows forth, blurring the separation between Self and Other.

Whereas *Tap* presented tap dancing feet as salvation, they represent doom and downfall in Spike Lee's *Bamboozled*. Besides serving as its choreographer, Glover has an important role in this film; he and Tommy Davidson play two down-and-out performers who ultimately meet their doom when Damon Wayans as a buppie television executive (Pierre Delacroix) uses them as the foil to carry out an intricate "lesson" that was intended as a satirical joke but is taken seriously all around. The film is a broad, brilliant satire on race, a topic that we Americans hate to analyze or talk about. Davidson (Womack) and Glover (Manray) are obliged to "black up," as did the nineteenth-century minstrels, and perform vintage routines. Glover's name is changed from Manray to Mantan, reminiscent of the comedian Mantan Moreland, whose work in Hollywood films of the swing era cast him in demeaning, minstrelized roles; Davidson is renamed "Sleep 'n Eat," indicating the things his stereotyped character likes best in life and recalling the dimwitted antics of Moreland's even more stereotyped (and darker-skinned) contemporary, Stepin' Fetchit.

As Mantan, "the uneducated Negro, but with educated feet," Glover performs old styles of vaudeville tapping. Before they were swept up by the media, Manray and Womack had danced for their supper on the sidewalks outside the skyscraper that housed the TV network's offices where Delacroix is employed. Unable to afford real taps, Manray stuck metal bottle caps in the soles of his shoes. Lee had good researchers working with him for this detail: Not only had caps served as taps for dancers of yore beset by hard times; there was even a swing-era eccentric tap team called Slick and Slack who danced barefoot, holding bottle caps between their toes as taps.[22]

Irony, parody, and grotesque satire are working at full tilt in almost every scene. There are several fine dance episodes, all centered on Glover. In one, Manray (soon to be transformed into Mantan) is in the office of the white

producer Dunwitty (Michael Rapaport) along with Delacroix and his assistant Sloan Hopkins, (Jada Pinkett-Smith). To show his stuff he jumps on the large executive table and begins to tap. He is literally kicking rhythms in the face of the white mogul seated in a chair at the table's edge, looking up at the dancer. This is Lee's take-off on many movie musicals wherein the dancer performs on tables, walls, chairs. It is also reminiscent of Charles Dickens's description of William Henry Lane, who "finishes by leaping gloriously on the bar counter and calling for something to drink."[23] The symbolism is unmistakable. The black man's feet kicking at the head of the white man in power: The feet (the body) belong to Us; the head (the mind, or more apropos here, the manipulation) belongs to Them. Satire is girded by an underlying sadness that pervades the film. This sobriety is palpable as Glover and Davidson prepare the run-through of their minstrel show before a live TV audience. We witness a parade of dancing minstrel stereotypes: Rastus, Aunt Jemima, Mantan, and Sleep 'n Eat, tap-dancing in blackface, wearing their traditional costumes. In caustic contrast these demeaning but demanding antics are performed to a millennial jazz score (by Terence Blanchard). Led by Glover, the ironic play of their exterior, ugly stereotypes against the beauty of their jazz-tap sensibility deepens our sense of loss at the waste of black talent wantonly spent on this white-engineered form of popular entertainment whose taint remains with us. It also calls to our attention the contested narrative, the conflict between self and stereotype that existed in the minstrel dancing body. Beneath the burnt cork and reddened lips were human beings—artists of great talent. How to reconcile the person with the mask?

As the film nears its climax, Mantan rebels. The minstrel show has become a big hit, to the dismay of its black cast and creators and the joy of the producers and black and white audiences. Finally, instead of performing his minstrel act, Mantan goes on stage in his hip hop, Glover persona, announces to the audience that they, both black and white, need to join him in saying, "I'm sick and tired of being a n — — —!" The crowd sits in stunned silence. Glover begins to tap, a cappella, more taps per second than ever before. He taps a spray of figurative bullets in a seamless net woven to protect his sanity. But this is not meant to be the end of the movie, for this is a social satire. The film turns grotesque, with several leading characters murdered. Glover-Mantan-Manray is obliged to tap as fast as he can to escape the real bullets aimed at him—smashing the metaphor of tapping for safety that he had created in the previous scene. Lee's message for black dancing feet—and, by extension, the black dancing body—is a sobering one that admonishes all of us, black and white, to beware the minstrelization and exploitation of blackness that we have come to know and accept, if not love.

To conclude this section let us examine the work that marked Glover's artistic coming of age and for which he earned a Tony Award for choreography, *Bring in Da Noise, Bring in Da Funk*. Glover has a particular way of using the word "noise."[24] To "bring the noise" means to do your best. "Noise" means excellence, a virtue that is achieved not by entertaining (dancing to please/placate the audience) but by "hittin'" (dancing righteously, and if the audience is pleased, that's a perk). The show is the quintessence of its title, and it "hits." Glover's memoir claims, "It changed the stodgy world of Broadway theater forever, opening it up to hip hop culture for the first time."[25] In creating a semi-autobiographical musical about the history of a people, Glover manages to use dance to tell the story, rather than making up a story as an excuse to dance. In 15 scenes the play (subtitled *A Tap\Rap Discourse on the Staying Power of the Beat*) moves us through the geography of the Africanist experience, using tap dancing feet as our guide from Middle Passage through slavery, Reconstruction, Jim Crow segregation, urban migration, the Harlem Renaissance, the Civil Rights era, and the present—and evocatively seduces us into this new way of telling African American history. Throughout, the interpretation of what tap is extends to include tapping rhythms with hands, body parts, sticks, pans, chains, chairs, stairs—percussion as music and dance are melded into one. Tap is even part of the beat in the voice of the narrator and the singing of composer-vocalist Ann Duquesnay. Tap is Glover's *Gesamtkunstwerk*, and rhythm—the beat—is its signifier.

The opening scene introduces us to the dancers as themselves (Glover, Jimmy Tate, Baakari Wilder, Vincent Bingham)—contemporary hip hop nationals in their indigenous "baggies" and knit caps—before they assume an array of historical roles. Their wide-legged style of tap is reminiscent of the posture of the South African boot dance, itself a form of tap dance, as well as James Brown's signature stance. Their arms semaphore, twirl, windmill in response to energy vectors set up by the feet and legs. They have surpassed a slew of Europeanisms and gone straight to the heart of black matters. In "Middle Passage," a solo, Glover is all in white, dreadlocks free, knees pulled up to his chest while he sits on the floor rocking gently. He slowly rises and dances a gorgeous tap to pure African rhythms, reminding us of the precedent set by Hines in the final scene of *Tap*. Thus, *Noise/Funk* begins where *Tap* ended. "Som'thin from Nuthin'" is about making do. It compares transforming the white man's edible leftovers into black feasts and transforming the absence of the drums into "the beat singin' rhythms through our feet" (as explained in this chapter's section on Master Juba). We are offered a dazzling display of plantation-era pigeon wing and buck and wing steps.

Next Raymond King and Jared Crawford, "The Pan Handlers," do just that. (And this is one of the minimalist aspects of the piece that is so satisfying: The terse

titles lead, rather than mislead.) These amazing young musicians have pots and pans attached to their torsos. They "play" each other, sticking out body parts to accommodate the sound making, and continue their jamming on a metal "kitchen orchestra" suspended from a frame. This scene reminds us of Glover's (and Chaney's) beginnings as a drummer. "Levee Blues," danced by Wilder, moves from a slow, sensual tap on a wooden plank atop a bale of hay into a swift, abstracted one that mimes a lynching, while Duquesnay sings "The 1916 Fifty Negroes Lynching Blues." Next, "Chicago Bound": In this Glover solo, a beautiful slow tap evolves while he dresses, slipping one leg into his trousers while keeping the standing foot tapping, never missing a beat as he dons vest, jacket, and hat. Then the beat accelerates with his mounting excitement (about leaving the South, goin' North). He taps atop his humble suitcase. Indeed, he dances the hopes and aspirations of the African American nation at the possibility of new life. Of course, delusion sets in. "Urbanization" follows, looking uncannily like the Diego Rivera work murals at the Detroit Institute of the Arts come to life. This is one of the high points in a work of impeccable artistry, with the tapping done in mechanized fashion to beats that sound like the clangs and whacks of factory equipment. In "Dark Tower/The Whirligig Stomp," more disillusionment, but from another segment of black society: the "niggerati," to use Zora Neale Hurston's epithet. In full evening dress Glover and his crew give a brilliant, tapped interpretation of the compendium of the era's dances, including quick takes on social dances like Truckin' and the Suzie-Q, as well as the *That's Entertainment* style of flash tap that was so popular with swing-era audiences. To pull this one off illustrates, again, how much Glover has soaked up from his mentors. (One of them, master choreographer Henry Le Tang, fondly nicknamed him "The Sponge.")[26]

"Where's the Beat," the next scene, makes a grim comment on the African American tap-dance style shaped and nurtured by Hollywood and here pejoratively termed "grin and flash." This scene greatly upset some elder members of the tap community, including Fayard Nicholas (of the Nicholas Brothers), who interpreted the critique as a personal insult. Indeed, Bill "Bojangles" Robinson and his white film partner, the child actress Shirley Temple, are sent up in a disparaging burlesque that presages the deeper level of satire that would occur in *Bamboozled*. In spite of protest and hurt feelings, the scene is not a frontal attack. It rings true in recognizing the degree of personal compromise involved for blacks to survive as working artists. It is about the sacrifice of rhythm's purity — the loss of "noise" — in order to gain visibility in the white world.

"Street Corner Symphony," a two-part scene, limns the tension in urban black enclaves, circa 1960s–1980s. In the second part, the crack-cocaine scene, Glover shows us the flexibility of tap. Like the black dancing body, it can accom-

modate to multiple needs. Accordingly, his slow, tentative, "crack tap" is just right for the task. It is not emotional or indulgent, just working, hittin', doing what needs to be done to fulfill the task. If ever anyone doubted that tap dance was an art (as they doubted that blacks could "do" ballet), those doubts must be dispelled by the masterful achievement of *Noise/Funk*.

The "Yo, Taxi" scene, another high point, shows four very different classes of black men trying to hail a taxi. None succeed: neither hip hopper, college student, corporate businessman, nor military man. The message is clear: Race trumps class and cash. The final scene carries the voiceovers of the dancers, as themselves, commenting on who they are and what is important to them: "My favorite thing about being black is . . . ," "My faith, my family, my future . . . ," "Tap saved me." As in the opening, they are back in everyday clothes. They perform a hip hop tap that says everything about who they are in solo improvisations that burst forth from the call-and-response jamming that is the signature and keynote of this art form.

Midway through the piece Glover performed another solo, "Green, Chaney, Buster, and Slyde," a soliloquy danced in front of a full-length, two-sided mirror, with Glover facing the mirror, his back to the audience, and the audience observing his reflections. As in "Where's the Beat," this scene ruffled some sensibilities in the tap community. All in black — baggy pants, loose T-shirt — he offers a glowing homage to his mentors (Chuck Green, Lon Chaney, Buster Brown, Jimmy Slyde) in the spare, unselfish style that has characterized the piece as a whole. As we hear his voiceover, he delivers the goods, dancing in the particular style of each of these four masters as he describes to us, in words and taps, their influence on him:

> Hollywood, they didn't want us. They wanted to be entertained. Chaney and Slyde — they were educating people, not entertaining. Hoofin' and rhythm tap are like music. If you can do an eight-bar phrase with your feet, and another person, not a dancer, can understand what you just did, you hit, you expressed yourself, you made a statement. Hoofin' is dancing from your waist down. People think tap dancing is all arms and legs and all this big old smile: naw — it's raw, it's real, it's rhythm, it's us, and it's ours. . . . Chaney hittin' [he demonstrates]. . . . Chuck Green, he does that slow [demonstrating Green's graceful movements, as Glover's body expands to embody Green's heft and height]. . . . I started doing Chaney and Slyde . . . all their steps . . . changing my style . . . lost all the big wings. . . . I just started hittin', reaching for rhythms, reaching for different tones in my taps, making

music . . . never did go back to flap, flap, shuffle step. There was noth-
ing there for me since I was 13. That's not even tap dancing. Now that I
know what hoofin' is I don't see how people would want to see that old
style of tap dancing when they know what's some hittin' going on over
here, bringing noise with it.

Glover's appropriation of Slyde's legendary slides/glides across the stage are
remarkable. He transforms his mentor's bebop sensibility into short, hip hop
bytes: quick, sideways, one-footed, two-footed slip-blip-slides. As La Meira, a
New York Flamenca, commented about the show, "I wish somebody would do for
Flamenco what Savion did for tap." He has explored new territories, rediscov-
ered old routes, and made a new map for tap.

THE BALLET AESTHETIC—FEET AND MORE

*Now it's more about the dancer's body rather than about the race of the
dancer's bodies. Because the bodies now can do the same things, and be-
cause they can do the same things the musculature has become similar.*

— *Gus Solomons jr*

We now take an artistic leap and move from those venues where black dancing feet
were supposed to be, to that place where they were taboo—the world of ballet. Let
us approach this revered edifice by an unmarked side door. This entrance takes us
back to an incident recounted in Shane White's and Graham White's work, *Stylin'*.
They open their chapter on dance with an anecdote about Anthony Burns, an en-
slaved African who ran away, was apprehended, and brought before a judge and a
volunteer lawyer. The author Richard Henry Dana (best known for his *Two Years
Before the Mast* [1840]) happened to be the lawyer. In the courtroom Burns is child-
like, docile, shrinking inside his large physical frame—in a word, slavish. Dana as-
sumes the worst: that the guy is fearful and meek and will opt to return to his master
rather than face proceedings. Then the tables are turned. Friends visit Burns and
convince him that Dana can be trusted. On their next encounter, Dana meets a
changed Burns: "self possessed, intelligent," and exuding "considerable force both
of mind and body."[27] The authors make the point that this example shows how ki-
nesics—communicative bodily movement—determines how we are interpreted,
what we project, what we hide or reveal. Further on they talk about the "reclama-
tion of the body"[28] that was a part of shaking off the shackles of slavery and moving
forward into the dominant culture. Applying this idea of the changing black body to
dance, we can address kinesics as a way of reclaiming movement and reshaping the

body in the post–Civil Rights era that paralleled that process in the Emancipation era. In dance and in life the black body has demonstrated incredible flexibility (as well as durability) in the face of adverse circumstances ranging from slavery to aesthetic segregation. Its mutability makes it ludicrous to assume that the black dancing body couldn't kinesthetically find its way into ballet: a piece of cake, compared to the life-threatening odds faced by Anthony Burns!

As in the Burns case, kinesics can be a sophisticated system of self-defense. When we factor in the concept of stereotype threat, we come up with an equation that may illustrate Bush's "soft bigotry of low expectations" on the part of those in power as well as those on the outside looking in. Failure may be a self-fulfilling prophecy. And after generations of having been inculcated to believe that ballet, this last bastion of white dance primacy, was off-limits for people of color, both blacks and whites bought into the myth.

It is noteworthy that the feet seem to hold a key to understanding the dance values of several cultures: African American tapping feet; Indian slapping feet; ballet's pointed feet. To do the dance of each culture correctly does not require an adept to spring fully trained from the womb; instead, enculturation at an early age is the route to success. In each example the feet can be educated and disciplined to the "correct" aesthetic position. To conclude this chapter on the feet we return to the reigning concert dance aesthetic of the millennial era—namely, ballet and ballet-influenced concert dance forms such as modern and postmodern dance. The voices of the dancers tell much of the story—their story—as it is played out on the contemporary concert dance circuit.

Meredith Monk offered some interesting observations on the ballet body:

> I feel like the western European tradition has a lot to do with shape and the outside of the body. In ballet it has to do with the kind of geometry of the human being relating to a larger geometric form. And so that's why they want the long bodies, these certain lines in space. It has to do with the positivist way of thinking about the human being as being higher than nature. In my opinion, this is where everything went wrong. Like Newton. It has to do with that kind of conceptual illusion, that man is above nature, that man controls nature. Descartes' idea, "I think, therefore I am," has to do with the body separating from the mind. And in ballet and other art forms during that rationalistic period [we see] the beginnings of specialization: Dancers are only dancers; singers are only singers; musicians are only musicians. . . . So there is a standardization within each voice and on top of that each person is only supposed to perform one function in art, or otherwise how could he or she be good?

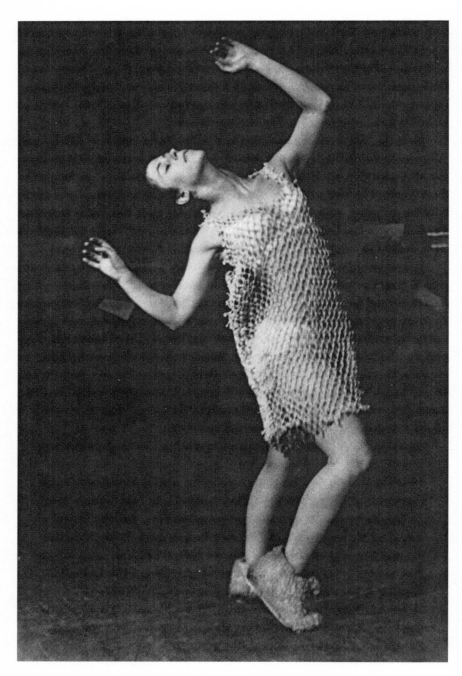

Challenging positivist premises. Meredith Monk (in *16 Millimeter Earrings* — Music, Images, Choreography by Monk, 1966). Larry Fink.

Monk continues, describing her youthful "body battle" to conform before she gave up and created her own mode of movement-theater: "The thigh-hip thing was very hard for me. I think that's why I became anorexic. . . . I was scared, I was 16, I was trying to get a body like a ballet dancer. And how could I ever?! I've got big, wide, peasant hips, that are good for picking; I've got short little legs and short little thighs—very good for picking beets in Russia. . . . If I was 90 pounds, I'd still have a tush. . . . So I just took my body away to make it better."

Clearly, it is not only about the feet, nor only about the black dancing body. Dancers of all callings are expected to master ballet. In some fields, like Broadway show dancing, ballet is the fundamental training technique, along with studio forms of jazz dance. This is borne out by Gus Solomons's statement about who is admitted into the dance program at New York University's Tisch School of the Arts, where he is a master teacher: "The bodies that get into Tisch . . . the first thing that confronts them in the audition is a ballet class. And if they don't do the ballet class like a ballet dancer, they don't get through the audition."

Ballet is accorded a holier-than-thou position and, despite its potential for change, reserves a strict attitude about the look of the dancing body. The only contemporary forms of American stage dance that are not in ballet's thrall are African American forms, including hip hop, club dancing, tap, and the R&B, funk world of MTV and touring, singing superstars. That the ballet aesthetic, feet and more, spills over into every aspect of concert dance is an accepted fact of life.

In addressing the black (male) dancers in Trisha Brown's company, Gus Solomons gives us a sense of the tight grasp held by these criteria: "When Trisha stretches her foot relaxed, there's still a lovely arch in the ankle. If Keith [Thompson] stretches his foot relaxed, there's an acute angle there. So it doesn't have the same visual energy that goes beyond the limb, and it looks stubby. Stacey, on the other hand [Stacey Spence, a second African American male in Brown's company] does have more articulate connections. . . . [H]is body doesn't look like a white body, necessarily, because it's elongated in the shins and the front, but he does have articulate feet."

Which brings us back to feet. The difference that Solomons perceives in Brown's and Thompson's feet is not a difference in ability or flexibility, but an aesthetic preference for a high lateral arch—a culturally conditioned visual preference that dominates concert dance. As stated earlier, it's not always about what the (black) dancing body can *do*, but what the observer wants to *see*. Zane Booker's take on the issue drives this point home: "I had decent feet at a young age [he began ballet training at eight years old]. . . . Some black people don't have feet, and some white people don't have feet. And even [all] feet with [high] arches aren't beautiful. . . . You can see a foot with an arch

and it looks just as dead. . . . Lots of times you can have a natural arch, but then you can also have a flexible ankle that points. . . . I have a huge running joke with a white guy who was a good friend of mine in Ballets Monte Carlo. He'd always talk about my feet. And I would tell him, 'My feet point. Your feet don't point.' And I really would wonder if he saw my feet. I said, 'Do you see my feet? They work. They use the ground, so just what are you looking at?' I wonder if he saw what was there . . . because there are a lot of white kids who don't have feet."

Booker points up the issue of the stereotype. His feet had been worked, since childhood, to meet ballet criteria, but because blacks are purported to not have ballet feet a white dancer looking at Booker's excellent feet sees not those particular feet but the larger stereotype of generically non-workable feet. As the Buddhist saying goes, "The eye cannot see what the mind doesn't know." Indeed, we can be blinded by our presuppositions, particularly when they are racial; and that is the juncture at which assumptions become prejudices. Like its counterpart in the larger society, the black dancing body has been demonized by blind-sighted observers.

Shelley Washington tells an anecdote that runs in a similar vein: "I always get a kick out of going to these ballet companies and sort of being this modern dancer who comes in and is teaching these works [she sets Tharp's works on companies around the world] and getting down and doing all of this stuff, and then one girl will have a point shoe, you know. Two or three weeks into [rehearsals] I'll just go over and say, 'Can I put that shoe on?' And it's 'Oh, be careful,' and, you know, 'La-la-la,' and I just put the shoe on [and go on point] and everyone just goes, 'Wow!' Because there is this perception that black people's feet just don't point."

An insidious memory about the feet emerges from an experience that I had soon after moving to Philadelphia from New York in the mid-1980s. I was at a regional dance conference. For the luncheon I was seated next to a revered dance teacher, white, who had run a dance studio in the largely black middle-class Germantown section of the city for a couple of decades. Somehow we started talking about blacks and ballet. Sure enough, this teacher who was loved by the black dancing community said to me, "Well, their feet are getting better [meaning black dancers' feet] because more and more of them are mixed bloods." Needless to say, I was floored by this unanticipated bias from a bastion of the dance community that I had just entered. Her assumption was an ancient and deadly one: Blacks are only as good as the white that rubs off on them. A quote from one of the informants in John Gwaltney's brilliant black oral history, *Drylongso,* is in order here: "They [whites] can't stand the idea of anything good

Feet that do the job! Zane Booker. Carles Asunción.

being black. If a black person does something good, they say he did that because of the white in him."[29] Dubbed the "mulatto hypothesis" by the authors of *The Color Complex — The Politics of Skin Color Among African Americans*, this belief rests on the proposition "that light-skinned Blacks were intellectually superior because of their White blood."[30] The dance teacher's statement was doubly blind, since black dancers of mixed ancestry were certainly not a new phenomenon in the 1980s. But old stereotypes die hard.

Having studied ballet since she was about six years old, Wendy Perron developed a medical condition known as "military back" (that is, a near curveless spine, especially in the shoulder area) by attempting to rid herself of her hyperextended spine and concomitantly prominent buttocks (which she terms a "hikey ass"). In her view, "It did seem like a lot of black dancers had a hikey ass. It did seem like blacks tended to have less arched feet than whites, but also men tended to have less arched feet than women. . . . A lot of white dancers can't quite point theirs, either. And I had all that ballet training, but I never got really beautifully arched feet." Later in our interview she recalled, "Early on, I did see Virginia Johnson [former principal with the Dance Theater of Harlem] do *Giselle* . . . and she was beautiful. She was as beautiful as any Giselle that I've seen. So I feel like, well, that argument [about blacks doing ballet] has been won."

In the same vein, Shelley Washington adds a revealing point or two:

My biggest thing was my lack of confidence because I couldn't stand at a barre like 99 percent of everybody else and have my legs rotate out [she refers to turnout, a basic integer in the ballet technique that can be seen in the ballet dancer's waddle, or duck walk, that carries over into everyday life]. And at some point in my life I had somebody say that that's a black thing. Then when I went to see Dance Theater of Harlem in 1970 . . . they came to where I was studying, and I watched a class, and I saw skinny girls like me with narrow hips with legs that were turning out. . . . When people said . . . black people don't have good feet . . . that's when I started putting my feet under this piano ledge thing, and I kept working those feet. . . . There are only two ways you get good feet. Either your parents give them to you, or you use them. You work them and use them: that's it.

Washington's bit about putting her feet under a low ledge is one of the many mechanical ways that ballet and ballet-influenced concert dancers work on increasing their point. The dancer sits on the floor, legs together, knees slightly bent, toes hooked directly under the low edge of a heavy sofa, piano, bureau, or

Working toward the ideal. Foot-Improvement Device as advertised in *Dance Magazine.* Courtesy of Victor Uygan.

table; next, she slowly straightens the knees; this simple action forces the arches and toes to fully (and painfully) stretch due to the pressure of the ledge across the metatarsal. The position is held for some time, with a number of repetitions. If this "therapy" is practiced over a period of time, it works. Rumor has it that Mel Tomlinson, who was a principal with the Dance Theater of Harlem, exercised on point to develop his feet. There are similarly extreme techniques for increasing turnout that involve different kinds of manipulation.

Returning to the larger picture of the ballet body criteria, the issue of weight is a prevalent one. Both Booker and Francesca Harper began their ballet studies before age ten, and already they were aware that "thin" was good. Booker recalled that "fat was the only thing that was really negative." Harper began her

ballet studies at the Robert Joffrey Ballet School [1979–82] in Manhattan, "and I think I was probably the only black there. . . . I remember already thinking that to be a little too curvaceous wasn't good, that you had to look slim in your pink tights and your leotard—it was just a nicer line." Harper continues, "And then I went to DTH [1988–91], and . . . there were a lot of eating disorders going on, and I knew that was also the case when I went to the School of American Ballet [1982–84]. . . . [T]his kind of obsession with being rail thin, about being the sylph—that was the term. . . . In the '80s it was . . . Balanchine and that was the look. . . . [I]t was hard for me because I have strong legs . . . I was always a little self-conscious of them."

As Meredith Monk mentioned, above, the geometry of line is an all-encompassing obsession in ballet, an ideal that must be worked toward in every part of the body—from feet to head, and everything in between. Ballet may be the form that is most concerned with external line, even above the concepts of mass and space. Here is a portion of the interview with Wendy Perron, wherein I attempt to interrogate ballet's rigidity and offer the idea that even ballet values are a changing landscape:

> WP: There's certainly as many fabulous black dancers as any other kind of dancers, but I never thought particularly [in] ballet would you find as many, because ballet is a certain type of body and as I said, I didn't have the turnout for ballet. Would you get as many of that type within the black community as in the white community? I don't know.
>
> BDG: Well, isn't it about training?
>
> WP: Well, obviously it is because I trained in that way, you know: I flattened my ass, why can't anyone else flatten their ass?
>
> BDG: I'm just thinking about something that Richard Thomas has said . . . that the one thing about ballet is that it can change bodies.
>
> WP: And so can modern dance. But I never got the turnout that I wanted. I trained and trained and trained, but I never did. [Note the similar reflection by Shelley Washington.] And now I feel like, well, that's probably good. Because if I had really forced it, I would probably have hip replacements.

This is a real danger in dance, besides knee, back, and ankle injuries. Even those ballerinas with idealized bodies, like Suzanne Farrell, Balanchine's muse, are subject to the same injuries as thwarted ballerinas like Perron and Washington. Farrell had both hips replaced by the time she was 50 years old. The career of a modern dancer can be just as perilous.

Solomons acknowledged the changing shape of the ballet body and its con-comitant aesthetic in the following assessment:

> My opinion has changed radically with experience and the evolution of the field. Back in the day when DTH started [1969], people asked me did I think that black bodies and white bodies could do ballet equally well, and I said no, because black bodies are built differently. *I think I was saying more that they didn't look the same doing it, but I don't think I meant that because they didn't look the same, they looked less . . . it's just different.* And now it's less different because of the training and the evolution of bodies. . . . My opinion has changed on the basis of what I now know about training as well as what I see in dancers' bodies as they evolve and self-select. . . . As I so wish that I had understood and/or had a teacher that understood, because the state of knowledge was not that great—you just did it with muscles. Because then I wouldn't have broken my body trying to change the shape. [Emphasis mine.]

Solomons's comments return us to the visual tyranny of ballet. His point is not that blacks couldn't *do* ballet but that "they didn't look the same [as whites] doing it." But in the more than three decades of DTH's existence he states that a combination of training and self-selection helped change his opinion. However, it is noteworthy that DTH was the culmination of a long tradition and the "coming out" of that tradition into mainstream white America. African Americans had been studying and performing ballet since the 1930s, but with black ensembles, teachers, and schools in black communities. A particularly strong black ballet community existed in Philadelphia with the schools of Essie Marie Dorsey in the 1930s and Marion Cuyget and Sydney King from the 1940s through the 1970s. The tradition continues today with the ballet training at Joan Myers Brown's Philadelphia School of Dance Arts. Probably black and white dancing bodies are looking more alike because of similar training in *integrated* classes. This is a major move: The black ballet dancers of the 1940s were trained in racially segregated classes by teachers who had also trained in racially segregated classes. This would be comparable to white dancers studying African dance in segregated white communities with all white students and white teachers who themselves had been trained by white teachers of African dance. Even in these examples it is important to point out that the issue is *not* the color or ethnicity of the dancers and teachers, but whether or not the dance form—ballet or African dance—is learned in its indigenous cultural and aesthetic context. Thus, contemporary black dancers like Virginia Johnson or the

Pennsylvania Ballet's Meredith Rainey—unlike those of the pre-DTH era—
will teach ballet from the native, white cultural context in which they studied
and performed. And, as Chuck Davis said, white bodies can do (and teach)
African dance if they have been trained in the African cultural context. In
every instance, the cultural riches are diluted by segregation from the cultural
source, resulting in an artistic vacuum and an aesthetic loss.

Regarding self-selection: Since the bodies are more the same and the under-
standing is clearer about what those bodies are supposed to do, Solomons and
Perron (and Monk, by implication) assert that those who feel they cannot make
the grade opt out. However, it remains primarily a visual issue: Part of the reason
that Monk dropped out was because she didn't have "the look," regardless of
how well she might have executed the form. Yet, Francesca Harper's reflections
on working in a major German ballet company offer hope for a different fu-
ture—the shape and complexion of ballet to come. During a layoff from DTH
Harper was invited to perform with the Frankfurt Ballet (William Forsythe,
longtime artistic director, is American). She worked with that ensemble from
1991 to 1999, enjoying a range of roles that had not been offered to her with any
American ballet company: "That was a different kettle of fish. . . . [T]he reason I
joined the company was because I saw this variety of people. . . . Kate Strong
was this huge, fat woman who had been trained at the Royal Ballet School but
just moved like the wind, you know. Then there was this really tall, very thin
black man, Stephen Galloway. Then there was this short woman . . . [with] tiny
hips. . . . He purposely chose people who were different, and it looks so beauti-
ful. . . . I was cast in lead roles all the time. . . . At one point it was literally half
and half: There were 10 to 12 black dancers." In 2001 Forsythe was described as
"the choreographer who is most important to the present and future of ballet, be-
cause he has immeasurably enlarged our notions of what the art form can do
both physically and theatrically."[31]

Adding another piece to Solomons's comments: Aside from the changes in
training and the phenomenon of self-selection, ballet in subtle and sometimes
overt ways has been opening itself to black cultural influences. In Balanchine's
Americanization of ballet, part of that process was an *African* Americanization,
with Africanist principles of energy and performance motifs "integrated" into his
choreography for his almost totally white ensemble. (For many years before he
founded DTH, Arthur Mitchell was the only African American in the New York
City Ballet, which numbered about 65 dancers during Mitchell's time, the 1960s,
and has since grown to its present size of about 90 members.) With Balanchine's
influence a pervasive element in the development of ballet nationwide, other cho-
reographers followed his lead, modernizing the ballet vocabulary with jazz-

inspired Africanisms as well as black-flavored pop-rock themes and scores.[32] The logical next step would be to integrate black dancers into the mix at more than a token number. We are still waiting for this to happen. The training has changed; the dancers have self-selected. For a long time ballet languished, missing what people of color had to offer. The future of the institution, like the ballet body itself, will depend upon its flexibility.

From the accounts given in the literature and the interviews carried out for this study, it is assumed that flat feet, thick thighs, and big bottoms are either "peasant" or non-white attributes, and arched feet, long limbs, and an overall slim frame are aristocratic and characteristically "white." These are the myths that we live by, at least in the dance world. They still hold sway, in spite of the fact that we know better: Again, Newton trumps Einstein. Sometimes the stereotypes are limited to African peoples; sometimes Jews or Italians are included. Bill T. Jones related an incident that occurred early in his career: "I remember the first time that I had to go to a foot doctor . . . at Binghamton (SUNY Binghamton, where he attended college) . . . and [he] told me that black people, 'just like the children of Israel,' had naturally flat feet. He said, 'Well, you know, I'm a Jew. . . .' So I remember reading what had been said about blacks and classical ballet, and I began to look at my body and look at the bodies of ballerinas, wondering if maybe there wasn't some sort of biological boundary."

Yet, Jones sees in his own company that these traits aren't simply biological. Seán Curran relates this story about working with Jones: "Bill would say, 'This is not a company that's known for its pretty feet,' and it was actually a white dancer named Damian Aquavella who had very wide feet, and his toes kind of spread out, and they didn't point too well, and he [Jones] looked at him and said, 'Those feet were not made for ballet, they were made for working in a field.' . . . So we all used to joke that we had 'working in the field' feet. . . . We used to call it a Fred Flintstone foot."

Merián Soto recalled an incident in which "the choreographer I was working with at the time said that this one black dancer's feet were like big slabs of meat."

Ron Brown recounted comments made by the white male who was teaching a (Martha) Graham technique class at the Mary Anthony studio while Brown and another African American male, C— — — G— — —, were company members. "G— — —," Brown said, "didn't have really nice arches, so R— — —[the teacher] was really on him. You know, 'What are you doing with those clubs? You've got to learn how to point those feet' . . . in front of the whole class [which is the way and place that most criticism from dance teacher to student occurs]. I felt like he

was describing a black foot and a problem that we would have as black people with these feet. And I think the thing that came in my brain was 'I have good feet; I don't have the normal clubs that black men have.'"

Whether delivered in jest or anger, these responses register the way the dancing body, black, brown, or white, is demeaned in dance class by teachers, black, brown, or white. According to Curran: "We have a joke, we say 'stretch those hooves.' That's not aimed at a black person. I mean, I have short, fat, flat feet, so it's a joke I use in class."

Obviously, there are lots of black feet out there that meet the ballet standard and lots of white feet that don't. Shelley Washington said, "The other day I was in a yoga class here in New York, and there were four of the most beautiful black women in the world in this class, and two of them had feet that went over and hooked around and did like this [demonstrating, with her fingertips curving inwards toward her wrist]. And I was like, 'O.K., well, there you go.' . . . There are people who have feet that will never point, and you don't notice it because they somehow dance from their ankles up . . . and there are people with beautiful feet but you don't care."

Chuck Davis had a similar comment about Mary Hinkson's feet: "Have you ever seen that woman's point? It starts here and then it breaks and just keeps going until her toes come back to touch her heel!"

But, again, it's all relative. Desiring a reading from another cultural perspective, I contacted Ananya Chatterjea, dance scholar-choreographer and former student of mine (while she completed her doctorate at Temple University). She began studying dance at age five in her homeland, India, in the Odissi tradition. Here is her response regarding feet in Indian dance aesthetics:

> I had no idea that flat-footed is bad. We use the forced arch position a lot in Bharata Natyam, Odissi, or Kuchipudi, and I think people just say, "whatever your foot is, it is—doesn't matter." The foot has to be super articulate to do all the footwork, but since we never work with relevé the arch issues don't even come up. I certainly never felt a lack until I arrived here and a fellow student, in my first week of classes at Columbia said "God, Ananya, those are the flattest feet I have ever seen in my life!" Then I realized it was an issue. Since the women [in India] are walking so much barefoot or in slippers (high heels are a "western" introduction), flat feet seem to be quite normal, I think, and probably help in the floorwork. Because the sound—which is based on the relationship of the foot to the ground, a giving in to the gravity, wholeheartedly—is important. Further the heavy bells emphasize a solid (vs.

ballet's tentative) relationship to the ground. So while flat-footedness may not be an articulated aesthetic, it certainly comes to be used.[33]

Our bodies are simultaneously fixed and mutable. We are who we are, but we are also agents and mediums for change when granted the latitude to respond to what is needed. Like that of Anthony Burns, the black dancing body is a "considerable force both of mind and body."

BUTT

Memories around this body part arise not only or primarily from the dance world. Perhaps in common with many other women, my butt memories take me into the larger cultural arena where women are ogled, commodified, and categorized according to degree and volume of "tits and ass." How can I explain, or explain away, that backward but primal female desire to attract male attention—in high school corridors, at dances and socials, on city streets—an attention that, scurrilous though it may seem from a position of critical distance, at a certain tender adolescent age seems to celebrate and affirm one's entry into the mysteries of womanhood? It is a craving to be included in the culture's contested narrative of femininity: a collateral pride and shame around the nubile female body, simultaneously prized and objectified (and, as we later come to learn, often abused and vilified). I had that craving! As a teenager it was already clear that I wasn't going to have much to show in the way of breasts. With my frontal "limitation" in mind, I needed to work my other extremity to get a rise out of the guys. And I had a little something to work with: an arched lower back that could be utilized to emphasize a high rear end. I could arch my back (thus pledging allegiance with armies of young women from all walks of life, including the high-fashion models of today and the burlesque stars of yore) and "stick it out," giving male onlookers something to ogle. But then, as I began to seriously study dance and work on my posture, something unsettling happened. As I self-consciously walked the streets of Harlem (where I grew up), groups of young men, instead of flirting with me, cracked up at my straight posture and lack of sway in my hips. At least once, instead of yelling out "Hey, baby!" as I walked by, someone called out "Hey, teacher!"

But never mind: By then I was a teenager who was going somewhere. I had a secret weapon against their "ignorance"—my safe haven, my very own dance world where teachers praised my potential while forcing my buttocks and spine into alignment. They used the metaphors that

carried the day, such as: "Pinch your buns together, as though you're clutching dimes and can't let them drop." Unlike the outside world, here, inside dance, my small breasts, lean frame, and long limbs put me in good stead. My butt was no more a focus of negative attention than anyone else's. I registered other rear ends (black and white) bigger than mine and, having internalized the aesthetic, also thought of them as too big. Of course, as Zollar points out, everyone was told, in the dance classes of the 1960s and 1970s, to tuck (the buttocks) under, pull up, and lock the knees. With enough flexibility in my lower back and hip joints, I could pull it off. Like all dancers, what I had to do in class was to fit into a tightly conceived body aesthetic that promised the possibility of success if the dancer agreed to have the rug pulled out from under her somatic comfort level.

Butt: what a term—abrupt, raw, softly explosive at the beginning and aggressively so at the end; it can be pronounced as a caress or a slur, a critique or a credit. The collection of terms that have accrued around this body part may not be as numerous as those for male and female genitals, but they run the gamut from science, modesty, and euphemism to nitty-gritty description: butt, buttocks, rump, posterior, hindquarters, haunches, loins, fundament, seat, bottom, derrière, fanny, rear, rear end, bum, backside, behind, can, duff, tail, ass, buns, heinie, hindpots, hams, tush, tushie, booty, popo, glutes (for gluteus maximus and minimus, the principal sets of buttocks muscles)—and there are more. Each generation invents its own neologisms to capture the essence of this and other contested body sites. "Phatty" was the hip hop currency for the buttocks as of 2001–2002. It is an interesting term that seems to interweave the older noun, "fanny," with "phat," a 1990s hip hop adjective meaning richly extravagant, expansive, or outrageous. Merging the two terms (and, clearly, "phat" is a positive value indicator that denotes breadth but does not mean "fat") highlights the Africanist veneration of the female behind. The same may be said for "dumps," the hip hop term used in the "The Thong Song," a novelty hit of 2000 in which the singer, Sisqo, after his opening phrases of admiration for a woman's thong— the G-string-like underwear substitute of choice for the stylish millennial pop female—goes on to say that she has "dumps like a truck." In other contexts, the word "dump" is slang for defecation. Here the negative connotation of this bodily function is revised, reversed, and complicated: With no hint of aversion, the "dump" of yore now signifies not the bodily function but the anatomical protuberance that excretes it, and a strong, sexy female rear end is identified with a dump truck, a sturdy machine that eliminates waste products; several complex connotations are conflated in this rude-boy compliment to (and, indeed, perversely sexist exploitation of) this part of the female anatomy.

It is 15 December 2001. I'm watching *Saturday Night Live.* I am fascinated by the female vocalist in No Doubt, the guest music group featured this evening. Her name is Gwen Stefani. She fits to a tee bell hooks's description (in *Black Looks*) of white assimilation of black priorities. The use of her hips, as she dances her way through the song, is decidedly Africanist, but more than that. Like Eminem and the millennial generation of white hip hoppers, Stefani seems to go further than the Mick Jaggers and Janis Joplins of an earlier generation. In her embodiment of blackness, this woman is more than a white Negro, and my "gear" is tame in comparison to her ample "can." Now, traditional logic would say that she's built like a black woman (or "a brick house," to use a cleaned-up version of notorious 1960s street jargon), but we know the fallacy of traditional race theory, so let us steer clear of old errors. To borrow the title of hooks's chapter, Stefani personifies "Eating the Other." She has taken in blackness: She wasn't born with it. But anyone who stays around it long enough becomes it. (Similarly, blacks growing up in white cultural environments become effectively white in attitudes and actions, as is the case with black children adopted by white parents, or black Germans growing up in white Germany, for example.) In fact, my youthful insider sources informed me that this was "the new Stefani" who changed her style and self-presentation in response to the current craze in white pop culture for big cans and black-to-African ways of moving.

Big butts have put the challenge to smaller ones as, more and more, black core culture becomes the currency of mainstream white practice. Not surprisingly, the 2003 lingerie sections of some mail-order catalogs for ladies' apparel carry ads for "padded rear shaper panties for derrière enhancement" (modeled by white women). It is important to note that this doesn't mean that all black women have big behinds. There is as much anatomical variation within the so-called black ethnic group as there is in the so-called white group; nevertheless, since the prominence of the buttocks is a positive cultural and aesthetic value indicator in Africa and African diasporan communities, daily postures and dance aesthetics emphasizing the buttocks have been practiced for centuries. In fact, the positive or negative male fixation on the female backside seems to be a given (at least in Europeanist and Africanist cultures), regardless of era or ethnicity. The buttocks are a secondary stand-in for what they hide—the labia, the vagina. As sexualized as other characteristics may be—from feet and legs, to hair and skin, and most of all, breasts—the butt is the sentinel standing guard over the hidden treasure. It is the back door of sexual encounter and points to a renewed cultural interest in anal sex. Yet, just as the female genitals themselves have been regarded alternately as beautiful or ugly (at least in Europeanist cultures), the buttocks are the contested ground of stigma-cum-

seduction. The female butt is part of a gendered discourse, with sexually charged energy surrounding the female fanny in general and the black bottom in particular, not only in dance but also in daily life.

Fear and restraint of buttocks power, especially the dancing buttocks, is a fundamental component in Christianity's dialectic on the corporeal capacity for sin. In an essentialist fashion the early church differentiated itself from "pagan" practice by its radical stance regarding the (dancing) body. Using evidence from cave and pottery art, Jean-Luc Henning, in his eloquent and witty volume on the buttocks, traces the use of the rear end as a principal instrument in expressive dance back to Dionysian feasts. He describes dancing maenads, whose "wild fervour allowed the buttocks to arch a long way back in their raging ecstasy." The curved back and protruding fanny were associated with abandon, pleasure, desire, unbridled physical freedom. Henning continues, focusing on one female dancer depicted in a cave south of Pompeii. (In this short chapter, "Dancing," he doesn't discuss the male rear end, affirming my argument about the gendered nature of the topic.) This one woman is "completely naked, shown from the back . . . and she has a fantastic bottom, one of the most beautiful bottoms in the world, [a] stormy, quivering buttocks. As she dances her veil describes an all-powerful rainbow around her, tracing a line reminiscent of the cleft between the buttocks." For Henning, this energy is reproduced in twentieth-century art works like Henri Matisse's *Dance* (1910), wherein "buttocks direct their aerodynamic fuselage everywhere."[1] He asserts, "Emotion from dancing is certainly the most pleasant movement felt by the buttocks, the most vibrant, the most irresistible."[2]

It was this energy that had to be reined in and harnessed in order to construct a "civilized" European body.

In this savage-versus-cultivated dialectic the buttocks symbolize the historical dichotomy between Africanist and Europeanist aesthetic principles. As discussed in chapter 1, the Africanist value placed on the democratic autonomy of body parts stands in sharp contrast to the Europeanist value on unity and line (meaning straight line) working toward one objective. "In traditional European dance aesthetics, the torso must be held upright for correct, classic form; the erect spine is the center—the hierarchical ruler—from which all movement is generated. It functions as a single unit. The straight, uninflected torso indicates elegance or royalty and acts as the absolute monarch, dominating the dancing body."[3] This vertically aligned spine is the first principle of Europeanist dance, and its line is dependent upon erasing those protuberances of the natural body— namely, the three "b's": buttocks, belly, and breasts.

In contrast, the Africanist dance aesthetic favors flexible, bent-legged postures with the component parts of the torso independently articulated forward,

backward, sideward, or in circles as well as in different rhythms. This multidimensional principle is captured in many examples of African sculpture, wherein the sculpted body in profile is an s-curve or even a z, with ribs and belly forward, buttocks back, and knees bent, in postures that suggest motion and kinetic energy. From the Africanist standpoint a vertically aligned stance and static carriage indicate inflexibility and sterility. By Europeanist standards, the Africanist dancing body—articulating the trunk that houses primary and secondary sexual characteristics—is vulgar, lewd. The presumption of promiscuity leads to the lubricious stereotypes attributed to black dancing bodies. This is where the black fanny butts in, and why it had to be "controlled," should black dancers trained in traditional Africanist forms hope to enter the white concert dance world. It was too sexy, and the black female buttocks bore the brunt of this criticism.

Even the social dances that originated in African diasporan communities had to be controlled and straightened up to a vertical, Europeanist standard before they could be considered acceptable for white consumption. This is true of African-based dances from South America and the Caribbean, such as the Tango, Rumba, Mambo, and Salsa, as well as African American forms like the Charleston and the Lindy. Grass-roots Tango is performed with the dancers' torsos "inclined inward toward each other and butts lag[ging] behind," while the official ballroom styles mandate that "hips are pressed under and the torsos are stretched outward."[4] Similarly, a 1950s manual from the Arthur Murray Dance School admonishes students not to dance with the hips protruding backward.[5] Emphasizing the buttocks indicates an unacceptable—read "black"—aesthetic standard.

In this chapter we draw closer to the buttocks by first examining Sara Baartman's "performance" as the Hottentot Venus. The attraction-repulsion narrative around her rear end is an important historical precedent for the reception and perception of the black dancing butt. We then move on to discussions of Josephine Baker; the butt craze in pop culture including Spike Lee's film *School Daze;* the explicit focus of Jawole Willa Jo Zollar's *Batty Moves;* and wind up with commentary from the dancers. The Baartman and Baker sections draw upon extensive research resources that are already in place. My focus is on the black female dancing buttocks, although the male buttocks will make brief appearances. In the world of popular dance aesthetics it has been the female buttocks, black but also white, that attract attention. Both Baker and Jennifer Lopez began as terrific dancers in performance venues that glorified and exoticized their asse(t)s, exploiting the buttocks' valence as sexual signifier. The concert dance and ballet milieus aim to desexualize and invisibilize this part of the anatomy and have subjected black males and females alike to a scathing buttocks-centered critique.

Debunking the black butt stereotype. Unidentified Bangala Men on a Belgian Colonial Post-card, ca. 1900. Brenda Dixon Gottschild private collection; gift of Manuel Jordan.

FROM SAVANNAH TO CIRCUS: "WHAT MAKES THE HOTTENTOT SO HOT?"[6]

[The buttocks] represents, for a lot of people, a sort of sexual epicenter.
—*Bill T. Jones*

I begin this chapter with Sara Baartman because the discourse on bodies and phenotypes from the Enlightenment era through Victorianism and modernism is directly related to performance and the way black performers were perceived and received. One of the quirks of the Enlightenment was the manner in which the conception of a European Self was contingent upon the creation and subordination of a (colored) Other. It is in comparison/competition with an Other that the concept of "white" comes about. World cultures were gauged on a comparative scale, with Nordic Europeans on top and "black" Africans at bottom. With the Age of Discovery as its buffer, Enlightenment explorers not only "discovered" exotic lands ("exotic" meaning everything outside the relatively small geographical see of western Europe) but also imported "specimens," animal and human, to be displayed and exhibited in European towns to show off a burgeoning (ethnocentric) concept of science and evolution. Non-European peoples were effectively categorized with non-European animals and treated as things, rather than human beings.

The so-called Hottentot Venus holds a special place in this sordid history. Called out of her name and given this oxymoronic moniker (for, after all, how could a Hottentot be compared to a Venus, except in ridicule) as well as the name Sara Baartman, this South African woman was exhibited in England and France for about five years until her death in 1815 at age 25. She was of Khoikhoi ethnicity. According to archaeologist and art historian Z. S. Strother, Khoikhoi means "people of people" in Khoe, a South African language distinguished by its clicks.[7] Early European explorers, ignorant of what to make of these sounds, devised the term "hottentot" to describe what they heard. The Dutch words *hateren* (to stammer) and *tateren* (to stutter) are the etymological roots of hottentot; French and English medical terminologies list hottentotism as extreme stuttering. Thus, the term itself is a distortion of the Khoe language and an insult to the Khoikhoi people who, like many indigenous peoples, were extirpated by the disease and enslavement inflicted upon them with the advent of European colonialism. Baartman was displayed not as a person, nor as art, but as a quasi-human artifact. Her presence was a representation: She was a thing, a concept, a relic of a species that supposedly was the link between European "races" and higher mammals—a rank she shared with the orangutan (which is the Malay word for "wild man"). In nineteenth-century Europe there were numerous illustrations, from cartoons to scientific and artistic renderings, of the Hottentot Venus. She was displayed for two reasons: her genital labia and her buttocks.

In his renowned essay on black and white bodies, Sander Gilman states that in visual arts "the representation of individuals implies the creation of some greater class or classes to which the individual is seen to belong. These classes in turn are characterized by the use of a model which synthesizes our perception of the uniformity of the groups into a convincingly homogeneous image."[8] In other words, he is addressing the making of stereotypes. As Gilman points out, Baartman's genitalia—the legendary Hottentot apron ("a hypertrophy of the labia and nymphae caused by the manipulation of the genitalia and serving as a sign of beauty among certain tribes")—and buttocks served as "the central image for the black female throughout the nineteenth century."[9] That over-arching image of black female sexuality continued its hold on the European (male) imaginary through the twentieth century. What is ironic is the way the love-hate spectrum of black-white interactions is played out. In this instance, Baartman's so-called steatopygia, or medically oversized buttocks, metamorphosed by midcentury into a fashion accessory worn by white women. The bustle was essential to the Victorian dress code. It emphasized the very part of the female anatomy that on Sara Baartman was the object of derision. It is another example of the "appropriation-

approximation-assimilation" syndrome of emigration/transformation from black culture to white. In this convoluted case, the white witnesses embraced the idea of enhancing the buttocks but rejected the original body from which it was taken. They loved the aesthetic premise but detested its embodied black precedent.

Another irony in the Baartman example is that the English army surgeon who brought her back from the recently conquered Cape colony purposely and perversely chose this particular woman because of her unusually oversized buttocks. By no means did all Khoisan women have this feature, nor was it exclusive to Khoisan peoples.[10] In pursuit of "science" she was "collected" for scrutiny as a typical example of a lower species on the evolutionary scale. Although she was the exception she was unscrupulously exhibited as the rule for Khoikhoi females—and, by extension, for black women as an entire class or race. As the Gilman quote points out, her representation was pressed into the service of stereotype creation.

There are many extant renderings of Baartman, mainly in the form of gross cartoons and perhaps even grosser scientific depictions. They indicate that European artists struggled with the "dilemma of representation" discussed in the previous chapter's section on William Henry Lane and the Vauxhall Gardens portrayal of him. Not knowing how to deal with Baartman's body, they relied upon "an image for an unfamiliar subject that evokes a *familiar* body of *conceptual* knowledge."[11] There is a canon of European imagery collected around the Khoikhoi that dates back to fifteenth-century explorers, with the earliest artistic depiction dated 1508 and attributed to Hans Burgkmair the Elder of Augsburg.[12] Each century the imagery, stories, and artifacts accrued. After battling to gain control of the Khoisan people in the latter part of the eighteenth century, the British established their definitive occupation and creation of the Cape colony by 1806. So, by the time Baartman was brought to England (and, subsequently, France) by Alexander Dunlop, English army surgeon in the colony, there existed a centuries-old Hottentot trope—a constellation of associations, ideas, and fantasies that had the force of an objective imperative but were, in fact, subjective, Eurocentric conceptions based on imagination rather than evidence.

The actual Sara Baartman, once in Europe for all eyes to see, was unseen, invisibilized, dehumanized. *We see through the lens of our culture,* and Europeans, blinded by this preconceived body of knowledge, were rendered incapable of "seeing" this Khoisan woman. One wonders what her real name was and how she moved and functioned before she was made hostage to "science." These things we cannot know. What we do know is that most of the renderings of Baartman show her in ways she was never exhibited to the public. Instead, we see her festooned in the artifacts that had been associated with the Hottentot

trope for three centuries: the smoke-colored face paint, the *kaross* (a sheepskin mantle or cape), Xhosa beads barely covering her torso, a beaded mantle over her genitals, her huge buttocks either totally exposed or slightly visible under the kaross (which hangs from the neck along the shoulders to the ground, leaving the front and sides of the body exposed)—and, to top it off, smoking a pipe. In actuality, she was exhibited in a skin-colored, form-fitting dress of some flimsy fabric that "was so tight that her shapes above and the enormous size of her posterior parts are as visible as if the said female were naked and the dress is evidently intended to give the appearance of her being undressed," according to an abolitionist horrified by the display. The audience was "invited to feel her posterior parts to satisfy themselves that no art was practiced." "One spectator pinched her, another walked round her; one gentleman poked her with his cane."[13] She was exhibited in circuses and museums (the Musée d'Histoire Naturelle, Paris), as well as in the salons of the elite. On at least one occasion — through psychological, if not physical, coercion — she posed nude for the artist commissioned to draw her by Georges Cuvier, the French "scientist" who was her final "master" before her death (since she was in a state of virtual slavery).

As in minstrelsy, Baartman's performance is rife with racism's conflicted narratives. The white minstrel, in blacking up, desires both to *be* and to *be in control of* the black image; Baartman's exhibitors need to appear as experts with insider knowledge of her and her culture, while demonstrating superiority and control over her Otherness. In mastering the culture of the Other, the white interloper must appear to be *in* it but not *of* it. In Baartman's case science was the guise, but sexual voyeurism (and concomitant, subliminal fears of inferiority) lay beneath the mask.

Like legions of people of color who have devised ways of undermining their stereotype, Baartman exercised a modicum of damage control over her image. Nearly all the many visual representations of her, from cartoons to "scientific" renderings, show her with thighs tightly closed. Although she submitted to being painted nude, apparently under pressure, she did not part her legs. Her elongated labia were not exposed to the white gaze while she was alive: "She held her apron carefully hidden either between her thighs or more deeply, and it was only after her death that one ascertained that she possessed it."[14] Indeed, the horror of Baartman's short life continued after her death: Cuvier was given her corpse in order to perform an autopsy. Thereafter, her genitalia were put on display at the Musée de l'Homme in Paris, along with a plaster cast of her body, as well as her skeleton. These were not removed from public display until 1982 and remained in the museum's holdings through 2001, when the French government decreed their return to South Africa. Although English and French audiences couldn't

see Baartman's elongated labia, they were grabbed just as firmly by her buttocks. Indeed, the buttocks stand as a secondary sexual substitute for the real thing. This "freak show as ethnographic type" presentation satisfied two needs of Enlightenment mentality: First, to see the black body as sexually deviant; and, second, to believe black bodies sufficiently abnormal to warrant the inferior, slavish status imposed upon them by European imperialism. The exhibition of "the body Hottentot" was one of the means that European colonizers needed to justify their ends. The Hottentot Venus was no "noble savage." If she represented the kind of people who inhabited Africa, then Europeans could believe they were doing a service by imposing imperialism, colonialism, and Christianity upon them. They were saving the heathen.

Yet, there was a fascination with this aberrant Hottentot butt. In a society where the display of an ankle was considered risqué, this Venus may not have been "de Milo," but her exaggerated essentials were authentic enough to arouse a substantial sexual frisson. Surely there was also an interest in finding out why elongated labia were preferred by certain South African cultures. What did those male Others find desirable in her? What would it be like to penetrate her, in every sense? These questions are not discussed in the literature, yet their suggestion lingers over and hovers beneath the Hottentot discourse. The bustle style indicates that the desire to possess this rump and make it fashionable was real; like all women's fashions, it was seen as an accoutrement that could attract male attention, indicating that European women were cognizant of white male interest in exaggerated buttocks.

It is significant that Baartman did not dance, nor utilize any part of her anatomy sensually or kinetically (and certainly not erotically). She was a static, unmoving image, reinforcing her deployment as artifact. Accounts describe her demeanor as sullen, sad, depressed. Indeed, she seems to have been a reluctant participant in the process of her dehumanization.

For those who believe in the past-present-future, birth-death-rebirth continuum, the following report may offer an intimation of transcendence to assuage the misery of Baartman's earthly existence. As recounted in international news media, her remains were finally returned to Baartman's homeland in 2002. The "homecoming" had been initiated by Nelson Mandela while he was president but was plagued by years of wrangling between France and South Africa. The *New York Times* reported on 4 May 2002: "She was given her first wooden coffin and a memorial service. The navy band played while scores of people, including mayors and ministers, stood to pay their respects." She was welcomed home "so that her

soul may find the necessary rest." Significantly, scores of South African women—some Khoisan—participated in the ceremony, calling her "Sister Ancestor" and offering supplications of heavenly guidance for her soul's repose. The event was a celebration and affirmation, with Baartman's salvaged remains metaphorically representing the "reclaiming [of] lost or neglected identities."

Indeed, in the Africanist world view and for her Khoisan descendants, "death is never the end of the story." [15]

WORKING THE STEREOTYPE—BAKER'S BUTTOCKS

What an ass! Excuse the expression, but that is the cry that greeted Josephine as she exploded on stage in "La Dance Sauvage." It gave all of Paris a hard-on.

—Jean-Claude Baker and Chris Chase, Josephine

The rear end exists. I see no reason to be ashamed of it. It's true there are rear ends so stupid, so pretentious, so insignificant that they're good only for sitting on.

—Josephine Baker, quoted in Rose, Jazz Cleopatra

I think they must mix blood, otherwise the human race is bound to degenerate. Mixing blood is marvelous. It makes strong intelligent men and takes away tired spirits.

—Josephine Baker, quoted in Martin, "Remembering the Jungle"

The white imagination sure is something when it comes to blacks.

—Josephine Baker, quoted in Rose, Jazz Cleopatra

With wit and irony Josephine Baker's dancing body balances on the cusp between coon and cool, minstrelsy and modernism—playing both images to the hilt as two sides of the same coin. Like William Henry Lane in mid-nineteenth-century London, she brought to the early part of the twentieth century a style of dancing that jolted Europe out of its blasé malaise. Beginning as a blackface dancing comic in black musical revues (including the original production of *Shuffle Along* in 1921–22, when she was only 16) where she was considered too short, too skinny, and too dark-skinned, she became the diva who, at one period in her career, trained with George Balanchine and put her angular, Africanized movements on point in a novel merging of jazz and ballet traditions. [16] Like James Brown, Baker represents all that this book stands for: Her body was an

embattled territory where the contest for power, recognition, and respect was waged. As was the case with Brown's feet, it is difficult to focus only on Baker's buttocks. She was a full-body dancer, the quintessence of Robert Farris Thompson's phrase, "African art in motion." Her shoulders, chest, rib cage, belly, knees, thighs, feet, and face —with her gorgeous eyes and mouth playing witty, generous tricks that were part comic, part seductive—were all equal partners in the World According to Josephine. Still, it was her breasts and buttocks that grabbed the public eye and became the most commodified parts of her anatomy, although her skin color and hair texture were other body attributes that caused groundbreaking cultural upsets. Baker was the Madonna of the early swing era (1920s-'30s). Like Madonna, she personified the agency, power, and autonomy of the female performing body both onstage and off. At times she was a free agent, setting the rules (or disrupting established ones) for a liberated, self-driven sexuality. Like Madonna, she didn't break the stereotype but "worked it" and challenged it from within rather than protesting it from an oppositional feminist perspective. (A third major sex symbol of the twentieth century comes to mind: Marilyn Monroe. But living, midcentury, in the repressive McCarthy era of conservative Hollywood, she didn't have a chance to shift paradigms as did Baker and Madonna.)

Besides its overall powers of persuasion, Baker's rear end had several important historical points attached to it. First, it was bared onstage (except for a brief bikini). Second, it was exposed in Paris and Berlin at a time when it would not have been appreciated in the United States. (In a metaphorical sense, she was smart to get her ass out of America.) Third, that butt was articulating itself in social dances like the Charleston and Shimmy—dances that transgressed repressive borders, celebrated full use of improvisation and individual expression of body parts, and challenged Europeanist verticality and "uprightness." Next, her behind was frequently festooned in feathers or similarly suggestive costuming (for example, bananas) to highlight it as a focus of attention, movement, and energy. Finally, through her uncanny self-possession and savvy control over her image, Baker managed to bare her behind while retaining her integrity, which is the reason why her performance was so charismatic. This was the factor that separated her from other near-nude female dancing bodies, black or white. She was the paradox incarnate: She both reinforced and transcended the stereotype.

In many ways Baker's body represented democracy—the democracy of jazz music and dance that for her generation stood in stark contrast to the monarchical exclusivity represented by European traditions of class, place, and hierarchy. The author Georges Simenon (who had been one of her many lovers) wrote that her *croupe* (a French slang for buttocks) inspired "collective fantasies that send a

deep incense of desire wafting toward her in steamy waves. . . . By God, it's obvi-
ous, that *croupe* has a sense of humor."[17] Indeed, Baker's clever disruption of sex-
ual stereotypes was due, in large part, to her talent as a comedian. She rolled
siren and comic into one unique voluptuousness. A wonderful one-liner given in
a command performance late in her career points to her verbal wit. In referring
to the early days and her skimpy costumes she quipped, "I wasn't really naked, I
simply didn't have any clothes on."[18] It is also a telling statement about what she
revealed or concealed from her public. Like all great performers, she bared only
what she wanted us to see. As one of her many biographers pointed out, she was
"so at ease in her sexuality that she is able to mock it, and to mock her audience
for being hypnotized by it. She is all joyous vitality—seductive, admirable and
almost frightening."[19]

But the going wasn't easy for Baker, even in Europe. Though she had a
strong support base, she also had many detractors. The fact that it was a *black* be-
hind that took over Paris and Berlin fanned the flames of the French and Ger-
man racism that was part of the European colonial heritage and would be a
major component of Nazism.[20] In the white-supremacist view this butt was the
degenerate sign and symbol of a black wave sweeping over Europe and threaten-
ing Aryan hegemony—a war of the races waged on the battlefield of Baker's
black behind, so to speak. Even from the liberal contingent that supposedly sup-
ported her, the ethnocentrism (if not outright racism) of the era was apparent:
"'Sem' (George Goursat), the famous caricaturist of the social scene, drew a
wicked cartoon that astutely observed the hopelessness of her desire to be ac-
cepted in society which showed her dancing, in profile, elegantly clad and bejew-
elled, but with a monkey's tail swishing from her cheeky behind."[21] (In the same
vein, African American soldiers were purported to have tails beneath their
trousers.) The animal analogues abounded. André Levinson, dance critic and
staunch defender of nineteenth-century ballet, described her as "an extraordi-
nary creature of simian suppleness—a sinuous idol that enslaves and incites
mankind"[22]—a roundabout way to say that, personally, he was sexually aroused
by her. The patronizing condescension of Janet Flanner, the Paris correspondent
for the *New Yorker* (using the pseudonym Genêt) extends the presumption of
white superiority. In a 1930 article she wrote: "Perhaps, however, enough is seen
of Miss Baker in the present instance, for she has, alas, almost become a little
lady. Her caramel-colored body, which overnight became a legend in Europe, is
still magnificent, but it has become thinned, trained, almost civilized. Her voice,
especially in the vo-deo-do's, is still a magic flute that hasn't yet heard of
Mozart—though even that, one fears, will come with time. There is a rumor that
she wants to sing refined ballads; one is surprised that she doesn't want to play

Othello. On that lovely animal visage lies now a sad look, not of captivity, but of dawning intelligence."[23]

But Baker was already intelligent, in mind as well as body, and knew more about performance and versatility, about race and racism, than the fledgling Flanner could imagine. Indeed, Baker was very much in control of what she was doing and would become the successor to the famous Mistinguett in popular French culture, admirably singing the very ballads that Flanner hoped were off-limits for her. And her astute race consciousness was a factor to contend with even in her early days, as shown by an anecdote about one of her many suitors (not to be confused with her many lovers and admirers). This particular young student camped outside her door, came to every performance, and craved her attention. She decided to grant him the privilege of her company and allowed him to take her out to dinner: "When he pulled out a thousand-franc note, I snatched it away and stuffed it into my handbag. He looked at me with utter dismay: It was his month's entire allowance. . . . [B]ut I was remembering the colored section of St. Louis [where she had grown up] and how hard it was to earn money there."[24] However, the young man continued to pursue her. She finally gave in and received him in her room: "The delighted student called me his *chou*. Shoe? I reached for my dictionary. 'Chou—cabbage.' A vegetable? I ordered the young man to his knees and planted him by my bedside. Then I left for the theater. Unkind? Perhaps. But looking back on it now, I wonder if the ghost of an African ancestor humiliated by an arrogant plantation owner hadn't been lurking someplace under my well-oiled scalp."[25] No: Flanner didn't know the half of it.

If Sara Baartman is at one end of the primitive spectrum, then Baker is at the opposite end. Both were objects of the white male gaze, ensnared in the primitive trope, but one symbolized abjection and the other agency. Baartman represented the (overtly) desexualized, gross Other: oversized, static, de-energized. Baker was marketed as a moving target of a sexual object: lithe limbs, fast-footed steps, animated face, and most of all, a brilliantly active ass. Nevertheless, there is a through-line connecting the European reception of the two women, and the term, "Venus," is a significant marker. As applied to black women, it is a double-edged sword. As Baker shrewdly observed, "According to another reviewer I was a 'black Venus.' . . . Venus, yes. But the black part didn't seem to help."[26] The term was meant as an epithet of ridicule when applied to Baartman; in Baker's case it stamped her as a noble savage. But, either way, both were Other. In our own era we see an interesting reversal: A famous, beautiful, talented young black woman was named Venus by her parents (and her equally beautiful and talented sister was called Serena). By choosing this name they disrupted the stereotype and played havoc with its power over them—just as, in the 1960s, the

comedian Dick Gregory explained that he and his wife named their daughter Miss to avoid the humiliation of having whites address her disrespectfully. So Venus Williams is truly Venus by birth! Yet, in the twenty-first century, Williams has been described in the English press as a savage, a "demented doe," a "predator," with "impossibly long legs" and "octopus-like arms."[27] It gives one pause that so little has changed in white perception and reception of the black female body. In Baker's case, Janet Flanner described her in the famous "Danse Sauvage" as "entirely nude except for a pink flamingo feather between her limbs" when, in fact, Baker actually wore a satin bikini beneath the feathers at her pelvis, as well as feathers around her neck, wrists, and ankles and in her hair.[28] Besides the fact that it might have made better copy in Paris of the '20s to forget the bikini and just talk about the feather, Flanner may also have simply described what she wished to see! How often the black performing body is seen not for what it is but for what white people want it to represent. Like Baartman almost a century before her and Williams over half a century later, Baker, in Flanner's description, is a screen upon which a European fantasy is projected.

Nineteen twenty-five was the year Baker made Paris her captive with the dance that was the final scene in *La Revue Nègre,* a black show brought over from New York. It was the year of the Exposition Internationale des Arts Décoratifs et Industriels Modernes, also in Paris. It is significant that two women danced at the exhibit's closing dinner—world-famous ballerina Anna Pavlova during the appetizer and the newly arrived Baker during the main course:[29] two women symbolically bookending the Art Deco movement. The Europeans were savvy enough to know that something special, new, modern, and as yet undefined was in the works in this black dancing body. The *Revue Nègre* played at the Théâtre des Champs Élysées from 2 October 1925 until 19 November, having been extended from its original booking for seven weeks. Other shows booked for the theater were put on hold until they threatened to cancel, at which time the show was moved to the Théâtre de L'Étoile, where it played into December.[30] Next, it opened on New Year's Eve in Berlin and took that city by storm. Baker's historical significance rests largely on her performance in the "Danse Sauvage" finale of this revue and her banana girdle dance in the Folies Bergère revue *La Folie Du Jour* the following year.

The "Danse Sauvage": Paris had seen nude and near-nude dances for at least 30 years before Baker's debut. So what was new about her presentation? Perhaps the biggest impact on first sight was the color of her skin. Then, unlike the dancing girls in French variety shows, she danced black dances: improvised torso and limb movements emblematic of the Africanist dancing body (to the detriment of the comparatively softer, balletic movements of French chorines)

that rhythmically articulated the breasts, belly, and buttocks and were essential movements in 1920s African American fad dances such as the Shimmy, Shake, Quiver, Grind, and Mess Around. These dances embodied the Africanist aesthetic principle of the cool, meaning that body parts might be working fast and furiously—or hot—in executing the steps, while in contrast the face exhibited either the detached, still life "mask of the cool" or offered comic relief with smiles and mugging (as was Baker's preference). Thus, parody and ironic contrast were key elements in Baker's act, rupturing the traditional, linear presentation of the female sex object. Finally, she was accompanied by complex (and, for Europeans, alien) jazz rhythms created by some of the brilliant jazz pioneers of the day: The band included clarinettist Sidney Bechet and pianist Claude Hopkins. The sum total was a redefinition of the dancing body, Africanist style, in the face of the European elite. One can't entirely blame Flanner for her misrepresentation: What she saw was too new and unknown to be read using the old familiar codes. Again, "the eye cannot see what the mind doesn't know." This bared body had "attitude," in the African American sense of the word. In fact, Baker danced so comfortably in her own brown skin, so freely in her sexuality, that the effect was a stripping away of convention, a denuding of the cabaret status quo. Reviews of this duet for Baker and Joe Alex, a dark-skinned dancer reported sometimes as African, sometimes as Caribbean, stress its shock value, with Baker's buttocks a central focus.[31] One critic described the climax as a "silent declaration of love by a simple forward movement of her belly, with her arms raised above her head, and the quiver of her entire rear."[32] Basically, this is a description of a bump-and-grind movement. (The revue was choreographed by company member and talented dancer Louis Douglas, although Baker's solo parts in the "Danse Sauvage" were improvised.) The detractors felt it was the end of Western civilization as the black "race" began its triumph over whites on the stage of a Parisian music hall. One artist compared the revue's opening night to the premiere of *Rite of Spring,* the Nijinsky/Stravinsky ballet collaboration that had elicited similarly shocked reactions in the Paris of 1913.[33]

Critic André Levinson felt that Baker exhibited "the splendor of an ancient animal, until the movements of her behind and her grin of a benevolent cannibal make admiring spectators laugh."[34] Of course, Levinson missed the point, the African American in-your-face point, of Baker's presentation. Despite his comments, his reservations about the revue as a whole, and his general contempt for black performance, he exonerated Baker as extraordinary, writing that "Certain of Miss Baker's poses, back arched, haunches protruding, arms entwined and uplifted in a phallic symbol, had the compelling potency of the finest examples of Negro sculpture. The plastic sense of a race of sculptors came to life and the

frenzy of African Eros swept over the audience. It was no longer a grotesque dancing girl that stood before them, but the black Venus that haunted Baudelaire. The dancer's personality had transcended the character of her dance."[35] Baker, the Venus victorious, had made Europe's capital come to her, on her own terms. Praised or mocked, loved or hated, she had moved the old aesthetic toward a new paradigm. She subverted Levinson's linear critique: Her zany humor, sweet craziness, and sense of fun undercut and parodied the exotic-erotic icon that he and his ilk longed to make of her. She manifested and personified the transformative power of Africanist dance, mining gold from dust and exhibiting the luminosity and brilliance associated with transcendent states.

The following year, 1926, Baker was only 20 years old but already a seasoned performer, having worked professionally onstage since she was a girl. Her first appearance in *La Folie Du Jour* is in the banana girdle for a scene described in detail in numerous biographies.[36] She enters a clearing in the jungle. It is night. A white hunter sleeps while his black helpers rest and make music. Enter Baker as "Fatou," a native. Her banana girdle was a brilliant design coup that says as much about the desire to emphasize the female behind as the bustle worn by proper Victorian women. But Baker knew how to work those rubber bananas in ways that bustle-wearers couldn't have imagined. One end of the bananas was attached to her waistband; the other end swung loosely and responded to her movements: phalluses stimulated by female potency. Although the entire setting in this and every scene is elaborately staged and costumed, in typical Folies style, Baker's dance is her own: "As she herself has said: 'I listen to the music and do what it tells me.'"[37] "She came onstage laughing, laughing at everything. She seemed to be everywhere. She danced, miming sex. She offered herself, withdrew the offer, offered again, drew back again and burst into laughter."[38] "She pushed forward her stomach, swung her hips, twisted her arms and legs and pushed up her bottom."[39] "It's a Charleston, a belly dance, Mama Dinks's chicken, bumps, grinds, all in one number, with bananas flying."[40] "She continues to shake her hips, gyrating her pelvis with wild abandon. The bananas flourish around her waist, quivering and jerking. . . . Turning suddenly sideways, she freezes, hands on bent knees, head held proudly upright, her bum poked out cheekily towards the sleeping explorer. [This is a typical Charleston position.] The dance is over."[41] This was the white male fantasy come true: "Danse Sauvage" was set in a Harlem nightclub, but the jungle fantasy realized in the banana dance had always been there, underneath.

If the jungle was the subtext, then the ever-present text of Baker's butt was the white male gaze. No fool, Baker knew this. She once said, "The white imagination sure is something when it comes to blacks."[42] But she was not merely the

object of this gaze; like Madonna, she was her own agent in manipulating it. She became a (very young) millionaire by working the stereotype while playing up the comic irony of that image and laughing all the way to the bank. She worked her sexuality, playing roles that she chose and becoming the chanteuse and music hall star who, by the 1930s, was no longer near-naked but swathed in designer clothes given to her by Paris's top couturiers. Baker was nobody's victim. Her ascendancy in white Europe was her personal triumph over black and white America, both of which had rejected her skin as too dark and her body as too small. In Paris she had to be discouraged from "whiting" up: Her producers and public loved, indeed craved, her natural brown complexion. Legend has it that she loved to preen, nude, in front of the mirror, finally coming to acknowledge her own beauty—although legend also has it that she never really accepted her brown color and returned to whiting up in the years following her early bare-breasted appearances. And, in some measure, there was a dagger of retaliation in her self-presentation, onstage and in life, as demonstrated by the "cabbage" anecdote and the way in which she wielded comedy with sex as her very own double-edged sword. If men used her, she used them as well; if the public used her, she used her public as well.

Baker possessed a second dance persona, different from the one she presented onstage. This dancing body came to life at private parties and late-night, after-hours gatherings. At least two of its appearances have been documented. Both took place in Berlin in 1926. The first was at the home of a playwright. Baker and several other near-nude nymphs are dancing together. It seems that the men are onlookers, although the women aren't dancing presentationally for the males but collaboratively for each other, in a group, to pleasure themselves: "Miss Baker danced with extreme grotesque artistry and pure style, like an Egyptian or archaic figure. . . . She does it for hours without any sign of fatigue. . . . She does not even perspire. . . . An enchanting creature, yet almost without sexuality. With her one thinks of sexuality as little as at the sight of a beautiful feral beast."[43] Although the exotic-erotic is hard at work in this description taken from Count Harry Kessler's diaries, clearly something else is going on. Baker is not offering herself to the men in the room in her usual provocative, comic stage persona. This off-stage dance, with no jazz music accompaniment, belongs to the genre known as modern dance, a form that was just beginning and still avant-garde in the 1920s. Thrilled by what he saw, Kessler wanted to write a ballet or pantomime for Baker and invited her to a gathering at his home where she danced, according to the story, "in front of Maillol's 'Crouching Woman.' . . . When she got into a rhythm, she . . . copied and then parodied its pose. It became the theme for her dance. . . . She pretended it was an idol and worshipped

it. Then she made fun of herself as priestess and the statue as goddess."[44] But nothing came of the ballet idea, nor of the offer made to her by the renowned theater director Max Reinhardt that she remain in Berlin and work with him. She was committed to return to Paris. She had signed a contract for the 1926 Folies Bergère revue.

What these dance examples tell us is that there were dimensions of Baker that were never tapped, perhaps ironically because her body itself was so sensational. Even before Paris, back in the *Shuffle Along* days—when she was looked upon not as a beauty, but the awkward, goofy, ugly chorus girl who somehow was allowed to stay—one review singled her out as "without question the most limber lady of whatever hue the stage has yet disclosed. . . . The knees of this phenomenon are without joints."[45] Later Carlo Rim, the man who wrote the screenplay for *Zou Zou* (1934) came to her home to discuss the script and, taken by her physicality, described her as "built like a boy, long nervous legs, knees without fat, square shoulders, flat chest, concave stomach. Her head has the perfect shape of an egg, and when she smiles, her lips let you discover the whitest teeth you ever saw."[46] When she was 30 (1936) and preparing for a new Folies Bergère revue, her friend Colette, the renowned author, wrote this about her after watching a rehearsal: "The hard work of company rehearsals seems to have made her slimmer, without stripping the flesh from her delicate bone structure, her oval knees, her ankles flower from the clear, beautiful, even-textured brown skin, with which Paris is besotted. The years, and coaching, have perfected an elongated and discreet bone-structure and retained the admirable convexity of her thighs. Josephine's shoulder blades are unobtrusive, her shoulders light, she has the belly of a young girl with a high-placed navel. . . . Her huge eyes, outlined in black and blue, gaze forth, her cheeks are flushed, the moist and dazzling sweetness of her teeth shows between dark and violet lips. . . . *Paris is going to see, on the stage of the Folies, how Josephine Baker, in the nude, shows all other nude dancers the meaning of modest."[47]* [Emphasis mine.]

There was something remarkably charismatic in Baker's body and demeanor that infatuated everyone who met her. Georges Simenon wrote of her "croupe which laughs, in a woman who laughs . . . and who possesses at the same time a most voluptuous body, no matter how it is adorned."[48]

I believe that the highest good a person can offer in a lifetime is to be fully, wholly participant and present to one's era. Should that presentness later translate into historical significance, fine. Nevertheless, what supersedes his-

torical resonance (which is always a matter of hindsight) is a person's relevance and value in, through, and with the contemporaneous body politic and social body, public and private, *while one is alive.* Baker superbly and quintessentially resonated with her era and exemplified how one could be a marketable commodity but still maintain agency and control. I am a child of my times, a gestalt that begins with my coming of age during the 1960s, growing up with the Civil Rights era, and becoming a hippie-Marxist-anti-war activist and, now, the cultural historian writing this book. As much as I appreciate and respect Baker's radical relevance to the 1920s–1940s, it is painful for me to watch her films. As a child growing up in Harlem in the 1950s, I esteemed Baker as one of America's black heroines, one who had escaped and gained worldwide renown. None of us had seen her films. We only knew that she lived in a world beyond racism, she looked gorgeous and "over the top" in elaborate makeup and expensive gowns, and she spoke French fluently. Then, in the 1980s when her films were rediscovered and shown in art-house cinemas, I took my pre-adolescent daughter with me to see the double bill of *Zou Zou* (1934) and *Princesse Tam Tam* (1935). This was to be a proto-feminist outing, a way of introducing my child to a hip "freedom fighter" who liberated the black female image on the French screen. What was to be an empowering, bonding experience turned into embarrassment for us both. Indeed, Baker transcends the mediocrity and exotic-erotic, bestializing racism of the films by her charismatic presence but, from the vantage point of our times, one has to make an effort to detach her from her context. These two films were made a decade after her "Danse Sauvage" and banana girdle stardom, at a time when she had already become the sophisticated, Gallicized toast of Europe. Though she is no longer banana-clad and bare-breasted—and her rear end is tamed—she is still exoticized and represented as the outsider.

In the opening scene of *Zou Zou,* Baker's talking film debut, the child actors who play Baker and Jean Gabin (Baker's co-star) as children are the opening act in a small circus playing at a carnival in Toulon. They are "freaks" (the subtitle translation for the word *phénomènes* in the spoken dialogue), "not like us," because, although they are twins, they were parented by a Chinese woman and an Indian man and born on a Polynesian island. The circus barker goes on to explain that, since the girl is "colored" and the boy white, the parents didn't want to acknowledge them, so the circus "adopted" them. This highly touted Baker film debut is, thus, an ironic coincidence of continuity with Sara Baartman and her freak presentation in Paris and London over a century earlier. A brief scene that follows shows this beautiful little brown girl sneaking into the dressing room of

one of the white circus dancers to powder her face with white makeup.[i] The message is obvious: She is not Us; she is Them, but she belongs to Us, and she longs to be Us. Even Baker's triumph in having a full-length film made as a vehicle for her is based on white superiority as its first principle.

Baker plays the naïf, the noble savage. In another scene she gleefully strolls through a marketplace releasing caged birds. This symbolism will reappear when she, herself, seated on a swing in an oversized birdcage and dressed in a few feathers, nostalgically sings of her Caribbean homeland, Haiti. She is beautiful, exotic, Other. She has one short dance sequence in the film. Dressed in a tank leotard, she gives a modest recap of her signature sexuality-cum-humor, doing a high-kicking, Charleston-style dance and horsing around by turning in profile, sticking her ribs forward and butt out. France, purportedly the nation of lovers, couldn't deal with an interracial love story. Baker is depicted as hopelessly in love with a white Frenchman to whom she is virtually invisible. The situation recurs in *Princesse Tam Tam.*

The final line in the opening scene of *Princesse Tam Tam* is spoken by the jaded Parisian hero who is feuding with his wife: "Let's go among the savages, the real savages—to Africa!" The camera fades from his chic apartment to open air, lush foliage, and Baker peeking through the bushes. Although this film parallels the Pygmalion tale of a female Other retrained to behave by a white male patriarch, it also parallels Sara Baartman's story—namely, the native woman brought to Europe to be displayed as an oddity. By now Baker sings more frequently than she dances. Here the song is "Under the African Sky." Whether African or Caribbean, she is portrayed as longing for a black homeland, not wholly belonging where she is. At the climax of this film she sheds her European clothes (she looks totally stunning, swathed in a form-fitting, golden couturier evening gown) and "goes native," unable to contain herself when, at a fancy ball, African musicians begin to drum. It is full-body dancing: belly, hips, butt, shoulders, head, breasts—no part remains uninflected. This is the old Baker of the previous decade's "Danse Sauvage." Her use of belly rolls and bumps and grinds focuses attention on her entire pelvis, and she makes sure to stick her fanny out as an exclamation point.

i. Deborah Willis's and Carla Williams's *The Black Female Body—A Photographic History* shows a photo on page 170 that may have been the prototype for this scene. Titled "Face Powder, South Africa" and undated, it seems to be from the era between 1880–1920. In it, a young, bare breasted adolescent African girl in traditional jewelry and coiffure kneels before a dressing table with mirror holding a cotton-white powder puff. She is caught in the act of applying white stage powder to her chocolate skin: Her face is half-brown, half-white.

Jump cut to 1940, and a film called *The French Way*. Baker is only in her early thirties, but she is already a French staple and plays not the sexy ingénue but the "older" woman, an entrepreneur who owns a club and plays Cupid to a young romantic couple. Still, her gorgeous sinuosity has a shining moment toward the end of this otherwise insipid venture. Her long, narrow waistline is on show, giving a rhythmic, swaying counterpoint as she sings and dances in her nightclub, wearing one of those 1940s full-length, two-piece gowns in which the midriff is bared. Here, too, the trope of the exotic outsider is captured in a song whose first line is "My heart is a bird of the isles." This mature Baker is precursor to the legendary heroine of my childhood: No longer the eye-crossing zany, she is the adult author of her own fate, with agency enough to turn into favor the adversity of the young lovers. She is "La Bakaire" (her French nickname)—the One and Only, never a freak, always a phenomenon.

In *This Sex Which Is Not One*, feminist writer Luce Irigaray asserts that women "recover the place of [their] exploitation by discourse, without allowing [themselves] to be simply reduced to it." In mimicking masculine logic—appropriating the agency of the male gaze, if you will—women "*remain elsewhere.*"[49] This theory applies to Baker. As she once said, "Not a dancer, not an actress, not even black: Josephine Baker, that's who I am. I can go on my heels and I can run on all fours, when I want to and then I shake off all piercing looks. . . . Because I'm not a pincushion either."[50] Here Baker tells us, in her own wonderful way, that she is a free agent, regardless of appearances. Unlike Sara Baartman, she has burst out of the cage created for her by European man and his symbols, categories, and labels. She can choose to walk tall or "get down." She will not be pinned down—symbolically raped—by the piercing look of the male gaze. She remains her own by "remaining elsewhere." She has presented to her audience only what she chose for us to see.

THE POPULAR BUTT

If I look at black people dancing, you know, no one's worried about butts—big butts and big thighs. Why am I so uptight about my wide pelvis? When I social danced I felt like I was getting all this articulation in the pelvis that I never had any concept of at all.

—Meredith Monk

In contrast to the disparagement of the buttocks in the worlds of ballet and modern dance, a wealth of reversals in core black culture (and increasingly in white pop culture) almost deify this part of the anatomy. According to George Fernandes in a

1999 article in *Rolling Stone*, the New Year's "must-have fashion accessory" was "a great big ass. Jennifer Lopez and her formidable glutes were the most famous . . . inspiring a horny cult of followers." Baker's and Lopez's behinds bookend a history of tributes that includes dances such as the 1920s Black Bottom and more recent fads such as the 1970s Bump and Da Butt, which surfaced in the late 1980s. Dances that celebrate and accentuate the butt are basic integers in the Africanist affirmation of individual body parts and date back to traditional dances of many West African cultures that were brought to the Americas in Middle Passage.

In the Bump clipping file at the New York Public Library for the Performing Arts, Dance Division, there are a paltry handful of entries, yet they can be analyzed for valuable cultural information. One is a photo from page 79 of the New York *Daily News* on 12 June 1975 showing Martha Mitchell, former wife of former U.S. Attorney General John Mitchell, doing the Bump with a young man at a Museum of Modern Art party. It is a rather milquetoast example of the dance. The formally garbed Mitchell and the T-shirted young man stand, side by side, her torso stiffly vertical, her hip barely jutting out in his direction. It is not in her carriage but in her facial expression that we see her hint that she is doing something naughty: An eyebrow is lifted, rather seductively, above pursed lips and lowered eyes as she peers coolly over a raised shoulder to check out the hip action. The young man seems to be having more flexible fun. But, then, he is not an elderly woman clothed in a close-fitting evening gown. (In other contexts and on other dancing bodies, such a gown might work as the perfect costume for butt enhancement in a buttocks-centered dance.) Regardless of the quality of their rendition, what the clipping indicates is the widespread mainstream popularity of this dance in the mid-1970s. Along with the Hustle, the Bump was to the 1970s what the Twist was to the 1960s. And, like the Twist, it swept across the United States, moving from black urban enclaves to posh white venues. A major player in the disco dance fever of the decade, it can be performed in several ways: standing side by side with one's partner, facing in the same or opposite directions; standing back to back; or facing each other. It began with partners bumping each other's hips but was soon extended to include behinds, shoulders, arms, heads, chests, knees, bellies—in other words, bumping any body parts possible with improvisation as the name of the game. Added to the sense of play was another position: one partner standing behind the other in a foreshadowing of what was to come in Da Butt.

According to Butler's *Encyclopedia of Social Dance*, the Bump originated in (black) Philadelphia in 1972 and by 1975 had reached white venues. Butler gives a nod to the fact that it had antecedents in other dances of earlier eras: "The concept of the Bump was not new, for in the mid-1930s the 'Boomps-a-Daisy' had

enjoyed wide popularity as a party dance with young people and adults. To Waltz tempo and to the tune 'Boomps-a-Daisy' partners dance sedately and then bumped hips as the special lyric indicated '. . . What is a Boomp between friends?'"[51] Butler's analysis doesn't go far enough since this dance, like all twentieth-century fad dances, is rooted in black traditions. The decorous Boomps-a-Daisy is clearly a white dance. Although bumping body parts wasn't one of its steps, the ur-buttocks dance of the early twentieth century is the Black Bottom. According to Stearns and Stearns this dance was performed in southern African American communities before 1910. African American dance songwriter Perry Bradford revamped his 1907 version of the Jacksonville Rounders' Dance because local folks didn't appreciate the connotation in the title. (Rounder was slang for pimp.) He revised the lyrics and renamed the song and its concomitant dance the Black Bottom. The sheet music was published in 1919. It did not reach the white community as a fad dance until it was introduced on Broadway in *George White's Scandals of 1926.* By then it was a watered-down version of what was probably a bawdy original: "The chief gesture that survived on the ballroom floor was a genteel slapping of the backside, along with a few hops forward and back."[52] But the original, black Black Bottom required the dancer to "get down" in posture and attitude, rotate the hips and articulate them in movements known as the Mooche and Mess Around, both of which involve full rotations of pelvis in a flexible, unbound manner that is commonly called a Grind. The behind wasn't gently tapped, but grabbed and held to accentuate the rotation. Even earlier than the Black Bottom is the Fanny Bump, practiced at the turn of the century in grass-roots black communities, with the name of the dance an indicator of the principal movement. Da Butt had a similarly bawdy precedent in a dance named the Funky Butt, as described by one of the Stearnses informants and dating back to 1901: "Well, you know the women sometimes pulled up their dresses to show their pretty petticoats . . . and that's what happened in the Funky Butt. . . . [Then, recalling a particular woman who was a specialist in this dance:] When Sue arrived . . . people would yell 'Here comes Big Sue! Do the Funky Butt, Baby!' As soon as she got high and happy, that's what she'd do, pulling up her skirts and grinding her rear end like an alligator crawling up a bank."[53] As outrageous as Da Butt seems in the music videos of the early 1990s, it is simply a recycled Africanist dance with a new spin put on it for a new era—and that is the story of all the popular social dances of the twentieth century and will probably be the same story for the twenty-first. These movements came from Africa with Africans and were transformed first into plantation dances, then minstrel dances, then social dances for the ballroom floor. By the time they reach mainstream venues they've been laundered in the appropriation-approximation-assimilation

"whitewash" cycle and are distilled/finessed to a white-approved version. At the dawn of the twenty-first century, the approximation part of this equation is occasionally, if not frequently, omitted, and black dances are wholly appropriated and directly included in the white culture—an indication of the blackening of white America.

Hip Hop choreographer Rennie Harris, a walking encyclopedia of African American social dance from the 1970s to the present, pointed out an interesting fact in conversation: By the 1990s youth culture was looking back to the 1970s in search of "retro" styles. In this quest, they retrieved the Bump, combined it with the more recent Butt, and came out with the extremely sexualized style of "booty dancing" that can be seen in the music videos of the late 1990s. According to Harris, a dance called the Freak followed the Bump later in the 1970s. It, too, was part of the retro retrieval of the 1990s. In Harris's words, it "allowed you to get a little closer to your partner" and included the Grind (in this instance, pelvis-to-pelvis contact accompanied usually by slow movements), but it also involved a generic, full-body dancing style that encompassed more than a buttocks/pelvis focus. He recalled that, with the advent of Da Butt, "everything changed [in] the way you danced at a party: dirty dancing was allowed, mainstream. You could get down to the floor, get up on a girl and grind her from behind."[54]

This style was epitomized in Spike Lee's 1988 film, *School Daze*. A masterful early work by a master of irony and the grotesque, this film is important artistically and politically. In it, Lee presents a parodic, hyperbolic treatment of class and color conflict within the community of contemporary black culture. The setting is an HBCU (historically black college-university) where tensions are building between the politically conscious students (pushing for the college to divest its South African stocks) and the Greek-letter fraternity and sorority members (who dominate campus life and cater to the light-skinned, bourgeois elite amongst the student body). The scene for analysis here is a poolside party. The main focus is the dance floor, not the water (which we never see). A song called "Da Butt" (music and lyrics by Marcus Miller and Mark Stevens, 1988) is the live musical accompaniment. Young men and women alike are clad in bikinis (this is the pre-thong 1980s). The rear ends of both sexes literally fill the screen. Male butts are shameless in their pulsing and articulation. Indeed, in Africanist aesthetics articulation of separate parts of the torso (chest, pelvis, shoulders, butt) is not solely the purview of women. In fact, a man's masculinity is enhanced by his flexibility and capability on the dance floor. So the men are "workin' it" as intensely as the women, with either sex at times descending completely and supporting body weight by placing hands on the floor either behind the torso (so that the pelvis faces the ceiling) or in front (so that the buttocks is pointing upward). Some

dancers steady themselves with legs spread, feet planted on the spot, bodies bent forward, buttocks stuck out, knees bent, arms straight, hands resting above the knees. This position allows a glorious opportunity to ground oneself and shake or grind the booty. There is one shot of two female butts "kissing" as they rub together. Some dancers caress and squeeze their own butts. There are several "sandwich" shots, with male-female-male pasted together, butt-to-pelvis-to-butt-to-pelvis. The front of the body may dance with one partner (or more) while the back, especially the rear end, dances with another. In fact, everybody is everybody's partner and no longer paired off in couples. The entire floor is pulsing, dancing, rising and falling together as bodies bent over in an array of get-down positions move like a continuous wave of energy — each different, but all moving in consonance. In this worldview there is no embarrassment in having a big butt — or, as proclaimed in the words of the song, "a big ol' butt" — as long as it is flexible, expressive, rhythmic, "phat."

Examining the microcosmic example of four buttocks-centered songs that span the late 1970s through the year 2000 may help us understand the blackening of America that was magnified in the final decades of the twentieth century. In 1977 the Commodores, a popular R&B group, recorded a song that has remained an enduring hit: "Brick House." The song, "Da Butt," and its accompanying dance hit the scene in 1988. In 1992, a rapper from Seattle named Sir Mix-A-Lot won a Grammy for "Baby Got Back," his "platinum-selling ode to bootie-ful women" (in the words of his website). And in the year 2000 the hip hop artist Sisqo had a hit on his hands with the "Thong Song." These four works are not simply sexist male exploitations of the female body, although that is definitely one of their salient characteristics. They also reclaim, proclaim, and acclaim the black female body — buttocks, in particular — as pro-active and powerful in its seductive beauty: the buttocks as agent, not victim. Given the pejorative connotations of the past (beginning with the Hottentot Venus), these songs are part of the canon revision that celebrates the black female body as a viable mainstream icon. It is the power of cultural change, as demonstrated by these songs and the pop culture from which they emerged, that created a Gwen Stefani and her white female peers who can flaunt their developed — *black* — buttocks. In true Africanist aesthetic style, these songs are lighthearted, humorous, tongue-in-cheek novelties that state matters in a raw, bawdy fashion that is rife with innuendo and double entendre.

The Commodores' song seems like a modest celebration of the female body when compared to the sexual explicitness of ensuing decades. As Rennie Harris explained, the term "brick house" did not refer only to the buttocks but also to the breasts. Thus, the woman is described in the song as "stacked" (well built) because she has prominent breasts and backside. Power is certainly implied in

this brick simile: The aesthetic value is for a woman with a strong, solid body —
neither willow nor flower, but the "house" the "wolf" cannot blow down. And
the idea of a female body as a house invites entry. The woman is also described
as "built like an Amazon." Measurements are given: the old Coca-Cola bottle
ideal — 36–24–36. There is an interesting and telling break in the song between
the words "brick" and "house" — as though another word could be inserted:
"She's a brick — —house." In the 1960s, the decade that preceded this recording,
there was a vulgar street saying to describe a woman who was "stacked": "built
like a brick shit house" was the phrase. Now, this was high praise, of the caliber
of "dumps like a truck" from the "Thong Song." It is likely that the break be-
tween the two words was to allow the listener to add the slang word that would
not have been allowed on a commercial recording. In any case, the break is the
rhythmic device that helps keep the repeated brick house phrase alive with syn-
copated vitality and makes the song one of the enduring "golden oldies" from
the 1970s.

"Da Butt," as its title suggests, focuses wholly on the rear end. In contrast to
"Brick House," it is an action song, and "doin' the butt" is part of the chorus. The
first stanza celebrates the body that mainstream fashions deplore. The singer
walks into a party and sees "a big girl getting' busy." She dances, shaking her
"booty"; he responds that it looked good to him. In another stanza he talks about
taking this "girl" onto the dance floor and "doin' the butt" until he was sore, then
continuing to do it all night. With these two comments we begin to understand
that the phrase, the dance, and the song may refer to sexual intercourse, with the
word "butt" as a stand-in for the genitals. In fact, Harris mentioned that in his
youth (the 1970s), when guys were talking about having sex they'd say "gonna
get me some ass," rather than "gonna get me some cootchie," a slang word for the
vagina. As it was with Sara Baartman, the buttocks and its attendant phrases act
as substitutes for the genuine genital article, so "doin' the butt" may be construed
as a dance for the boudoir. In any case the song and dance are paeans to the
(black) female behind. The final chorus allows dancers to add in names of
friends to the repeated refrain, "(Add in name) got a big ol' butt; (Add in name)
got a big ol' butt," and so on. The message is loud and clear: Black people have
their own loved and revered standards of female beauty.

Moving right along in terms of explicitness, we come to 1992 and Sir Mix-A-
Lot's strong, politically conscious statement about the black female behind. The
"back" in the title, "Baby Got Back," is a euphemism for the buttocks, and eu-
phemisms end right there. Everything else about the lyrics is gloriously, naughtily
explicit. At the same time, this is more than a sexploitation song. Before the male
singer begins we hear voices of young women, their bourgeois status given away

by their diction and speech patterns. They could be black or white: It doesn't matter. Ethnicity is subordinated to class. They vilify a grass-roots black female by stating that she looks like a prostitute, like the girlfriend of a rapper. They focus on her buttocks ("it's so big . . . so round . . . just out there . . . gross") and her skin color ("she's . . . so black"). Enter Sir Mix-A-Lot to the rescue: Indeed his name is a play upon Lancelot and Camelot. And he is the hero who is out to pursue and save the dark-skinned, urban, poor, black female body from calumny.

His song frees her from the barbs of the bourgeoisie: He disparages the fashion magazine belief that flat fannies are fantastic. He says that black men want women who "pack much back." He doesn't want *Playboy* women who've had their bodies surgically enhanced because silicone parts belong in toys. He praises the "thick soul sistas." He then deprecates pimps, stating that they won't like this song because they like to "hit it and quit it," but he wants to "stay and play" and will not curse or abuse these women. Again he mocks the reigning mainstream definition of female beauty by slinging a barb at "Cosmo" (*Cosmopolitan* magazine—wittily titled "Cosmopygian" in the MTV video), stating that he is not beholden to its values. They would describe his dream girl as "fat," but he isn't "down with that." He cleverly jokes and rap-rhymes about Jane Fonda, then the exercise queen of weight watchers' videos, stating that she doesn't have "a motor in the back of her Honda"; female magazine idols are "beanpoles." For the final stanza he again deplores the pimps who abuse these well-endowed "sistas" and the white culture that rejects them, again assures them of their beauty and desirability, and ends the song by giving them his telephone number and the refrain, "baby got back." The humor in the song is undeniable; equally as strong and satisfying is the message of pride in blackness and those attributes that traditionally have been associated with and disparaged in the black female body.

The song's music video is a primer of contrasts in Europeanist and Africanist purviews: Hip Hop Aesthetics 101, if you will. The visual setting is an ingenious, neo-surrealist landscape dominated by a larger-than-life yellow sculpture installation in the shape of the buttocks, with the cheeks facing heavenward. Sir Mix-A-Lot makes his first appearance atop these cheeks, straddling them as he gesticulates in the hand language that is a staple in the rap repertory. Thus, the fact that the black buttocks are idealized is apparent in the opening frames. As the aforementioned teenage preppy females disparage her looks, an ebony-skinned woman wearing a spandex-tight, short yellow dress stands on a pedestal against a backdrop of pink and blue sky, smoothly swaying her buttocks from side to side while soft music is heard. The color palette is a work of art. She is the ideal: Her insulters are the losers. The video features teams of women dancing with their backs to the camera. The choreography is playful and powerful, the

dancers moving in swift, hard bumps and powerful shakes, with an occasional karate kick thrown in. Like Josephine Baker, they perform these movements with ironic humor, and their rumps are undeniably witty. At times they move in the exact same, fast, double-time shimmy used by Baker in her banana skirt dance. In fact, to show us that they know their stuff, the videographers included a quote from Baker's most famous number, with a brown-bodied, banana-skirted dancer on screen for a few frames. The dancers are dressed for comfort and power, as well as for speed, in flat-heeled black boots (so they don't totter off stiletto heels), yellow spandex short shorts (tight, but not French-cut) that reach the waist and are accented by wide black belts and matching yellow midriff tops. These are power outfits that parallel those worn by the Urban Bush Women in their dance *Batty Moves*, a far cry from the near nudity (and vulnerability) of the women in the millennium booty videos like the "Thong Song."

The video is laced with humor of the old-school variety. For example, fruits suggestive of sexual organs are flashed on screen at appropriate times: a wagging banana; tomatoes; a ripe pear with a vertical groove down the center; two lemons paired as testicles. In a send-up of the advertising practice of encoded subliminal visual messages, the screen flashes large print letters of words like "rump, thick, rear, stuffed, bubble." Racial divisions implied in the song are reinforced: The preppie girls at the beginning are, in fact, white, as is the cover girl fashion model; the dancers flaunting their behinds are all brown-skinned black females; the line about silicone for toys is illustrated by a row of white Barbie dolls. A praise song to black females doubles as a political commentary on race and racism. Recognizing the white love-hate, attract-repel relationship with the black buttocks, the video ends with the white female "Cosmo" type adding a ludicrous protuberance under her tight pants to manually enlarge her own buttocks. Nevertheless, none of the messages is overly serious or accusatory. The overall feel of the video is informed, playful, and liberating on all sides.

By the year 2000 the political thrust that characterized much of rap music in the 1980s and early 1990s had been all but abandoned. Social critique by groups like Public Enemy, A Tribe Called Quest, Arrested Development, and Digable Planets was aborted and sex became the name of the game, along with the "gangsta" ethos of drugs, guns, violence, and every *man* for himself. In this climate Sisqo's "Thong Song" glorifies the behind indirectly by addressing this genital covering that has replaced women's underpants. The thong, in the song, is a metaphor for the buttocks, as in "Girl . . . show . . . that thong." With the narrow slit of fabric tightly wedged and almost lost between shimmying "cheeks" mooning at the camera, the rear string of the thong acts as a visual substitute for the penis in anal sex: The foreign "object" knocking at the back door of sexual en-

counter. Metaphor gives way to bald lust as the words encourage: "make your booty go," and "move your butt."

In this video it is only the women who dance, whereas in "Da Butt" scene in Spike Lee's film men and women were equal body partners on the dance floor. The woman addressed by Sisqo (the woman is generic: she could be any female) is characterized as having a devilish look in her eyes and as being "so scandalous" that other men couldn't handle her. Without the socially conscious scaffolding of "Baby Got Back," the playful lightheartedness of "Da Butt," or the comparative modesty and innuendo of "Brick House," this song verges dangerously on total exploitation. The women in the video (and in a slew of similar millennial "booty videos") perform movements that are staples in the couch dancing repertory. They are the inverse of Colette's statement about Josephine Baker: Impaled on their thongs, they show all women how the male gaze can strip the female body of all individuality. They are interchangeable integers—all body, devoid of personality. Paradoxically, although she is clearly an object, woman is somehow depicted in the thong video/song as a powerful shaker and mover, deploying her sexuality as a free agent who is beholden to no man. She is sex incarnate—beyond good or evil—liberated in a perversely existential, detached way.[ii] There is no doubt that the lure of women in videos such as this is the reason for the widespread popularity of the thong as the underwear replacement for this era. The thong serves as the metaphor for sexual liberation and the definition of feminism for generation XYZ. We can draw a parallel between the popularity of Sara Baartman and the emergence of the bustle, on the one hand, with the popularity of booty videos and the emergence of the thong in the bourgeois wardrobe, on the other hand.

Asked if he could give any examples of female rappers having extolled the male buttocks, Harris replied that, no, the equation did not work in the opposite direction. Except for what he termed "novelty" songs that referred to the size of the penis, female rappers did not focus on butts or any other specific part of the male anatomy. Instead, they referred to character attributes, such as rough men (frequently a compliment that indicated rough sex) or "playas" ("players," or philanderers, a bane to women in all walks of life). It seems that

ii. According to dance anthropologist Yvonne Daniel, whose areas of expertise are Candomblé, Santería, and Vodun (African-based diasporan religions), this liberated sexualized zone beyond good or evil is, in her work, the site "where sexuality and age/wisdom meet and spirituality can unfold" (correspondence, April 2002). So there is an Africanist line in Sisqo's work that, unloosed from its traditional moorings, is adrift at sea.

the female buttocks captures the male imagination in ways that can be liberating and exploitative, celebratory and pornographic, all in the same stroke.

Moving back in recent history and returning to white popular culture, a paragon of the black dancing body in whiteface is the jockey dance, immediately preceding the finale of the "American in Paris Ballet" from the 1951 movie musical *An American in Paris*. The brilliant Gene Kelly had a body that easily fit the mold and shape of the black dancer known as Chocolat in the famous Toulouse Lautrec rendering *Chocolat dansant dans un bar* (1896). It is remarkable that Kelly chose this Lautrec depiction of a dancing black Parisian to give him the opportunity to make a dance that simultaneously addressed something essential about Paris and something essential about himself, an American who grew up with black-inspired dance forms. There is interesting information encoded in the Lautrec drawing. Chocolat is standing, poised to dance, in the center of the floor of the Irish and American Bar, a watering hole for serious drinkers where Lautrec, who later died of alcoholism, was a regular. The dancer is wearing a beige jockey's habit: smart, checkered beanie with brief brim, tight, long-sleeved turtleneck shirt, form-fitting pants. Although Lautrec depicted jockeys in several works, Chocolat is not a jockey or a professional dancer, but a circus clown. After performing in the Nouveau Cirque he often came to this bar with friends and occasionally danced.[55] So his outfit is a costume.

What is interesting is that this was an era when, in the United States, most jockeys were black (as shown by the jockey statuary of the nineteenth century, now collectibles, that were placed at the entrance to a home or club for guests to rein their horses and used in the North to signal points on the Underground Railroad). Thus Chocolat's costume, consciously or unwittingly, pays homage to African American jockeys. Likewise, Kelly's ingenious dance pays homage to the black (male) dancing body, with a lovely emphasis on the rear end. In the movie we first see a copy of the Lautrec depiction: The back of Chocolat's body faces the spectator, and his face is in profile over his right shoulder. His stance is Europeanist, and it has been suggested that he was performing an Irish dance. His torso is lifted, rib cage balletically jutting forward, standing left leg well turned out in a courtly manner, the right toe pointed and lightly touching the floor, while the right arm is lifted in a rounded ballet or folk-dance position and the left arm is bent at the elbow with the hand on the left hip. As was the case with the Vauxhall Gardens rendering of William Henry Lane, it may be that Lautrec unconsciously finessed the black man's body to a white standard of excellence. Or in both cases it may be that the performers, themselves, internalized both Africanist

and Europeanist ways of moving. But leave it to Kelly to reintroduce the black elements as he dances not an Irish jig but a black vaudeville medley.

In the tight riding habit that is an exact replica of the Lautrec costume, Kelly literally moves into the poster, replacing Chocolat's body with his own and bringing the drawing to life. His dancing body subtly shifts the emphasis of the static pose from Europeanist to Africanist, his arched back and protruding buttocks signaling black dance. (In addition, the back of Kelly's cranium has the perfectly rounded, slightly protruding shape that, in racial anthropology, was seen as an African anatomical attribute, while a flat back of cranium was interpreted as typically Aryan.) Kelly animates the still pose, performing a magnificent black-based jazz dance, working principally in the bent-kneed, get-down Africanist position appropriated by white jazz choreographers from Jack Cole through Bob Fosse. Of course, his movements are distilled and modified to a Hollywood-friendly version, but blackness and his connection with it are unmistakable. He includes hip wiggles (although he never articulates the pelvis in forward thrusts, or bumps) in profile and twice with his full buttocks facing the screen. He ends with the strutjumps of the Cakewalk. By using the blackness of Chocolat as his starting point, accompanied by the jazzy, blues-ragtime Gershwin score, Kelly instructs the viewer in the black rudiments of jazz dance and demonstrates the correct posture for the genre—knees bent, back arched, butt out. In this routine he shows us the root history of popular dance, white and black, in the twentieth century.

Moving forward to the millennium, white popular culture in the year 2000 registered a testimonial to the blackening of Broadway, according to *New Yorker* dance critic Joan Acocella in the 15 May issue, page 98. Reviewing the musical *Swing!*, she asserts that black-white Ryan Francois and Jenny Thomas are "the best couple"; then she states that to find out in the program notes that they are married "still makes an impression." She continues: "Even more striking than the racial message is the sexual message. Goodbye slim thighs and ponytails. Hello dye jobs and big rears. . . . One is grateful to see a real bottom doing the black bottom. Furthermore, it seems unquestionable that one of the reasons the Broadway chorus line looks so terrific is that our current *politics* has allowed casting directors to draw from a larger pool of applicants." (Emphasis mine.) It is refreshing that Acocella attributes thigh and buttocks characteristics to gender qualities, rather than racial imperatives. She sees that white bodies, too, have these attributes and lauds a more democratic eye on the part of casting directors for allowing these bodies their latitude.

The recursive way in which the popular stage influences the ballroom dance floor is echoed in an article that appeared several months after Acocella's review. On page two of the December 31, 2000 Styles section in the *New York Times*,

Julia Chaplin wrote about a white club phenomenon, "rear-ending," that she attributes to "so-called booty videos, a sub-genre of hip hop." These dancers imitate the video dances "with studied precision," bending forward with arched backs and jutting fannies to make it easier to shake their behinds. The songs of choice include Mystikal's "Danger," Juvenile's "Back That Thang Up," Dr. Dre's and Snoop Dogg's "Next Episode," and Jay-Z's "Big Pimpin." The names of the songs aptly describe their drift. The accompanying videos feature professional strippers who are adept at a variety of buttocks-centered movements. Circa 2000 the zeitgeist had moved far beyond the 1989 controversy surrounding one of the earliest uses of professional strippers in the 2 Live Crew video "Me So Horny." That video's release resulted in a legal controversy over obscenity; a decade later its message was de rigueur.

THUNDER BUNS ON THE CONCERT STAGE:
BATTY MOVES AND BALLET MORES

I think there's a love of the big butt [in the black world]. I remember I was losing weight, and one of the dancers said, "Ron, you're losing your butt!"—and there was this sadness in his voice.

—*Ron Brown*

On 17 February 1998 I received a telephone call from a reporter commissioned by the *Philadelphia Inquirer* to write an article on the Pennsylvania Ballet. Someone had suggested he talk to me. After a few cursory questions, he cut to the kill, going exactly where I expected him to, although beginning innocently enough with a lead-in question: Why are there so few blacks in ballet? I respond: Racism. He proceeds to inform me of the response he has gotten from others he has interviewed. He says that they say the problem is the black body. I say that I do not believe that people are still offering up that lame excuse and ask what sources he's consulted—assuming that they must be denizens of small, ballet-tap-acrobatics studios in the Philly suburbs run by non-professional independents. But, no, he says he's been told by New York professionals that African Americans have "too much tits and ass" for ballet. So much for progress.

Before we once again broach the tyranny of the ballet aesthetic, let us look at a concert stage dance that instead honors and celebrates the black female dancing buttocks. In the repertory of the Philadelphia Dance Company (Philadanco) and first performed in 1995, *Batty Moves* ("batty" is a Caribbean slang for the buttocks) was created by Jawole Willa Jo Zollar and revised in 1998, the year it was performed by her company, Urban Bush Women (UBW), at Aaron

Davis Hall in New York (with live percussion accompaniment by Kwame Ross and Michael Wimberly). The nine women dancing in this performance (some of whom are shown in the accompanying photograph on page 179) were Diedre Dawkins, Michelle Dorant, Maria Earle, Carolina Garcia, Dionne Kamara, Christine King, Kristin McDonald, Francine Sheffield, and Amara Tabor-Smith—with cameo appearances at the beginning and end by Zollar. For this performance Zollar verbally introduced the dance, explaining and physically demonstrating the schizophrenia she experienced in dancing Africanist dances at parties and other social situations (demonstration); going to her college dance classes and "pullin' up and tuckin' in and apologizin'" (demonstration); and swinging back and forth between these opposing worlds. This dance is her effort to end the bipolarity. In her words, "I needed to find a way to bring both traditions together to claim who I am and all my gifts from Africa and bring them [to the] present. . . . That tradition has to do with the celebratory ease of movement within the hips. Whenever you see African peoples you see movement in the hips. . . . I wanted to continue that tradition with this piece, *Batty Moves*, to celebrate what is just a glorious, wonderful, beautiful, and fun part of the body."

There is an exhilarating democracy in the UBW collective dancing body. Short, tall, slim, stocky, light-skinned, dark-skinned, new and mature dancers are represented at any given time in the company roster. What they physically share in common—and even here there is a wide range of diversity—is that they all wear natural hairdos: braids, locks, twists, or short cuts, but no chemically relaxed styles. In their enlightened interpretation the "batty" becomes much more than the "seat" of sensuality. It is a center of power and gravity (literally and metaphorically). They perform in continental African fashion in the sense that individual prowess is celebrated in the context of collective, communal identity. What is so enticing about their performance is that, by reinterpreting the performative context and intention, they liberate the black female buttocks from centuries of stereotyping. They celebrate it and even flaunt it without ever "selling" it to the audience, without ever playing sex characters. They personify the "counter-hegemonic art," as theorized by bell hooks, that does not iconize the artist or the work of art, but allows us to see ourselves through the power of the work. They are sexy not because they are playing age-old come-hither games but because they celebrate their bodies—their batties—with forthright spirit and righteous energy. By focusing on this body part, Zollar and her company reclaim, reintegrate, and redefine the black female buttocks as their own. They have shifted the paradigm: Their body parts are not objects but subjects. The black female (dancing) body is given back—or takes back—what has been stolen by the white colonialist gaze since the days of Sara Baartman.

The dancers accomplish their task through a simple stage ploy: By facing upstage for many parts of the performance, they show us the beauty and power of their batty moves. They have a warrior spirit (and the woman warrior is a key trope in Zollar's work). Agency is signified not only by batty moves, but also by the overall strength and confidence of their strong, high leg kicks, leaps, turns, and arm thrusts, all contained in the grounded sensuality of the total choreographic concept. Dressed in black spandex running shorts and midriff tops with white UBW T-shirts tied around their waists (the sleeves knotted in front, the body of the shirt draped and flapping over their behinds: a perfect costume for highlighting their active buttocks), the women present themselves as star athletes. They exhibit team spirit as they cheer each other on. The opening scene uses a playful, bluesy rhyme, "Big Mamas Comin' Down," for each dancer to introduce herself individually, using the "Big Mamas" rhythm and refrain for a personalized phrase of movement and line of verse. To begin this sequence Amara Tabor-Smith steps forward from the semi-circle of women to "show and tell":

> "I'm an African American, Of the Seminole tribe,
> My legs are big, And my hips are wide,
> I'm big and strong, But I'm sweet and shy,
> Back home they call me coffee, 'Cause I grind so fine!"

Another rhyme is shared by Diedre Dawkins and Francine Sheffield and spoken in a fast, hip hop rhythm:

> "Diedre is my name and I'm a Brooklyn girl,
> If you show me respect I'll let you into my world.
> My name is Francine, My people call me Queen,
> Because with my brick house curves, I reign supreme.
> We two sistas are living proof,
> The blacker the berry, the sweeter the juice!"

After everyone has been "introduced," they sing in unison,

> "Big Mamas comin' down, Big Mamas all over the land,
> Get together and make a stand. . . . Big Mamas everywhere!"

Like "Da Butt" and "Baby Got Back," the Big Mama refrain celebrates buttocks and black women (which here include African diasporic women of Caribbean

Salute to the glutes! Urban Bush Women in *Batty Moves* (l. to r.—Allyson Triplett, Maria Earle, Carolina Garcia [wide-legged plié], Wanjiru Kamuyu [pointing], Kristen McDonald [obscured], Francine Sheffield [jumping],Michelle Durant [obscured], Amara Tabor-Smith, Joy Voeth, Christine King). Photography by Richard Corman.

and Latino heritage as well), with the phrase, "Big Mama," synonymous with the "big ol' butt" phrases from *Da Butt*.

In keeping with diasporic traditions of signifying and testifying with physical gestures as well as the spoken word, the dance contains a bunch of cultural stances that use the buttocks for punctuation. The dancers "show attitude" by putting a hand on the waist and throwing a hip out, shaking the behind while walking away from a situation, and by deploying lots of wonderful Africanist examples of buttocks isolations: fast or slow, partial or full pelvic rotations, side-to-side hip thrusts, shimmies—any of which may be accompanied by shuffle steps, hops, jumps, on relevé, in plié, every which way, even down on all fours, bobbing

the bum up and down for a few beats, and sometimes just standing in place and grinding away. Wimberly's and Ross's magnificent percussion accompaniment travels across African diasporic traditions, taking us from rap to reggae and cha-cha, from Yoruba to African American tap rhythms, in seamless mastery. In this sense the dance and score show us the continuity of African music and movement retentions across time and space. The company works wonderfully with their voices, offering Africanist shouts, yips, yells, sighs, hollers, chants, and phrases ("Oh yeah," "All right," "Go on now!"), encouraging each other and working contrapuntally with the percussion score. They are one of the few concert dance companies who are in command of their vocal instrument and use it as powerfully as they use their bodies.

As they line up horizontally across the stage and begin the finale in unison, their teamwork and sense of ensemble power is almost overwhelming. With backs to the audience and remaining in line, they begin with a deep plié in wide second position, stretching the arms (lifted shoulder height) to the sides as they bend knees and sink their collective buttocks straight down toward the floor. From this deep pose they lunge to the left, torso following through. Moving through the lunge, they first shimmy the buttocks and follow with a full, andante pelvic roll, then a series of staccato pelvic contractions and releases, front and back, with the torso moving independently side to side. Next, they slide the feet into ballet first position with arms again raised shoulder height and stretched out to the sides. Retaining the formality of the first position in their feet, they perform a full, balletic plié, return to standing while shaking the hips from side to side, execute a ballet fifth-position port de bras (formalized positioning of the arms above the head) while they incline the torso to one side and continue moving, circling the torso into a forward bend over their straight legs, their heads touching their knees. What this means is that even though their legs and feet are in first position, ballet style, their buttocks are turned up and sticking out at the audience. They have merged European with African. From this forward bend, buttocks-to-audience position, they begin to pulse the knees and buttocks, keeping rhythm with the drum beat for four counts before breaking out of the line formation into Africanist mode, bringing in their shouts and chants that punctuate and accentuate the percussion. The piece concludes as Africanist ceremonies frequently do, with each dancer coming to the center and performing an amazing individual display of excellence. Of course, these tours de force focus on the buttocks. Indeed, Zollar succeeds in masterfully doing what she set out to do—to integrate her Africanist and Europeanist traditions in this display of the beauty and power of the black female dancing buttocks.

These rear ends are wry, wise, and witty.

Contrary to Zollar's liberating perspective are the testimonies from dancers black, brown, and white—and mainly female—about commands to make their behinds invisible. Let's begin with thoughts provided by Wendy Perron, whose body battle is a signature and keynote for the female struggle to attain the ballet ideal. Like Monk in the epigraph that opened the previous section, Perron realizes that an African-based dance posture feels familiar to her particular spinal (mis)alignment. In trying to adhere to the ballet ideal while subjected to ill-informed ballet instructors, she ended up with more anatomical problems than she bargained for:

"I remember feeling that in African class you could be sort of pitched forward. . . . In ballet I was always being told to pull up, and I am naturally pitched forward from my sway back. . . . I remember taking African class and going, 'Oh, wow: this is great!' . . . I didn't mind being pulled up in ballet, but I think I did kind of distort my body. My chiropractor says I've taken the curve out of my upper back. They call it military back. So I have a very, very straight upper back which is fine for ballet but, in taking the curve out, it's actually given me back problems. . . . I just remember [in ballet class] always trying to pull up in front and relax the back, so that I didn't have such a big butt."

At another point in our interview she shared these early memories: "Harry [Sheppard] and I were friends at Bennington, and he said something like, 'you have what we call a hikey ass.' . . . And the thing is that I've worked so hard on my alignment that people now just think I have no ass at all. It disappeared after all my hard work! I was trying to get rid of those hip muscles and stuff for ballet. I was always so relieved when I got to wear a tutu, because it covered my belly and ass. . . . But I remember at the Joffrey School when Mr. Joffrey came by and looked at me in a leotard and said, 'you should be wearing a girdle.' And I already was wearing a girdle."

This comment was directed to Perron when she was a high school student and aspiring ballerina. Still, her body was considered workable, amenable to the concert dance world's rigid criteria because, in spite of her alignment battle, she was thin. What is important for our purposes is to point out that the root of the problem was not that she had a big belly or buttocks: As Zollar points out in her interview, it is an issue of alignment. However, Perron's instructors approached it not from a muscular-skeletal, anatomical perspective but from the standpoint of *appearances*. Perron had a comrade who endured even harsher criticism:

"My friend Karen who also ironed the hair [that is, had her hair manually or chemically straightened]—the Jewish girl from Ridgewood—she had an even

bigger butt [than mine]. She had narrower hips, but she had a really muscular [buttocks]. . . . It was just jutting out. . . . She always had trouble convincing the ballet people that she was a good enough ballet body. . . . She'd get [physical corrections from the ballet teachers] like, with a stick, 'Get your popo in!' . . . We [also] went to Matt Mattox together and took jazz classes. And she felt great in that [class] because she sort of had the tits and ass for it."

The dance world that Perron describes is still with us, even in the new millennium. Based on old clichés of body types and reeking with the same brand of received wisdom communicated to me by the *Inquirer* reporter, it is a world that categorizes people according to "tits and ass," rather than training potential and embodied knowledge. Although her friend couldn't fit into the rigid ballet standard, Perron says "she could jump. She would always jump with the men. She would wait in the back because the men's tempo was always slower. . . . And what does that mean? If you have a hikey ass, maybe you have a better Achilles [tendon]? I don't know." [In traditional ballet classes and in some modern techniques women and men jump in sex-segregated groups, since women are trained to jump less high, slightly faster, "delicately," and with a different dynamic thrust than men.]

Perron's question about the relationship between high buttocks muscles, a strong Achilles tendon, and the jumping capacity was echoed by Zollar and also by Meredith Monk, who went to Sarah Lawrence College and took dance classes there with fellow student Carolyn Adams, the black woman who was a principal dancer with the otherwise white Paul Taylor Dance Company for many years: "I remember with Carolyn, I used to go, 'Can she get off the ground because her butt is so high?' And like, 'Why don't I have a butt like that. . . . Why do I have this droopy drawers thing? That's why I can't jump!'"

Although it may be an indication of lack of jumping talent, Monk's query, longing, and scathing self-critique are more an indication of how dancers are obsessively focused on their own bodies, frequently in a negative, comparative, competitive way. The point to be made about Perron's and Monk's comments regarding the buttocks is that this is not a black attribute, but one that comes more easily to some structural, anatomical configurations than others—a facility that has little to do with racialized body types, as shown by the fact that Perron's Jewish friend, Karen, had this ability, as do many white ballet dancers (including Baryshnikov, in the example given by Zollar in her interview).

Merián Soto's recollections about her jumping ability and the strength of her gluteus muscles sound a bit like Perron's description of her friend Karen: "I was always very muscular. . . . But I was thin. . . . I was very strong. I could jump. I was really a strong dancer. My parents would send me to New York [from

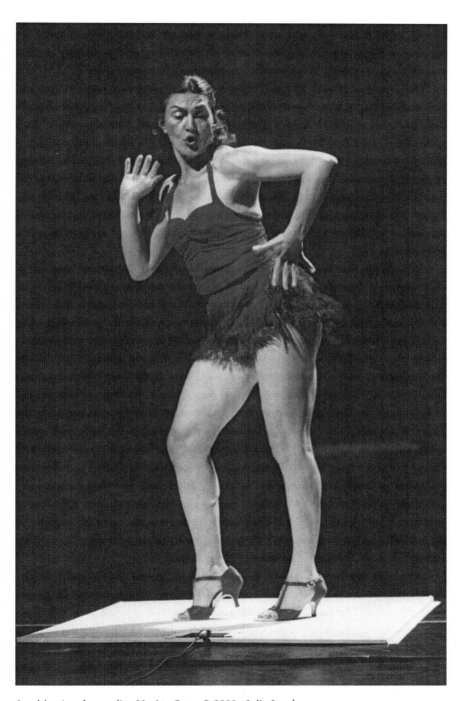

In celebration of sensuality. Merián Soto. © 2002, Julie Lemberger.

Puerto Rico] in the summers when I was a teenager to study dance, and I remember walking up Lexington Avenue or something and some guy turned around to me and said, 'you have the roundest ass I have ever seen!'"

She was only 16 and did not like her buttocks, feeling they impeded her ballet line. Soto began to understand the beauty and importance of a powerful, well-built backside as she became a professional dancer and choreographer: "As I grew older I would make dances where I would want [to emphasize] my butt. I did this movement a lot [she demonstrates, on all fours, with buttocks pointing upwards in a pose akin to the yoga "downward dog," except she is "shaking her booty" at the audience]. . . . I discovered pelvic power. I was doing a lot of working on my sit-bone and pubic-arch connection, and sit-bone-heel connection: I wanted to be able to jump from [a] sitting [position]. Then I realized that this butt is powerful!"

Like Zollar, Soto describes her transformation in body knowledge and movement capacity through the acquisition of alignment training and body sciences, knowledge that has only recently become available to dancers and is debunking the old body stereotypes and destructive training methods for perfecting one's technique. Most of the dancers I interviewed studied at an early age with teachers who were entrenched in outdated methods and rigid body concepts and lacked the language or training to reshape the body and restate the issues. These teachers communicated through a lexicon of stress and willpower, forcing and pushing the body toward the ideal with key phrases that were universally understood in the Europeanist concert dance world: Tuck in the fanny; suck in the belly; pull up the spine; straighten the back; straighten (or even lock) the knees; drop (or even push down) the shoulders. New training methods mentioned by Zollar and Soto are grounded in what are known as "release" techniques, meaning anatomically grounded, kinesthetic or body-science techniques that encourage a softening of tissues to allow change to occur. Commands are more in the order of "engage the abdominals to support the spine; lengthen the back and float the shoulders downwards; loosen the buttocks and breathe the muscles."

Although her somatic issues weren't focused around the buttocks, Trisha Brown addresses the problems she encountered from a hyper-extended (sway) back. She was hyper-flexible as a child and had trained in acrobatics: "My [corrective] training asks me to extend my back [she means to lengthen the back, to avoid the problem of hyper-extension], and I believe in that because I had so much difficulty with my back until I got to the position of alignment. . . . I used to be hysterically hyper-extended. And they trained it out of me, and someone once said to me, 'they should have trained it out of you, but kept the elasticity there.' . . . I did get definitely neurotic about it, trying to keep it straight."

In essence, Brown's statement is in accord with Zollar's comment about alignment. Zollar's teachers focused on her buttocks; Brown's, on her hyper-extended spine. As Brown indicated, something is lost to the dancing body by training techniques that attempt to correct alignment in rigid ways.

Marlies Yearby discussed an important issue that points up a level of ethno-centrism amongst white critics writing about certain black dancers, herself included:

> I noticed that sometimes my butt or the way my butt moved was dis-
> cussed in critical response to some work that I might have been in, not
> necessarily in a negative [way] in a review, [but] a lot of discussion of
> the hips, from article to article. [These] reviews [are] predominantly
> from white people . . . mention[ing] some sort of shaking and the move-
> ment, hips, circular, hips, moving, hips . . . [in places where the butt]
> wasn't the focus. They could certainly have talked about a lot of other
> things. . . . Sometimes the [written] pieces become descriptions about
> how your hips move and your chest shakes and they say, "ritual," but
> they don't know how to talk about it beyond that, when there's another
> thing that's happening that could be discussed. There's another level of
> education . . . that had not occurred, and that is what I'm talking about
> when I say you look back to a day when we now historically say, "Well,
> these were very prejudiced and limiting ways to look at black dance —
> lewd and lascivious and this and that." And all that language has been
> codified and transformed into today's language, but yet it's still, in a
> sense, the same discussion.

Yearby's profound comment is convoluted for a reason: It deals with the sublimations and repressions required by the etiquette of separation that places a higher premium on certain aesthetics and certain ways of moving over others. The sad part is her conclusion that the language has changed, but the issues and discussion remain the same. For some, like the *Inquirer* reporter, nothing has changed.

Although this small sampling of female testimonials indicates that the but-tocks critique is not limited to black female targets, it is still true that a protrud-ing buttocks is seen as a black attribute, even when it is attached to a white dancing body. Thus, Perron's friend, Karen, is described as though she has a black dancing body. And Zane Booker, describing his experiences working as a ballet dancer in Europe, said, "There were so many different female body shapes in the Netherlands Dance Theater, and there was a girl from Australia whose

hips and booty . . . she had a big problem with her body, because she was built more similar to a black woman than . . . a white woman, or what we perceive as a true classical ballerina."

The black male buttocks takes some heat as well. Gus Solomons jr doesn't recall "any snide remarks," but stated that through his ballet training "[I] self-imposed the idea that I shouldn't have buttocks, because I saw those European flat backs. . . . I thought, 'Okay, no butt.' I stretched out my lumbar curve and did all that kind of stuff. I jammed up my sacrum trying to turn out." Studying with Merce Cunningham, Solomons stated that there was "nothing race specific, nothing about 'your feet should point more,' or 'your butt's. . . . ' Merce's pliés were legendary. He had enough spine [long back with proportionately short legs] that he was still vertical [Solomons then imitates Cunningham's typically flawed plié, with his butt sticking out]. So he wasn't going to talk to us about our fannies!"

Solomons's point about Cunningham's pitched alignment brings us back, yet again, to the fact that bodies differ as widely within so-called racial categories as they do from one ethnicity to another. Zane Booker echoes this thought and appends to it the sad reality that differences of many sorts are allowed for white dancing bodies, but the same divergences from the "ideal" are not as permissible for black dancers: "White male bodies are so different. The Russians are thicker than some of the black males. Lindsay Fisher [of the New York City Ballet] has butt and thighs and calves. I mean, he's Dutch. And nobody says anything!"

To end this chapter on a positive note I turn to Garth Fagan, whose glorification of the "glutes" (his favored term for the buttocks) is one of the many pleasures in his spectacular choreography. In his words, "When I choose to do jetés [jumps] with the glutes to the audience because I want to see that convex form there, interrupting the line, and then making the leg longer, [it's a conscious choice], which Picasso did, and it was [called] Cubism! And when we performed in Cameroon we heard it [the Cubism reference] ad nauseam from the Cameroonians. . . . But when we do it [here] it's wrong because it's not the way it's taught in the little ballet school. And that was a choice on my part, and when I see it done in the other way, for classical ballet pieces, of course that's the appropriate way. . . . You know, my story is different. I love to see those glutes sculpted that way. I spend years changing dance steps and shapes and silhouettes to suit *me*. It's not the only way; it's not necessarily better. It's just a different way of looking at it."

Fagan frequently choreographs movement with the dancers' backs to the audience. He will give them movements that emphasize the buttocks (works such as *Trips and Trysts*, choreographed in 2000, and *Prelude—"Discipline is Freedom,"* made in 1983, are ones that immediately come to mind). He highlights the buttocks in nuanced, sophisticated ways, even while his company image refutes

any stereotypes regarding black butts. In *Woza* [1999—Zulu for "Come"], besides the overall joy and power of celebrating black soul and spirit, one is struck by the way blackness is emphasized in something as simple as the showing of palms of hands and soles of feet in the third movement of this dance. These are the kind of beautiful, striking contrasts that have aroused strong feelings, making black skin hated or loved, desired or detested.

SKIN/HAIR

IN YOUR FACE: SKIN

Skin: so many memories—painful memories. When I was a teenager I had a close friend, lighter than me, whose father warned her not to bring any dark-skinned boyfriends home. It was fine for G———and I to be girlfriends, but she'd better not get into a situation that would imply marriage and black-skinned babies. It was a rude awakening for me to experience, first-hand, this convoluted adult practice that I'd lived with but not really been aware of all my life— black intragroup racism based on skin color. This syndrome is all the more a puzzle and paradox because many black families—even siblings—come in a range of skin colors, and many black babies are white-skinned at birth, with their "true" color settling in during early childhood. (Hair textures vary within the same family, too.) My mother was light-skinned, with what were considered white facial features (small, "turned up" nose, narrow lips¹). Her three sisters ranged in color from very light to brown to dark brown—each sister a gorgeously different shade of what it means to be black. My father had clear, unblemished, ebony-colored skin and a large, flat nose. We siblings came out in close but different shades of a rather even,

i. The idea of "white" or "black" facial features or other physical attributes is as flawed a concept as the other pieces that constitute the puzzle of racial mythology. Many "whites" have large mouths, noses, or lips; many "blacks," whether light- or dark-skinned, have small facial features. We see what we are programmed to see and categorize arbitrarily, as attested by this comment from a black but very light-skinned woman in her interview in John Gwaltney's *Drylongso:* "If I tell white people who are darker than I am that I am black, they will see me as being darker than I am and darker than they are. . . . [W]e don't see straight when we talk about colors." (79)

smooth, chocolate brown, none of us as light-skinned as our Mom or as dark-skinned as our Dad. Although her skin color is much, much lighter than mine—lighter than some of my white friends—my daughter resembles me in ways that seem unmistakable to black people but are dubious to whites. The difference in black or white reactions when people are introduced to us is quite remarkable. Especially when she was a baby, whites seeing us together assumed I was her nanny. They failed to see physical similarities; they saw only skin color differences coded and defined by the legacy of slavery that placed black women as caretakers to white children. On the other hand, blacks, accustomed to the many shades of black and wanting it to be understood that they saw her as my daughter, frequently responded with a comment like, "She looks just like you!" Musician Nana Vasconcelos is my skin color but, like many Brazilians, his family is white, black, and brown. Literary critic Anatole Broyard, in order to pass for white (which he did successfully until his true identity was revealed posthumously), was obliged to cut off contact with his siblings, whose brown skin would have given him away.[1] Although the color spectrum in black families is highly unpredictable, many light-skinned families try to beat the odds and keep the light skin going by avoiding sexual contact with dark-skinned blacks from one generation to the next. Unlike my family, G———'s parents and her two siblings were pretty much the same light color. And she continued the tradition: She married a man with about the same complexion.

So in adolescence I became aware that the black world prized light-skinned blacks more than they prized me—that, yes, some boys were interested in me, but others were interested only in light-skinned girls. I was routinely recognized as "the smart one," in both black and white milieus. But I needed something more. Unlike Maya Angelou in the opening scene of I Know Why the Caged Bird Sings, *where she imagines herself white with blond curls, I wanted the opposite. I wanted the world, black or white, to come around, to see me—poor, skinny, and black-skinned—as beautiful. I didn't want to become someone else but to have the world make space for me and my kind of beauty. I was Cinderella, and some day some prince would recognize my comeliness, my physical value. In some ways that has happened, due both to the near revolution in beauty standards and to my inhabiting artistic realms where my blackness has been celebrated and desired. I believe this is one of the reasons (besides my aesthetic interests) why I gravitated toward the white avant-garde: I needed positive reinforcement about my physical attributes and, ironically, I received more affirmation—personal and professional—from this sector of the white population (at home and in Europe) than from blacks. Yes: The exotic-erotic trope was working overtime in the white dance, theater, visual arts, and social worlds that I moved in as a young woman living on New York's Lower East Side and in London, Paris, Stockholm, and Helsinki. No matter: I was getting the constructive input that is the stuff of positive personality formation, once the child leaves home. As a young dancer I modeled for visual artists at prestigious New York schools and private studios where the color of my skin, my arched back, dancerly flexibility, and, as I was once told, "Ingres-like breasts" (read "small") were valued. A new aesthetic was cracking*

the blond-haired/blue-eyed ceiling in the 1960s "black-is-beautiful" round of black pride, a movement that can be understood as an update on the 1920s Jazz Age, with its admiration for Josephine Baker and brown skin and the Harlem Renaissance, which looked to the "New Negro," defined by and predicated upon a black aesthetic. Indeed, my previous husband and present husband, both white, were attracted to me before getting to know me because of—not in spite of—my brown-black skin.

On the one hand, in the white dance world that was my training ground, I knew that my skin color and even the light-colored skin of some of my dance friends was the first and most obvious barrier that disallowed us a shot at dancing in certain mainstream venues. On the other hand, in the modern dance world of the 1960s, the only personal example of skin color discrimination I experienced was the one mentioned in the first chapter. Indeed, the Martha Graham Company, the leading ensemble of the era, embraced black and Asian performers of all hues as a matter of course and served as a model of color and ethnic integration on the concert dance stage. Modern dance was certainly no refuge of racial equality but, compared to the Broadway and ballet worlds, it could be regarded as the haven described by Wendy Perron and Shelley Washington, provided that the black-skinned black dancer ascribed to its reigning Europeanist aesthetic.

More than the other contested sites in the black dancing body, skin is the alpha and omega of racial difference. The darker the skin, the more likely will its inhabitant be excluded from white power and privilege, or even the chance to approximate it. Skin—so personal, so all-encompassing, literally and figuratively. We see the skin and its color before we discern buttocks, feet, hair texture, facial features. Skin protects us; skin reveals us. Life experiences may leave us thin-skinned or give us a tough hide. It is our first defense from attack or disease, yet it is vulnerable and can be easily penetrated, wounded, bruised—in every sense. Unbeknownst to most white people, black skin as brown as my own may blush and flush—after, all, we are flesh and blood; or burn from over-exposure to the sun—after all, we are flesh and blood. Writer/actor Dael Orlandersmith, in an interview that preceded the premier of *Yellowman,* her play on in-group color prejudice, commented on the insidious nature of "society's complex ideal of beauty." Citing the "contortions Caucasian women go through trying to live up to these ideals, from nose jobs to having the hairdresser and colorist on speed dial," she mused, "as inane as it sounds, there is something racial beneath that. . . . If this standard of beauty causes so much antagonism in the white community, can you imagine what it does to people of color?"[2]

A study conducted at the Social Cognition Laboratory of Tufts University reported in *Black Issues in Higher Education* that "racial bias and prejudice are related to the lightness or darkness of a Black person's skin — rather than other features such as hair length or texture, lip fullness or nose width." According to Keith Maddox, director of the lab, "Our research shows that both Blacks and Whites associate intelligence, motivation and attraction to light-skinned Blacks, and being poor or unattractive to dark-skinned Blacks."[3] Even in continental African communities in recent years women have suffered injury and illness from using skin-bleaching products. For the dark-skinned black person it is painful to feel rejected as less than beautiful by one's own people on the basis of skin color. Some researchers have dealt with the roots of this intragroup racism as it is played out in African America.[4] Others have tackled the pervasive issue of white skin privilege as manifested across continents and cultures for centuries (for example, see Malcomson), but that story is beyond the purview of this book. In brief, there seem to be several reasons why blacks and whites privilege light skin over dark: (1) whites feel more at ease with people who look more like them; (2) consequently, blacks whose skin color looked more like whites were frequently able to gain economic advantages not accessible to their darker siblings; (3) during the plantation era the lighter-skinned enslaved individual was commonly the master's child by an enslaved African woman. Although a non-inheritable "illegitimate," she was still the white man's child, recognized and rewarded as different from and superior to her darker siblings. Segregated from her mother and siblings, she worked in the master's house and was a "house slave." Her African kin were assigned the sun-scorching, back-breaking agricultural and manual labor and were known as field slaves; (4) thus, the lighter the skin the more the black person had a natural passport to some small measure of white advantage, in both black and white worlds. In sum, light-skin/white-skin privilege is an entrenched, knee-jerk reaction, and old habits die hard.

To examine the general bias against dark skin color, let us compare one aspect of the public reception to two swing-era jazz musicians, one dark-skinned, one light-skinned. Louis Armstrong, African American, ebony-complexioned, wide-mouthed, with large eyes, natural hair, and a generous nose, smiled and laughed a lot when he wasn't holding a trumpet to his glorious lips. For a terrible middle era in his career his good humor was characterized as an embarrassing, minstrel-like representation of blackness, a "disgrace to the race." Cab Calloway, African American, white-skinned with straight hair, a wide mouth, and thick lips, also laughed and clowned a lot. Yet Calloway was not stigmatized as an "Uncle Tom." Part of the difference in reception had to do with skin color. When a brown-skinned person smiles, his white teeth are more clearly

delineated against the skin than the smile of a lighter-skinned individual. Thus, when Calloway showed his pearly whites, it wasn't a big deal; but when Armstrong did the same (and in spite of his talent, which far outstripped Calloway's), the white teeth and full lips in black skin reminded the public of minstrelsy and blacking up. The association was not Armstrong's fault; it was the heavy duty paid for the legacy of slavery, minstrelsy, and racism, all rolled into one and displayed in the performing body and laughing face of this great American musician. Luckily for us, Armstrong refused to let such prejudices cramp his style or alter his self-presentation.

A similar example was provided in the 1980s by a well-known white New York dance critic. In a review of a Dance Theater of Harlem performance at the New York City Center (a white, midtown venue) she took both the ensemble and its black audience to task. In her mind, the audience needed to learn the etiquette of concert hall behavior and restrain itself from spontaneous outbursts of applause and verbal encouragement.[ii] For the dancers, she cautioned them that "grinning" is inappropriate on the ballet stage. There are debatable issues here, but for my purposes I shall focus on the caveat given the dancers. As is the case with the Armstrong example, a smile, particularly on stage, reads more declaratively when white teeth are landscaped by black skin. It is not that the DTH dancers were grinning: The word, itself, is an insult to their intelligence and their understanding of the work. For audience members for whom white skin is the norm and black skin the deviation, every black smile runs the risk of being seen as a grin. It is not the dancers who need to be taken to task but the critic, for her entrenched ethnocentrism and narrow aesthetic response. But she is not a villain, and she is not alone: Like the rest of us, she is haunted and nagged by the vestiges of the minstrel legacy and the ongoingness of white-skin privilege, whether she knows it or not.

African Americans, even revered historical figures, are also at fault. W. E. B. Du Bois, honored and renowned sociologist, academic, and civil rights activist (he co-founded the National Association for the Advancement of Colored People), was light enough to pass for white. He championed a form of integration that would push forward the "Talented Tenth" of African Americans to intellectual achievement comparable to his own (he had earned a doctorate from Harvard and pursued advanced university studies in Berlin, Germany). In other

ii. In an April 2002 correspondence Yvonne Daniel cites a parallel case: "A stage manager ran out of the tech booth to ask me and a few women of color to stop 'making noise' during a Cuban dance [performance], when the other audience members were silent, charging [us with] poor etiquette or protocol for the proscenium theater."

words, he was out to create a black elite. Since slavery, the black upper class had consisted of light-skinned folks like Du Bois, so there was no reason to imagine that his Talented Tenth would be of a different hue. Marcus Garvey was a black-skinned, working class Jamaican who immigrated to the United States and espoused a doctrine of black self-sufficiency as the backbone of his "back to Africa" movement. The theories of the two men were in direct conflict: the one a Europeanist and integrationist, the other an Africanist and separatist. As explained in the second section of Louis Massiah's 1997 film, *W. E. B. Du Bois—A Biography in Four Voices*, there was a moment in the early 1920s when Garvey's sway over black New York threatened to take ascendance over that of Du Bois and the NAACP. The February 1923 issue of *Century*, a white magazine, ran an article titled "Back to Africa" written by Du Bois in which he fought for turf, attacked Garvey's cause, and stooped to the level of physical insult, calling upon black self-hatred to malign his opponent. Page 539 of the article is projected on the screen: Du Bois describes Garvey as "a little, fat black man, ugly, but with intelligent eyes and a big head." Clearly, "black" and "ugly" are paired in this description (as are "little" and "fat") as negative value judgments. In the 1920s the word "Black" was not used to favorably describe African Americans: "Black" was derogatory; esteemed African Americans were "colored" or "Negro." Insulting one another with the terms used by the white dominant culture is a pervasive tactic in black intragroup racism. Muhammed Ali indulged in comparable insults in his barbs against his black boxing opponents. And when the 1990s scandal around Clarence Thomas and Anita Hill hit the headlines, some in-group jokes around Thomas lampooned his physical features, conflating dark skin and Africanist features with monkeys and gorillas.

Color-caste discrimination is one of the major cultural configurations in African American life and has been treated in black fiction since its antebellum beginnings. One of the first novels written by an African American, William Wells Brown's *Clotel* (1853) is based on intragroup color prejudice as its starting point and is "a fantasy about Thomas Jefferson's gorgeous mulatto daughter."[5] In 2001 scholar Henry Louis Gates discovered "The Bondwoman's Narrative," a manuscript written in the 1850s by Hannah Crafts, a female octoroon and house slave. In her superior position she refers to the field slaves as dirty and smelly. The heroine of Wallace Thurman's 1929 novel, *The Blacker the Berry . . .* , applied skin whiteners before venturing out to socialize in Harlem. Zora Neale Hurston's play *Color Struck* (1925) follows the descent into insanity of a talented, black-skinned woman who disbelieves that any man might love her. Hurston herself experienced "the virulent racism of light-skinned mulattoes toward blacks in Jamaica" while there to write *Tell My Horse*, published in 1938.[6]

In their treatment of black color prejudice, the authors of *The Color Complex* point out that, stemming from old antebellum habits, a "mulatto elite had clearly emerged as the intellectual and political leaders of the Black community." Psychologically speaking, blacks of all hues unconsciously adopted "a defensive reaction known as 'identification with the aggressor,'" and imitated the dominant culture's mores as a survival mechanism. Black Americans had become so conscious of skin color that by the 1940s a social study of middle school black students revealed "as many as 145 different terms to describe skin color, including 'half-white,' 'yaller,' 'high yellow,' 'fair,' 'bright,' 'light,' 'redbone,' 'light brown' . . ." and so on, through an array of equally subtle gradations in the color spectrum ending with "'ink spot,' 'blue black,' and 'tar baby.'"[7] Given the centuries-old history of color-caste prejudice with light skin at the top of the hierarchy, the darker the hue, the more insulting the connotation: White is right; black is unconscionable. It is sad but true that most African Americans are obsessed with grades of skin color in their quest for power and privilege in a white-dominated world. Like racist whites, they too "have gotten colors all mixed up with ideas about what is good or bad or nasty or clean."[8] Cultural critic and film studies scholar Richard Dyer calls this syndrome "the conflation of symbolic and racial color." It is practiced in everyday life, as well as in literature and philosophical thought, whenever "hue, skin, and symbol"—separate notions—are fused and interpreted as one.[9] As a white-skinned black woman admitted in *Drylongso,* anthropologist John Gwaltney's remarkable ethnography of a southern African American community, "[T]here was a time when I was shamefully exultant at being able to rattle off such phrases as 'Was my face red' and 'I blushed all over.' I thought of myself as precious for all the wrong reasons, and most people I knew seemed to share my opinion of my purely external merits. I really don't think most black people are much saner than I was."[10]

Accordingly, by the 1960s (as in Garvey's 1920s) when blacks could finally, with James Brown, "Say It Loud: I'm Black and I'm Proud" and wear their hair in the natural, "Afro" style, their stance represented a radical break with past practices and a shift in paradigm that was not only political and cultural but also spiritual and psychological. And indeed Brown, himself black-skinned, was instrumental in these changes. Had he not recorded the song, many blacks would not have had the courage to proclaim its message. Like a cultural descendent of Garvey, Brown followed through and even wore his hair in a "'fro" during this period.[11]

Since the 1990s the idea of a separate "racial" category on the United States Census for people of mixed ethnic heritage has been an issue. What does a separate category mean? Who of us—white or black—is not of mixed heritage? What would happen to the already splintered black family? Would the separa-

tion category begin with mulattoes and end with octoroons? Who decides? Would my mother and my daughter have to check a category different than mine? Would the siblings of Anatole Broyard or Nana Vasconcelos belong in different divisions, because some looked white and others colored? If all African Americans are of mixed heritage, then what about those blacks like superstar Michael Jackson who have bleached themselves to whiteness? Is skin color the most important characteristic and definer of ethnicity? If so, then where should we place the many Jews, Italians, Greeks, and other "whites" who have darker skin than some of my "black" friends and relatives? What is race? The idea of yet another "racial" category in an area that is already muddied with confusion points up how useless, ineffective, and unscientific these categories have always been. *The issue of black racial identity shows us that race is not a biological imperative, but a social construct!* As Barbara Love, educator and director of the Co-Counseling Institute, said: "Our goal should be fewer racial categories, not more . . . until race has lost its power to predict privilege."[12]

There is a wonderful line from one of the songs in the Noble Sissle–Eubie Blake 1921 musical *Shuffle Along* that declares: "If you've never been vamped by a brown-skin, then you've never been vamped at all." The song goes on to specify high brown, chocolate brown, and sealskin brown complexions among the females it extols. It is, in a sense, a black pride song. The irony is that all the chorus girls in the show were light enough to pass for white, as was the custom in black musical revues from their inception in the late nineteenth century through the post–World War II era. Josephine Baker was the only brown-skinned chorine in the show, and she endured discrimination through taunts and harassment by her lighter colleagues and was forced to whiten up as much as possible. Baker and, earlier, Ida Forsyne, were dancers who learned the hard way that black was not considered beautiful in their United States. Forsyne, who in the teens toured Russia as a specialty dancer, was forthright about the skin color prejudice amongst black and white Americans: "I couldn't get a job because I was black, and my own people discriminated against me." [13] In the same era and also on the basis of her brown skin color, Edna Guy was barred from dancing in the ensemble led by Ruth St. Denis, then diva of (white) modern dance, or even from dancing in black musical revues.[14] By the late 1930s and along the same lines, Joan Myers Brown describes the color caste system in the elite black Philadelphia dance school where she studied as a child. It was founded and directed by Essie Marie Dorsey, a white-looking black who had trained in ballet, passed for Latino (in her era, termed "Spanish" or "Hispanic"), and may have performed

with the Mordkin Ballet[iii]: "In that environment, there probably was . . . some white skin . . . [ascendancy] that the little light girls [had]. . . . I'm sure there was that little play because I remember advantages to the little light-skinned girls." When asked what kind of advantages Brown replied: "Well, Dr. So-and-So's daughter was featured [in a school recital] where the rest of us were just not, we were just there. And I think it was about class more than color, but most of the people in that class situation were light-skinned because their fathers were caterers, doctors, lawyers, undertakers because of the house n — — —and the field n — — —. So the house n — — —s got the education, so when they moved North they could go into business in the black community."

Brown makes an important point that reinforces Du Bois's Talented Tenth concept and shows how class, caste, and race can act together to form an elite. With light-skinned blacks having had the edge over darker individuals since plantation days, they comprised the majority of the black middle class. Nevertheless, the existence of this black elite did not mean that its members wanted out of blackness; nor should these examples mislead the reader into believing that the quality of life was better for light-skinned African Americans—or even that all light-skinned blacks were well-off. In the long run, all people of African lineage, regardless of skin color, endured harsh discrimination and oppression from the dominant culture and were regarded as inferior to whites. The sentiment expressed in D. W. Griffiths's *Birth of a Nation* (1915) was not uncommon: Rather than gaining white favor, mulattoes were often despised more than "full-blooded" blacks were.

Before inroads were made during the Civil Rights era, African Americans—light- or dark-skinned—were discriminated against in academic Europeanist art forms such as ballet and orchestral music as well as on Broadway and in mainstream musical theater. The prejudice against black skin in the performance arena has been a burden for black males and females alike, regardless of their skin color, but the burden rests more squarely on the shoulders of black women. Males, white or black, simply have the advantage over females in a field that is glutted with women and has a chronic shortage of men. Arthur Mitchell was a member of the New York City Ballet (beginning in 1956) long before any black female had been recruited. The participation of this dark-skinned dancer raised

iii. It was founded in 1926 by Mikhail Mordkin, Russian émigré, who came to the United States from Lithuania in 1924, having left his post as director of the Bolshoi Ballet after fleeing the Revolution. He is regarded as one of the pioneers of the newly emerging American ballet tradition. For the sparse print data available on Dorsey, see White, 1987.

some white hackles when, like other male dancers, he was called upon to partner white women. Reflecting on controversial topics broached in the past by *Dance Magazine,* then Editor-in-Chief Richard Philp commented that the publication "received letters of protest, phone calls, and subscription cancellations because we ran a cover photograph (February 1967) of a black danseur, Arthur Mitchell, with a white ballerina, Mimi Paul, both of New York City Ballet, in Jacques d'Amboise's *Othello*-inspired *Prologue.*"[15] In spite of this bigoted public response, Mitchell continued to dance with NYCB until he voluntarily resigned in 1969 to found his own Dance Theater of Harlem. On the female side, talented, beautiful, light-skinned Carmen de Lavallade was not allowed to dance with white Glen Tetley as her partner on the nationally televised Ed Sullivan Show in the 1950s lest white America be offended.[16]

Let us skip to a radically different example of black-on-black skin color bias, this time against a dark-skinned female, taken from Bill T. Jones's memoir, *Last Night on Earth.* Jones offers a grass-roots perspective on the black skin color of a superb female dancer remembered from his childhood. His father described the woman as so black that a piece of charcoal could be used to draw a white line on her.[17] Jones then goes on to describe this woman's exquisitely sexy dance in a juke joint. My specific interest is in the elder Jones's comment about the dancer's skin color. Black was clearly not seen as something good, but something to be joked about. The dancer's excellence was commented upon in contrast to her "unpleasing" skin color. The black dancer—male or female, black- or white-skinned—had to deal with both white and black discrimination based on skin color.

Black skin is the most accessible, obvious marker of Otherness onstage. Why should there exist differences in reception to or discrimination against skin color based on gender? Through centuries of conditioning across many world cultures (though perhaps not in traditional African societies), dark skin has become associated with masculinity and male modes of manual labor that require physical strength and, frequently, exposure to the sun. Black skin represents stamina and physical robustness; white represents delicacy, fragility, and a social class that is not obliged to toil in the sun. In the ageless battle of the sexes (as in the ageless battle between black and white), male seeks to dominate female (as white has sought to dominate and colonialize black) and to see this ascendancy reflected in his cultural aesthetic models. Thus, to be definitively dissociated from maleness and its concomitant physical prowess (and from the laboring lower classes of society), women—even black women—needed to be light-skinned in order to be counted as acceptably female and respectably distanced from the opposite gender. As mentioned earlier, this convention was adhered to in black and white show business until the 1960s "black is beautiful" era; and

dark-skinned women from Ida Forsyne and Josephine Baker to present-era artists have had to deal with this type of exclusion. Taking the equation to its logical conclusion also helps explain the white fear, male and female, of black males, particularly those with the darkest skin: The blacker they are, the more powerful (or dangerous) they may seem to be; the lighter they are, the more they may be like "us." This also explains the myth of the "strong black woman": If a female is black-skinned, regardless of her weight, bone structure, or personality traits, then she is presumed to be robust and masculine.

The dancers I interviewed expressed a range of reflections on skin. Merián Soto mentioned what she perceived as an issue for one of her colleagues. "She's a little darker than me, but she's very Taina looking—Taina is an Indian from Puerto Rico." The woman, described by Soto as "really an accomplished dancer," auditioned for Urban Bush Women and didn't get in, "and I always wondered if she was too white, or too 'Latina,' if there is such a thing." One of the prices paid for the societal practice of skin color discrimination is that that practice is suspected even when it is not used. As Jawole Willa Jo Zollar, UBW's artistic director, said in her interview, she has been accused alternately of taking too many light-skinned people or excluding them, whereas company members are chosen not for skin color but aesthetic fit with the group. In fact, Carolina Garcia, a Latina, was in the 1998 cast of *Batty Moves*, and was an active member of UBW.

Soto questioned whether there was also a general discrimination against the very dark-skinned black dancer, giving artists Niles Ford and Maria Mitchell as examples: "[With] both of these people I asked myself, 'Is it the color of their skin?' Because they're obviously such spectacular dancers who are not working. When you look at a lot of the black companies there's a lot more fair-skinned people on that stage than really dark-skinned people. It always makes me wonder how much internalized racism there is."

Soto's comments show us the complex predicament that black dancers face because of skin color: They may be considered too light or too dark, if not by artistic directors, then by color-conscious spectators who may be pleased or disturbed by what they perceive as favoritism or exclusion. Light-skinned Marlies Yearby echoed Soto's sentiments but used a more modest language to insinuate in-group racism: "[W]e often talk about non-traditional casting when we think about white and black, but even within the controls of our own domain, we often place ourselves in a traditional casting mode."

What also needs to be questioned is why this cadre of talented dancers isn't employed by white choreographers. Zane Booker's comments bring us back to dominant-culture discrimination. He sees the black female bearing the brunt of the problem, even in Europe, and suffering a greater degree of dis-

crimination than males: "It's not about bodies, it is just clearly about skin color. . . . There's a girl that is darker than me at Netherlands Dance Theater. Feet, legs, extension, pirouettes [are all excellent] — [she] trained at the Conservatory in Paris. She's a little bit short, that's the only thing they could say. Why [doesn't she get lead roles]? Because of the color — it has nothing to do with her body. . . . It is purely a skin color and perception thing. . . . I just think that black women have it harder."

Yet, when the exotic-erotic trope is at work, skin color may serve as an unanticipated (even unwanted) buffer and protector for the black male or female working in a white milieu. Shelley Washington recounted an anecdote about a Tharp company performance in Paris which was not well received. She and her black partner were the only dancers in the ensemble who were cheered. Her skin color gave her the edge over her white colleagues — or did it? As Washington explained, "the French presenter would say in Paris, 'We love the black woman.' They don't say you're a good dancer, but really it's the color of your skin: 'No one would boo you and this man with the dark skin.'"

Comments like these oblige us to see the love-hate, attract-repel syndrome as two sides of the same coin. In the extreme, both positions are tainted — colored, if you will — by presuppositions that obscure and trivialize individual talent for the sake of the stereotype. No artist wants to be positively or negatively singled out on the basis of skin color. This issue plagued the youthful Booker during his early career in Europe. His experiences ran more along the line of Shelley Washington's, rather than the darker-skinned black dancer he mentioned earlier. Besides their excellent dancing Washington and Booker are both of a medium brown complexion that clearly defines them to an audience as people of African descent. Unlike Washington, who traveled abroad with an American company of American dancers, Booker lived in Europe and worked in situations where he was in the minority both as an American and an African American. His experiences run the gamut of possibilities for inclusion/exclusion based on skin color, along with the potential for destabilizing Booker's self-confidence, since he was frequently unsure whether he had been chosen for roles because he was excellent or because he was black. He makes an important point with his suggestion that we think about the race picture in reverse: "People don't realize that if you were to reverse — I'm not trying . . . to whitewash the situation, but I just don't like crutches . . . — if you turned it around and you put a white person in an all-black company, they would stand out, too. I'm not saying that diminishes us, but being a black dancer in a white company . . . you question yourself whether it's because you're black that people compliment you. . . . You just question your talent a lot of the time. You know you have presence and stuff, but is your presence just because

you're black and the rest of the people are white? Or is your power because you actually have presence?" Booker's successes did not increase his self-confidence. Instead, he confides, "I remember always the reverse. I remember getting things and feeling distinctly that I got that because I was black. When I didn't get things or something didn't go my way I didn't blame it on color."

Early in his career he had been cast in a leading role in *Sarabande*, a ballet choreographed by Jirí Kylián, artistic director of the Netherlands Dance Theater. This auspicious beginning was not followed through, leading to Booker's suspicions about racialized casting: "At the end of the season I said to Jirí, 'Was one of the reasons I was cast in the ballet because I was black?' Because that was a main role in a ballet, and the rest of my year didn't follow up [from] that kind of debut. . . . and he said, 'I don't see the color of a person's skin, I just see the color of their soul,' which he would later change. . . . But I just had a problem with not discussing it and then not having that [initial] success . . . parlay into other choreographies."

Sarabande is not a narrative or story ballet, so Booker's role was not a character dependent on a racial identity. Nevertheless, as Kylián later explained to Booker when they again discussed the issue (and as related in chapter 1), he was interested in the effect of using the black dancer's skin color as an aesthetic value in his stage picture and had no qualms about deploying skin color as a "costume." George Balanchine had set the precedent for this practice by assigning Arthur Mitchell to partner white-skinned Diana Adams in the original cast of his abstract ballet *Agon* (1957). In fact, it has become a tradition in revivals of this ballet that the role Mitchell originated is danced by a black male partnering a white female. But did this mean that Booker, Mitchell, and others were cast in lead roles only when their skin color advanced the stage picture?

What Booker describes is an unfortunate situation for the black dancer working in an environment where there is no considerable black presence in the community or society at large to act as a buffer and sounding board. Sensing outsider status, it is easy to suspect that one's work is filtered and seen exclusively through the lens of the exotic. As he put it, skin *color* is everything. Again, it is noteworthy that Booker's successes did not increase his self-confidence in his early career. Of particular note is his statement that when he didn't get a role he didn't blame it on racism, but when he was chosen he wondered if it was because of reverse racism. Such are the dilemmas and internal battles waged with self and society around this and similar body issues for all dancers on some level, but for black dancers in particular.

Booker has matured and seasoned with his experiences in Europe: "Now I've been freelancing, so I kind of pick my own projects. When I first left Nether-

lands Dance Theater I did *Mephistopheles* [choreographed by Kazuko Hirabayashi for the New National Theater of Tokyo], and Kazuko asked me if I'd be comfortable doing the role . . . 'because, you know, some people think that black, because you're black, and the connotation of evil, and that correlation.' . . . And I said no, I was perfectly comfortable with it." Hirabayashi's comments demonstrate how, as stated earlier, skin color has become confused with good and evil in ways that reflect deep-seated, irrational cultural biases that conflate "symbolic and racial color," to again use Dyer's apt phrase.

Sometimes skin color arises as an issue in a nuts-and-bolts way, as in the case of photographing an ensemble whose complexions differ. Take Meredith Monk's considerations for photographing brown-skinned Blondell Cummings in group shots: "And Lanny [Harrison, longtime member of Monk's ensemble] and I had whiteface on! You know, we had to be really sensitive about Blondell being lit properly." The photographic and film media cannot replicate "true" skin color for any human being, black, white, or brown, and they flounder considerably when faced with a wide range of difference in one frame. If the lens is focused on the light-skinned person, the dark-skinned companion looks like an indistinguishable black spot; if the reverse is done, then the white person is reduced to a paper-white splotch. With proper lighting, good equipment, and an accomplished photographer, the complication can be resolved, but one wonders why the photographic and film industries haven't researched this question.

Generally the person (or people) of color is looked upon as the "problem": Dark skin is difficult to light. But, really, it's not a black problem: It is an issue arising out of white privilege, as explained by Richard Dyer in "The Light of the World," his devastating chapter on the photographic and film media in his book, *White.*[18] Citing "the white-centricity of the aesthetic technology of the photographic media," he explains that "[t]he photographic media and . . . movie lighting assume, privilege and construct whiteness. The apparatus was developed with white people in mind and habitual use and instruction continue in the same vein, so much so that photographing non-white people is typically construed as a problem."[19] But it doesn't have to be that way. Like other Europeanist-centered constructs that have gone unquestioned, so also photography. Dyer and other revisionist thinkers (including the African American photographer, performance artist, and writer Carrie Mae Weems) interrogate these assumptions, insisting that "what is at one's disposal is not all that could exist. Stocks [the chemically prepared surface itself], cameras and lighting were developed taking the white face as the touchstone. The resultant apparatus came to be seen as fixed and inevitable. . . . Experiment [sic] with, for instance, the chemistry of photographic stock, aperture size, length of development and artificial

light all proceeded on the assumption that what had to be got right was the look of the white face. This is where the big money lay, in the everyday practices of professional portraiture and amateur snapshots."[20]

Apparently, mixed-color groups and dark-skinned peoples have not been deemed important enough to warrant investigation of precision methods for their documentation and recording.

Séan Curran addressed similar practical details: "If you have African Americans on stage and it's a black backdrop and it's a black floor, you've gotta hit them with some front light, because they disappear. That's a specific black dancing body thing. . . . [Here's another example:] I have a piece called *Symbolic Logic* and there's a soloist in the middle and then there's a trapezoid of four dancers around them, and I was going to put a black dancer into it, and I realized that what it's doing for me is framing and because she's black . . . it didn't work. So I took her out. Could I have the audience stretch?"

I can understand Curran's aesthetic consideration in this example; however, I long for the day when a multicolored world will be so commonplace that choreographers and spectators will discern the framing and geometry of a pattern independent of the skin color of the dancers. What I am suggesting is not color blindness, but *color acclimatization.* For decades it had been believed that there couldn't be one black-skinned swan or Wili among the corps de ballet in *Swan Lake* or *Giselle,* nineteenth-century European classics that remain in the repertory of contemporary ballet companies. Yet, when interracial casting has occurred, generally audiences have accepted the black-skinned ensemble members with little fuss, probably because Wilis ("the embodiments of the spirits of dance-loving brides who died before their wedding day")[21] and girls-turned-swans are already extraordinary enough to make a skin color contrast not all that important. Additionally, when one thinks about the wide range of difference represented in a "white" ballet corps or a Rockettes– (or Las Vegas–) style chorus line—pale to dusky skin, platinum to brunette hair, and narrow to generous facial features— the racial discrimination against including blacks seems pompous. What the dance world has failed to realize is that using an interracial cast in the already fantastic world of dance could probably be easier to accept than integration in everyday life.

Rennie Harris and Marlies Yearby brought up other issues around skin that have set black dancers apart, for better or worse. "Usually white dancers are lean," says Harris, "but we don't have a sense of their muscular[ity] or whatever and even if you take an Alvin Ailey dancer, even though they're not bulky, they are *cut,* beautiful dancers and you can see that, but you can't necessarily see that on the white dancers *just because of skin tone.* [Emphasis mine.] Yearby says that

"ashy legs have been a big discussion, and discussions about what oils are okay to put on your feet and legs when you're going to perform because 'I've slipped on your oil—you can't use that oil.'" This is a very interesting issue that is probably new for most white readers. Black skin, whether light or dark, appears ashen when, untreated by moisturizers, it takes on a dry, grayish surface pallor. White people have dry skin, too, but their "ash" is barely visible. Of course, beyond aesthetic conventions, there is no reason why dry skin should be unacceptable or looked upon as a mistake, on stage or off.

Yearby has had to tread rough waters within the black community, her work as a dancer and choreographer being almost exclusively with blacks: "I find myself to be in an interesting place on the stereotype of the light-skinned black woman. And I will say that it's a stereotype. . . . I was a light-skinned black woman without refined features and long hair." Of course, light- or dark-skinned people share a wide range of facial features, body builds, hair textures: So much of what we see is not what it is, but what we expect or imagine it should be. This is how Yearby describes herself: "I have a wide nose . . . and very large lips. My face to me is very much like an African mask. [As a child who lived for her formative years in Japan and then returned stateside as an adolescent] I was really chastised because of the way that I spoke: 'You sound like a white person, you sound like . . . ' So I became very aware then that I sounded different. . . . At the same time, I was called 'duck lips' . . . so that there was a lot of shame in my face, growing up."

As Yearby continued, she addressed the photographic problem which I now extend into the psychosocial question of how light-skinned blacks are assumed to relate to their darker kin: "It's . . . interesting . . . having photo shoots, where you as a light person must be balanced [with darker skin tones]—and maybe that means you get stuck sort of back there somewhere, and over off to the side because 'we don't have to see too much of you because you will unbalance the light,' or even a funny technical thing of being placed in spots so that you don't suck up the light! . . . weird little things like that . . . and then, of course, there's the more . . . confused historical side . . . there just being prejudices and assumptions in the room based upon the fact that you are the light-skinned person and what that dynamic means, what roles you can play within a black company . . . so therefore there is casting [as another issue]."

Given the points made by Dyer, Yearby's colleagues were correct in their assertions about her lightness usurping the photographic image. Yet, it is sad and ironic that a condition engendered by white skin privilege should do an about-face and play out as a reverse bias in the black community. The photography and film media sorely need to develop a contemporary, literally multicolored, mode of lighting, shooting, and processing.

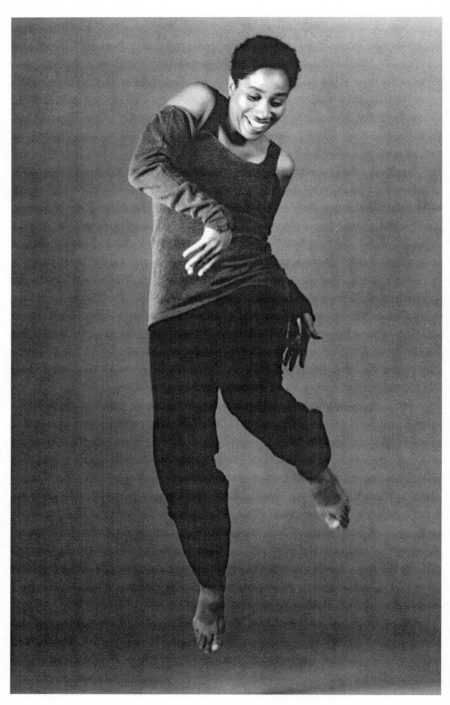

Mediating the conflict and bridging the divides. Marlies Yearby. © Stan Williams.

For two German choreographers, Hellmut Gottschild (my husband) and Susanne Linke, the very features for which Yearby and many other blacks have been derided are most pleasing and satisfying. While people-watching on a New York subway train with my husband, both of us enchanted by the beauty of a black-skinned woman sitting across the aisle, Gottschild waxed poetic about the shape of what he termed a classic African face: "Not aggressive but soft, regal, giving—sloping out and ready to give and to receive." Likewise, Linke's comments focus on her experiences on public transportation. I had asked her to specify the site where she centered what she characterized as "the beauty of the [black] body." Her response surprised me: "For me, the faces are beautiful. For me, it comes out from the face. . . . When I was sitting in New York in the subway, for me the most beautiful people are the black people. . . . When I came from Africa [after choreographing *Le Coq est Mort* in Senegal] . . . landing in the airport, and look[ing] at the white people after being in Africa, it was quite a shock."

HAIR

Growing up at a time before wigs and weaves were popular, the Dixon sisters—my two older siblings and I—were praised for our tresses. Hair was regarded as part of the female arsenal for winning male attention and garnering peer respect and admiration. As in traditional African cultures, a well-kept, well-coiffed, "healthy" head of hair indicated order, control, and some sense of self-possession. We three sisters had the same kind of hair: thick, black-brown, shoulder length. And like that of almost all the black people I know, our hair texture was not uniform. The sections toward the nape of the neck (affectionately termed the "kitchen," in black speak) were softer and could be curled with water and hair pomade. The hair on top of the head tangled most easily and was the toughest to groom. In addition, our hair transformed from birth through pre-adolescence, from baby hair (all soft and straight, then soft and curly, then thicker and more tightly curled) to identifiably "black" tresses. For me—as for many women, regardless of ethnicity—my hair texture changed while I was pregnant and lactating, growing longer and reverting to the softer texture of my childhood. The hair of my mother and maternal aunts differed on a spectrum as wide as their skin color. Like many other light-skinned blacks (and contrary to myths about white skin, white facial features, and white hair textures being inextricably linked), my mother's hair was short because it did not grow beyond a certain point due to its tightly curled texture and a history of unhealthy grooming practices. (Laughingly, she described her hair as "nappy as a shoe brush.") Her eldest sister had my grandmother's limp, thin, naturally wavy hair. Another sister had hair like my mother's; and the "baby," the chocolate-brown-skinned sister, had long, wavy, thick black hair. My daughter has long, black-brown, wavy-curly hair. When she chooses not to

wear it loose, there is no question about her ethnic identity: "If I wear it loose," she says, "it's like — 'What is she?!' When I wear braids or a bun, I'm black."

In 1971–72 I taught in the theater department at Bennington College and took dance classes with Judith Dunn, the postmodern dancer who shared a position there with her black husband, composer Bill Dixon. I became friends with Dunn's dancers. I remember the time when one of them patted my Afro, expecting it to feel like Dixon's. She was surprised to find that it didn't. It hadn't occurred to her that black hair is not all the same. In 1969, when I was still performing with The Open Theater and first began to wear braids (long before it was in fashion), the wife of one of the white actors (I was the only black in the group) asked me what the braids meant. Somewhere she had heard that braids were African, and African coiffures held encoded meanings. Her question was offered to show sensitivity and acceptance. But my hairdo, like most African American styles, was not traditional. My personal mean-ing, encoded in the braids and the Afro I had worn before, was simply this: "I am of African descent. I am not you — not white — and I don't choose to be."

Krause Haare, krauser Sinn,
da steckt der Dübel drin
[Frizzy Hair, frizzy mind,
There's the devil inside]
 — Quoted by Petra Kugel[iv]

Here is a quote from a *New York Times* "Sunday Styles" feature, May 20, 2001, page 6, to launch us on our excursion into the world of black hair: "When he isn't heat-blasting, straightening or snipping the heads of Sarah Jessica Parker and Minnie Driver, Anthony Dickey scours Harlem for the fragrant salves and potions essential to his craft." Described as an "ethnic" hair specialist, this young man (white-skinned with reddish curls in the accompanying color photo; identified in the article as black) declares that "African American women, His-panic women, Italian and Jewish women all have textured hair that ranges from frizzy to curly." Of course, some women in all these ethnicities — including black — have straight hair. And there are whites from other ethnicities, like my German colleague, dancer Petra Kugel, who have thick, big hair. Dickey con-

iv. This taunting rhyme was directed at Kugel as a child growing up in Germany. She is white and has naturally thick, full, big hair. (Conversation, 4 July 2001)

tends that people don't realize that "with black women alone there are over 50 hair types."

At this point in time, and with the tremendous quantity of black cultural and aesthetic information glutting white mainstream society, it may be that hair is the least contested site of the black dancing body. As the Dickey quotes attest, these days it is easy for anyone to make her or his hair short, long, curly, straight, or any number of colors—or to wear dreadlocks, twists, braids, weaves, or extensions, whether one is white, black, or brown—without much ado. Hair is the body geography that generated the least amount of commentary from the dancers I interviewed. This particular feature has become a contact zone for liberal exchange between cultures, classes, and ethnicities in a way that other physical attributes have yet to attain. Hair is, indeed, an important signifier. Since the 1960s, coifs that represented political and cultural liberation for African Americans—Afros, cornrows, puffs, twists, locks—have been adopted/adapted by whites to represent their own freedom movement. Carefully constructed cornrows may have signified order and adherence to communal values in traditional African cultures, but on the other side of the Atlantic they expressed sociocultural protest for the African American activist, businessman, or professor (male or female) and raunchy radicalism or primitive sexuality for whites.

A healthy degree of recursive intercultural exchange has occurred, with whites adopting the curly perm in the early 1970s, which I interpret as the white response to the Afro; then blacks responded with the chemically produced perm, the "jerri-curl"—blacks imitating whites imitating blacks. When braids became a mainstream currency, the Bo Derek braided, beaded "10" was created by her managers as the white response to this African-inspired hairdo (for the 1979 film of the same name in which her hairstyle was featured). And since the 1980s blacks have given a new definition to what it means to be blond. Although some African Americans have dyed their hair red or blond for most of the twentieth century (and hair dyeing or bleaching with natural plant products such as henna is common to many traditional continental African cultures) it became a black national pastime in the '80s and continues to capture black imaginations. My middle sister was a doo-wop groupie in the 1950s; her hair was honey blond for a while, in a trend that was popular with young, black, working-class women of her era. Earlier, the wonderful, brown-skinned gospel artist Sister Rosetta Tharpe wore blond tresses at various times in her career. At one point she sported yellow, Brunhilde-like braids lapped atop her head (in the period before Americans, black or white, knew anything about African braiding styles). On all sides, the possibilities for exchange and experimentation are dizzying—and fun.

One of my own "black hair moments" bears repeating. It was the summer of 2001 on a typical July New York day: hazy, hot, and humid, or what some would call a bad hair day. I had stopped off at one of the ubiquitous and friendly coffee bars in the Park Slope section of Brooklyn. I struck up a conversation with the young, white, male server, and we commiserated about the weather. He said it was so humid that his hair was "a big 'fro this morning" when he awakened, so he wore a "do-rag" to work—a bandanna that, until the hip hop era, had been associated almost exclusively with black heads. This intimate exchange between two strangers, black-white, male-female, young-old, said more than words can tell. In a few simple sentences we acknowledged that it is not only black people who have "black" hair. And it was clear that he relished the idea.

But this was not always the case. In fact, the history of black hair in the United States is one of repression, malign intent, and abuse, the fuel for racist fires. Enslaved Africans were stripped of the basic rudiments for personal grooming in the larger effort to dehumanize them. (For if they were less than human, then slavery would not be inhumane.) In their arsenal of torture slave owners used insidious means of humiliation. Jealous plantation wives took it upon themselves to personally cut the hair or shave the heads of the female objects of their enraged gaze. The enslaved were not allowed time or tools for grooming and resorted to using animal fat and grease to moisturize skin and hair, and sheep carders or even table forks as combs. On occasion they were punished for referring to their hair as hair, rather than wool.[22] This is an important point, for if the mantle on black heads was something other than hair, then blacks were, indeed, Other: "By the 1850s, Peter A. Browne, a self-proclaimed scientist, was contending that 'the Negro has on his head wool and not hair,' and that 'since the white man has hair, they belong to two distinct species.'"[23] In traditional West African societies unkempt hair is seen as a sign of internal disorder, conflict, or insanity on the part of its bearer. Thus, the level of insult resting upon the enslaved was magnified, cutting her off from her past and disabling her in the present. It is noteworthy that the terms still in use for black hair are white-generated negative descriptors: wooly, frizzy, kinky, nappy.

Josephine Baker and James Brown belong in this chapter. Both of them wore hairstyles that became enduring symbols. Baker transformed a close-cropped masculine look into the ultimate female statement; on Brown a neck-caressing female style was transformed into his own macho-masculine definition. It is folly to describe either look as simply an attempt to imitate white hair. It should also be pointed out that, independent of colonialist intervention, using oils, plants, and other natural methods to straighten hair and effect particular styles were common techniques in continental African cultures.[24]

Baker's cap-like coif added a new twist to the 1920s revolution in hairstyles. Of course there was no possibility of wearing one's natural black hair during the Jazz Age, but bobbed hair had finally become accepted as an alternative to long, flowing tresses. Femininity was being redefined in a liberated way. White film actor Louise Brooks's era-defining "black helmet" bob went a long way in pushing the envelope. What had been considered masculine was now boyishly sexy, and Baker's athletic body and short haircuts fitted right in. For over a decade her perfectly shaped head was capped in a straightened, marcel-waved "do" that ended in a side-curl over the forehead, or was sometimes all brushed straight back. Her style was a reinvention of hair itself—not individual strands of straight hair, but an improvisation on it. The coiffure's shiny overall effect of uniformity was achieved by coaxing the separate strands to stick together like a tight-fitting cap. It was ironed, oiled, and shaped into a new texture that had very little to do with white or black hair. In her routinely radical way, and long before its time, Baker was making the kind of fashion statement that we now characterize as postmodern.

As mentioned earlier, Brown had already made his mark on African American manners and mores with his hit song about black pride. His Afro haircut of the time served as a visualization of what the song was all about. He later did a turnaround and allowed his thick black hair to grow out, after which it was chemically straightened, waved, and curled, rivaling the long hair of the white rock stars of his era. Besides his widespread influence on black Americans, particularly young black males, Brown was the mentor and friend of the minister and politician Al Sharpton. In homage to his idol, Sharpton adopted Brown's flowing hairdo as an ongoing tribute. Men and women of all ethnicities, ages, and lifestyles color, tint, dye, straighten, curl, wave, clip, design, and groom their hair in a multitude of ways. Again, for black people to do so is not necessarily an indication of trying to be white; often they are trying on different ways to show themselves off. After the repressive restraints imposed on black hair during the slavery era, African Americans have every right to continue the creative traditions of the Motherland and to improvise and expand upon them. Baker and Brown took a white premise (straight hair), redefined it by a black process (chemical straightening), and assimilated it into the fabric, texture, and context of their own black hair. Their hair choices can be seen as a "cultural riff," or a visual pun played off white hair, "or a third way *between* black and white hair, a creole phenomenon."[25]

Nevertheless, there are conflicted perspectives on what black people do with their hair. For some blacks who straighten their hair (or stay out of the sun to avoid getting darker) it may be a matter of power politics: "For many African

Americans embracing Whiteness is a matter of economic, social, or political survival."[26] Certainly, that is what was on the mind of the father of my teenage friend who wanted to keep her away from dark-skinned black men. In the same vein, relaxed (meaning chemically straightened) hair has been described as "not the pursuit of white beauty, but the pursuit of white power—the power that goes along with having these accepted white characteristics."[27] In spite of that, these tactics may also mean spiritual and psychological demise, particularly when the individual doesn't have the clout and purse of a Baker or Brown.

Personally, it breaks my heart to see some of the black magazine ads for chemical hair straighteners for little girls. In the August 2000 issue of *Essence* magazine an ad was run for a hair product by a company called Dark and Lovely. The commodity for sale, "Beautiful Beginnings," is captured by its slogan, "Lovely from the Beginning!" Pictured are three black girls ranging from light-skinned to chocolate brown and probably from six to ten years old. They all have shoulder-length hair that has been straightened by this product and styled into wonderful pony tailed, curled, top-notched, and slicked-back styles. Three things disturbed me. First, the children are dressed all in white, and each is hugging an oversized white teddy bear. I suppose even in *Essence* the color white represents innocence and purity. In this context the color symbolism suggests a relationship with the racial designation of the term (again, Dyer's "conflation of symbolic and racial color") that cannot help these girls, or others like them, in their quest for a sane black identity in a white world. There is no riffing or improvisation here. Second, there is a message in fine print that is probably overlooked by most readers. It is written from bottom to top along the left, rather than the right, margin of the page, so the reader must either scrunch to the left or turn the magazine on its side to read what it says. Once it is deciphered, we understand why the advertisers made it so difficult to get to. It reads, "Warning: Please follow directions carefully to avoid skin and scalp burns, hair loss, or eye injury." Now, why would anyone want to expose children to such hazards, if at all avoidable? Third, the "Lovely from the Beginning" slogan carries a lethal subtext that is subversive to the psychological and spiritual health of young black girls—that, beginning as kids, straight(ened) hair is what will make them lovely; that black girls with straight hair are the ones who are beautiful.

But this is not just a black issue. It is a gendered dilemma that has also shaped and determined the social and cultural lives of girls from other ethnicities. Wendy Perron's early hair memories are particularly poignant and worth retelling. The long quotes that follow point to the ongoingness of a hair obsession that was unwittingly instilled in Perron by her mother and reinforced by her environment. The fact that this account came from a white woman reifies the idea of

the uselessness of old categories to describe "racial" characteristics. Perron's story refers us back to the *Essence* magazine example and drives home the sense of insecurity and impotence that these dicta create in children. In Perron's words,

> I have very curly, frizzy hair. My mother would always cut it and keep it short. It would never grow down: It would grow out. It was big hair.... When it was visiting day at camp ... I remember my mother ... running toward me and she goes—she doesn't even look at me in the eyes and she goes, "Oh, I have to cut your hair!" And she pulls out her scissors and cuts my hair at camp. ...
>
> My ballet teacher [Irine Fokine, the niece of Michel Fokine] would take us to Cape Cod for these wonderful, idyllic summers where we would take a two-hour class in the morning and a two-hour class in the late afternoon and then be on the beach the rest of the time. It was just wonderful, and I think it was the second summer we were there [1962: Perron was 14] ... we gave a ... a recital of stuff we had prepared [for the local population]. ... [Ms. Fokine] came downstairs to our dressing room ... in some town hall in this little town. And she just came straight at me after the performance and she goes, "You! Your hair! You look like an African fujiyama on stage!" And I didn't know what that was, and I just thought, "Oh, yeah, I haven't had my hair cut recently." It was this terrible transgression. ... Everyone else had their hair in a bun, and I just didn't. ... I started growing my hair long after that and pulling it back in a bun like everybody else's.
>
> In one of Ms. Fokine's reunions a few years ago one of the girls who became a ballet dancer ... was there too ... and I said how much I remembered that her mother would wash the girl's hair and rinse it in cold water ... long, long hair, down to her waist, the kind I could never have. ... And then Patty told me her memory of me, which is that I was always playing with the other girls' hair ... how I was so obsessive. ... It was all my wishes that I would have this kind of straight hair that you could actually get a comb through. ...
>
> [My hair] was a continuing source of shame in my high school ... Ridgewood High School in Ridgewood, New Jersey, a public high school ... a totally gentile, Republican town. ... One other Jewish girl in our school and I, we would straighten our hair together. There was one black boy in our class ... and one Asian boy, and other than that, it was this huge high school, and hair was just so important. I did not get asked out on a date almost the whole time I was in high school.

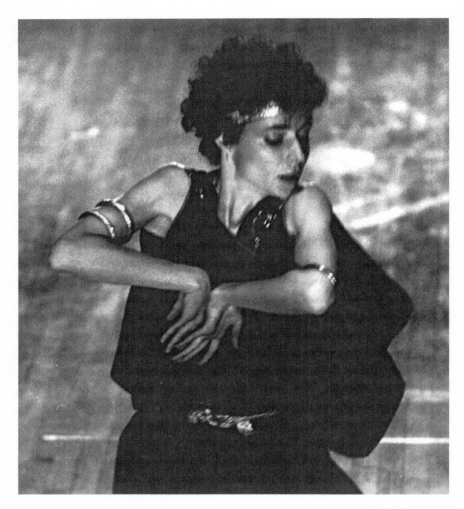

Hair as the battlefield. Wendy Perron (1980s). Photograph by Nancy Tutko © 1987.

Across the ocean at about the same time in Germany, dancer Petra Kugel experienced similar ostracism for her hair and was dubbed "the white Neger." At one point in her adolescence her mother took her to a doctor to find out if anything could be done to "correct" her "condition." Of course, the doctor had no solutions. Meanwhile, the hair that as a child had been soft and fluffy-curly became harder and thicker—or, to translate Kugel's word, more wiry—in puberty. Both Perron and Kugel would have been better off had they been taken to a black beautician (which would have been possible for Perron but not for Kugel in post–World War II Germany). Indeed, both girls would have felt saner, less

isolated, and better able to cope had they lived in ethnically integrated, diverse environments with other girls, black, white, and brown, with similar hair.

Nevertheless, black people can react negatively too. Yearby gives this account of in-group cattiness that shows us the power of black hair to provoke fearful reactions: "I remember one time we were on tour in Atlanta, Georgia. I was with the Urban Bush Women . . . and we were all sitting around the table [in a diner] and everybody had natural hair, whether it was an Afro, braids, or locks. And the sisters and brothers at the tables around us literally talked about us amongst themselves loud enough for us to hear, about how we didn't have our hair combed, what were we doing, what did we think [we were]."

In the dance world there were times when both the Alvin Ailey and Dance Theater of Harlem dancers were not allowed to wear braids, locks, or twists. Were these economic, cultural, artistic, or inferiority-complex considerations? Francesca Harper, who studied and danced with major ballet companies here (DTH) and abroad (Frankfurt Ballet) and performed in 2001 in the Broadway production *Fosse*, reminisced with me about her hair odyssey: "I straightened my hair for years to put it back, to slick it back and put it in buns. . . . That was required at the Dance Theater of Harlem, and that was also just growing up. My mother straightened her hair. . . . And then I went through the last six years — and maybe it's my age — but I just felt it was important to have natural hair. And then I straightened it again last year, and I was profoundly unhappy. . . . I had a weave at one point. I had a couple of different weaves. [A weave is a way of blending false hair at scalp level with natural hair, so that the wearer appears to have naturally long, straight hair.] They were just not right to me . . . I actually get more compliments now that [my hair] is natural and in twists. . . . [In *Fosse*] actually I wear a big Afro sometimes . . . [and] they like it . . . the hair person in charge of the show told me so."

We have come a long way since the Josephine Baker era. Harper's comments show a change in aesthetic sensibilities and an acceptance of natural black hair, at least in certain sectors of the white dance world. Charles Dickey's and Wendy Perron's comments oblige us to question the idea of black hair as black hair. A more useful construct for our era is not black or white, but "morphed" hair — textures and styles that deconstruct and debunk traditional ethnic definitions and range from blacks with naturally straight blond hair to whites with brunette Afros and everything in between.[28] In this millennial moment some of her contemporaries envy Perron's curls. When I mentioned Perron's hair stories to straight-haired Monica Moseley, her reaction was to praise Perron's tresses. Not to straighten it chemically, not to pull it back and control it, but to allow it to be loose — which in earlier periods was considered "messy" — and to create new

styles on the naturally textured hair or leave it as it is: All are now considered highly desirable options. Yet, others tenaciously hold onto the old order and the straight hair aesthetic, including Perron's mother, who was also her first dance teacher. As Perron told me, "I had an interview the other day, sort of an important, job interview type thing, and my mother called me up the night before and she said, 'Wendy, I know I shouldn't say this, but please could you go have your hair done before, have it colored and cut,' and here I am 53 years old, and it's the same thing."

To conclude this section I turn again to the innovative, timely work of Jawole Willa Jo Zollar and her Urban Bush Women. Their *Hairstories* premiered 23–26 August 2001 at the Jacob's Pillow Dance Festival in Becket, Massachusetts. For several years Zollar had been developing ideas for a story about black women's relations with their hair and had performed pieces of the work in various settings, including private showings, conferences, and workshops. The result is a dance-theater piece with onstage performance augmented by videotaped interviews with UBW dancers and African American and white women from other walks of life. (Taped sections are screened on a large video monitor suspended on one side above the stage.) The dancers (Shani Collins, Christine King, Makeda Thomas, Wanjiri Kamuyu, Tania Isaac, Francine Sheffield, and Zollar) tell this hair story from a variety of perspectives and with a sense of humor. At several points Zollar appears in a black suit, bespectacled, behind a podium, lecturing as "Dr. Professor" on the finer points of "black hair-ology." Each time she assumes this role she adopts a mockingly shrill authoritarian voice. Thus, a topic that has caused undue grief for black and white women is given a wonderful send-up from an insider perspective. After all, it's only hair! Sections have titles like "Women Talk Hair," "Back in the Day," and "The Hot Comb Blues." Indeed, one of the main thrusts of the piece is the drawbacks of hair straightening. In one of the videotaped interludes Zollar is on screen touching her hair, feeling her neck and ears, as she recalls the many little nicks and burns inflicted on these areas when she was a child and the women "did" her hair.

Although the piece is full of factual information via the videos and can be seen as a primer on the evolution of twentieth-century black hair practices, the live dance-theater action is what carries the day. A couple of sections of brilliant dance-drama are performed to James Brown songs, including "Cold Sweat" and "The Payback," two of his mega-hits. The ensemble parodies the innuendo in the songs to enact, with gusto, the resistance tactics of pre-pubescent black girls who ultimately are forced to have their hair untangled, combed, and straightened. Using Brown's famous "Please, Please, Please" in a section titled "A Tender-Headed Dilemma," Zollar begins by dancing solo. One side of her thick hair is

combed out like a big Afro, the other side held down by the teeth of a large comb, with the handle pointing up from her scalp. She is the child running away from an unseen "torturer," probably her mother. It is a brilliant ploy and gender reversal for Zollar to have redirected Brown's male-centered love songs to a female purpose. As the song ends, the "grown-up" women enter and throw a red plastic beauty parlor cape around her shoulders, using it to restrain her. Satirizing Brown's famously pleading climax to this song (as described in chapter 3), they drag away a kicking, rolling, resister-sister. Finally, to Brown's *Got That Feelin'*, they dance a section titled "I Gotta Itch It, Can't Scratch It Shuffle." This dance centers on the desire to scratch the scalp, a typical response associated with habitual use of chemical straighteners. Scratching causes the scalp to become irritated and develop sores. The dance is perfectly, wonderfully frantic, with dancers imitating the staccato urgency of Brown's song, their bodies dancing with and against the rhythms as they gesticulate with wide palms and splayed fingers, beating and patting their scalps so that the itch is relieved without the prohibited scratching action.

The idea of hair morphing is the centerpiece of Zollar's "Dr. Professor" lecture titled "Nappology 101." The subject, here, is a clipping from a Philadelphia newspaper (the clipping, with color photo, appears on the video monitor) that referred to Chelsea Clinton's "nappy" hair. The "professor" questions the terminology, insinuating that black hair is not only black and, perhaps, that white people are not only white. Next, dancer Wanjiri Kamuyu delivers a rousing "lecture" on "Lockology" in the style of a black Pentecostal minister. Her voice rising and subsiding with shouts and signifying "humphs," and using repetitions and chant-like intonations, this preacher's message is that African locks (and she is wearing her hair in beautiful, shoulder-length blond dreadlocks) — like human DNA — are shaped in a spiral, thus attesting to the fact that black people are "the original people." The fact that outrageous concepts like this are delivered as comedy allows them to float in the air as flights of fancy that are not entirely out of the realm of speculation.

Toward the end a glossary of black hair terms adapted from Ayana D. Byrd's and Lori L. Tharp's *Hair Story — Untangling the Roots of Black Hair in America* is projected on screen. In-group descriptors — "tender-headed," "nappy," "hot comb," "hair grease," "relaxer," and so on — are accompanied by a cleverly constructed dance that doesn't attempt to illustrate the projected vocabulary but establishes, in postmodern style, a series of movements that can be repeated and may by chance seem to illuminate one of the definitions. Thus, hip wiggles parallel a description of "kinky hair," and a movement that seems to melt the dancers' bodies coincides with the definition given for hair "going back."

There are two serious sections, one intimate, the other historical. In the first Zollar contrasts her own head of hair with her sister's — Zollar's long and thick, her sister's short and stunted. Hair lust haunts the sister, and she is shown trying on one wig after another in a repetitive, obsessive motion as the scene ends. The second scene focuses on Madame C. J. Walker, the African American woman who in the 1910s developed the first nationally produced hair-straightening products, which caused a revolution in black America. Her beauty schools and salons made her a millionaire. Zollar tells her story (with archival footage) and dreams of a reversal, an alternative fantasy of Walker espousing the idea of "happy to be nappy," and leading black women in a "black is beautiful" movement instead of one that disparaged and destroyed black hair.

The piece ends with "Dr. Professor" Zollar expostulating on hair as freedom, personal art, and individual statement in a lecture titled "Embracing Artifice." The good professor begins her lecture with a definition of Afrocentricity: "placing African ideas at the center of any analysis that involves African culture and behavior." This important concept can be credited with physically returning black hair to black women and, on a larger scale, spiritually returning black destiny to black peoples. With the mix of humor and depth that has informed the entire dance, Zollar continues and talks about the incredible creativity expressed in contemporary black female coiffures, that this degree and kind of innovation is a freedom movement led by "our nation." By now she is boogying behind her podium, and ends by saying, "Just for the funk of it!" This line is a quote from and lead-in to the 1970s disco-era hit that accompanies the finale — George Clinton and his Parliament Funkadelics' *One Nation.* Dancer Tania Isaac, whose hair is cropped, bleached blond, and done up in small twists covering her head, leads off this section and sets the tone with Zollar's gorgeous hip hop/Afro-postmodern choreography, a blend and fusion of forces that gives these women power and prerogative. The words of the song, "ready or not, here we come. . . . and nothing can stop us now," take on a metaphorical hue and tone beyond even Clinton's innuendo of (black) liberation. With UBW "in the house," the song becomes an anthem of African American female ascendance: Here they come, whether or not the world is ready for them, to own and occupy their rightful place and space. Not only do they dance with their beautiful, luscious bodies, they also dance their hair, swinging and circling, bobbing and bouncing their braids and locks and even caressing their heads with circling hands.

Paralleling the *Batty Moves* perspective on the black female buttocks, *Hairstories* clears the air around the discourse on black hair and promises deliverance to the black female of the power, self-determination, and self-possession that are centered in this embattled territory. Both of these dances are timely additions to

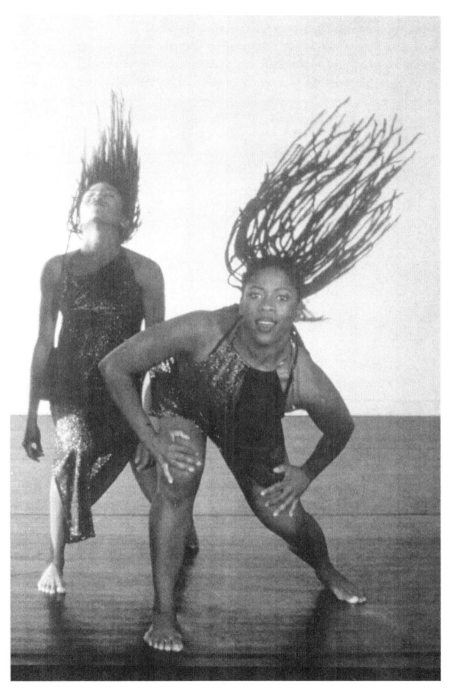

Dancing the Hair: Urban Bush Women Francine Sheffield (front) and Wanjiru Kamuyu (rear) in *Hairstories.* Jennifer W. Lester.

the current interrogation of externally generated, internalized stereotypes and signal a trend toward reversal of long standing limitations on black body attributes, limitations whose heaviest burden was placed squarely on the black female body.

Hairstories brings this chapter full circle, and it is my childhood dream come true: having the world come around to see me—that is, the beauty of black woman, as represented by Urban Bush Women—for who I am.

LOCATION: TO BE OR NOT . . .
(CONTINUED FROM LOCATION: WHO'S THERE?)

If your skin has ever been ashy and you know what that term means, check black . . .

If you have ever used a black eyeliner for a lip liner, check black . . .

If when you shave, your face or neck bumps up, check black . . .

If you have ever used a pressing comb, check black . . .

If you have ever used a box relaxer or wave, check black . . .

If all your pillow cases in your home have grease stains, check black . . .

If you sleep with a bag, wave cap, or do-rag on your head at night, check black . . .

If you have ever used grease and water to make your hair lie down and look naturally wavy, check black . . .

If you can wear a comb or pick in the back of your head, walk around, and it doesn't fall out, check black . . .

If your hair is 2 or 3 inches [long] and the next day it is half way down your back, check black . . .

If you have ever used a gel or Dax to hold your hair down or make a ponytail, check black . . .

—Anonymous email circulated winter-spring 2000

Again I refer to this savagely savvy Census "instructions" guide to close out this section. The real Census is put to the test by what is happening in everyday life — namely, the blurring of old ethnic categories and the deconstruction of established physical markers.

Because they are far ahead of the dance world in dealing with politics, race, and identity, theater practitioners furnish potent models for a new paradigm. So, again, I turn to English director Peter Brook. If *Hamlet* is to speak to our times (and Shakespeare remain alive), he needs to be a child of our times. Brook speaks about his choices for mounting his 2000–2001 touring production of that classic: "The actors wear no makeup, no wigs. Adrian Lester's dreadlocks are his; we wanted his

natural self in the part. We tried to make our everyday life a natural link to the part. If someone told Adrian that in playing Hamlet, a Danish prince, he should look less like a black man, that would be appalling."[1]

Black playwright Charles Smith adapted for the stage Mark Twain's gripping *The Tragedy of Pudd'nhead Wilson* (1894), the story of a light-skinned enslaved woman who switches her baby with her master's child, since both boys are the same in color, features, and age. African American Walter Dallas, artistic director of Philadelphia's Freedom Theatre, staged the touring production. The two men were interviewed by *American Theatre* magazine. Here is a portion of their comments:

> Dallas: When Charles and I initially discussed the idea of how the roles of the brothers should be cast, there was a moment of exhilaration when we realized that our visions were in synch. As the director, I wanted to help Charles push the envelope in terms of challenging notions of race and perception. What if each of these characters appeared, racially, to be at the very extremes of our centrist expectations? What if one were so black he was blue, so black you could almost hear drums, so black that you could almost taste bushmeat and *fufu* when he entered the room? And what if the other were so white that when he entered the room you could hear Mozart and taste watercress or asparagus? If we were going to challenge notions of race and perception, I wanted to go as far as we could.
>
> Smith: The result is a dark-skinned African-American actor playing someone who, in the play, is thought to be white. The character *thinks* he's white, and all of the other characters in the play are told he is white; therefore, when the other characters in the play look at him, all they can see is someone white. Likewise, we have a white actor playing someone who, in the play, is thought to be an African-American slave. Basically, it says that race is a state of mind.[2]

Indeed, we *think* we are black or white, and that (mis)perception *colors* our vision. If race is a state of mind, then where can we situate black, white, brown, on the map of our consciousness?

THE CONTINENT

LATITUDE III

I went up to Harlem and saw the abandon and freedom and spontaneity of spirit of these people. It was so different from the stereotyped Fascist spirit of Europe. The stirring imagination of the Negro and his innate understanding of the fundamental values have left deep, permanent impressions on the arts.

—Eugene Von Grona (ca. 1937)[1]

The body is spirit, too. . . . I think that the business or the mission of art is dis-illusionment. To make us see the double nature of reality—that it is both material and spirit.

-Li-Young Lee[2]

I believe that environmental imprints—sociocultural upbringing, attitudes, beliefs, and practices—are primary shapers of the ethnic characteristics that we call race. In acknowledging that definitive characteristics of the black (or white) dancing body reside in geographies beyond biology, the third part of this work is devoted to the "continent" of soul and spirit.

In the world of experience, soul and spirit are interrelated, interdependent constructs. They are inseparable, interactive processes, not static phenomena. Although the two concepts are inextricably linked, they can be "exported" to the world of theory and discussed as separate entities. To do so brings them into a space/site (words, paper, and the fixity of written concepts) that is foreign to their energy and existence in the realm of being. But this is the case with any number of concepts that have to do with the ineffable subtleties of life. There will be places in these two chapters where it becomes almost impossible to separate soul from spirit. At those points I'll address them as convergences.

I offer the following premises: First, spirit and soul are *embodied*, meaning that their location and means of expression for all human beings are in the flesh; secondly, through soul power, the body manifests spirit.

Soul represents that attribute of the body/mind that mediates *between* flesh and spirit. It is manifested in the *feel* of a performance. It has a sensual, visceral connotation of connectedness with the earth (and the earth-centered religions that distinguish West and Central African cultures) and, concomitantly, a reaching for the spirit. Soul is that groundedness that allows us to name James Brown "The Godfather of Soul" and to give the title "soul" to that glorious music with the driving beat of jazz-and-blues-gone-gospel. Soul, the term and the concept, has been irrevocably linked to and associated with African American expressive performance styles. Of course, all performers who do what they are supposed to do—namely, act as mediators and conduits between the observer and the intangibles manifested in the words, music notes, or dance steps of their medium—exhibit soul power. In Flamenco culture, the soul analogue is *duende*. It is similar also to the *rasa*, or flavor, that is spoken of in Hindu aesthetics. However, each term is culturally specific and not exactly synonymous (that is, equal does not mean same). For African American performers, soul is the nitty-gritty personification of the energy and force that it takes to be black and survive. Rhythm, and the many textures and meanings implied in the concept (percussive drive, pulse, breath, and heartbeat, for example), plays a pivotal role in generating and disseminating soul power. Soul is about going in deep, gettin' down: Soul is the digger. Soul leads to spirit by means of those characteristics that are fundamental to the Africanist aesthetic: radical juxtaposition of unanticipated elements; call and response; polyphony and syncopation; ephebic energy; and the balance between hot and cool, dubbed "the aesthetic of the cool."[3]

Spirit is the valence—or perhaps the release—at the outer end of the body-soul-spirit continuum. It is manifested in the *resonance* (fullness, depth, power, and reverberation) of a performance and rooted in African danced religions, where cosmic forces present themselves through the dancing bodies of devotees. Spirit is the reacher, extending our bodies beyond our pores and allowing us to mirror and reflect (to embody) the aura bodies of ancestral and cosmic entities in the housing of our own physical baggage.

But, again, soul and spirit are sisters. We need soul (or rasa, or duende, or other culturally specific concepts) to get to spirit. Indeed spirit shows up whenever and wherever sublime dancing occurs. It is the element that makes this ordinary thing we all are—the body—the conduit for the most extra-ordinary experiences. Both soul and spirit partake of faith, which triumphs over fear and powerlessness. Faith can be considered a "meme," the neologism originated by Richard Dawkins, evolutionary theorist, "to describe a thought that spreads through the population and seems to take on a life of its own."[4] The new word

was used in a *New York Times* article about the aftermath of September 11, 2001, with fear as the meme. Likewise, faith is the survival meme of oppressed peoples.

We humans are all subject to forces beyond our control, whether it's the baby in a world of grown-ups, an enslaved African on a plantation, or an investment broker at the mercy of the stock market. The examples are not as far-fetched as they may seem and are called on to point out the ongoing helplessness of the human condition: "outta control," as the saying goes! One way to cope is to develop ideologies or value systems that place us in a sphere of power beyond our global impotence. This is the locus at which spirit comes into play, acting as a fixative and providing the legendary "balm in Gilead, to heal the sin-sick soul," to quote the lyrics from the African American spiritual. Spirit heals soul! Individuals and cultures that live in the light of the spirit (and in the knowledge that humans are not the controlling element in the universe) exude a vulnerability that is its own kind of power—a vulnerability that opens up the possibility for extraordinary levels of performer-audience communication. Those who were presumed victims turn out to be the victors. As ballet-trained Zane Booker mused, "Dance is sensual and sexual. And when somebody is aware of sensuality and sexuality, or even if they are unaware, but it just oozes, then it carries across the footlights. And then maybe it goes back to always having to be 150 percent better or work 150 or 200 percent harder than they [whites] do. And it goes back to a definition of black dance where I guess sometimes what you have to say and what you have to hold back and whatever anger you have is very deep."

Perhaps these are the qualities and conditions that led the *New Yorker* critic to write, as mentioned in part I, that blacks dance beautifully because of lives that are on the line. Soul/spirit, then, is a shared experience and radiates outward, pulling in the spectator and trespassing the boundary between audience and performer, between the "here" and the "there."

One of the reasons the black dancing body exhibits such a palpable, tangible, almost material sense of spirit/soul is its heritage: *Danced* religion and *dancing* divinities reside in African and African American history as well as in the Africanist collective memory. It is *not* a matter of biology, *not* genes, but a *cultural unconscious* that lives in the spirit and is reconstituted—re-membered—in the muscles, blood, skin, and bone of the black dancing body. In continental and diasporan African religions the devotees *embody* the deities. The divinity is manifested by entering the body of the practitioner and becoming the "divine horseman" with the dancing body as its steed. In Europeanist outsider-speak, this practice is called "possession." But that term doesn't begin to approximate the culturally sophisticated, learned response that is entailed in divine energy dancing, singing, and living through one's body. Possession sounds like chaos, hysteria, disempowerment,

whereas "embodying" bespeaks the strength, groundedness, and healing energy imparted to the devotee who dances her deities. This practice of divine dancing exists even in Africanist forms of Christianity. Although there is only one Christian deity, blacks in many Christian denominations "get the Holy Spirit" and dance, shout, and let the spirit move them in their worship services, just as their African ancestors did in homage to traditional pantheons of divine forces. Diasporan religions like Haitian Vodun and Cuban Santería have incorporated Catholic saints into their pantheons, thus effecting a successful integration (or syncretism) of Christian and African systems. Dancing as a holy, spirit-filled practice is, therefore, a familiar concept to peoples of African lineage.

"There are over eleven hundred languages in Africa," says the Reverend Dr. Wyatt T. Walker (with a Ph.D. in ethnomusicology), pastor of Harlem's Canaan Baptist Church. "Not one of them has a word for 'secular,' which is a Western concept." Walker was addressing African American musics and concluded that "[a]ll music is prompted by the Creator."[5] These statements, delivered in an article on the 2001 Harlem Jazz & Music Festival, apply to dance as well, giving further credence to the premise that black dance carries with it a specific connection to spirit. Social, folk, and concert dance forms are all potential conduits of spirit, since spirit in an Africanist sense is not confined to a sacred box.

After examining the concepts soul, spirit, rasa, and duende in chapter 6 I want to discuss a performance genre that survives in only a few communities on the Georgia coast and Sea Islands. Because the Gullah people were physically estranged from the mainland, their songs and dances retained African-based plantation characteristics that disappeared from other geographical areas of the United States. Through the year 2000 they still performed a fairly traditional version of the Ring Shout. Because of its function as a cultural repository for an African-based, African American expression of spirit, this dance form belongs on a trajectory with dances like the Alvin Ailey masterpiece *Cry* (1971) and Ronald K. Brown's *Gate Keepers* (2000), both of which will be discussed with the Ring Shout in chapter 7. Soul/spirit is treated as a continuum in the discourse on these works.

Although adrenaline, endorphins, hormones, pheromones, and other chemical controllers of mind/body function are all part of the picture in the body-soul-spirit confluence, the whole equals more than the sum of its parts. The physical attributes discussed in the previous chapters—geographical checkpoints, if you will—are markers on the map of the black dancing body. But, animated by soul/spirit, that body bursts its prescribed boundaries and exudes a power and purpose that reverses negative assumptions even while it is appropriated, imitated, and assimilated by the dominant culture. The black dancing body shapes the course of history and fashions the fabric of the future.

SOUL/SPIRIT

I am recalling the feeling of ecstasy coming from nowhere and about nothing in particular that would distinctly, momentarily overcome me at unforeseen moments in childhood and early adolescence: a sense of rightness with myself, the world, the moment, maybe even the future. This resonance, independent of and autonomous from what is actually going on in life, is one of the ways that I have experienced spirit. Later, I remember being "in the spirit" after taking dance classes at the New Dance Group Studios on West 47th Street near Broadway. It was the summer that I was 16. I had just graduated from high school (having skipped a grade of middle school) and before entering City College in the fall was using my typing and steno skills as a full-time temp secretary at the National Council of Churches headquarters on Riverside Drive. At five o'clock I'd leave my "day job," take two back-to-back dance classes in non-air conditioned studios during the hot New York summer, then emerge on the steamy streets, sweaty but ecstatic. The dance experience connected me to the very air that enveloped Broadway and all that that air suggested for my future. Of course, part of the euphoria was caused by the release of endorphins from the physical exertion, but it was also something more. I can remember (but not re-member) an inexplicable joy of being. In the most intimate and specific ways my dancing body was all tied up with spirit.

Then, somewhere around 1962 or 1963, I had the good fortune to see Alvin Ailey's Revelations—*and it was a revelation for me. Combined with my Marxist political leanings and Civil Rights—era activism, this dance justified me and my existence. Watching it, I entered a collective cultural memory that embraced my own family history. At a time in my life when I had disclaimed all religious belief systems, it made me feel the power of black spirit and the righteousness of black soul.* Revelations *reified my cultural and individual identity (as*

did the Civil Rights Movement and Marxism) and fueled my efforts to transcend and deem as trivia all the material things I didn't have as a poor black girl growing up in a Harlem tenement.

It is my oldest granddaughter's seventh birthday. A small celebration of grown-up friends and family is planned on the actual day, a weekday. (The "real," kids' party will be held the following Saturday.) After singing birthday greetings, consuming cupcakes dressed in candles, and opening gifts, the dancing begins. The birthday girl chooses a CD by Michael Jackson, with whom she has been obsessed and infatuated for nearly two years. While he belts out old hits like "Wanna Be Startin' Somethin'," "Rock With You," and "Billie Jean," the seven-year-old and her three-year-old sister boogey down. Having watched Jackson's videos countless times with rapt fascination and adoring imitation, big sister breaks out into robot moves and moonwalks that have the grown-ups laughing and shouting with glee. Amazed by her agility and somatic intelligence, we egg her on. She even drops to the floor and does her own version of break dancing, balancing on her arms while windmilling her legs beneath her. We are delighted, enthusiastic, even euphoric at her display.

This scene has been reenacted for decades in African American communities across the United States: The young'uns dancing in the safety of the living room or backyard, with the grown-ups forming a protective ring around them, enjoying the spectacle of yet another generation of their kith and kin mastering the latest social dances. It marks the period when children and pre-adolescents can try on sophisticated, polycentric, polyrhythmic adult moves with youthful innocence, although the steps and phrases themselves are not at all childish. This early rite instills in the new generation the status, value, spirit, soul, and love of dance as central to the good things in life.

Churchgoing, a near-obsolete practice in many American communities, can still be observed in African American neighborhoods on Sunday mornings. The phenomenon is particularly visible on holidays like Easter Sunday or Mother's Day (which one of my friends dubbed "The Unofficial National Black Holiday," since veneration of mothers is such a big deal in African American culture). Forget the New Age come-as-you-are approach to worship: Black folks dress up for church. It's a way of paying homage to God by taking the time, effort, energy, and money to look good. In the Harlems of the nation, elderly ladies and little girls may wear decorative gloves, gorgeous hats and frilly dresses that are creative flights of fancy. Little boys and their fathers and grandfathers are suited up to a tee. Makeup, cologne, and hair grooming are also part of the picture. There is a rustle of excitement and a sense of pride and celebration that accompanies these preparations. The drive or walk to church, the greetings on the exterior steps (or in the churchyard), the entry into the sacred place, all are part of the ritual. Then, walk into the house of worship itself, stay for the service and, more likely than not, you will be hit by a sense of spirit that

creeps up and catches you by surprise. With almost none of the solemn attitude or aesthetic touches associated with European Christianity (stained-glass windows, subdued lighting), and with a liturgy that is largely shaped by improvisation, the spirit power in a traditional black church service is generated by the active body-and-soul participation of the communicants. Spirit stirs voices to shout spontaneously and moves bodies to stand, stomp, or wave lifted arms during the sermon or while the choir or a soloist sing a particularly moving offering. Music, and the musicality of the spoken word, is a major element in the service. Despite the beautiful clothes and obvious care taken in self-presentation, devotees allow the spirit to move in them in whatever way "It" may choose: Hats may fly off, buttons pop, and ecstasy result in a sacred dance in the aisles or a stiff, full body faint in the pew. It is just as likely that the minister of the word, the minister of music, or a choir member, deacon, or deaconess may "get happy" as a member of the congregation. All emergent manifestations of spirit are embraced, and waiting arms catch the enraptured ones before they fall, just as consonant voices join in with the person who shouts "Hallelujah!" or "Yes, Lord!" Spirit heals soul and reinvigorates soul power. This is what the preparation was all about: to lead us to the spirit. Not the symbolic breaking of bread and drinking of wine, but the spontaneous outpouring of spirit is the central point of the African American Christian worship service. Along with the African American community of the 1950s–1960s, my family hadn't a clue as to the Africanness of these practices. This is the tradition in which I was born and bred, and it has shaped me in ways that I respect and honor more and more as I grow old.

SOUL GEOGRAPHY

When you come from a place where confidence is the only thing that you have to rely on, even if you lost you won.

— Rennie Harris

[E]ven those of us who have no notion of what the auction block was can still feel it, as if the memory of it is handed down to us through our mother's milk. . . . It is there with me when I dance. . . . My eroticism, my sensuality is often coupled with wild anger and belligerence. . . . I am a person with a history—and that history is in part the history of exploitation.

— Bill T. Jones[1]

Researchers at Duke Medical Center have shown that face-to-face encounters with racism can overwork the heart and elevate blood pressure

in African Americans, symptoms that are known to boost the risk of
heart disease and other illnesses.

— Black Issues in Higher Education[2]

By dint of life experiences in the United States where they deal with it on a daily basis, most African Americans have developed a high threshold for psychological abuse. If they hadn't, they wouldn't have survived. In this, as in many other ways, the African American "normal" is very different from the white norm. Nevertheless, as communities and individuals, we each have a point beyond which we cannot go. Some of the most potent artworks have come from experiences on this border of tolerance. Here are a few recent examples in a long history of channeling abuse to better use: Ellis Cose wrote about black bourgeois anger in *The Rage of a Privileged Class* (New York: Harper Collins, 1993); Public Enemy made an album titled *Fear of a Black Planet* (1990), containing songs like *Burn, Hollywood, Burn,* their response to stereotypical casting in mainstream movies; Jawole Willa Jo Zollar choreographed *Shelter* (1988), a dance about homeless women on the streets of New York. As Walter Mosley wrote, "Music and style in black America are so vibrant because they are barely veiled codes that express the pain we've experienced for so many years — pain that is common to all women and men, black and white."[3] That is to say, the universality of pain and suffering is made specific through the particular life experiences of black Americans. This is what I mean when I say that soul is what it takes to be black and survive. The style and aesthetic that evolved from this soul character have given to the world — not only to black people — artists and movements that help us navigate the perilous waters of life. Nevertheless, bell hooks hits the target when she states, "White folks who do not see black pain never really understand the complexity of black pleasure."[4] So the superficial aspects of the black experience are sought-after commodities in the dominant culture, as pointed out by White and White:

> To a considerable extent, the struggle over what freedom meant [in United States history] centered on the bodies of African Americans . . . on the appearance of individual blacks and on the ways in which they collectively presented themselves in public. What emerged in the early decades of the nineteenth century was a pattern of black initiative and white response, as many of the consequences of emancipation were worked out publicly on the streets of Boston, Philadelphia, New York, and other northern cities. African Americans were only a small minority of the population in these cities, but the very openness and exuberance

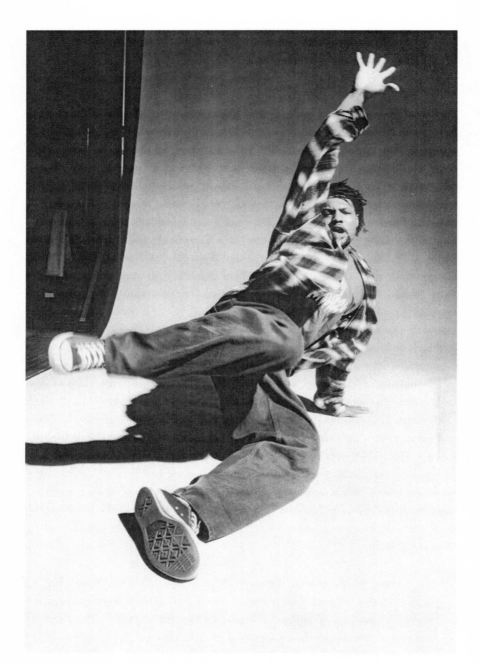

A matter of attitude. Rennie Harris. Bob Emmott.

of their public behavior attracted a disproportionate amount of attention from whites. . . . [T]hey, their lives, and their culture were appropriated by whites and packaged for entertainment and profit into something that could fuel the fantasies and longings of their oppressors.[5]

In other words, whites, seeing African American "soul survival," lusted after it. As Seán Curran said, "There is something attractive and sensual [in the black dancing body] and for me it's a connectedness to soul and to spirit. About not just how African American people move, but the African American experience, and survivors, and a musicality and a profound understanding of complex rhythms, and stuff that is desirable and you get a hunger for."

Soul power is both personal and collective. Doug Elkins, who is white, commented that, "In African and Latino . . . cultures . . . the body is a dialogue and the body is allowed to represent the individual and that person's cultural community. . . . When I went out in a [break dance] battle, I felt a certain sense of responsibility to my crew. You have to *represent*."

Elkins's words imply self-confidence in spite of all odds. The individual is obliged to "represent," in the hip hop sense of the word, to rise and be counted for a specific community, to positively and righteously stand up for a "crew." Part of the power of representing lies in displaying attitude. In the African American vernacular sense of the word, attitude means panache, élan, brashness, style, "gettin' down with the program"—and often exhibiting an angry energy. This is what Rennie Harris meant in the epigraph when he talked about confidence as all that one might have to rely on. But that, of course, is a lot—and that's what soul power is: having something intangible that is an invaluable asset, when one has almost nothing of value that is tangible. Confidence is the meme that runs parallel with faith. Confidence allowed the young Donald McKayle, growing up in a black working-class New York family, to begin to choreograph before he actually began to study dance technique.[i] Although Harris is a hip hop artist and McKayle a modern dance master, what they have in common was the courage to trust their creative impulses before turning to the formalities of technique. To reiterate Mosley's point, these examples do not mean that soul and attitude are exclusively black properties, but they are signposts of a culture-specific vibrancy in the dancing bodies of these African American artists and have become universal

i. McKayle, in a presentation at The Painted Bride, Philadelphia, 17 December 2000. He was inspired by the first concert dance performance he'd ever seen, given by the great Pearl Primus.

because they can so specifically address the bittersweet, paradoxical human condition. Bill T. Jones bears witness to the paradox. Addressing his work he contends that he had

> stood on stage and done and said outrageously transgressive things around the issues of race, sex, gender, because of the confidence I have. I feel that I'm good-looking, and I don't say that normally. . . . It's been a shield . . . a way that you can get by. . . . Then use that. So that gives you entrée. So then once in there I have used that and this: a burning sense of righteous anger and indignation that I inherited from my mother. And I'm saying, "You are here because people have been lynched and hung so that you can be here. So when you stand there, boy, you better stand up."
>
> I've known how to do that difficult thing or make that outrageous movement because we are a people who have always known how to be outrageous. Listen to Louis Armstrong sing. What is that voice? And he put that voice across and charmed people with it, you know.

Jones's words bespeak a confidence grounded by standing on the shoulders of the ancestors. It is the impetus that led to the creative forms that have emerged from African America: spirituals, the blues, gospel music, jazz, social dances created for every decade of the twentieth century—from the Turkey Trot at the turn of the century through the hip hop dances of the millennium, as well as innovations on the concert dance and music stages of the world. Soul power: It is made up of part responsibility to the elders, the ancestors, and history, part daring originality and brash creativity, and part anger and pain at being black in America. Poet and lyricist Thulani Davis touched on some of these points in an address on the relevance of art to society:

> Jawole Willa Jo Zollar . . . told a story last year of studying Caribbean dance with Pearl Primus and being stopped and being told, "You African Americans do the dance, but you're adding something that's not there. . . . Anger. It's a courtship dance, there's no anger." She has since observed this same additive in popular dance at certain times all over America. . . .
>
> I heard my cousin [Anthony Davis, the award-winning composer] say, when he was asked to defend his decision to move from his roots in Thelonious Monk into opera, that it was his understanding of the jazz ethos that he honors Monk by finding his own voice, and by changing things.

A master drummer I heard last year also reflected this thought and he said that whenever African American drummers and dancers came to Africa to learn traditional drumming at his school, he could see them thinking, even before they learned everything, how to change it and use it to create something else.[6]

The same impetus—a combination of confidence, angry energy, and homage to history—is reflected in the Harris, McKayle, and Jones examples. Comments about confidence and the black dancing body rose spontaneously from these dancers without my prompting. Harris's and Jones's emerged from the question of whether they had ever had the edge over a white dancer in an audition, grant, or commission circumstance. For them the advantage resided in what can be called soul force, which they each, independently, characterize as confidence. When I asked Ralph Lemon to address the largest, most prevalent area of stereotyping of the black body by blacks he, too, launched into a response that hinged on the idea of confidence. Here is an excerpt from his interview:

RL: That's an interesting question. . . . I think in my black body experience and the black bodies I know, the black body is extremely confident.

BDG: Confident?

RL: And I don't see them buying into any insecurities. Most of the black bodies I've experienced, if they're big they love the bigness, if they're small they love the smallness. There seems to be a comfort with . . .

BDG: Living in their bodies.

RL: Living in their bodies. . . . [Y]ou get anger from exclusion, but . . . I've not sensed a sort of self-deprecation that "I wish I had a different body." It's [more] like, "It's really fucked up that my body can't, is not accepted in that situation or that genre." You know, that's a power righteous thing that African American existence has [created] in America, just out of survival. It's like there's not an acceptance of being . . . inadequate, and maybe that's the new modern type of existence.

BDG: Yeah, but maybe that's also what's carried us through [in the past as well].

RL: I can truthfully say that that is something that I've sensed in any and every dancing black body. Even when they're not capable of doing my work in an audition . . . there is a boldness and confidence however it is that they moved.

Later in the interview, Lemon, the "downtown" choreographer, described his work with the Alvin Ailey dance company: "They really respected me and I really respected them, and we really had a great time. They were dancing to Beethoven. I mean I went up there with my white postmodern world, and I was like, 'This is who I am right now and so we're going to have this physical experience,' and their bodies got small, and they tried to translate what it was I was saying."

Lemon's reflections speak worlds about the chameleon potential of the black dancing body (and of the black body in the white world in a more general way, as in the example of the Anthony Burns runaway case, discussed in chapter 3). This quality, a cultural adjustment, is a survival mechanism. The Ailey dancers "got small" in imitation of the quality that Lemon required of them. Doing what is mandated does not exclude dancers of other ethnicities: They, too, must make adjustments in order to keep their jobs. But the black example is part of the saga of Africans in America where (as in the Burns case) the body's ability to change shape and character—to switch codes—was often a life or death matter. Blacks have become excellent kinesthetic transformers. But even in the act of translation or mutation the black dancing body retains its sense of self, as indicated by these accounts of confidence.

Soul as rhythm, and rhythm as soul: In order to be displayed in the dancing body, the attitudes and attributes that constitute soul force need a medium, a conduit—and rhythm fits the bill. From heartbeat to pulse beat, to pulsing drums and percussive feet, to hips, shoulders, head, and chest articulating accents in thin air, rhythm is soul's topography, metaphorically mapping "the surface of the body with reference to the parts beneath."[7] The two are inextricably linked and justify the discussion of duende and rasa as consonant cultural resonances. Like soul they, too, are connected to a strong and complex percussive tradition. It is noteworthy that Flamenco and Hindu dance genres use the feet for percussion, as do many Africanist dance styles, including the South African boot dances and African American styles of tap. Although his reasons for giving the example are quite the opposite of mine, dance critic André Levinson, back in 1927, recognized this affinity and stated that "between the Spaniard [Escudero, the famous Flamenco dancer] and Jimmy Huggins, the black clown of the Revue Nègre, there is no difference excepting in the dance routine and in the general deportment of the dancer."[8] Like most Europeans of his generation, Levinson was incapable of hearing anything but "the heavy accents of a monotonous but striking rhythm" in Flamenco and tap: For him, both were inferior to European ballet. (We can forgive his ignorance but still deplore the arrogance that led to such Eurocentric delusions of superiority.)

Polyrhythms and counter-rhythms (exhibiting different rhythms in different parts of the dancing body) are fundamental to all Africanist dance forms. Savion Glover says that dancers use the floor—play the floor—the way drummers play their drums. This tap artist brilliantly merges soul and spirit by using "da beat" as a moving symbol, literally and figuratively. His *Bring in Da Noise, Bring in Da Funk* is both an African American story and "the history of rhythm in America,"[9] the story of black soul-as-rhythm and of the resilience, endurance, and survival of African American spirit. Again, that spirit is not confined to sacred or secular spheres. Those terms are categorical errors in the landscape of Africanist endeavor. (As Michael Cuscuna, a white record producer, said in part 9 of Ken Burns's *Jazz:* "We used to get up and dance [in Birdland] to Coltrane: It was as close to having religion as I ever got.") The words of Glover, who grew up in a world of rhythm, say what many dancers feel—not only tap artists: "We hit! It's a gut thing, an artist's thing. You *know* when you're hittin'. When you're straight layin' it down, communicating, saying something, expressing yourself, getting on the floor the rhythm you live by, that's hittin'."[10] Glover's term, "hittin'," and his glowing definition describe the essence—the soul—of soul and encompass rhythm, groundedness, and, surely, attitude.

Soul-as-rhythm is imprinted in Africanist traditions: the synesthetic sense of rhythmic complexity seen in the patterns of traditional African textiles[11]; the dance, music, and speech patterns in Africanist performing arts; children's play such as Hambone, double-Dutch jump rope games, and the exquisitely complex hand-clapping games created and improvised by young African American girls ("Miss Mary Mack" is one delightful example). All are accompanied by verbal rhymes that give added syncopation and layering to the display. Derived from an African-based plantation practice called "Pattin' Juba," the Hambone game involved the rhythmic striking of body parts with palms and backs of hands while the feet patted a steady beat and the performer chanted a part-set, part-improvised rhyme ("Hambone, Hambone, where ya been?/ Down the road and back again./ Whatcha gonna do when you get back?/ Take a little walk along the railroad track.") Part of the excitement and challenge in the verbal play is to improvise new rhymes that fit into the patted rhythms and are added on spontaneously. The game "teaches 'independence'—that is, the ability to execute simultaneous cross-rhythms with both arms, both legs, the head and the torso"—elements that are basic integers in jazz music and almost all traditional Africanist dance forms.[12] These games endow the child who masters them with "rhythmic dexterity . . . bilateral as well as multileveled," inviting the possibility of doing "different things with his right and left sides, meanwhile moving his feet and middle body and shoulders to other beat patterns."[13] These games are seamless fusions

of movement, music, and song melded together by rhythm. And if the player misses a beat, she's "out."

And then there is dance itself. In culturally communicated experiences African American children, like their African counterparts, are inculcated with an aesthetic that values mastery of complex motor skills and a democratic freedom of movement. As explained by Shelley Washington: "I think there is a freedom . . . in the black body. . . . [Y]ou get together on a Sunday in Detroit or something, they'd put the music on and your aunts and uncles would sit on the side and the kids would get up and dance, and it would be almost nasty dancing in the '60s which you couldn't do unless it was . . . with your cousins, and everyone would be 'Oh, go on, girl, get down!' As long as you were doing it with your parents and your grandparents around they'd be egging you on."

Early in life African American kids may come to pride themselves on having this skill, one that may be regarded as something whites don't have and can't get, as demonstrated by this recollection recounted by Bill T. Jones: "We made fun of white dancing. I mean, what can I tell you, we thought we knew the dances. We were doing the Twist easily two years before the kids in my neighborhood, this German Italian community, were doing it. There were dances that we were doing that kids in my school had no idea [existed]. So that, we just assumed, was the difference between white and black people. No big deal, there were just some things that were just part of our world and that were not part of their world."

There is no way to write about soul without giving special attention to James Brown. He was named the Godfather of Soul because that's unquestionably who he is! When asked about soul in a spirited and thoughtful *Time Out New York* interview on his voluminous website, he declared, "Everybody's got soul! Everybody doesn't have the same culture to draw from, but everybody's got soul."[14] Nevertheless, few of us from any culture or era exhibit soul the way Brown does. His performing body is the quintessence of soul-in-rhythm and rhythm-in-soul due to, first, his impeccable sense of timing and playing with the breaks between one rhythm and the next; and, second, his attitude—a fine-tuned combination of hot-and-cool. A good example of Brown's seamless fusion of song, dance, shout-scream-chant, and music is his 5 April 1968 Boston concert. As mentioned in chapter 3, this performance was given 24 hours after the assassination of Dr. Martin Luther King Jr. and included a plea for peace by the mayor of Boston to head off riots. The concert is charged with energy that can go in any direction. With this performance of his song, "Got That Feelin'" (actually, with the concert as a whole), Brown artfully wields the techniques of soul-as-rhythm and through his performance guides, leads, conducts the huge audience with breaks and micro-stops that switch rhythms; with repetitions of physical moves and verbal in-

cantations ("I got the feelin'," and "Baby, baby, baby"—over and over and over again); and—besides dancing all the while he is singing—by breaking out into pure dance when the words, screams, and shouts aren't enough, when movement alone gets down to his soul. All of these techniques are fused into an integrated whole. If only racial integration could be as seamless as this! In Brown's perform-ances the timing of breaks, repetitions, syncopations, and rhythmic shifts acceler-ates to a level that leads either to the lucidity of ecstasy or that of madness. At least in this particularly charged performance, the "feelin'" in "Got That Feelin'" was the movement of soul reaching out, demonstrating soul as the bridge to spirit and the irrelevance of terms like "sacred" and "secular."

Soul is again epitomized in this performance of "Say It Loud (I'm Black and I'm Proud)," with the audience joining in a call-and-response manner. Brown in-tones, "Gonna have a funky good time, gotta take you higher" as, indeed, he con-ducts the energy to a high pitch but keeps the multitude under his thumb. Another song urges, "ride your pony, get on your pony and ride": Just these words are repeated, riffed, repeated. Then he asks the spectators if they "feel good," if they "got the feelin'." By interpolating one song into another, improvis-ing the key and tempo changes, and simultaneously talking with the audience through the words of his songs, he takes them over the top. It is an auspicious co-incidence that Brown used the imagery of riding a horse when, in Haitian Vodun, to embody the deity is to be ridden by the divine horseman.

Besides the many pop artists he directly influenced, Brown's grasp reached those who grew up in post-1960s American culture and went on to careers in concert dance. In an August 2000 *Dance Magazine* article, several postmodern choreographers testified to the legacy of soul accorded them by Brown. Bill T. Jones grew up in the Finger Lakes region of New York State in one of the few black families in his community. Listening to Brown on the radio, dancing to his work at get-togethers, and "[w]atching the Ed Sullivan Show one Sunday night, witnessing James Brown scream 'like a woman,' my father said, [and] fall down in paroxysms of erotic despair, wailing 'I lost someone,' was a bonding ritual like no other for my beleaguered family."

Jawole Willa Jo Zollar talks about her pre-adolescent memories of the Godfather of Soul in terms of another basic aspect of soul—namely, funk—a term that is intimately linked with Brown and the particular driving, hard beat that was his innovation and signature: "When I first saw James Brown 'live,' I was about ten years old. . . . The dancing, dancing hard, the music, sanctified funk, the drama of his famous 'Please, Please, Please.' Begging on his knees, sweat dripping, not worrying about being pretty but being REAL! . . . So now, I am trying hard to keep it real, not pretty . . . dancing hard and keeping it real."

And Doug Elkins put it succinctly, "James Brown as an entity is a natural force, just barely contained by the perfect amount of form. He is a conduit, the essential chromosome for the DNA that contains the genetics of funk!"[15]

In doing his job as the Godfather of Soul, Brown points us on the path of the spirit.

Soul and spirit converge at many meeting points, and separating the two concepts is largely for the sake of discourse. Bill T. Jones describes a place that resides in his chest that he calls "the hallelujah spot": "It's also the aching place where there are tears and anger and laughter and desire all at the same time." For Jones this is the locus where soul and spirit intersect. The site can also be collective, with African American community events frequently serving as unanticipated soul-spirit "convection centers," again driving home the Rev. Wyatt Walker's point about the sacred-secular continuum. For example, from 24–26 January 2002 I attended the International Association of Blacks in Dance annual conference in Brooklyn, New York. This is the only dance conference I have ever attended where a prayer precedes the luncheon speaker and the Saturday evening program. In this way, and in a good sense, an air of sanctity was established as a basic value in the world of "black dance." The evening prayer, given by a young male to open an awards ceremony for outstanding black men in dance, was particularly moving and took on the tone of the black church, with a couple of responsive Amen's coming from the guests. Then, master teacher and elder Walter Nicks, in his acceptance speech for his award, declared, "Dance is not only my life: It's what holds me together!" With each presenter and recipient reinforcing it, the sense of soul-spirit as a basic integer in our work danced across our tables.

There is a bleeding interface between soul and spirit in traditional African American musical forms such as blues, gospel, and jazz. Wynton Marsalis, jazz composer and trumpeter, speaks of jazz holding the potential to "raise the *soul quotient* of America. It can teach us about listening to, and respecting, one another. . . . Democracy is a process; so is jazz improvisation. Around the world, Americans are perceived as a loud, arrogant, profane, superficial and spoiled people. Jazz music and the art of swinging create *spiritual growth* and give us a different, more homegrown mythology, one in which heroes like Coltrane and Ellington are the antithesis of the ugly American."[16]

Indeed, jazz and other contemporary forms of African American musics emerged from a line of continuity (unbroken, in spite of Middle Passage and the breaking up of the black family) that has its roots in African forms of syncopation, polyrhythms, repetitions, and microtones. A beautiful example of this soul-spirit bleed can be found in Bessie Smith's version of "St. Louis

Blues," in the short film of the same name, where she is backed up by a jubilee chorus, the kind usually found in black churches. Smith was known for "the 'spiritual touch' to her singing."[17] Soul and spirit come together in African American churches even when the occasion is not a traditional worship service. Thus, music concerts or prayer meetings can be as spirited and soulful as Sunday morning worship services. These experiences are by no means limited to the African American church, the African American community, or the United States. Marsalis's words are for all peoples. The gospel chorus has become a phenomenon in Germany over the past decade. A *New York Times* article characterized gospel as "a music that looks backward at a traumatic history but also forward to a hopeful future," thus making it fit the needs of contemporary Germany. The article cites a website that lists "hundreds of German gospel choirs . . . who perform the music as devoted amateurs, both in concert and in church."[18] And a poignant example of the soul-spirit connection at work in a secular, non-black milieu was recounted in the following letter of praise published in "The Mail" of *The New Yorker* magazine, in response to an article by Henry Louis Gates on the "chitlin' circuit" of urban black popular theater: "Henry Louis Gates, Jr., notes that black audiences' 'intensity of . . . engagement is palpable.' Last summer, I acted in a short play based on immigrants' oral histories that was performed at the Ellis Island Immigration Museum. One afternoon, our audience consisted largely of retired African-American women. Without disturbing the flow of the play, these women continually gave us—four white actors—sighs and murmurs of sympathy and understanding. We actors gave our best performance of the summer. Wherever black theatre may be taken by its authors, producers, directors, and actors, it will be able to build upon this tradition of participation, which is an asset beyond price."[19]

Bringing us back to dance, and concluding this section, an anecdote told by dancer Bebe Miller is apropos. She described an experience that arose while improvising with Ralph Lemon during the initial process for *Three* (a film she and Lemon made with Isaac Julien, independent filmmaker, 1999) in which she seemed to dance the subconscious muscle memory of her female forebears: "It was defensive. It was highly physical, there was a lot of partnering, lifts and throwing and . . . I felt like I was representing women, black women, against this black man. And then I felt that I was channeling all of my female relatives. I said, 'This is my aunt's back,' or 'These are mother's legs.' . . ." By assuming their gait, physical frame, and familial attitudes, Miller seemed to channel the body parts of her ancestors, giving her movements cultural and historical ground and allowing soul to point the way to spirit.

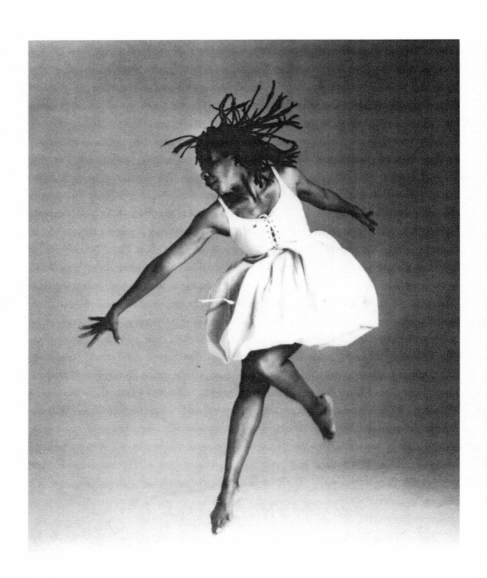

Maneuvering the mystery. Bebe Miller. © Chris Callis, 1996.

SPIRIT LAND

*I love my body. I think my body is beautiful. I have always believed that
it was a place of transformation and that my body, my whole being,
would become a conduit for experiences that were greater than I.*
 —Bill T. Jones, Free to Dance *(part 1)*

*It feels so good to give yourself over to the dance, to just let your spirit go
on that journey, being connected to the divine in the way that you're con-
nected to that when you shout, when you praise in church.*
 —Ron Brown, Free to Dance *(part 2)*

Faith in transcendence, transformation, and a divine flow in the physical body is
a basic integer in the Africanist life/arts equation. This conviction is rooted in
traditional West and Central African philosophy that regards past/present/future
as a continuum and predicates the physical life as lived in/within the spirit. It is
ironic but utterly conceivable that these beliefs were reinforced by American
slavery and racism, two institutions that halted black potential (and frequently
black life itself) in its tracks. The only hope for liberation was in the soul-spirit,
that spark of divine energy that endured despite this hellish existence and would
burst into the flame of freedom in the afterlife: "This little light of mine, I'm
gonna let it shine," says the spiritual. In *One Drop of Blood* Scott Malcomson talks
about blues culture as transcendent, with tropes of freedom, escape, and release
as central to its conception.[20] Likewise, Ralph Ellison addressed the blues as "an
impulse to keep the painful details and episodes of a brutal experience alive in
one's aching consciousness . . . and to *transcend* it . . . by squeezing from it a near-
tragic, near-comic lyricism."[21] The blues aesthetic sprang from the plantation
culture of spirituals and work songs, was the mother of jazz, and is still a viable
force in African American expressive arts, in the black dancing body. From the
African tradition of embodying cosmic forces and dancing one's religion,
Africans in the Americas already had the template for manifesting soul and spirit
in their dance genres.

Talking about spirit is like trying to catch a ghost. "Boogeymen," "hants"
and other disembodied entities figure in all cultural mythologies and held power-
ful sway in the African American past, with many blues songs addressing them.
Spirit and ghost constructs were brought together by Bill T. Jones's use of the
"catcher," a concept that warrants a brief description. In one of the many inter-
views he did with Jones while on tour, Curran responded to a question about
working with him by characterizing Jones as a "kinetic transchanneler." Curran

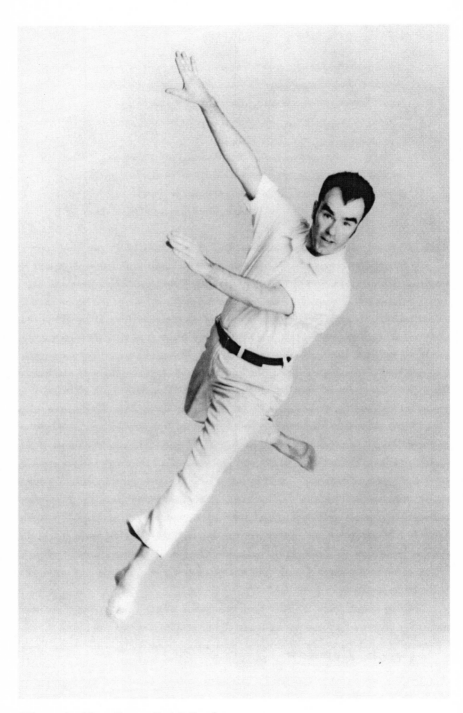

"Ghostcatcher." Seán Curran. Leticia London.

remembers: "Bill said . . . 'Well, if that's true, Seán is my catcher.' And after that, this idea of catcher became part of the [rehearsal] process, and he's had many catchers. We would either watch him move in the studio, try and imitate, copy, you know, spit back, as it were, to him, or he would improvise long passages on videotape, give us the video and we would take it home, we'd work in the studio with it." The idea was to catch the spirit of the movement, as well as the movement itself, to feel it where it came from in Jones, if not to move as Jones did.

The catcher construct returned in a different form years later as *Ghostcatching* (1999), a cogent, seven-minute collaboration in computer animation or "virtual dance" between Jones and video artists Paul Kaiser and Shelley Eshkar. It was presented in Philadelphia on 8 December 2000 as the centerpiece of a program devoted to Jones and his performance philosophy. He is an eloquent, moving speaker, and it was a privilege to see and hear him at the Art Sanctuary, which is a community venue housed in a decaying but vaulted and well-respected church in North Philadelphia, the Harlem of this city. It was serendipity that this edifice—originally dedicated to the spirit and now transformed into the sanctuary for a program that names art as holy—was the setting for an evening whose subject was "ghost catching."

Addressing his aesthetic sources and perspectives, Jones in person introduced the experimental project that we were to see later on a large screen set upon the altar. His deep desire in dance, he said, is "to run faster than history—people watching me'd forget their bodies and through my body we'd commune."[ii] He agreed to collaborate in spite of his reservations. He questioned a process that is based in him, his body, his particular movements, but "seems to exist outside of me," and referred to the traditional Native American feeling about having one's photo taken: "Would it steal my soul?" From these concerns emerged the title, *Ghostcatching*. Kaiser and Eshkar utilized a technique known as motion capture technology. Ping-pong ball sensors were attached to major muscle groups in Jones's dancing body. He was then encircled with 16 infrared cameras that bounced off the sensors, with their photographs programmed into a computer where they could then be digitally manipulated. What the viewer sees on a black screen are white chalk lines limning Jones's motional form and creating a highly sophisticated, animated, multidimensional stick figure which (or who) is alive and well in virtual reality. It is a line drawing in motion, and the

ii. This resonates with a statement by master poet Stanley Kunitz: "I want to write poems that are natural, luminous, deep, spare. I dream of an art so transparent that you can look through and see the world" (*The Collected Poems*, "Reflections," n.p.).

drawing process continues before our uncomprehending eyes. Sometimes his fig-
ure replicates itself, talks to itself (there's a sound track), or draws a path of mo-
tion on the screen that it can either lead or follow. The figure seems to be in the
process of inventing itself, and lines of energy (which seem to represent the spirit
and dynamics that lie underneath the movement) begin to dominate the screen,
so the picture vaguely resembles a complex, da Vinci–like sketch/draft for an oil
painting (yes, I found myself returning to old, familiar reference points to try to
understand the process: using Newtonian thinking for a post-Einstein problem).

The onscreen picture is an abstraction based on a real body—Jones's living,
breathing, black dancing body. My sense was that it would look quite different
had someone else been the mover, that the virtual experiments with Merce Cun-
ningham (whom Kaiser also worked with) were another matter. So the issue of
losing one's soul seems irrelevant: The video image can't exist without a specific,
individuated body/soul/spirit to animate it. In the midst of this visual abstraction
based on his body, we hear Jones humming what sounds like a hymn or folk song:
"Sail away, oh Honey . . . if I had wings," simultaneously reinforcing the ordinari-
ness and the otherworldliness of the event. At another point one of the chalk lines
becomes a path leading to his figure moving at the end of it. In the final section,
Jones's image is multiplied sevenfold, with all the figures attached to one another
by interweaving lines creating a cat's cradle effect on a mega-scale—a hurricane
of connective tissue created of stick figures joined by linear extensions.

For me, this experiment was a cunning exercise prompting questions like,
"Who are we?" "What makes us tick?" "Where does self end and Other
begin?"—and that old favorite, "What is this thing called Life?" It engendered is-
sues uprooted from the time and space we are accustomed to think we live in and
brought this observer to think about the energy behind the mover, the force that
makes us who we are. In a prepared statement made in 1998, the year the project
was developed, Jones said, "*Ghostcatching* holds out the promise of transcending
my personality and my performance by creating a virtual performance populated
by creatures whose movements, though directly descendant from my own, in-
habit a world removed from ours. The possibilities here are astounding."[22] It sug-
gests a new kind of reproduction, an Other relationship with past and future,
creating new descendants from a common ancestor for, indeed, these figures are
sprung from Jones's dancing body.

Just as one of the defining ingredients in soul is attitude, one of the basic el-
ements in spirit is energy, and this energy is often interpreted as a sign of libera-
tion. Turning again to Curran and his work with Jones, as he described his
experience as Jones's "catcher," he said, "I think it's connected to spirit and
soul. . . . It has to do with an articulation of limbs in a literal, physical way, an ar-

ticulation of the spine, a moving from the joints, a freedom." So the paradox: The people who endured four centuries of slavery in the Americas are the dancing emblems of liberation; a flexible dancing body implies freedom of the spirit. Let us take a closer look at this spirit-energy convergence. Several dancers addressed this meeting place from different perspectives.

When asked what she imagined white choreographers would say about black dancing bodies, Marlies Yearby's answer hinged on (black) spirit. She approached the issue in terms of energy, saying the choreographers have to "pull the other cast [members] up to that kind of black dancing body that is very energized by their spirit when they dance. How do they contain that? Or how do they inspire their other dancers to move up to that? Or does that mean that they give [the black dancer] all the time the specific kind of role in what they're creating that [has in it] that kind of dynamism. . . . I think [that] probably is a discussion that might happen." Thus, Yearby imagines a black-specific energy setting the black dancer apart from the white ensemble.

At the end of my interview with Ralph Lemon, and as I did to conclude every conversation, I asked if there was anything I omitted that should be included. He responded by talking about his work with "the Africans"—nine men from the Ivory Coast, Guinea, and the United States—"and the anger and fear that came out." This piece, titled *Geography*, premiered in 1997. Lemon was taken aback by the Africans' "energy and freedom. That wasn't at all dancing that I grew up respecting . . . but how clear it was to me that I was really afraid of that kind of freedom. . . . And I think that [I made an] attempt at dancing outside of my body, that taking my body apart was the only way that I could reconcile the need to go there, because there certainly was a need to have that black—at least what I perceived as a black—body experience. There were times during that performance when I turned my back on it and just faced the wall because . . . it was too much: It was just so alive. And I'm not going to stereotype it as wild and dangerous, but it was just so alive. That was a very, very profound experience for my body and one that I wanted."

In fact, Lemon had addressed the topic of African energy earlier in the interview but obviously felt it was important enough to be revisited. Here are some of his initial comments. Let us remember that, like Gus Solomons jr, Lemon grew up in white America, at one time had an all-white ensemble, and works in the postmodern, "downtown" (read "white") genre of concert dance: "It's like, I'm looking at these incredible beings and . . . there is nothing at all there that I could identify with, in the sense of my being a director looking for dancers. They moved completely differently. Other than the energy. They had an energy in the way they moved that was something that I could get very, very excited about and

inspired by. . . . I saw their energy as something quite almost noble and heroic, and so somewhere along the line I looked at that energy as a good thing, that it was powerfully alive. . . . Their energy is really the only way I could define it . . . within that whole *Geography* project . . . those three years of working with those Africans—that my body then changed. They pushed me on an energetic level that took my old dancing apart, and that was clear."

Asked if he could be more specific about how his body had changed, he responded:

Well, it brought up a lot of anger, so there's a lot of anger in the dancing. There was also a lot of my . . . dancing my body apart, my taking my body apart energetically. . . . It wasn't as simple as flailing, but I think that that would be an easy definition for somebody who knew nothing about movement. . . . It was like an internal moving that was about me literally taking my old self apart. . . . The best thing about the situation is that there was something that I wanted and I think I got more than what I wanted.

That was sort of something that I was able to recognize the moment I landed in Africa, the energetic power they have that's completely around you. I know it's a dramatization but I think most African Americans, we have a powerful energy that exists but it's not grounded. It's very schizophrenic. And so a lot of what I was identifying in their work was just this very pointed, directed energy that had a tradition and knew where it was going.

To a greater degree than Lemon might have imagined, that tradition was indebted to the practice of dancing the deities and embodying their cosmic energies. What Lemon attributes to energy is arguably the spirit marker that defines this section and, like other ontological areas, defies linear analysis. Monica Moseley's comments resonate with Lemon's. (Interestingly, Moseley and Lemon worked together in Meredith Monk's ensemble, The House.) Her reflections were given in response to my questions about the largest, most prevalent area of stereotyping by the white culture about the black dancing body. They closely parallel Yearby's response to the same question: "I think it has to do with energy. And it's something that I happen to enjoy in performance and it's not universal, but that there are so many black performers, and I think about Donald Byrd being one of them, and Ron Brown as another, [and] in the Ailey company, where the magnification of energy is an important element to the performance, and that's one of the things that I see as a white audience identifying with [in]

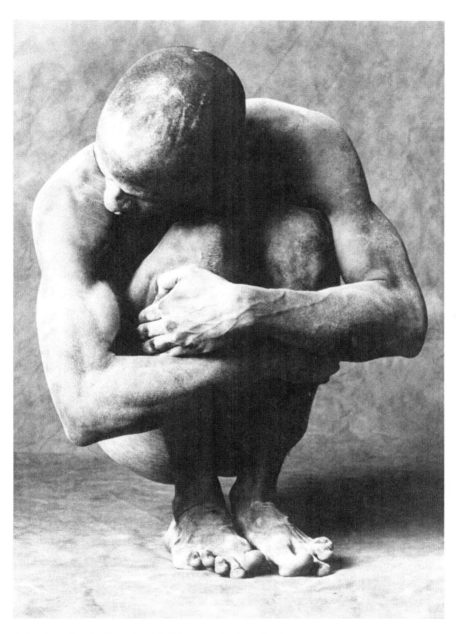

Balancing cultural tributaries. Ralph Lemon. Andrew Eccles.

those performers. Complexions [the relatively new ensemble co-directed by for-
mer Ailey stars Desmond Richardson and Dwight Rhoden]. . . . they push it to
almost an exaggerated degree . . . a kind of frantic level." It may be that what
Moseley describes is the kind of energy that prompted Lemon to sometimes turn
his back during the performances of *Geography*.

At the beginning of our interview Bebe Miller talked about her experiences
studying with Murray Louis and Alwin Nikolais as a child and later in her early
twenties. (In 1948 Nikolais became director of the Henry Street Playhouse on
the Lower East Side of Manhattan, reorganizing it and establishing his dance
school and performing ensemble. Louis joined forces with him in 1949.) Realiz-
ing that she was not going to be invited to join their performing ensembles (it did
not seem to be a racial issue since there were blacks in their companies), her
comments—like Yearby's—show how the idea of the spirited black dancer can
undercut her career potential: "I was valued for something else, like my spirit
more than my dancing body." I then asked her if she could target any dance in
which specific physical attributes affected the way she choreographed or per-
formed. In asking the question I was thinking of the very physical body parts
and aspects—buttocks, feet, skin color—that are discussed in part 2. Instead,
Miller's response jumped right into spirit: "I don't think of it in terms of my
shape, but I know that maybe throughout my performing history, I feel that
there is something about how I do it [solo work] that is more, I don't know if it is
more spiritual or some mix of all of this, where kind of the me of it comes
through. And I feel that that is where I look for some amalgam that is the body,
that is the history in all of that, and that becomes my voice. . . . I'm not being
very articulate about that. . . . It's not about form. . . . [But] when I make some-
thing for myself form serves this mystery, and it's the hardest thing to do when
you choreograph for other people, is to try to find that mystery in form for some-
body else."

It may be that a choreographer cannot program in the mystery—or what I'd
call the spirit; the dancing body, black white or brown, must embody it on her
own. This conversation occurred at the beginning of our interview. A little later
Miller challenged several assumptions about black spirit while also giving the
nod to it. This is her response to my request that she speak what she sees in her
mind's eye when I say the term, "black dancing bodies": "Well, I see that there is
an assumption about, in both black and white people, about a particular spiritu-
ality being more evident. A spirituality, that thing that is in our bodies that takes
us out of just form. That seems to be that ineffableness and although I think that
sometimes is, there are black dancers who are trying to figure that out and trying
to get some, and it's not native, but we sort of assume that it is."

Much of Miller's work can be seen as manifesting the enigma. Is this spirit? Deborah Jowitt's review of Miller's ensemble in the May 1–7, 1996 issue of the *Village Voice* was dominated by the reviewer's sense of Miller's mystery. At New York's Joyce Theater (16–21 April), titles for two of the works on the program—*Blessed* and *Heaven + Earth*—signify a metaphysical direction in Miller's focus. Of *Blessed*, Jowitt wrote: "Yet all the big, hot, juicy movement seems in thrall to some current that's pushing it on. The logic of that current is often shrouded in mystery. Sweating, grinning, breathing hard, she and the eight excellent dancers of *Blessed* propel themselves to a state of grace. Excess is part of it, but as one fine song by The Café of the Gate of Salvation succeeds another I feel as if I'm drowning, that the river is endless. Maybe Miller likes conveying endlessness."

Writing next about *Yard Dance*, the third work on the program, Jowitt said, "When Miller's onstage, you can't take your eyes off her; no one else has her funky poetry. Mysterious yet startlingly real thoughts seem to shape her gestures. Sometimes she looks like a shaman telling the air around her to shush." Jowitt winds up her review with words about *Heaven + Earth*, citing Miller's score (gospel music by the Five Blind Boys, a shape-note hymn, a Balinese Monkey Chant, Gabriel Fauré) and concluding that it is "even more enigmatic. " The final line of the review states: "Does the stick know why it's traveling downstream?" Now, enigma doesn't necessarily add up to spirit, but Jowitt's ending suggests a Buddhist spin on the evening as a whole and reinforces Miller's comments about mystery.

Bill T. Jones's name kept coming up as I delved into the idea of spirit. In his memoir he describes his early artistic process that evolved soon after he moved away from home and helped assuage the yearning for his family and the soul-spirit grounding they provided him. He'd put on a Mahalia Jackson recording, improvise alone in the studio, and find himself in tears. He began to choreograph solos that drew upon family memories and history, with his mother's spirituality his basic frame of reference, claiming that Mrs. Jones's praying was his first and truest experience of theater.[23] A *New York Times* feature article on Jones focuses on the choreographer's search for beauty in his work.[24] For him this attribute is related to spirit and to his family, as indicated by this story recounted in the article: "Mr. Jones's career as a searcher started early on. His first experience of being moved by beauty was seeing his mother in church, tears streaming down her face: 'My mother said, "Child, you've got to get out of self to know the Lord!" She was talking about ecstasy. Then I went in search of it.'" When he sings onstage, as in *Ghostcatching*, you can hear his mother's spirit, the African American cultural spirit, in his voice.

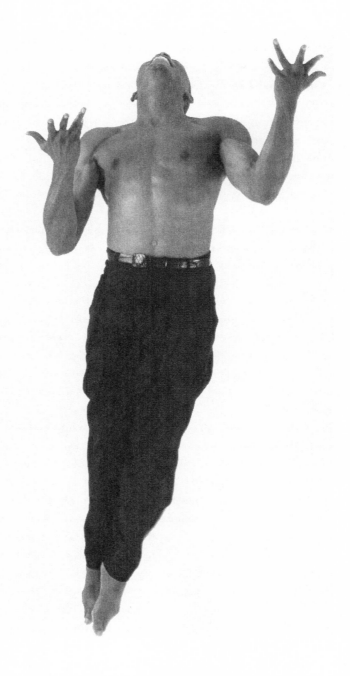

The "Hallelujah" spot. Bill T. Jones. From *Dance! With Bill T. Jones* by Susan Kuklin. Copyright © 1998 Susan Kuklin. Reprinted by permission of Hyperion Books for Children.

⌘

It's Friday night in Philadelphia. The Joni Mitchell special *Painting With Words and Music* is broadcast on my local PBS station (26 April 2002). Besides being a wonderful tribute to her long and respected career as a vocalist and songwriter, the program reveals Mitchell the visual artist. Here, too, her work shows integrity. In a prelude before her first entrance we see glimpses of her paintings, the stage lit in gorgeous color and awaiting her arrival, and we hear her voiceover describing, I suppose, "the races of humankind." She names them — red, yellow, white, black — and assigns each one both a compass and character orientation: "The stage is designed like a medicine wheel — north, south, east, west. North: I know. East: I see. South: I feel. West: I sense. North: the white race, the body. East: the yellow race, the mind. South: the black race, the soul. West: the red race, the spirit." This mélange of New Age philosophy, Europeanist mysticism, and old-fashioned stereotyping makes me want to go through the floor with embarrassment for a woman whose artistry I find inspiring. (And these awkward beginnings are not followed up in the rest of the program, so it remains questionable why they are introduced.) But it is an indication of how steeped our world is in antiquated racial concepts, whether romantic or demonizing in nature. Nonetheless, I am interested in Mitchell's unusual stereotyping, for we know that the white "race" has been stereotyped as "mind," and black as body. But she believes that it is soul that defines blackness and reaches the same conclusion that I do: Namely, that soul is characterized by the feel of things. (I assume she defines the white "race" as body in the sense of material aspirations.) While I am theorizing about the geography of the black dancing body, Mitchell, by coincidence, is theorizing her own connection between "race" and geography. So let us see if we can "catch the spirit" — not by clichés or stereotypes, but by examining specific dances in the final chapter. First, let us see what commonalities are found between soul and two consonant concepts, duende and rasa.

DUENDE

For a long time I wanted to make a film about Andalusia . . . to seize the soul of the region and its music. It's what they call duende — something untouchable. And when you find it, it's stronger than grace.
— Tony Gatlif, director of Vengo[25]

I first became aware of the connection between Flamenco and Africanist percussive dance forms when I supervised Meira Weinzweig-Goldberg's dissertation,

"Carmen Amaya's Dance of Power: Flamenco as a Forum for Cross-Gender Movement," completed in 1995. Here is what "La Meira" (Weinzweig-Goldberg's professional name in the Flamenco world) said, in a letter written to me in 1994: "The connection between African American forms and Flamenco keeps coming up: I got a hold of Amaya's last movie made in Spain in 1936 [*Maria de la O*, directed by Francisco Elias] which includes a scene of El Kursaal, the legendary Flamenco Music Hall . . . and the scene opens with a tap dancer! And, of course, we know that Antonio Gades worked with a tap dancer and Antonio Triana, Amaya's partner, worked as a tap dancer in Spain. Also, Amaya's first Hollywood movie included Lena Horne's film debut and some incredible footage of the Berry Brothers, and I had bought the film [*Panama Hattie*, 1942, directed by Norman Z. McLeod], only to find that she had been cut out of it."

Weinzweig-Goldberg had begun her studies at Temple University as an M.F.A. candidate. During her first year (1985–86) she performed a Flamenco solo that was accompanied by the African drumming of Joe Bryant, master Yoruba percussionist, making visually clear her point about the Afro-Flamenco connection. Historical links between African and Flamenco culture are extensive, due to the Moorish occupation and contemporary Spanish interest in African American tap dance. This history is honored in the traditional Flamenco repertoire. For example, in the spring, 1999 issue of *Attitude*, a dance journal, the review of a Flamenco concert in New York described two dances of interest for our purposes: "'Las morillas de Jaén' is the story of the Moorish girls of Jaén. . . . Next came 'Zorongo gitano.' The program notes define the 'zorongo' as 'a dance that originated with American blacks' practiced by the Gypsies at the beginning of the 20th century."[26]

Let us examine aspects of duende as set forth by Federico García Lorca in his inspiring essay "Play and Theory of the Duende," first given as a lecture in Buenos Aires in 1933. As Tony Gatlif indicated, above, this modality is associated with Andalusia, the southern, Mediterranean region of Spain. To address duende Lorca again and again uses tropes of blackness and conflates mood, hue, and ethnicity in a way that Richard Dyer would probably take issue with (see chapter 5). He quotes a colleague who "pronounced this splendid sentence on hearing Falla play his own *Nocturno del Generalife:* 'All that has black sounds has duende.' And there is no greater truth." He explains "black sounds" as signs and symbols of "the mystery . . . the mire that gives us the very substance of art" and connects this description with the paradox of duende: "'A mysterious power which everyone senses and no philosopher explains.'" Here he quotes from Goethe's autobiography, and Nietzsche comes into the frame in the next paragraph, as well as Greek mysteries. Duende is "the dark, shuddering descendant of the happy marble-and-salt demon of Socrates. . . . Every man and every artist,

whether he is Nietzsche or Cézanne, climbs each step in the tower of his perfection by fighting his duende, not his angel . . . nor his muse." He then explains that "the angel dazzles," and "the muse dictates," the one giving light, the other form, "but one must awaken the duende in the remotest mansions of the blood."[27] In other words, duende comes from the feeling within.

With a poetic voice that describes and analyzes as successfully as that of scientists or scholars Lorca gives a compelling example of duende in action as he recounts an evening's performance by a famous Andalusian singer whom he describes on pages 45–46 as a "dark Hispanic genius." Does this mean that she's moody, dark-complexioned, part African, or all of these? She sends her voice to "the farthest, darkest bramble patches," but is working it only from technique and form. Not until she "began to sing with a scorched throat, without voice, without breath or color" did she reach her duende. Thereafter, "[S]he was able to kill all the scaffolding of the song and leave way for a furious, enslaving duende, friend of sand winds, who made the listeners rip their clothes with the same rhythm as do the blacks of the Antilles when, in the 'lucumí' rite, they huddle in heaps before the statue of Santa Bárbara." Here Lorca connects this Spanish attitude directly to Africanist practice. Murdering the song's "scaffolding" suggests that, as in Africanist practice, energy trumps form and improvisation wins out over codification.

The essay is rich in delicious, enticing examples of duende as feeling, force, power, and process. After describing duende as manifested in vocal expression and music, Lorca saves the best for last and climaxes his piece by examining it as the force that animates dance and, that most singularly Spanish of art forms, the bullfight. Throughout, duende is personified, as in "[a] duende . . . who made the listeners tear their clothes," above; and "duende is at his most impressive in the bullfight," on page 51.

The duende, like African American soul, is grounded in the blood, skin, bones, and muscle memory of cultural experience. It is bare, raw, "beautiful-ugly," to use a Caribbean phrase. Like its African American cognate, it is a culturally specific attitude. It deconstructs and re-forms form through the force and power of feeling. We may recognize its "dark," digging, deep mystery in individuals from other cultures (whether Cézanne or Nietzsche, Janis Joplin or Yo-Yo Ma) and, by extension, say that they, too, have duende or soul. Nevertheless, the origins are culturally specific (although, to repeat, *not* a matter of genes or biology).

Like soul, duende is activated by and predicated upon tropes of sorrow. Central to the character of both is the bittersweet joy-sadness of the human condition. Now, all peoples suffer, but as the Walter Mosley quote points out in the Soul section of this chapter, there are ways that one culture's experience of the human condition speaks so loudly as to touch a resonant chord in all peoples. Accordingly, on

page 47 Lorca declares, "[E]very art and in fact every country is capable of
duende, angel, and muse. And just as Germany has, with few exceptions, muse,
and Italy shall always have angel, so in all ages Spain is moved by the duende, for it
is a country of . . . death. . . . Everywhere else, death is an end. Death comes, and
they draw the curtains. Not in Spain. In Spain they open them."

With this statement we discern yet another in his associations of duende with
black: Black is also the color of mourning/death. (At the same time, in traditional
sub-Sahara African cultures, white is the color of death; and amongst the Maasai
of East Africa, black symbolizes good and is personified as the benign side of
Enkai, the Maasai deity.[28]) If Spanish duende equates with death, then African
American soul's mate is survival, shaped by the cultural experience of Middle
Passage, slavery, and American racism. What Ralph Ellison said about the blues
applies to soul: "They at once express both the agony of life and the possibility of
conquering it through sheer toughness of spirit."[29] Despite their differences, the
concepts of duende and soul are not only consonant cultural tropes but have
crossed paths, both in historical time and in contemporary theatrical practice.

RASA

With no known historical or geographical points of contact between the two cul-
tures, there are obvious (and more than superficial) resonances between African
American soul and the Hindu concept of rasa, nonetheless. Both are driven by an
aesthetic of feeling. Likewise, for duende, soul, and rasa, collective affirmation of
individual expression is necessary "based on the audience's knowledge of the
technique, prior knowledge of the culture, as well as their emotional empathy."[30]
However, in its focus on the calibration of degrees of feeling in Hindu art forms
(including literature), rasa differs from its Spanish and African American
cousins. It adheres more closely to the highly codified aesthetic forms of Hindu
culture, whereas soul and duende embrace the concept of deconstruction and re-
formation—discontinuity—oftentimes in a radical, breakaway fashion. "Rasa is a
codified normative system which does not allow room for dissonance or disequi-
librium," according to dancer/scholar Pallabi Chakravorti.[31]

These comments are not value judgments or critiques. Over the past 40 or so
years I have attended performances by sitarist Ravi Shankar and Alla Rakha, his
master tabla accompanist; and by Zakir Hussain, Rakha's son; and by Kathakali
troupes here and in London (where, in its thrall, I attended all the performances
by one visiting company for a solid week in the summer of 1967). I've been
moved by countless other Bharata Natyam performances and recorded vocal
and music concerts; and by the early films of Satyajit Ray (especially the *Apu* tril-

ogy[32]); and I've felt that these works by a people of color exuded a passion of af-
fect that I seamlessly translated as soul. Even though classical Hindu forms long
predate European colonialism and imperialism (which is true of Africanist forms
as well), all the performers I've seen and heard are products of the colonial past.
Perhaps it is the commonality of oppressed peoples who have survived that
strikes a chord in me. But more probably it is the universality of art that be-
speaks the human condition, as Walter Mosley stated earlier. We are moved by
great art—be it animated by soul, duende, or rasa—regardless of our socioeco-
nomic status, national allegiance, or cultural background.

A major difference that I detect in this cursory examination of soul, duende,
and rasa is that soul and duende reside within the individual practitioner; rasa is
codified within the art form. Indeed, rasa theory names and categorizes the feel-
ings it aims to produce: "According to Bharata, *rasa* consists in the *active creation*
of one of eight defined *emotional* states that figure as the theme or subject of an
artistic work. The four positive emotional states that Bharata singles out are *rati*
(love), *hasa* (mirth/laughter), *utsaha* (dynamic energy), and *vismaya* (wonder/as-
tonishment). The four negative emotions, in their turn, are *soka* (sorrow/grief),
bhaya (fear/terror), *krodha* (anger), and *jugupsa* (disgust). Later speculation in-
cludes in this pantheon the ninth positive emotion of *sama* (serenity/calmness)."[33]
Nevertheless, despite codification, "[r]asa . . . is about direct connection between
performer and audience and belongs in the public domain."[34]

Although it doesn't run on a parallel course with rasa theory, African aes-
thetics has its directives as well. The constellation that I am most familiar with
was put forth by art historian Robert Farris Thompson, in his informed and in-
spired perspective as a (white) cultural outsider. It is by no means the only one:
Continental Africans (including Cheikh Anta Diop, V. Y. Mudimbe, and Alexis
Kagame) and Europeans (including Janheinz Jahn), past and contemporary,
have theorized different systems.[35] Thompson codified the characteristics he had
observed in over 20 West and Central African cultures in his Ten Canons of Fine
Form. Explained in a stunningly limpid, poetic fashion in *African Art in Motion*
(pages 5–45 with subsets and examples), they are based upon centuries-old oral
traditions that give directives for both philosophical overviews and practical ap-
plications. They are applicable to all Africanist visual and performance art forms
and are summarized as follows:

1. Ephebism: the Stronger Power that Comes from Youth—implying vigor
 and vitality, regardless of age;
2. "Afrikanische Aufheben": Simultaneous Suspending and Preserving the
 Beat—indicating syncopation, as well as suspension of expected patterns;

3. The "Get-Down" Quality: Descending Direction in Melody, Sculpture, Dance—which means zeroing in on the focus of one's art, getting down to business, which is sometimes expressed in a virtuosic bursting forth of energy;

4. Multiple Meter: Dancing Many Drums—meaning the superimposition of different meters in performance arts or different levels (metaphorical meters) of representation in visual arts;

5. Looking Smart: Playing the Patterns with Nature and with Line—implying virtuosity, vigor, vitality, even showing off;

6. Correct Entrance and Exit: "Killing the Song," "Cutting the Dance," "Lining the Face,"—indicating high-affect juxtapositions through contrastive openings and closings, beginnings and endings, and the "break" from one meter, rhythm, or affect to another;

7. Vividness Cast into Equilibrium: Personal and Representational Balance—meaning the interrelationship of contrasting elements and/or the complementarity of opposites, resulting in a mean or mediating force;

8. Call-and-Response: the Politics of Perfection—which points to the dialectic of individual and community as reflexive concepts;

9. Ancestorism: Ability to Incarnate Destiny—which indicates respect for and honor of what has come before, and the sense of the ancestors (the past) and destiny (the future) as continuous (and contiguous) with the present;

10. Coolness: Truth and Generosity Regained—this is the Mother concept, the cultural signature of the Africanist aesthetic that contains and animates all the others, integrating them into a seamless whole in an attitude of "being-ness."

Although both Hindu and African systems have other aesthetic guidelines, the rasas and the canons are central to each respective cultural context. I find it helpful to line up the two theories as we scrutinize similarities and differences. The Africanist premises, committed to print documentation in the twentieth century by in-group philosophers and friendly cultural outsiders, have been codified over the centuries by the force of *oral* tradition (practical and theoretical). The rasa system is laid out in the sixth chapter in the *Natyasastra*, the oldest known work on Hindu arts theory, *written* by Bharata probably in the third century A.D. with further commentary added in the eleventh century.[36]

The Hindu system distinguishes the rasas from the 33 "'transitory' feelings, which include despondency, languor, envy, and elation; these feelings are personal in a way that the aesthetically refined rasas are not."[37] This differentiation

between private and collective affect is not present in Africanist aesthetic theory. The question, then, arises as to how to rationalize enjoying the rasa of sorrow or grief: How can one take pleasure in a sad story? The answer is that there is a discontinuity between the aesthetic experience and the lived experience, between savoring and suffering. In the rasa system an aesthetic experience such as sorrow is "not to be confused with the actual experience of day-to-day living. What the spectator is being offered in this artistic experience is not the real world (in which such a painful experience is shown as taking place) but a world transformed by the machinery of art and by the artist's *prathibha* or imagination."[38] Africanist soul reverses the paradigm, with the individual spirit and imagination activating (driving, nudging, forcing) inspiration over and above the "machinery" of the art form itself. In Hindu aesthetics, life's raw emotions *(bhavas)* are transformed by artistic imagination into aesthetic emotion (rasa) "and presented through the vehicle of art."[39] In the soul sphere and in Lorca's examples of duende the boundaries between these feelings are blurry, and part of the power of the African American and Spanish forms is the dangerous matter of trespassing borders and pushing the envelope of form to accommodate new, raw, unrefined nuances of feeling.

Then again, in the Africanist worldview the joy-cum-sorrow experience of traditional African American musical genres (spirituals, gospel music, and the blues) is more a matter of bringing real life *within* the domain of the art form than making a separation between life and art. Similarly, those devotees in African American Christian churches or in traditional religious rituals (from Yorubaland in West Africa through diasporic cognates in the Caribbean and South America) who shed tears of joy or experience in other ways the simultaneity of grief and ecstasy are transcending life's travails by going *through* them via their art forms. "The only way out is through": There's something essentially Zen in the "being-ness" of the Africanist worldview. This experience of joy-sorrow is part of the high-affect juxtaposition subset of Thompson's sixth Canon of Fine Form.

Nevertheless, rasa is not a rigid concept. Like soul and duende, it is more processual than product-oriented, concerned always with the being and doing that lead to feeling, with "an emphasis on emotion and spectacle rather than tight narrative, on *how* things will happen rather than *what* will happen next. . . . The theory of *rasas* (flavors/moods) is concerned with moving the spectator through the text in an ordered succession of *modes of affect (rasa)* by means of highly stylized devices. All Indian classical drama, dance, and music draw on this aesthetic."[40] Besides this over-arching concern about and attention to the feeling — and feel — of performance, other parallels between rasa and soul include devices of repetition, improvisation, call-and-response, and multiplex fo-

cuses that are parallel but culture-specific (meaning that they play out differently in each culture). These components are common in world performance genres that are not spatially oriented in a linear way (that is, with spectators seated in the house or auditorium and performers on a stage, emoting frontally to the audience). Whether in a blues jook joint in Charleston, a Pentecostal church in Harlem, a Yoruba courtyard in Lagos, a Flamenco cabaret in Cadíz, a Tango "palace" in Buenos Aires, or a Kathakali village school in Kerala—intensity of feeling is magnified by the performers' repetition of movement or verbal phrases; by improvising, so that the feeling of the present moment is honored; by the call-and-response of audience participation through verbal and physical movement (shouting, dancing, singing in the aisles, so to speak) to show appreciation (or critique, or even disdain). In this kind of theater "the audience is not expected to pay rapt attention at every moment."[41] Focus, then, is not linear, but bounces around the performance environment and may even mean that eating, talking, or grabbing 40 winks is part of the multiplicity of focuses involved in audience participation.

Now, with these cross-cultural points of reference for soul and spirit in place, let us see them in action in the world of African American dance.

BLOOD MEMORIES, SPIRIT DANCES

Alvin has done what the old song tells us to do: "This little light of mine, I'm gonna let it shine." He has let it shine, let it shine, let it shine, let it shine.

George Faison[1]

In a commercially distributed video of his company made in 1986 by Thomas Grimm, Alvin Ailey alludes to the concept of "blood memories" as he introduces his most famous choreography, *Revelations* (1960). Here is what he says:

"The first ballets [that I choreographed] were ballets about my black roots. I lived in Texas . . . until I was 12 . . . so I have lots of what I call blood memories . . . about Texas, blues and spirituals and gospel music, ragtime music . . . folk songs, work songs—all that kind of thing that was going on in Texas in the early '30s, the Depression years. And I had very intense feelings about all those things. So the first ballets that I made when I came to New York were based on those feelings. . . . [As for *Revelations*,] all of this is a part of my blood memory: my uncles, my family, my mother, all were in these churches . . . very intense, very personal [stuff]."

A German colleague of mine was upset about the idea of blood memories, even in an African American gestalt. For him, a professor of American Studies at Berlin's Free University, the idea of anybody's blood memories smacks of the racism that resulted in Germany's notorious ethnic cleansing. But my rejoinder was that we must always be culturally specific in our observations. African Americans are not Germans hoping to establish an Aryan identity. Ailey is talking cultural history, not racial imperialism, and uses the term historically, not genetically. In the Ailey sense,

blood memories are a subtext in the script of what we see and experience as African American spirit. As Bill T. Jones said, quoted as an epigraph to the *Soul* chapter, you don't need to have been enslaved to remember the auction block. Still, this doesn't mean that only African Americans can successfully dance the works of African American choreographers, as is proven by the personnel in both Ailey's and Jones's ensembles. Yet both men indicate cultural memory as basic to their creative impulse.

Contentwise, any dance can capture the spirit. It is not a matter of what a dance is about—*the what*—but the dancing body's performance, the living dance in the present moment—*the how*—that is the essential ingredient. Nevertheless, there are certain movement techniques and motifs that help to harbor spirit. Alvin Ailey's work is based in part on a modern dance vocabulary known as the Horton technique. Developed by West Coast choreographer and legendary teacher Lester Horton (who was white and trained a host of exquisite dancers, including Ailey, Carmen de Lavallade, Janet Collins, Bella Lewitsky, Joyce Trisler, and James Truitte), this way of dancing holds exceptional possibility for spirit catching. For example, in one of the signature Horton "layouts," the dancer, with her spine in a deep, deep arch (so that her back is nearly parallel to the floor—"laid out"—with chest and face open to the ceiling), simultaneously lifts one leg forward and stretches it so far up and out—simultaneously high and away from her body—that the pelvis and standing leg are pulled forward from her center of gravity by the force and direction of the lifted leg. It looks as though she will tumble but she doesn't, because one or both arms are stretched overhead (meaning parallel to the floor) pulling her in the opposite direction and, thus, creating a seesaw counterbalance. This kind of dramatic movement, a reaching of every part of the body in opposite directions, is a metaphor for human longing, for aspirations beyond our means and desires beyond our condition—paradoxically, body tension implying mind/spirit release. Besides this stretching technique, another spirit catcher is the torso articulation that is integral to all African-based movement forms. Just as in traditional Africanist religions, where cosmic forces are embodied through similar torso motifs, the articulation of shoulders, rib cage, stomach, pelvis, buttocks, and neck with rolling, undulating, shaking, circling, or rocking motions, combined with syncopated rhythms and movement repetition, are known means of calling forth the spirit. There is an undeniable connection between these kinesthetic (muscular and motional) movements and their ability to generate certain affective (emotional and spiritual) states. Yet another spirit catcher lies in the gaze. Eyes may look outward, upward, seemingly beyond the physical to the supernatural. Head and chest may follow through,

lifted up and open or thrown back. The savvy dancer may luxuriate in these techniques and, like a Method actor, fill them with her subjective subtext for whatever this kinetic challenge may suggest on the affective level.

Like the movements involved in tap dance, social fad dances, and the holy dances of African American Christianity and traditional African religions, the movements described above are abstractions. I've never understood why "black" dance has been characterized as narrative. Africanist dance is symbolic movement. It may tell stories, but these stories are about the movement itself and about concepts—the body dancing its symbols. And no dance form is more abstract than tap, where the "story" is the rhythm. If a floor-scrubbing, drug-taking, or bird-flying image is woven in, that realistic flash acts as a momentary anchor in an ocean of free-floating signs. These aspects of daily life or nature, though used thematically, are seldom literal or linear representations of, say, an ostrich or a battle. Instead, they evoke the ostrich quality of the human body, an abstraction from nature placed in the conscious artifice of the dancing body; or the essence of battle through a codified, stylized, theatricalized war dance (and traditional black dance genres place high value on technique and artifice in the service of expressiveness). Part of the excellence in representing a bird or a battle (and part of what Africanist aesthetic criteria rest upon) is the level and degree of personality and meta-commentary brought to bear on the performance by the individual dancing body. It's not about the thing-in-itself (for Africanist art forms are seldom naturalistic, which is why there is no landscape art or portraiture in traditional genres), but the reinvention of the thing *through* the self, if you will. As for *Revelations*, critic Anna Kisselgoff wrote that it "is not an illustrative work but an abstraction of certain emotional states. A ballet version might offer a more pure-dance approach. It would look more plotless but not necessarily as abstract in the sense of extracting the essence of a quality."[2] Thus, in Kisselgoff's usage and in mine, the word "abstract" as applied to this dance genre indicates choreography that may include symbols or emblems from naturalistic practice but is dependent on creating a life of its own, generated by and through a motivating idea or thesis (such as those expressed in this chapter by Ailey and Ronald Brown). Like the work of Martha Graham, Ailey's and Brown's abstraction is based on the dramatic use of human affect (emotion, expressiveness) rather than the suppression of it.

To give an example, Brown describes his work *Gate Keepers* (2000) as a dance about people waiting at the gates of heaven.[3] But the spectator cannot know this by watching the performance; this insight is Brown's private subtext (augmented by information given in a program note) for what is a symbolic, abstract, yet spiritual dance. From the audience perspective we see no concrete evocation of heaven or of souls trying to enter it. What we do see are certain

poses (standing at attention or at ease) that suggest a militia or a similarly regimented corps, with uniformity reinforced by the simplicity and similarity of the dancers' costumes (males and females dressed in camp shirts and matching twill pants in neutral shades); we see the upward or outward gaze described earlier; we see kneeling positions combined with this gaze (here suggesting that the dancers are momentarily felled by the force of the Holy Spirit, recognizable as such to those of us who are familiar with African and African American religious practice), and positions in which chest, neck, and face are lifted and tilted on an upward and backward angle suggesting attention to heavenly stimuli. What we sense as spirit does not reside in verbal or linguistic translation of Brown's stage event (nor in the thought-images that Brown had in mind as he choreographed) but in the way the dancers *embody* an energy that we collectively identify and characterize as spirit, and the way we as audience enter the dancers' experience at their level — not verbal or cognitive, but kinesthetic, intuitive, and affective. Finally, a rhythmic terrain is an integral attribute of spirit in dancing, with rhythm interpreted in its broadest definitions — ranging from beat, tempo, pulse, and attack to flow, cadence, reappearance of themes, call-and-response, undulation, swing, balance, proportion, symmetry. All of these specific and generic landmarks may usher the dancer and observer into spirit land.

Nevertheless, spirit can be aided and abetted by form. For example, in the opening dance of *Revelations*, performed to the spiritual "I Been 'Buked and I Been Scorned," the ensemble is clustered together with arms extended in a descending flank of limbs that serve as a place of refuge. The dancers spill out from this collective shelter in expressive individual movement and then roll, dash, slide back to the haven of the group formation in synchronicity with the stanzas of the hymn. This formal structure — gather-spill-regroup — in itself is a powerful tool in the hands of a master choreographer like Ailey. To be able to move the space — not only to design the bodies in the space — is a task that many choreographers have not mastered. Taken in harmony with the inspired dancing bodies and the music, this opening statement ushers in a transcendent theatrical experience that sends chills up the spine of this observer. Indeed, use of spatial formations in *Revelations* is a quintessential concert dance model of spirit catching. In other contexts, particularly the ritual sphere, the circle formation has been utilized as the frequent form for catching the spirit. Most Africanist ceremonies on the continent and across the diaspora are performed with practitioners moving in a counterclockwise circle for a central portion of the ceremonies.

Again, spirit shows up wherever and whenever sublime dancing occurs, be it in hip hop, ballroom, ballet, Bharata Natyam, club, disco, "downtown" postmodern, or any other spheres. Spirit transcends and transgresses categories and

is not confined to or defined by a specific form or venue. It resides in the dancing body and is manifested in "per-formance"—going through and beyond form.

Before the performance begins some African American–led dance companies hold a collective prayer or meditation backstage. There are many superstitions that compel all performers, regardless of ethnicity, to do or say certain things in particular ways to guarantee good luck ("break a leg," "merde," and many others). However, collective prayer is imported from another shore of black life and reminds its participants of their connectedness to the wider sphere of black endeavor. Most companies rotate the individual who leads the ceremony. According to Joan Myers Brown, the Philadanco leader for the particular evening first says "whatever the spirit moves them to say. Then we end up with the Lord's Prayer and the statement, 'We have nothing to prove, and we have everything to gain.'" According to Chuck Davis, his African American Dance Ensemble converges in a meditative circle (he explains that there are too many different belief systems amongst his dancers to adhere to any one tradition). Usually Davis will designate who is to lead. That person is obliged to "make a positive statement," as do others in the circle. Two gestures end their coming together. First, some traditional African gesture of respect is offered—either a call-and-response; the utterance of the word *Àṣẹ*, which is analogous to saying "*Om Tat Sat,*" "Amen," or "so be it"; or a ritual called *Dobale*, with gestures toward heart, earth, air, heavens, and everyone present offered in a symbolic fashion. Second, "everybody gives everybody *genuine* hugs!"[4]

Ronald Brown's written response to the same question is as follows: "We come together, alternating man, woman; we hold hands, close our eyes, and pray silently, independently. We open our eyes, when we are individually ready, and then we raise our hands, still holding on, to the chest level, and we walk in towards each other until our hands are touching. We put our heads together and breathe naturally. And then all together we back up, each in our own direction, until our hands pull apart, and we reach our hands out to the sides and up towards heaven, confessing our intention to spread that energy that we summoned up. And when we are as far away from each other as possible and still in the circle, we are done. Some folks touch the ground to finish the blessing. And then we hug, each one finding another, wishing them well for the dances that we are about to do."[5]

With so many signifiers in thought, word, and deed, it is no wonder that spirit manifests so tangibly in these dancing bodies.

Let us focus on the Ailey masterpiece *Cry*. In the Grimm video Ailey explains how it came about: "I made *Cry* in 1971 as a birthday present for my mother. It

was made very quickly [according to Judith Jamison, in eight or ten days, after they had just returned from yet another tour]. It's a tribute to black women. It has to do with the struggles of black women in an abstract way through images of slavery and servitude and in the second part, rage and anger, and finally joyfulness."

Ailey mentions this work as an abstraction, which is basically true of all his work in the sense in which I have discussed the concept. As with the spirituals suggesting a frame for the movements in *Revelations*, so the tripartite score of *Cry* forms a landscape for containing emblems, symbols, motional tropes of suffering, longing, survival, triumph, and joy. After Ailey's statement, Jamison addresses this solo that was originally made for her: "*Cry* goes from—in my image of it— being in Africa . . . being forced onto a ship and taken across the seas and forced into slavery and putting up with the hardships of living in a ghetto but triumph- ing over all the badness that this life can bring—a black woman!—and still tri- umphing over all of it with the head held high. And that's what it feels like when you go from the center of that stage and start walking slowly down toward the audience. Not only do you take the audience with you, but you're on a trip your- self, you're on an excursion, you immediately get pulled into the situation of the dance and by the time you finish you feel [demonstrates with an expansive, open-armed gesture, generous smile, and satisfied sigh] triumphant."

Cry, then, is a solo journey of some 16 minutes' duration, a pellucid victory dance that heralds the energy and spirit of (black) womanhood as contained in a thesis-antithesis-synthesis format: The problem is stated; the struggle ensues; and the resolve brings closure. How significant that Ailey chose to have a solo fe- male statement of black womanhood symbolize the liberation of the spirit; and that he made this statement in homage to his mother—really, to all black moth- ers! Revering the mother is a powerful emblem of cosmic spirit in the Africanist worldview; and Africa is considered the Motherland (whereas Europe is often characterized as the Fatherland). As womanist scholar Akasha Gloria Hull stated, "African American women are indeed 'doing it'—are still being spiritual carriers in a predominantly white, patriarchal society."[6] Socially and economi- cally, black women in America have always been at the bottom of the barrel— layered beneath black men, then white women, with white men at the top.

In this 1986 performance Deborah Manning dances the role originally cre- ated by Jamison.[7] The first section is performed to the music of Alice Coltrane (a composition titled *Something About John Coltrane*) and is a statement of African and African American roots; the middle section uses Laura Nyro's *Been on a Train* to frame its message of urban struggle and oppression; the final section, set to Chuck Griffin's *Right On, Be Free*, is a triumphant celebration. Like the work of

Ron Brown that begins in the 1990s, the soul-spirit power of a danced idea gathers force by the techniques described above: accumulations of movements in the flexible articulations of the torso; limbs shooting, flying, or stretching away from this center; bodies manifesting rhythmic syncopation; and the yearning gaze, with uplifted, arched, open, longing stance in chest and face.

The Coltrane section is an invocation and prayer. What we see as the lights come up is a pillar of white: Manning is dressed in a full-length, voluminously wide white skirt that ends in two even wider ruffles. Her invisible arms stretch straight overhead to the ceiling, concealed, as are her face and torso, by a long white shawl that hangs draped and suspended from her raised hands down to her feet. Slowly, ceremoniously and soberly, she lowers and stretches her arms forward and begins a serene, winding walk from upstage to downstage, the shawl now lying loosely over her extended arms like a ritual offering to the spectators. We may feel she is opening the door to her past, presenting to us the book of her life and inviting us to join in her story. This one prop moves through several transformations as the dancer swiftly travels through a bevy of nuanced moods, some irreducible to word translations. She is the ancestor, the all-seeing one who proffers movement constellations that evoke birth, awakening sensuality, childbirth, captivity, abuse, protest, servitude, with a heroic self-possession that remains intact through each transition. The scarf begins as a sacred cloth and is sometimes transformed into a prop: a bedsheet for a child or other loved one; a scrubbing rag; a crownlike turban; a shawl; shackles. Like Coltrane's gorgeous music, the movement is simultaneously minimal and richly clustered. Tropes of servitude, slavery, and suffering are abstractions that are given shape in a flash before they dissolve, subsumed by the next movement motif. At one point the shawl is scrunched together while the dancer uses it for a few seconds to scrub the floor in short, staccato gestures; but the motion is so distilled that it could be Lady Macbeth trying to erase a spot of blood. The movement vocabulary of expansive arm and leg extensions, turns, and full torso contractions maneuvered in variations of direction, dynamic, focus, and intensity are used at points with fists clenched and/or wrists crossed to suggest shackles and perhaps also rape and childbirth. This opening section is a dance of recall, remembrance, re-membering—as in putting back together all the parts and phases of a life to make it whole and holy again. It ends with the dancer lying vertically supine at center stage, her head downstage, feet pointing upstage, hands crossed over her breast, the cloth stretched horizontally across the front of the stage and above her head—where it will remain for the final two sections—suggesting death's winding sheet but also peace. The sections to follow are key chapters from this life book: the middle, grief period; and the phoenix rising.

A few key words supplied by Laura Nyro's exquisitely expressive song are enough to set a ghetto soundscape and stage picture for the middle section: words that speak of seeing someone "take a needle full of hard drugs and die slow"; of being "on a train," to never again "be the same"; of coming up from the South, as did so many blacks in successive twentieth-century waves of migration. Looking for a better life, they encountered new forms of oppression. Actually, the dancer begins before the music. From the final position of repose in the Coltrane section she performs the following sequence of movements in about five seconds: sit up, still on the floor; snap the head over the right shoulder, sending a sharp gaze out past the wings; follow through with the torso turning to follow the gaze, the legs now positioning in a low lunge (like a runner at the start line, left leg forward and bent) in the direction of the gaze, while clutching a huge swath of the skirt hem with the right hand; remain in lunge, but snap the head (and gaze) forward, throwing an angry glance to the audience; on one count lift the body and pivot to face front, planting legs in a straight-kneed, wide stance; in this straight-up pose, fling the skirt out of the right hand in a gesture of anger, as though throwing it (or this part of one's life) away. Then the music begins, and the memories take shape. Manning now uses the contractions in a different way and for a different purpose. Her torso concaves, sending out a palpable affect: The word "anguish" sort of touches on it but, again, much of dance is untranslatable, and words merely approximate the body-mind-spirit connection. Arms reach out but seem not to grasp. Sometimes the hand/arm seems to wave, be it to beckon, bid farewell, or ask for acknowledgment. And the gaze — the gaze flickers anger, remorse, dread, self-assertion, with subtle gradations and changes moving through Manning's eyes and facial expressions as the movement travels through her body. The arms retreat, with the contracting torso, hands forming tight fists; they reach out with stretching-yearning energy, and then retreat again in unfulfillment. Neither narrative nor illustrative of quotidian states, the movement travels through landscapes of physical and emotional affect — the terrible-wonderful, bittersweet feeling of reaching, turning, and contracting in such a way that the motion evokes the emotion. In a dance such as this the face is used expressively as the spectator bears witness to the unfolding of a drama — a dance-drama. Nyro's lyrics tell of a man who has more (needle) tracks on his body than tracks on a train. This middle section is black woman's response to black male pain and intimates that black males are an endangered species. It ends almost as it began, but with a difference: Resignation and grief replace anger and defiance. Manning returns to the wide-legged stance of the beginning, kneels momentarily while burying her face in the ruffles as she again clutches the skirt in her hands, returns to standing and the contractions and reaches of the beginning, though

they feel slower, longer, and less energized. There is a final, incredibly long reach of one arm (surely her shoulder must ache) with the torso following through; then, in one swift movement as though a rubber band has snapped, she rebounds back to her center, curving/dropping forward from the waist, head toward floor, as legs bend into a wide squat. For now, defeat has won out.

But not for long: From this position she uncurls her spine to stand and begin the liberation section. Now, ah now, the same movements—torso contracting, circling, reflecting the rhythmic syncopations of the score—are put to a new service. The contractions are used rhythmically and in an upbeat tempo to open the chest and rib cage and suggest flight and freedom. These movements have a direct sense of Africanness that is absent from the other sections. In one flash we think we are seeing a West African Ostrich Dance in the use of arms and torso and body carriage. At another point the dancer holds the hem of her skirt at both ends (as one would do to prepare to curtsy) and, with a syncopated turning step, reveals strong brown legs kicking high against white ruffles. The face is an active, joyful participant in the celebration. This dancing body is laughing and the sense of the journey from the beginning to this climax opens the hearts of the spectators. We fly on the wings of her spirit, her energy. The Griffin lyrics ring out a message of going with the wind, flying with wild geese, flying free, flying high, flying home. Manning's skirts are wings, wind, and a banner of freedom all in one. Her dancing body is spirit and soul personified, her dance a transcendent experience for her and her witnesses, in a movement vocabulary that leads both performer and spectator to soulscapes and spiritland.

Choreographer-dancer-teacher Ronald Brown says he has "always tried to get people . . . dancing with their souls."[8] David White, artistic director of New York's Dance Theater Workshop, said of Brown's work: "You see a joy of movement and a joyousness that comes from the movement. . . . Such a joy can't be underestimated in our time."[9] Like Abdel Salaam and his Forces of Nature Dance Theater, Rennie Harris's PureMovement hip hop company, Maia Garrison's M'Zawa Danz and the work of Nia Love, Brown's ensemble (named Evidence) is pushing the envelope of contemporary concert dance through an African letterbox, with a diasporan message sealed inside. The results are a fabulous, joyous celebration of dance, soul, and spirit. One of the dance genres that has profoundly influenced his choreography is *Sabar*, the national dance form of Senegal (whose fast footwork, turned-in knee and hip positions, and flying or windmilling arms ending in flexed wrists was a defining characteristic of the signature dance of the

1920s, the Charleston[i]). The results are layered and subtle: Brown knows how to dig under the obvious rhythms atop the movement and show us the pulsing flow of energy beneath. (This is an Africanist aesthetic premise of contrast that is another way of channeling energy in the service of spirit.) Not that his rhythmic scores are obvious: He works with some of the most sophisticated and highly skilled composer-musicians in world music today. And in Brown's own black dancing body we see African ancestors meeting and melding with their diasporan descendants. What is interesting is to see how Brown uses the same vocabulary, largely African, and sagely moves it to include particular motifs—like the praise movements from the African American sanctified church—to tailor his basic movement vocabulary to specific purposes. He may also take what seem to be purely African movements and change their meaning by simply performing them to a gospel hymn accompaniment. He utilized both methods in *High Life* (2001).

Of his aesthetics, Brown says, "I've always thought of my dances as being physical narratives or physical journeys."[10] In this observer's eyes, his dances contain hints of a theme upon which he hangs sensational movement. In that one sense his choreography is analogous to classical ballet: The story is an excuse for the dancing (the pas de deux between male and female in *Sleeping Beauty* more important than the fact that the female is Princess Aurora and the male a suitor). But Brown does not work from fairy tales, and his "physical" stories are abstract strokes that feature the dancing body as the evolving adventure. And, given the world we live in, he differs from ballet in that everything in his world speaks to and of a people—black people—who traditionally hold dance as the (spirit) center of life itself. In his non-narrative, non-literal, physical stories Brown's choreography harnesses this unnameable energy and power that we attribute to the magic and mystery of spirit.

An interesting stratagem that Brown has used in dances such as *Dirt Road* (1994) and *Gate Keeper* is to have performers remain standing or seated onstage while others dance. This device increases the sense of storytelling by introducing a participant-observer and connects with the African American church, wherein the concept of "bearing witness" to one's neighbor is central. Another concept that Brown utilizes is that of a "holy army." As early as 1992, with his work *Combat Review: Witches in Response*, he was concerned with "[h]ow we all need to come together and make this army. We were talking about AIDS issues, women's

i. These characteristics are African retentions that were reinterpreted in each successive generation of social dance and were able to survive due to the segregation that kept blacks and whites living in separate worlds. See Dixon Gottschild 1996 for more on this.

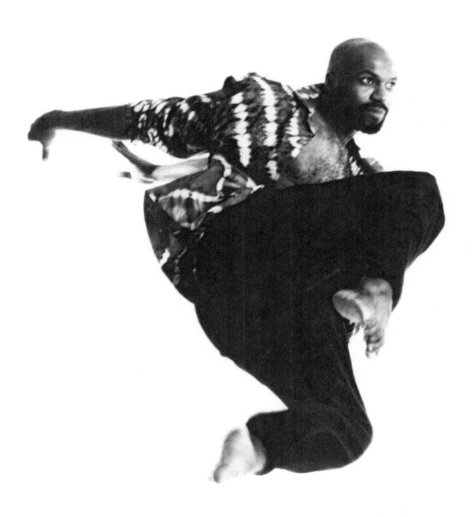

Soul spirit soaring. Ronald Brown. Photo by: Rose Eichenbaum.

rights issues. We were going to do it all—the physicality and the politics." At some point he had to concentrate his focus, realizing that in taking on all these issues he wasn't telling his own story.[11] At a 2001 Philadelphia showing of "Lessons," a section from a larger work titled *No More Exotica* (1995), he prefaced his introduction by describing our era as "this time of spiritual warfare."[12]

Enter *Gate Keepers*. Premiered in 2000 on the occasion of Philadanco's thirtieth anniversary, this 19-minute work was the final section of a four-part tour de force, *On the Shoulders of Our Ancestors*, with the first three sections choreographed by Walter Nicks, Milton Myers, and David Brown, respectively. Performed again as an independent work on a showcase by Danco in the spring of 2001 and at the Lincoln Center Out of Doors Festival in August 2002, it holds its own as a moving, powerful experience in Danco's repertory. The program note for the premiere performance stated, "This ballet symbolizes the dancers as 'soldiers walking toward heaven, searching for the wounded and looking out to make a safe haven for others to follow.' This piece brought together two collaborators, Ronald K. Brown, choreographer, and Wunmi Olaiya, composer-designer, who are on a similar path in terms of their interest in honoring tradition in the context of contemporary artistic expression. *Gate Keepers* is a story of homage, celebration and an acknowledgment of conscious continuity, interconnectedness, history, tradition, and perseverance."

The original cast of dancers, five women and one man, were Kim Bears (who retired from the stage at the end of the season), Hope Boykin (who joined the Ailey company the following season), Candace Whitaker, Willia-Noel Montague, Hollie Wright, and Gabriele Tesfa Guma.

Here are Brown's words from the videotaped prologue section of *On the Shoulders of Our Ancestors:* "*Gate Keepers* is about the gate keepers of heaven, kind of a reminder to all of us to be mindful of our duty and service to God, and always focused on work. Politically and socially it's connected to Eleo Pomare . . . always challenging us on the political and social, and the spirit always being there because that's what sustains us; and Audre Lorde who was an incredible poet and would always challenge and ask you, 'Are you doing your work?'—just on this planet—are you focused on your work. . . . So I think of the two of them. . . . [*Gate Keepers*] is [pause] kind of like some children running to the gate of heaven to wait for themselves." In this context the word "children" has multiple connotations.

I discern three sections in this work. Unlike *Cry*, there are no clear demarcations between them. Like water (and like *Water*, the name of a similarly silky Brown work from 1999), they flow into one another. The first part stakes out the territory; in the second the dancers face the challenge and figuratively wrestle with the angel; the third is homecoming.

Gaze. The upward gaze. The eye of transcendence. The escape gaze, with the eyes as the window of the gaze, sighting the escape route from human bondage; that is, we may go as far as the eye can see, if the eye can see far enough, and see enough. The Brown gaze is devotional, and there is a gesture of surrender in it — chest, neck, and face opening upward, bared in all their vulnerability to come what may, and trusting that God will provide. There are moments when the dancers' gaze seems to engulf the stage space. They are lookouts — gatekeepers — peering left, right, backward, upward. In the first section the gaze is combined with a crouching pose: kneeling, but with the knees off the floor, the body tilted backwards (and open in "the gaze"), the weight supported on one arm stretched behind the body, with hand on the floor, so that the dancer momentarily looks off balance, about to fall or already knocked over by the force of the Holy Spirit.

Then there is the stance, the posture. The dance begins with the full cast on-stage. They stand "at ease," with feet shoulder-width apart, hands easily clasped behind the back. The effect is simultaneously proud and humble, a still point to come back to after breaking out into glorious constellations of movements. Like the gaze, this position will recur in the piece and, combined with it, will form the final, light-filled image that ends the work.

Between gaze and stance is Brown's innovative movement vocabulary, a language that helps heal the wounded mind-body-spirit. Integrating African, European, African American, modern, postmodern, concert, club, hip hop, and disco styles, Brown trespasses the divisions that segregate these genres. He is working with microrhythms in this flowing, stop-start, repetition style established by the "drum and bass" club music that is his accompaniment (and is shot through with vocal echoes wafting in and out). Like the enticing soundscape, bursts of movement erupt and abruptly stop like sentence fragments, suspended phrases, exclamations, and intimations in verbal conversation. Omitted are the resolutions and transitions that we are accustomed to in ballet-based dance forms. These are talking bodies speaking Ebonics! Some of the gestures come from traditional African practice and in ceremonial settings are used to encourage the deities to come or to signal that cosmic forces have been embodied. African movements become identified with African Americans "getting happy," getting the Holy Spirit. In a signature example of Africanist reversal, the loosely flying, windmilling, *Sabar*-style arms actually establish a balance in what looks like chaos. What seems uncontrolled movement is really a virtuoso display: maintaining a traveling center while spinning the arms and legs and moving across the stage in swift, syncopated movement phrases. We can recall such virtuosity in excellent examples of traditional African dance. In both cases the spirit is suspended in these energetically soulful moments like a physical specimen captured in agar.

At times the dancers perform a gesture of pushing the arms to an open position through flexed hands. The movement can be seen to clear the air, to repulse negative energy, to open the stage space, the heart space: closing off one thing to open to something else. Another arm gesture is used in the opening section: Inclining the body as in preparation for a bow, the dancer extends the lower arm like a sword or gauntlet toward the floor in a staccato gesture. Both gestures are brief flashes in a whirlwind of movement, markers on the road of Brown's physical narrative. Brown's choreography is as technically proficient as Ailey's, but stretch and leg extensions are different, more Africanist than balletic. Arms may be flung, rather than elongated, creating body angles and lines that in ballet would be considered uncouth. There is something like the human heartbeat in this repetitive but never static movement and music: Fast and fluttering, then irregular, then arrested, then steady pulsing; and the idea of spirit builds through the intensity of this visceral, visual experience of felt rhythm in sound and movement.

"To dream is to realize, to realize is the fact that you have dreamt," chants the voice in the score as the second section opens with full cast onstage; "whatever you choose in life . . . just as long as you dream." Mooring this section are two duos and two gorgeous solos (danced originally by Kim Bears). It is also interesting that Brown incorporates no lifts in the choreography—another similarity to traditional African dance. (The practice of a dancer, usually male, lifting another, usually female, is Europeanist.) His duo sections are not so much duets but call-and-response between two people, one partner moving, while the other watches, the second responding when the first has finished. After completing a densely clustered phrase of intricately patterned movement the performer simply stops (instead of winding down or segueing into a conclusion), almost literally turns off, actually moving from hot to cool in one beat before either standing to observe the next performer or walking off stage. Bears's solos do not exactly bookend this middle section (that'd be too obvious, in the world according to Brown), but one is near the beginning, the second near the end. She then returns to lead in the opening of the third and final section. Camp shirts have been shorn, with dancers in their tees as they dance the spirit of the score: "I live for joy, I live for life, come with me, come dance with me, come move with me, feel with me."

As in Africanist Pentecostal churches, the energy of the movement spills beyond the boundaries of dancing bodies—past the constriction of clothes and the confines of flexed hands and arched spines. Just as the ritual space of a *Vodun* or *Candomblé* event is charged by the proceedings so here, too, the stage space—not just the bodies moving in it—is charged by the energy spill taking place. Here, as in

Cry, the final section is the victory, the dancers pouring out phrases and spinning the magic web of the danced moment. The very last movement speaks to me of the possible terror of ecstasy, that maybe angels aren't cute little cupids but awesome beings: The dancers abruptly stop their joyful movements; coolly clasp hands behind backs in the "at ease" pose; turn and walk upstage, backs to the audience; stop in a horizontal line across the upstage area. As blazing white light washes across their faces and upper bodies from the right side of the stage, in unison they turn their heads over the right shoulder and send their gaze into the light. Then, blackout.

If my description of *Gate Keepers* seems impressionistic, almost infatuated, it is because I've tried to write in the way that I received the work. Brown's gift is in channeling emotion into motion, neither in a romantic nor conceptual way, but in a direct, unsentimental, kinesthetic transfer that touches the spirit. As one reviewer put it, "if spectators came away [from an Evidence concert] not knowing quite what to think, they certainly were reminded of what it is to feel."[13] This "feeling" is physical and kinesthetic as much as it is affective—again, the motion as the vessel or channel—the call—for the emotional response that transforms into spirit. Brown's work is a paragon of dance as catharsis: The dance doesn't mean something else or give another message—it *is* the message.

Unlike the praise dance and liturgical dance movements of today, the Ring Shout was made to be experienced, not observed. It is still practiced in small pockets along the coastal area and Sea Islands of Georgia including the two communities that form the basis for my discussion, in McIntosh County and on St. Simon's Island.[14] The film *The Georgia Sea Island Singers* was made in a recording studio, and the McIntosh County Shouters' performance was videotaped on an unlit lecture stage, half of which was dominated by a podium. Thus, both examples were presented in alien settings. Although the performance environment disallowed the ambience of a cultural Ring Shout, I still felt grateful to see some semblance of what these dances must have been.

The word "shout" may have its origins in an Afro-Arabic noun, *saut,* which means "a religious ring dance in which participants continue to perform until exhausted" (according to African American linguist Lorenzo Thomas, and cited in the McIntosh County Shouters video). Although this counterclockwise circular dance most likely formed the center of antebellum Christian practice by enslaved Africans, nowadays it is performed on specific holidays (Christmas and New Year's Eve, for example) and is a ceremony that follows the more standard, Europeanist sit-down service. For example, a New Year's Eve Watch Night service would include prayers, testimonials, and a sermon. Then, at midnight the entire

church would kneel to thank God for bringing them into the New Year. The pews would be pushed aside and Ring Shouts performed, often till daybreak.

I have given a description of the origins of this dance and the basic foot movements in the section on William Henry Lane in chapter 3. Adhering to the white Protestant taboo against dancing (with dance defined in Europeanist terms: jumping or skipping; lifting or crossing the feet), these Shouters never let their feet leave the ground: Based upon this prohibition they created an innovative form of danced worship that later was elaborated into buck dancing and early forms of tap dance. Shuffle steps forward, sideward, backward, double shuffles, half-time shuffles, and more are performed as the Shouters circle, with torso lifted and relatively quiet or with articulations of pelvis, rib cage, shoulders, and arms to add counter-rhythms and occasionally symbolic gestures (such as rocking a baby in a McIntosh County Shout called "Hold the Baby"; or collecting leaves in the Sea Island Singers' "Adam in the Garden Picking Up Leaves"). Although the direction of movement is generally counterclockwise, one Shout performed by the McIntosh County ensemble had the instruction, "Go the other way," and the circlers obliged. In addition, circlers can make small turns (circles around their own bodies) while traveling in the larger circle. They may occasionally face the dancer nearest them and move momentarily as a couple while maintaining the traveling integrity of the larger circle. Women may grab hold of their skirt hem (as was done in Cry) and move the fabric in rhythm to enhance a step. At times designated members of the circle take turns dancing, singing, clapping hands, and playing either tambourine(s) or a stick (most frequently a broomstick or walking cane). While the player (male, in both versions I have seen) is seated on a straight-backed chair, he stands the stick on end, vertically balanced between his legs, and beats a constant rhythm on the floor, adding syncopation by lifting and dropping his heels in counter-rhythms. All the while multiple-part a cappella singing is performed, adding another layer to the complex of rhythms carried by this genre.

The Ring Shout is one of many African retentions in Sea Island and Coastal Georgian culture. These pockets of spirit energy were cut off from mainland culture, white and black, in a blessed isolation that allowed them to preserve traditions that in other regions were syncretized and assimilated, or simply disappeared. Like other Africanist socio-aesthetic traditions, the Ring Shout blurs the divide separating sacred and secular—terms that are categorical errors in an Africanist cosmology. By shifting roles from singer to dancer to musician and allowing people to take a break and sit or stand on the sidelines, this genre also blurs the division between audience and performer—another Africanist characteristic. One can imagine a glorious sense of flow and change when the dance is performed in its proper cultural environment, rather than as a staged

event for outsider audiences. Both groups of Shouters are direct descendants of enslaved Africans, and these dances were passed on to them in an unbroken lineage. Other retentions include the counterclockwise circular movement (which obtains in almost all African and diasporic traditional ceremonies); creating musical instruments from found objects; call-and-response; techniques for rice cultivation, basket weaving, textiles, ceramics, and architecture; agricultural products, including okra and sweet potatoes; and folk tales.

Some Shouts have themes from everyday life. The McIntosh County Shouters' "Hold the Baby" is about taking care of a sick child. They also perform a beautiful, truly joyful Shout, "Religion So Sweet," that illustrates call-and-response and repetition as basic integers over which intricate counter-rhythms in the feet and broom can be layered to complement the words:

"[call] Oh, dat 'ligion, [response] so sweet. . . . ;
[call] On a Sunday morning, [response] so sweet. . . ."

After every successive line the "so sweet" response comes in: "I walk that 'ligion/so sweet; I talk that 'ligion/so sweet; I sing that 'ligion/so sweet . . . ," and so on, with the opportunity for improvised calls to be inserted. It is true of all the Shouts, but I find that this one particularly illustrates the earthiness of the Africanist worldview: Religion is right here, right now, which is the reason why the concepts of sacred and secular melt into each other. Yes, they speak of a heaven over there—especially given the unspeakable atrocities endured by our people in this place, in this time. But the Ring Shout gives physical and cosmic space for the heavenly spirit to inhabit the present moment and for us to experience, here and now, a taste of the goodness and freedom that is promised "in the sweet by and by." This Shout was one of the liveliest. From an outsider perspective it might have seemed the most secular, but in a cultural environment that sees the dancing body as holy, the opposite obtains.

Other themes come from the Old Testament, with Moses and Daniel figuring frequently as heroes. The McIntosh Shouters perform a rousing shout, "Rock, Daniel, Rock," with the name, Daniel, repeated as the response to the terse, instructional calls:

"[call] Rock, Daniel, Rock, [response] Daniel;
[call] Move, Daniel, move, [response] Daniel."

After each line the "Daniel" response is intoned: "Do the Eagle Wing/Daniel; Shout, Daniel, Shout/Daniel; Rock where you are/Daniel; Go the other

way/Daniel. . . ." Some of these directions are dance instructions, their usage fore-
shadowing the spate of instructional dance songs of the pre–World War I period,
such as the "Bullfrog Hop" (1909) and "Messin' Around" (1912), both composed
by African American songwriter Perry Bradford.[15] The Eagle Wing was a particu-
lar step that dates back to plantation days and later showed up as the Eagle Rock
in the song "Ballin' the Jack" (1913), written by two African Americans, Chris
Smith and Jim Burris. (The song was introduced to white America in Florenz
Ziegfeld's *Follies of 1913*).[16] Here, when directed to do so, the circlers performed a
genteel, symbolic waving of the arms. (According to Stearns and Stearns the Eagle
Rock, a dance performed in African American religious services after the Civil
War, contained "the high arm gestures associated with evangelical dances and reli-
gious trance" dances including the Shout and the Buzzard Lope.[17])

One of the most poignant, fatalistic Shouts performed by the McIntosh
County ensemble is titled "In the Fields We Must Die." Feeling that there would
never be a way to break the chains of slavery, the composer of this chant writes
of suffering the same fate as his enslaved ancestors. However, by giving the
shape and form of their own living, breathing bodies to this Shout, with their
African memories alive and well in the circle, with clapping and call-and-
response, the performers transcend the riffed response, "We must, we must die."
In this Shout the dancers reduced their footwork to the smallest, tightest steps,
with accompanying torso articulation subtle and contained.

In the 1963 film of the Georgia Sea Island Singers, the Shout "Adam in the
Garden, Picking Up Leaves," is a triumph of understatement. This innuendo of
shame—for the song doesn't deign to say why Adam gathers leaves, since we all
know too well the reason—says more about the concept of Original Sin than a
handful of sermons on the subject. As they progress around the circle the perform-
ers use their arms in an abstract gesture symbolizing picking and gathering leaves.

What is compelling in all the Shouts I observed is the constancy of the
footwork and the overall form—a metaphor for a people with a strong sense
of character who held fast to their principles and self-possession in spite of a
hostile environment and changing styles in African American expressive cul-
ture. In fact, the Sea Island ensemble performed a beautiful Shout that re-
flects just the opposite: humility as strength, specifically in the face of evil. In
"Bright Star Shining in Glory, Jesus Been Down to the Mire" the group be-
gins together for the first two lines, then the caller directs the song and the
movements:

"[call] You must go down, [response] to the mire;
[call] You must bend down, [response] in the mire;

[caller calls particular person's name] Mary, bend down, [response] in the
 mire;
[call/response pattern continues] You can rise up/from the mire;
When you rise up/from the mire;
You can Shout!"

This instructional dance requires each respondent to be directed downward by
the caller to a kneeling pose (while the circlers momentarily move around these
two). Both keep the rhythm while bending over, the caller holding his hand gen-
tly above the shoulders of the respondent, guiding him to a full kneel. The beauty
of this Shout lies in the way each respondent interprets the command to kneel, in
accordance with age, agility, and mood. One older gentleman performed this
movement in almost total stillness: As he slowly descended, his entire body and
demeanor were exemplars of steadfast composure; only a slight, syncopated up-
and-down movement of his shoulders kept the rhythm. When the caller
sings/chants the line "You can rise up," the respective circler bounds up from the
kneeling pose and rejoins the fast shuffle footwork that the others have contin-
ued. This Shout is like a baptism without water, a symbolic cleansing of spirit by
the physical gesture of getting down and rising up again. Perhaps this is why
many traditions feel it is important to kneel in prayer. This is honorable humility:
as adults, to acknowledge the dependency of humankind upon forces beyond our
control, and to bow in respect.

Praise dance: Although all the forms discussed in this section (and, in the largest
sense, all dance that pays homage to the force of spirit) can be considered praise
dance, there is a new flowering of dance in institutionalized religion that carries
that official title and serves as the coda to this chapter. Granted that all dancing
performed in African American Christian churches is somewhat indebted to and
descended from the Ring Shout, the current outpouring—as seen in white and
black Protestant and Pentecostal churches and in the concerts of gospel mega-
stars like Cece Winans and Kirk Franklin—looks very little like that historical
antecedent. In a Winans show the dance presentation resembles an Aileyesque
concert dance amalgam of ballet and modern styles. (It was performed by soloist
Tobyn James on the program televised in 2002.) Franklin's dancers, a full en-
semble known as the Steps of Praise, perform in hip hop style occasionally ac-
cented with a fraternity-type step routine. My first experience (in the mid-1990s)
with these genres was at a choir competition announced on a local gospel radio
program, Philadelphia's "Gospel Highway Eleven," where I often tune in for a

shot of instant spirit/soul. A stadium-sized temple in North Philadelphia was the setting. It was a hot summer evening, but the place was packed, and the joint was jumping. It was an intergenerational, interethnic crowd (largely African American and Latino). Several fine vocal ensembles were accompanied by praise dancers representing both modern and hip hop styles. At first I didn't know what I was seeing. It seemed as though these movers were sign-language interpreters (so common at many performances, readings, and lectures) because of their extensive use of hand gestures, but I couldn't figure out why they were moving so much. Then it occurred to me: You are seeing a form of liturgical dance! The modern dancers used movements that combine symbolic hand gestures that resemble sign language with stretches, spins, and leg extensions. This style of praise dance is filled with turns, leaps (as much as the usually tight altar space will allow), outstretched arms, and, again, the upward, outward gaze—all indicating the dancing body as a vessel of spirit. At the other end of the spectrum, hip hop praise dancers make extensive use of the bent-elbowed, splayed-finger angularity of gestures associated with that genre. Then there are groups who "praise" utilizing African American step dance. This form, familiar as a basic means of expression in African American fraternities (and popularized by Spike Lee's film *School Daze*) is unmistakably Africanist in style and flavor. There is a military-like precision to this percussive form that relies on the dancers' stomping rhythms, beat out with the feet, as well as hambone-type "rapid-fire movements, slapping their hands on their hips, stomach and legs, crossing and recrossing their arms."[18]

An ancillary form of praise dance is the synchronized, part-choreographed, often improvised arm and upper-body movements of the local pick-up "mass choirs" who back up soloists like Winans and Franklin; and the full-body movements performed in place by the smaller, permanent back-up singing group (usually a trio or quartet) who are part of the star's traveling entourage. (The contemporary gospel star usually makes a point of working with combined local choirs when she/he comes to town.) There is a wonderful scene in the film *Savion Glover's Nu York* (as discussed in chapter 3) in which Glover, Franklin, a female rapper, and a youthful chorus perform together at Harlem's Church of the Master. The entire event is a gospel rap: The young choristers' singing and movements are hip hop style—the hand gestures and body angles, the running-in-place feet and staccato stops and starts that we know and love from this newest addition to world popular culture. Out in front, Franklin raps the gospel and dances as the spirit moves him, in what seems to be improvised fashion. (I cannot vouch for this assumption: Gospel performance has become so choreographed and calculated that not much is left to chance.) Then Glover,

a master of stylistic flexibility, tailors his performance to fit the needs of the overall event—and "rap-tap" is his basic genre, anyway.

Franklin's traveling show is perennially on the road and draws huge crowds. In 1999 his Nu Nation tour (promoting and extending his Grammy-winning 1998 CD, *The Nu Nation Project*) played to a crowd of 19,000 strong in Baltimore. This performance was videotaped and has since been televised and marketed. Franklin reinstates dance as a central element in black worship, but with a difference. Unlike African-based traditional religions in which the articulated torso (pelvis, rib cage, buttocks) is a central means of expression, Franklin's dancers stick to the peripheries, exhibiting lots of arms and legs. They perform like Europeanized Christians and avoid inflecting the innately sexualized body regions. This is one of the key factors that distinguishes gospel hip hop from the hardcore version common in popular entertainment. Here we find no verbal or physical profanities, no humping, grinding, or crotch-grabbing gestures. Franklin does a brilliant job in shifting the paradigm just enough to capture a corner of the juvenile market but retain his Jesus-centered message. This particular show opened with the superstar chanting "Do you want a revolution," as he and his ensemble danced a vigorously energetic, squeaky-clean routine. The content of the "revolution" he was referring to was not social or sexual but spiritual; yet the form he used was one familiar to any hip hop enthusiast. In another subtle but telling shift, he chants in his hit, "You Are the Only One," "Get your praise on," which is his holy revision of the street-smart phrase "Get your freak on," a term as sexually perverse as it sounds. Dance infuses the show from start to finish, for spectators as well as performers: This mega-audience was on its feet, encouraged verbally by Franklin to dance their spirit as well.

Still another form of liturgical praise dance is pantomime. Some churches, like the True Light Fellowship Church in the Oak Lane section of Philadelphia, have a permanent group attached to the congregation that also performs at other churches and community events. I spoke to Adicia Johnson, director of True Light's mime ensemble.[19] First, she defined praise dance as "any movement form done to inspirational music." Her group performs in classical mime fashion— whiteface, white gloves, black garments—and uses pantomime as well as sign language, "putting action to words to bring the song to life," she said. This particular group is intergenerational. Johnson explained that "junior mimes" are ages six to twelve, and their work is "very choreographed," whereas the older groups who have more experience in the form have a greater leeway for improvisation. Her comment shows that improvisation remains an acquired skill and aesthetic value in Africanist expressive forms: It cannot be utilized effectively until the rules of the particular form are mastered and understood. Toward the end of our

conversation Johnson mentioned the fact that pop artists have picked up on the lead established by groups like hers, adding miming and similar moves to the ensemble work in their live shows and videos.

Praise dance thrives, in many forms and styles and on professional, amateur, and grass-roots levels. What held fast in all the forms I witnessed was the truth of the spirit, regardless of the venue. Even in the mega-concerts there came the moment when the action got down to the heart of the matter: the fact of human pain and suffering and the window of release through spiritual transcendence. For African Americans the memory of pain — the auction block — hovers right under the skin. The gospel milieu, amateur or pro, skillfully calls forth the wound and massages it with spirit salve. As if turning on a dime these performances and services shift mood from upscale and upbeat, through black duende, to triumphant salvation. Indeed, Jesus' unwarranted suffering is a subtext of and metaphor for the African American experience. Despite the bodily restrictions imposed by Christianity, the praise dance movement succeeds in resituating dance as a central component in worship.

And let us not forget the basic praise dance that is still the most prevalent. It has no name — not even Ring Shout — but is created, case by case, by the dancing bodies of individuals who are inspired by and enthralled in the Holy Spirit and simply get up and dance as the spirit moves them. Then and now, and in a multitude of ways, people of African lineage continue dancing the spirit.

POSITION:
FROM COON TO COOL

I had this stunning moment when my brother brought this great black athlete to the house for dinner. . . . I had never seen a black person close. This was when I was in high school, real early '50s. . . . And I was embarrassed to look right at him, and I wanted to look at him a lot, you know? But I didn't dare do that. There was a mirror and there was a bouquet on top of the mirror on the dining room table with white linens. God—and I could see him by looking down, I could see him in the mirror. So you know, that was the first step.

—*Trisha Brown*

Having stated that the question of the color line was *the* question for the twentieth century, what would W. E. B. Du Bois say about the twenty-first? How far have we traveled from coon to cool? Has any substantive change occurred in the perception/reception of the black dancing body since minstrelsy? If so, where and how?

From coon to cool: As stated at the outset in the first chapter, the paradox is that the black (dancing) body both is and isn't. Like all mind/bodies this one has taken on the shapes of change predicated by the environment. Is it a matter of nurture or nature? What a simplistic proposition, in the face of such a complex phenomenon! This is not an either/or scenario, but and, and, and more and. Nature and nurture are life partners, two sides of the same coin. No individual comes into this world an empty vessel; but neither is life predestined according to ethnicity, genes, biology, society, politics, or anything else. We fail to take into account the amazing plasticity and flexibility of the human brain and our potential for adaptation, regardless of physical or psychological circumstance. I watched one of those incredible public television programs (probably in the *Nova* series) on the human brain and toward the end the voiceover said, "The environment writes on the developing brain but not on a blank slate. In response to the demands of the world the baby's brain sculpts itself." From day one we are adaptive creatures in an ongoing process that trespasses

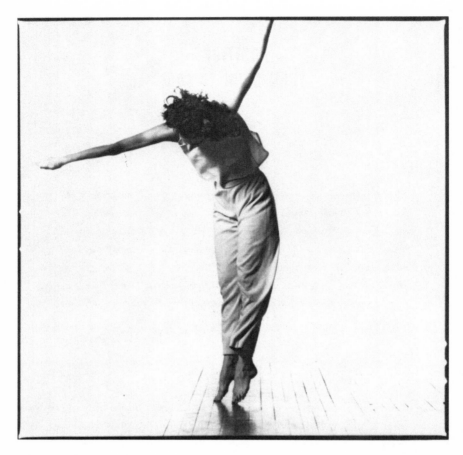

"Flying on the Wings of Art" (John Duffy quote). Trisha Brown (1980s). © 1987 Lois Greenfield.

ethnic, cultural, and genetic boundaries. Whites can learn to perform African dances, and blacks can do ballet. Each one of us adjusts, using our God-given gear in ways that may have been unimaginable to parents, peers, or the powers-that-be. Perhaps our capacity for change is as great as our ability to imagine and envision. Black bodies were thought unfit for ballet, and black minds unfit for so-called advanced forms of strategic thought, whether that meant having black quarterbacks on the football field or black scientists in the laboratory. Only the most xenophobic individuals could cling to these beliefs in the twenty-first century. But as we know, old beliefs die hard—and slowly.

The black body, dancing and thinking in the technology age: I have seen television reports in which black and/or white youths avow that racism no longer

exists or, at least, not for them, not in their world. It is a thing of the past. How interesting: Here they are, making sense of the layered, split-screen, intertextual world of cyberspace, yet they fail to access the figurative parallel between the subtle gradations and levels of cyber data and the equally subtle gradations and levels of racism. They fail to comprehend that racism has receded to the hidden screen on their life monitor—but the file can be activated and called up, reconfigured from the database.[i] In a moment we shall examine a small core of that data, as collected from the people interviewed for this book.

From coon to cool: Back in the day the black buttocks, feet, and attitude were minstrelized into the "coon" construct. But even then there was the contradiction: The coon body and spirit were also cool, which is why minstrelsy became a regular musical comedy form for white America and Europe during the nineteenth and early twentieth centuries. Even then, the same qualities that were demonized were lusted after: How can I, white Dan Emmett, white Thomas Rice, and an army of white male minstrels, be black, acquire "their" talent in movement, music, and mime—their attitude, their spirit—and still make it clear to audiences (and to myself) that I really am white, but that I have the innate, superior power to master and manipulate the culture of this inferior people?[1]

From coon to cool: In another sense this phrase indicates the larger cultural movement of whites toward black culture and blacks toward white beginning probably with the first encounters between blacks and whites, even before their clash on American shores. As novelist and art critic John Berger stated in a foreword to *Deep Blues: Bill Traylor 1854–1949,* "Before the slave trade began, before the European dehumanized himself, before he clenched himself on his own violence, there must have been a moment when black and white approached each other with the amazement of potential equals. The moment passed."[2] And, as the moment passed, the love/hate, attraction/repulsion tropes associated with the coon/cool binary were born. André Levinson's 1927 essay *The Negro Dance under European Eyes,* reeks of this contradiction. He values and validates Africanist aesthetic forms only inasmuch as he believes they can light a fire under Europeanist creativity. After that, he indicates their usefulness would be depleted. Levinson was wrong: White culture continues to appropriate black aesthetic values, and

i. All they need do is listen to the biased, ethnocentric commentary aimed at Venus and Serena Williams by white sports announcers and players. (But, as Chris Evert pointed out at the Wimbledon 2002 finals, the Williamses maintain their dignity and never return the insults leveled at them.)

both aesthetic systems continue to perform a mutual dance of approach-retreat. Whites become more black as blacks become more white.

As I reflected on this epilogue, I was struck by the following group of statements coming from a variety of sources. I offer them here, before proceeding, in the spirit of the epigraphs offered in the previous chapters:

Ralph Ellison, speaking to a Harvard student-faculty group in 1973: "You cannot have an American experience without having a black experience. . . . Nor can you have the technology of jazz, as original as many of those techniques are, without having had long centuries of European musical technology, not to mention the technologies of various African musical traditions. . . . *Usually when you find some assertion of purity, you are dealing with historical, if not cultural, ignorance.*"(Emphasis mine.)[3]

Meredith Monk, near the end of our interview, when asked if there was anything that hadn't been covered that she'd like to add: "Well . . . my gratitude, that somehow I've been allowed to have this [African American experience] as part of my life and my culture. I start really becoming aware of it when I'm in Europe and Europeans are trying to rock-and-roll dance and it's kind of pathetic . . . and then you realize how much of America is black culture. . . . We've had the privilege of having this as part of what we've grown up with. . . . I feel that so much when I'm away, out of America and how, actually, the dominant culture has been the black culture on a certain level in terms of what's going out to the world. *What people are getting from America is black culture.* . . . [E]ven though I'm white I feel like I have that in my body, I have that loose thing in my body. . . . [B]ut then I have to say [this] with total gratitude and awareness, not that I take this for granted, that I take this . . . with great gratitude." (Emphasis mine.)

Film and television actor (and Latino) Edward James Olmos, 2002 Commencement Speaker, National University, San Diego: "Every single person in here and on this stage today still uses the understanding that there is a Caucasian race . . . an Asian race . . . an African race, and an indigenous race. Well, I'm here to tell you, you should have never invited me if you didn't want to learn one thing today. And that's that there's only one race, and that's the human race. Period. I've spent my entire adult life trying to realize *how in the world are we ever going to come together when we keep on using the word 'race' as a cultural determinant?* How can we even look at one another and understand our unity of humanness when we consider ourselves different races? . . . Why was it started? We all know why. Because it's easier for me to kill you because you're a different race, and for you to kill someone else because they're a different race." (Emphasis mine.)[4]

Doug Elkins, when asked if he wanted to add anything to wrap up our interview, gave several searing examples of cultural clashes and finally wound up

with the following observation: "Of the dynamic tension sometimes: Cultural messages from all sides to come close, but stay at arm's length — 'Come closer, but you don't understand me.' . . . I find it hilarious, fascinating, compelling, that Willy [Ninja, Vogueing expert and one of the originators of the form] teaches young 16-year-old white girls who are entering the world of modeling to 'walk like a woman.' So they are being coached by a gay black man in an over-exaggeration. . . . Again, realness: I can wear all the accoutrements, the movement vocabulary, and do it bigger and better. The makeup game: *I'm aware of what these things are, and they are actually constructions. I can play this game. And if you gave me . . . the field, I would tear it up!*'" (Emphasis mine.)

Ralph Lemon, addressing black and white dancing bodies: "If you put a really powerful African dancer on stage with a really, really forceful hip hop dancer, they're not going to outdance each other . . . energetically. . . . What's so interesting is nothing is getting lost. A lot of this dancing body discussion is about us as human beings, I think, staying alive . . . and the many different levels at which we relate to that reality. We're pissed off or we just love it or we have a passion . . . or it's not a racial issue or it is a racial issue. Yes, there is racism and, yes, there's black and white issues but at the same time we are all truly negotiating trying to be, to live with each other and what we reference and what we give up to define that is real. *And so I wonder, as Americans, what is really left of where we come from?*" (Emphasis mine.)

An entry from the penultimate page of Bill T. Jones's memoir, *Last Night on Earth*:

> 7:30 p.m. I am driving, filled with the familiar desire to escape the city. The back seat of the car is a jumble of my dance clothes, Bjorn's computer, our yet unopened mail, and shopping bags of what will be our late-night supper. . . . We leave the George Washington Bridge and cruise along the familiarity of the Palisades Parkway. I stop by a closed exit so that Bjorn can relieve himself. *We are immediately accosted by a suspicious highway patrolman who, after confiscating my license, is joined by another police officer. Ordering me out of the car, he announces that I am wanted for armed robbery in Chicago. The police bulletin calls for an incriminating tattoo on my right arm, which they are unable to locate. I produce a recent copy of* Time *magazine with my portrait on the cover. They apologize and nervously let us go.* Shaken, Bjorn and I climb back into our car."[5] (Emphasis mine.)

Each of these statements evocatively points up questions and issues of central importance to whoever has read this far. How can we allow that Bill T. Jones,

master choreographer, dancer par excellence, and MacArthur "genius" award recipient, is mistaken for an outlaw solely on the basis of skin color? Would Peter Martins, blond, Danish-born artistic director of the New York City Ballet, be pulled aside by the cops in such a manner? This incident begs the question "Has anything changed?" Lemon's and Monk's statements tell us that Americans as a people have changed, whether they like it or not, whether they can admit it or not. Ellison's and Olmos's debunk concepts of cultural or racial purity. And Elkins's crystalline stream-of-consciousness reflections scathingly highlight the way the race trope squanders talent.

So what future can we hope for as dancing artists, black, white, or brown? How far is the journey *from coon to cool?*

CHANGES? PLUS CA CHANGE . . .

What we see on the concert dance circuit has changed considerably, beginning with the ascendance and universal popularity of the Alvin Ailey American Dance Theater in the 1960s. Ailey's company accustomed world audiences to seeing the black aesthetic in a modern dance vocabulary performed by black dancing bodies. "American" is a very important part of the company name, highlighting the fact that black is as American as white. It is largely due to Ailey's undervalued influence that, nowadays, all the people I interviewed and all the genres they represent are produced on the concert dance circuit. This performance environment is no longer the exclusive aegis of ballet forms and white privilege.

Merián Soto echoed my sentiments: "I think people like Alvin Ailey and Katherine Dunham have made inroads so that we get to see the black dancing body on the concert stage more. . . . I think there are more media images of the black dancing body. Also because of this globalization we get to see more of the roots. . . . And the white body seems more aware of the black body to me, and more open to receiving that, more inclusive in a lot of ways. . . . There was more of a fear in previous generations."

Still, there is a long way to go, and there are those who bemoan the opening of erstwhile exclusive circuits to dancers of color and world dance forms. By and large, the personnel in concert dance groups and the Broadway musical circuit remain segregated, showing that dance is a measure of society, not an exception to it. In both the dance realm and the larger culture we are good at tokenism, so there may be one white dancer in a black company or one black in a white ensemble, just as there may be one black family in a white neighborhood, or a minority black population at a white college. What will it take to reconfigure

generations-old patterns of segregation and self-segregation (and that's all that "self-selection" really means)?

Shelley Washington was hopeful about some of the changes she had recently witnessed at the New York City Ballet: "There are four beautiful black boys out there in the corps. . . . And dark, I mean, not 'Is he Puerto Rican or Latin, or Mexican with a tan?' I mean black men. And you know, there was a time maybe 20 years ago there was maybe one, and it kind of shocked everyone because there's a whole line of people in the same outfit and then there's this really dark one. So things really are changing."

To this I must counter that seeing through ethnocentric lenses is the reason why people are shocked by a dark-skinned individual performing in an all-white ensemble. Ironically, many "shades of white" are accepted, but, as Scott Malcomson put it, "Under pressure, whiteness could make room for many shades of white, even Irish Catholic, Jewish, Turkish, or Egyptian white. It could not, on the whole, accommodate black white."[6] The true test will be when that difference is acknowledged, even celebrated, and doesn't register as an anomaly—for why should it? There are also many instances in which the participation of one African American dancer in an ensemble is played up for all the market value it can muster. Such is the case in Philadelphia with Meredith Rainey, who for years was the only black male dancer in the Pennsylvania Ballet.[7] Notwithstanding this tokenism, year after year he has been prominently featured in the annual "new season" brochures and outreach literature, leading the uninformed reader to assume that there is a black presence in the company. However, it is another example of the American talent for commodification and its attendant exploitation. But it also indicates that we all know what we ought to be doing and where we ought to be headed: We all know that segregation and discrimination are unhealthy for both its perpetrators and targets.

In chapter 1 Joan Myers Brown suggested that tokenism may be a function of comfort level, that the people who form dance companies may feel that other ensemble members would be uncomfortable with more than one black person in the group. Her response to my question as to whether she saw changes in attitudes between the present generation and earlier ones was one of resignation: "I think, no, there hasn't been a change. I mean, here I am, I'll [soon] be 70 years old, and they are still doing what they were doing in 1950. There's one or two [black members in an ensemble] when they could be half and half."

Likewise, Zane Booker states wryly: "You or I would have to design a company specifically to be interracial and do classical or contemporary works. That's the only way it's going to change. They are not going to integrate. If they haven't

done it by now, it's not going to happen. And we keep going backwards. . . . I just don't see it happening."

Garth Fagan, too, feels that things have regressed. Addressing the larger-than-dance picture, he said, "Back in the '60s it was your choice. . . . But now, it's like all the blacks are in this room, all the whites are in this room, all the dancers in this room, all the doctors in that room—it's very sad and very limiting. And agewise, too, you don't have the blending at parties that you used to have. So how do you learn things from people who only know what you know? . . . [T]here's more to be learned about people who do different things. Very upsetting. . . . Racism is going to be here every single day; in the most unusual or unexpected places, it's going to rear its ugly head."

It isn't surprising that, after the minor inroads made in some sectors by Civil Rights era advances, Americans gradually re-segregated themselves: Old habits die hard. Contrary to these opinions, other dancers give exhilarating examples of trespassing normative boundaries. Meredith Monk describes a class she observed in the dance department at Connecticut College: "These three guys from Japan, one who's got dreads . . . are teaching this class in hip hop to these kids who are both black and white! I'm seeing this black kid learning Japanese hip hop. . . . I can only tell you that it was totally Japanese what they were doing. . . . And then what I noticed was that there were all kinds of bodies in there, which was so nice. . . . I realized, 'Oh, boy, we came from such a repressed generation!'"

Chuck Davis marveled, "Did you know now there is an all-white African dance company? In Asheville, North Carolina, and the group is called Common Ground. But also I was in Japan, left Japan, went to the American Dance Festival, and 45 students from Japan came over [to study with me]. I returned to Japan and they took the choreography that they had learned, they sent seven dancers to Africa with me on my Cultural Arts Safari. They recorded everything, and now there is a Japanese African dance company. And they sent to Africa to get the drummers to come and perform with them."

On a more ambiguous note, Marlies Yearby comments that "at any given concert that I see [with] any white choreographer creating the work, I will either hear our music, our text, our voice in the word, or I will visually see our [popular] dance. I see more white people now in African dance classes [with the number] growing over the years."

Although the mutability of the dancing body was discussed in the chapters on feet and buttocks, let's briefly revisit the topic. Bodies, even grown-up ones, can continue to change, as Shelley Washington, Brenda Bufalino, and Jawole

Willa Jo Zollar indicate about their own bodies, while Gus Solomons jr addressed the overall changing shape of ballet-trained black dancing bodies as they approach and approximate white aesthetic criteria. Dancers black, white, and brown have moved beyond the stereotypes set for them by studying and mastering specific techniques. Zollar and Bufalino point out that cultural upbringing and physical training can change the body. Zollar also observes that minds need to be rerouted to think in non-stereotypical ways, that the issue for some black bodies attempting ballet is not the buttocks, but alignment. Meanwhile, in core black culture, the buttocks are prized, as is the arched spine, which also works to lift and display the breasts—all in direct conflict with the aligned, subdued white body image. But it can change! As Bufalino says, it is the culture that makes the shape. After entering ballet culture, Washington redesigned her feet. Again, we underestimate the body's capacity for transformation.

The degree and kind of physical discrimination bandied about in the dance field is very in-house and passes over the head of the average audience member who attends a dance concert. The woman who approached Zollar at the end of a performance to praise her "straight feet," seeing them as a value rather than a hindrance, is a good example. In the same vein, Bill T. Jones was on the Charlie Rose television show during the premier of *Still/Here* at the Brooklyn Academy of Music Next Wave Festival in 1994, about the same time that Jones's face graced the cover of *Time* magazine. Rose asked Jones to address the fact that many people claimed he had the perfect dancer's body. Jones modestly contended that, no, that was not the case and briefly addressed, for Rose's lay audience, the fact that his feet are not "perfect" for ballet. Around the same time Jones was also completing his memoir. There he had this to say about his body: "My feet were big, flat, and did not have high, supple arches. [Note—High arches are not necessarily flexible.] ... My buttocks were hard and pronounced. ... My shoulders were muscled with great affinity for my ears. My carriage was low, grounded, and round, not pulled up, elongated, and gracefully vertical. ... The ballet barre became the site of a battle between what I was and what I willed myself to be."[8]

As we have seen in the accounts of several dancers, black and white, ballet was/is the site of a body battle royal. I offer this assessment by Jones of his body before he began to study dance as another indication of the possibility for transformation and transcendence. Anyone who has seen Jones dance would be hard put to locate him in the description given above.

Shelley Washington's body issue was her lack of hip flexibility. But in her forties she experienced changes that amazed her: "There are some postures that I

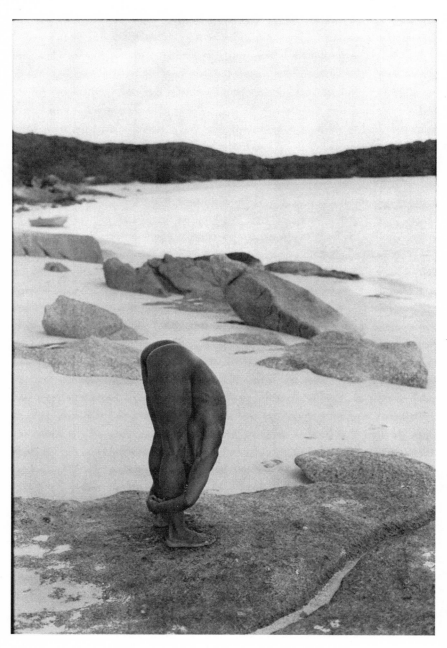

Crafting "the shape of things to come." Shelley Washington. Robert Whitman.

remember trying 20 years ago in the few yoga classes when Twyla brought yoga teachers in to work with us: No way, José, no way. Have these people come near me like they're going to push me or help me, and I would have these panic attacks because I was too tight, and then, one day—shwoop! So the body still can learn, and the body still can open."

Nevertheless, despite the body potential for transformation, despite civil rights advances, there is a backwater of issues ripe for change. From the black dancing, jigging memorabilia displayed at the end of Spike Lee's *Bamboozled*, now collectors' items on the world market (especially in Japan), to the obviously black male dancers in the New York City Ballet—surely there are changes afoot. Still, the question remains: How has the geography shifted and the continents moved? How far is the journey *from coon to cool?*

Ellison should have received a MacArthur award, for he was surely a genius. At a time of black nationalism and civil rights fervor by blacks and whites alike, he chanced the unpopular opinion that minstrelsy was a complex, intertextually layered phenomenon and that minstrels were doing something more and other than what they seemed to be up to: "Beneath the submissive grin lay the storehouse of Negro history and humanity, he said. . . . [T]he minstrel image would be permanent, he said, recurring again and again with only cosmetic variation."[9] How telling and how true are both these contentions; and they are not contradictions. They are the paradox of "is and isn't": Minstrelsy was good in providing legitimate, paid work for black performers and preserving black plantation forms that might have otherwise disappeared; and it was bad in etching a dire stereotype. As Ellison indicates, erasing the images of minstrelsy would not eliminate the minstrel trope but only make it go underground. He could probably have predicted that those little laughing Mammy figures and buck-dancing field hands would end up as collectibles. Whether overt or under wraps, racism is as destructive in its modern dress as it was in earlier eras. Things have and haven't changed.

In response to my question as to whether there are differences in perceptions or attitudes from past eras and the present, Monica Moseley's response sounds a lot like Garth Fagan's. Moseley focuses on audience composition. Referring to a millennial performance of the Merce Cunningham company at New York's City Center, she says, "I don't remember seeing a single black person in the audience. . . . And when I go to Trisha Brown's performances also. It's really a white audience. And sometimes I just look around me at performances and say, 'Why are we settling down into these categories?' Which I think wasn't so much true — I think that there was more mixing of audiences ten years ago, and that audiences

are sort of re-segregating themselves again for some reason." I asked her about the audiences for Meredith Monk's work when Moseley performed with The House in the 1960s and 1970s. "I'm just thinking about looking at audiences during the period of *Quarry* [1976] and *Education of the Girl Child* [1973] where there were enough faces of darker color there, and I think it has become less so lately."

It is open to speculation and research (and, indeed, the topic for another book) as to why Americans continue to segregate themselves. I believe it has something to do with comfort levels and contact zones. Now that it is legislated that discrimination is illegal, does that mean that minds and thoughts are freed of the old bonds?

Here follow two anecdotal examples of ways in which, from an artist's and a choreographer's standpoints, political interpretations of the black dancing body lead to misconceptions of what is really going on, indicating the need for a change in perception. "Shelley and Suzanne," or "maids and monkeys": Each narrative centers around a noun that carries with it a host of stereotypes foisted on blacks. Indeed, these two "m" words are nearly as loaded with unsavory racist tropes as the "n" word. Can Washington's and Linke's stories be summed up as "uncool" throwbacks to the age of coon in what is supposedly the age of cool?

The first story was related by Shelley Washington when I asked her to talk about how black or white dancing bodies figured in her professional environment. She turned to the issue of her role in the first version of Tharp's *Catherine Wheel* (1981) — not a racial problem in her view, but a shock to some critics:

> I played the maid in it, and Chris Yuchida played the house pet. And Chris is Japanese. Now, at the time when this movement was made, Chris was chaos, and I was order. And you can see in my home, and anyone who knows me, I like order. I have an army background and upbringing, and this neurotic scorpio thing in me — all books are alphabetical, CDs. I've always been order. So when Twyla was making the movement everything I did was orderly. . . . Chris was chaos . . . she'd create a mess and I'd come behind her and fix it. And all of the movement was made this way. . . . It would become a dance that wouldn't become a dance and then that would be taken from that dance to [make] another [dance], and finally that [chaos and order movement theme] was in the *Catherine Wheel*. Well, all of a sudden I was the maid and she was the pet. I never thought of it as anything except for order and chaos. . . . And my Grandmother Nana was a maid her whole life. Well, people were appalled. There was definitely some flak. . . . And strangely enough, as the years went on, the maid role, the pet role, the parent role, they all got rolled into one, and who did it? Me. And who got the Bessie

that year [a prestigious dance award named after legendary dance composition teacher Bessie Schoenberg]? Me. . . . I think sometimes when you know where you come from or you know where you can go home to, everything else in the middle is an experiment, it's a change. . . . And I would be a great maid, in any color, shape, or form, because I have that "hm-hm-hmmmm!"

Like Ellison's comment about minstrelsy, Washington's take on the maid's role urges us to go behind the stereotype and suggests that many women, black and white, including her paternal grandmother, worked as maids with pride, dignity, and self-possession. How far have we come *from coon to cool?* Can we allow Washington to play a maid and see it as cool? Whoopi Goldberg got away with it in films; why not Shelley Washington on the concert dance stage? Or, even playing it cool, is there always a racist signifier embedded in the casting of a black person in a serving role? Is there a way to escape the stereotype? What about Merián Soto's comments in the Stereotypes subsection of chapter 2 about reappropriating stereotypes for the history they contain (which is similar to Ellison's comments on minstrelsy)? Would it have made a difference if Washington's maid role had been created by a black choreographer—or performed by a white dancer?

More complex issues emerged from the work of German choreographer Susanne Linke with the all-male Senegalese dancers of Germaine Acogny's Compagnie Tant-Bi. Contested issues of gender, culture, and ethnicity loaded the process of creating and performing *Le Coq est Mort* (The Rooster is Dead).[ii] Created in Senegal and performed there as well as in France, Germany, the United States and Canada between 1998 and 2000, the finale was the part that raised hackles. Linke decided to make a connection between the futility of war and the human destruction of nature. To mix the metaphors she hit on the idea of having the men transform into monkeys and be shot down: "And I was asking Germaine if maybe this is too strange or radical or political but she said, 'Let's try it.' . . . The most [of the] dancers didn't like to do this . . . but by speaking with them about the theme, then they started to understand why I wanted this. And that was for me very important."

Asked what kind of feedback she received from audiences, Linke replied:

"That was very split. A lot of discussion came out from it. And Senegal is very influenced by the French culture . . . they were really blocked [she may

ii. "Coq" here symbolizing colonialist France, male, phallic power, and childhood (a nursery rhyme).

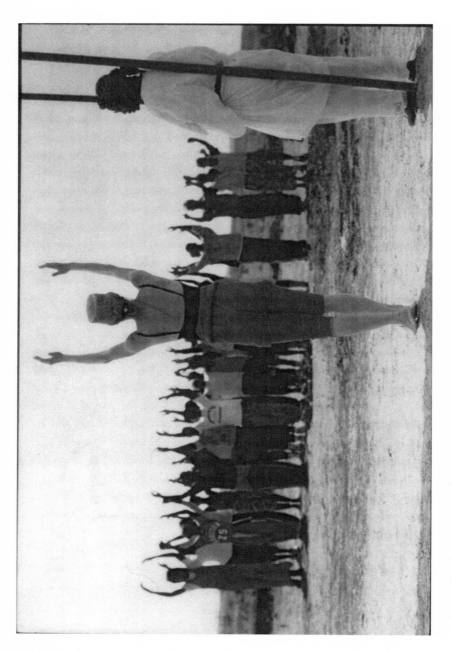

Embracing the Other: Susanne Linke (with Germaine Acogny, right, and Compagnie Tant Bi). Thomas Dorn.

have meant "shocked"] by the idea—how a white person can be so nasty to do this with the black dancers dancing like monkeys."

When asked how she dealt with this conflict, she replied: "I said, 'This part is the most important part of the whole piece, and when it is not allowed, then . . . don't show the piece, it is over.'"

To conclude our extended conversation on this hot topic I asked if there was anything that she wanted to add. Linke said, "From this I got a little bit more of the knowledge about the pain and about the slave history, of feeling what the black race went through. That is a horrible story—also your kind of a Holocaust: what he, white man, brought to the black people. And this is of course the power. The power. . . . Germaine Acogny says—this is what I realized also—that the black people are the same as we are. There are good ones, bad ones; there are different kinds of characters; there are more intelligent, there are more musical; there are also black dancers that are much more stiff than me."

This work and Linke's artistic process hold enough juicy implications to become a book similar to Ralph Lemon's *Geography* (2000) which recounts, in journalistic impressions, Lemon's work in creating his boundary-bridging piece choreographed, like Linke's, with African male dancers. In her halting English and tentative grasp of the devastating politics of race and art, Linke succeeds in getting the point: power. The issues can be summed up in that word: The power of an old stereotype, with blacks depicted as simians across cultures and centuries as a way to demonize and dehumanize them (though, clearly, that was *not* Linke's intention); the power of the market economy to forge such an unequal collaboration (and, of course, the funding for these ventures is European: Africa remains a seat of unconscionable poverty); and, finally, in spite of Linke's sincere good intentions, the power of a white, European woman over a black African dance ensemble, with intimations of neo-colonialist white privilege. There is no way to escape the power politics *encoded* in these roles. *Let me underline, here, that this is not an indictment of Linke.* The work has been praised in terms of the overall choreography and Linke's talent.[iii] She took on the commission

iii. I corresponded with Leanore Ickstadt, a Jewish American expatriate who has lived, taught, and choreographed in Germany for three decades; and Irene Sieben, a German dance writer/teacher. Both saw the dance in Berlin. Neither felt the monkey section was racially problematic. Maurine Knighton, executive director of the BAM Harvey Theater in Brooklyn, New York, saw it at the Brooklyn Academy of Music and said that, as a person of African lineage, "the transformation hit a nerve: African people being barely removed from simians can never be simple or unfettered by history." All three parties praised the overall artistic quality of the work. (Correspondences, July 2002.)

with a great, almost romantic love of the African dancing body and a desire to embrace the Other. The result brought work, salary, and travel to the Senegalese dancers. Linke stepped on a historical minefield, and it is impossible to escape history.

Although power politics are inherent in the relationship between choreographer and dancers (at worst, a master-servant one; at best, one in which the two parties regard each other as equals and behave accordingly), problems developed in the *Catherine Wheel* and *Le Coq est Mort* because of the roles whites choreographed for blacks. The controversies surrounding both reinforce the observation that art cannot ignore politics or history. Linke and Tharp are accomplished choreographers and liberal-minded women who were daring enough to take on these projects. It was a good sign that audiences and/or critics posed challenges: That is a message to the choreographer that her work is significant and raises crucial questions. Choreographers and performers need to understand the choices they are making, why and how these choices resonate in the larger-than-dance world, and what history is attached to these choices.[iv] Sometimes it suffices to simply add an informative program note that gives some background on process and/or history, indicating that the artists are aware of what they are putting before the public and take responsibility for the effect of their work on an imperfect society where racism and power politics pervade all walks of life—even the dance world. The question remains: When is a stereotype not a stereotype? Who can justifiably make use of a stereotype? And how much is the world of art beholden to acknowledge and deal with history and culture?

THE GENEALOGY OF CHANGE

From coon to cool: What other areas pose questions, and how can we travel beyond our present thinking? Ralph Lemon makes a good case for going beyond the labels. I quote him here because my intention has never been to suggest that black dancing bodies are superior to white ones. Instead, my sentiments echo his: "I've danced and choreographed for years on white bodies, and white bodies know themselves [as well as black bodies know themselves]. I've

iv. As London-based literary consultant Neil Hornick pointed out, "it's not only historical. As a recent TV documentary on football hooligans sickeningly showed, monkey grunts and postures are still used aggressively by white British thugs to taunt black players and spectators alike." (Correspondence, 12 July 2002.)

seen some of the most brilliant, heartbreaking, heart-moving dancing I've experienced with white bodies. . . . It was a white male body that first inspired me to dance."

A major aim of this work is to debunk the white/black body construct, the white/black race construct: to show that white bodies are black bodies are white bodies are brown bodies, and so on. I mean this not only in terms of aesthetics but also of identity and biology. Let us talk a little about genetics and identity — how science sees us and how we see ourselves.

Instead of putting them to rest, the Census 2000 and the 2001 completion of the human genome sequence upped the ante on old anxieties about race and identity. There are several statements regarding race and genealogy that will help in opening the line of thought I want to pursue. Before turning to them, I want to make it clear that, although I hope to disempower the concept of race, I am *not* discounting genetics as a human determinant: That would be shortsighted. Genetics is part of a large, complex, multidimensional map of humankind. The corrected equation is "nature *and* nurture," not either/or.

In his singular work on race, *One Drop of Blood*, Scott Malcomson at one point makes this comment:

> Genealogy is a strange pursuit. After Alex Haley's book *Roots* was published, the writer Ishmael Reed wisely wondered what the story would have been if Haley had traced his white ancestors back to Ireland, rather than following his black ancestors to Africa. Haley grew up black, was considered black by the people around him, and so was black. Yet the African story was not his whole past; it was only the past that he was permitted to have by the accident of skin color, the people around him, the many influences that had worked on those people, and perhaps by his own imagination. These attitudes and accidents — apart from his imagination — set the limits of what he could inherit that would seem believable, and therefore meaningful, to the public, and maybe to him. So the racial present determined what of the past Alex Haley could plausibly inherit. Considering how wide the genealogical field was, as a factual matter — and most of us Americans have very wide genealogical nets to cast over the waters — Haley's African inheritance was comparatively small.[10]

Malcomson's sense of the peculiar pursuit of genealogy is reflected in a different way by these quotes from an article by *New Yorker* staff writer John Seabrook:

Genealogy is also the second most searched-for subject on the Web.
(Porn, of course, is No. 1.) . . . [It] serves two often incompatible
human impulses: the desire for self-knowledge and the desire for sta-
tus. . . . [It] is the oldest form of social climbing in the world. . . . [I]f
DNA can help us discover who we are, it can also tell us who we
aren't. . . . [A]s any genealogist will tell you, the father is only ever the
presumptive parent, whereas the mother is almost always the genetic one.
The rate of false paternity in the United States is estimated to be be-
tween two and five per cent — not large, but over ten generations the
likelihood that a bloodline suffers what geneticists refer to as a "non-
paternity event" could approach fifty per cent. This means that many of
the fancy pedigrees cherished by great families may not, biologically
speaking, be accurate." [Emphasis mine.][11]

The way in which the Census and other surveys intersect with race was the
subject of three articles that bagged the cover of the *New York Times* "Week in Re-
view" section on 3 June 2001. An incredible finding was reported in one article:
"[T]he National Health Interview Survey . . . allows people to list themselves as
more than one race. . . . [I]n recent years 25.2 percent of the people who de-
scribed themselves as both black and white considered themselves white; 46.9
percent who said they were white and Asian thought of themselves as white, and
80.9 percent who designated themselves as white and Indian believed themselves
to be white."[12]

What these statements have in common is the sense of race as choice, not
biology. It's extremely interesting that so many mixed folks (and aren't we all?)
chose to list themselves as white. Forget multiculturalism and the 1980s culture
wars: These people want a piece of the white privilege pie — and why not? In
fact, the same article states that the two quoted experts, who might disagree on
other points, were "in accord on a more fundamental question. They are both
asking whether people should be classified with a particular group using the
old criteria of skin color or language, or whether they should be classified
based on behavior or attitudes."[13] This thought is not as radical as it may seem.
I find it exhilarating to imagine there might be a time when humankind lifts the
reins on categories and ways of thinking that have put blinders on our poten-
tial for centuries.

Genome theory further supports such radical-sounding, but pretty well
grounded, claims. In another *Times* article, titled "Genome Analysis Shows Hu-
mans Survive on Low Number of Genes," we are told that humans have far
fewer genes than was imagined — only about 30,000, whereas the roundworm

has 19,000 and the fruitfly 13,000. (The human genome is "the set of DNA-encoded instructions that specify a person.")[14] It had been believed—hoped, imagined—that the differential would be far greater, proving and substantiating our complexity and ascendance over "lower" forms of life. Shouldn't such a finding lead us to conclude that genes are not as fully responsible for who we are as we might have believed? Doesn't the evidence point to all our systems and structures, all the stuff we call culture—civilization—as central determinants? Couldn't all this evidence be used to dismantle the twin structures of race and racism? (Invariably, the one predicates the existence of the other.) Since there is comparatively so little genomic difference between us and other forms of life, can we accept the fact that there is even less difference—genetic, biological difference—between us and the next person? Can we accept that we all carry both Hitler and Buddha within us? As Susan Lindquist, professor of medical sciences and Howard Hughes Medical Institute investigator at the University of Chicago puts it, "In truth, where it matters, human beings differ from each other hardly at all. This doesn't mean we are 'our brother's keepers': It means we practically are our brothers. The 'family of man' [I wish she had said 'human family'] is not a cliché but an irrefutable fact."[15]

From coon to cool: Black, white, brown, our dancing bodies are not racial constructs, but muscle memory constellations of cultural traits and tendencies!

LOCATION:
HORIZON

*But as servants of God we commend ourselves in every way: through great
endurance, in afflictions, hardships, calamities,
beatings, imprisonments, tumults, labors, watching, hunger;
by purity, knowledge, forbearance, kindness, the Holy Spirit, genuine love,
truthful speech, and the power of God; with the weapons of righteousness for
the right hand and for the left;
in honor and dishonor, in ill repute and good repute. We are treated as im-
postors, and yet are true;
as unknown, and yet well known; as dying, and behold we live; as punished,
and yet not killed;
as sorrowful, yet always rejoicing; as poor, yet making many rich; as hav-
ing nothing, and yet possessing everything.*

—2 Corinthians, 6:4–10

There is an irrefutable, special link connecting African and Jewish peoples, a bond
of oppression, diaspora, and perseverance that renders Old Testament heroes
(Moses, Daniel, and especially Isaiah) particularly relevant on the black side of the
equation. These verses are one of my favorite prose/poetry passages. They are a
"new testament" in the tenor of that young, revolutionary Jewish heretic who
preached tough love and peace, regardless of ethnic heritage. This passage is fre-
quently recited on Ash Wednesday, the beginning of the Lenten season of fasting
and meditation. It bespeaks the death-into-resurrection ethos of Christianity in a
way that has resonated for centuries with the phoenix rising, "we shall overcome"
spirit of Christianized peoples of African lineage: We read into it our history and the
power and centrality of our presence in the human equation. We are survivors and
transcenders, before and beyond the horizon.

The symphony orchestra is one of the great accomplishments of European culture. To bring so many people and instruments together—frequently upwards of a hundred—to produce a "harmony of sound," the literal translation of the word, is a major feat of cooperation and collaboration. Likewise, the jazz band is one of the great accomplishments of African American culture. Whether a small combo or an extended orchestra, it is a paragon of democracy, with everyone pulling their weight for the good of the collective while simultaneously improvising and shining their individuality. In a figurative sense it is in such collectives that we need to study the human genome as well, not only for medicine and science to heal the body/mind but also for cultural role models to heal the soul/spirit of our species and to transcend the boundaries we have set for one another. We deserve better.

DANCE PRACTITIONERS MENTIONED
IN ORDER OF APPEARANCE IN TEXT

PART I

Rod Rodgers (deceased) maintained a dance company based in New York that was first formed in 1967 and continues to operate under the direction of Kim Grier.

Eleo Pomare is an important American choreographer and artistic director whose work in the 1960s era was considered politically radical.

Sounds in Motion, the name of the modern dance ensemble founded by **Dianne McIntyre,** captures the essence of this choreographer's interest in merging live (black) musics (jazz, blues, gospel) with her Africanist-rooted movement innovations.

In the first quarter of the twentieth century master teacher **Enrico Cecchetti** (deceased) developed a ballet technique that has since been utilized and disseminated by many American dance teachers to both ballet and modern dancers.

A legendary teacher/choreographer of a white jazz dance style, **Matt Mattox** performed in Broadway musicals and Hollywood films, including *Seven Brides for Seven Brothers*.

Ulysses Dove (deceased) was a well-known African American choreographer who had danced in both the Merce Cunningham and Alvin Ailey companies. His dancing career is a good example of the scope and versatility of the black dancing body.

Sevilla Fort (deceased) was a highly respected teacher and dancer who came through the ranks of the Katherine Dunham Company and school.

John Bubbles (deceased), tap dance innovator, is credited with inventing a genre known as rhythm tap.

As a principal dancer with DTH, **Stephanie Dabney** danced a stunning version of *Firebird*.

Pearl Primus (deceased), dancer and dance anthropologist, was probably the first (African) American to choreograph authentic African dance for the concert stage.

Talley Beatty (deceased) was a dancer/choreographer who danced with the early Katherine Dunham Company. His choreographies are in the repertory of several "black" dance companies, including Philadanco, the Ailey ensemble, and the Dayton Contemporary Dance Company.

Both **Loretta Abbott** and **Alastair Butler** danced with the Alvin Ailey ensemble.

Donald Byrd's choreography is distinguished by a near acrobatic technical acuity, daring, and speed. He disbanded his company in 2002 to become artistic director of Seattle's Spectrum Dance Theater.

Reggie Wilson is artistic director of the Fist and Heel Performance Group whose work reflects his Africanist heritage in movement, rhythmic grounding, and vocal and musical accompaniment.

Philadelphia-based choreographer **Kariamu Asante** is the founder of Umfundalai, a neo-African concert dance technique, and artistic director of Kariamu and Dancers.

Renowned swing dancer **George "Shorty" Snowden** (deceased) purportedly invented the Lindy Hop. A swing dance step was named after him.

Earl "Snake Hips" Tucker (deceased), another legendary swing-era dancer, spent much of his career as a soloist at the Cotton Club and had a dance variation named after him.

Games, one of **Donald McKayle**'s signature works, was choreographed in 1951 and is in the repertory of several "black dance" companies. McKayle and Alvin Ailey are key figures in the second generation of choreographers who brought themes of African American life to the concert stage. (Katherine Dunham and Pearl Primus are the major presences of the first generation.)

Blondell Cummings, former member of Meredith Monk's ensemble, The House, is currently a freelance artist/educator.

Carolyn Adams performed for many years as the sole African American dancer with the Paul Taylor Company. She and Meredith Monk were dance majors at Sarah Lawrence College at the same time.

Stephen Petronio, former member of the Trisha Brown Company, is the artistic director of his postmodern dance ensemble.

David Dorfman Dance performs in a playful, athletic postmodern style and occasionally integrates non-professionals (athletes, community members) in company concerts.

UCLA-based **David Rousseve**'s work integrates postmodern principles with his African American cultural heritage. He was founder and artistic director of david rousseve\REALITY.

Sylvie Guillem is a contemporary French ballerina.

Internationally famous soloist **Erik Bruhn**, originally of the royal Danish Ballet, was considered one of the finest ballet dancers in the world.

Dancer/choreographer **Robert Joffrey** (deceased) founded his namesake ballet company and school in Manhattan. It served as a major training ground for aspiring ballet dancers.

Nancy Hauser (deceased) established a reputable regional dance company and school in Minneapolis.

Harry Sheppard (deceased) attended Bennington College with Wendy Perron and danced with her and other "downtown" postmodern dancers.

Broadway dancer **Harold Pierson** (deceased) frequently partnered Joan Myers Brown on cabaret bookings.

A former soloist with the Alvin Ailey Dance Theater, **Desmond Richardson** is an internationally renowned freelance dancer/choreographer and co-artistic director of Complexions, a New York-based dance company.

PART II

Mary Hinkson, along with Matt Turney, was one of the first African American members of the Martha Graham company, joining in 1952 and dancing major solo roles.

Niles Ford has danced with Merián Soto, Bill T. Jones, Marlies Yearby, and many others.

Maria Mitchell and Soto worked together in the politically activist group Barrunto Dancers (directed by Beti Garcia).

PART III

Janet Collins (deceased), prima ballerina of the Metropolitan Opera House ballet ensemble (1951–54), was the first avowed African American dancer to hold such a position with a white American ballet company. She and Carmen de Lavallade are cousins.

Based in Los Angeles, **Bella Lewitsky** studied with Lester Horton and danced in his company until 1950, forming her own ensemble in the early fifties.

Joyce Trisler (deceased) studied with Lester Horton and danced with his company as well as with the Alvin Ailey ensemble on its first European tour (1964). She also formed her own ensemble and worked as a freelance choreographer.

A student of both Janet Collins and Lester Horton, **James Truitte** (deceased) was a principal dancer and associate artistic director of the Alvin Ailey American Dance Theater until 1968, after which he became a university dance professor.

NOTES

LATITUDE I

1. Appiah 1992, 31, quoted in Monson 1996, 204.
2. Furthermore, "two people within the same racial category have an 85.7 percent chance of having the same characteristic at a random chromosomal locus while two people from different 'races' have an 85.2 percent chance. There is then only a 14.3 to 14.8 percent chance that two individuals taken at random from the world population will have a different gene at any particular site on a chromosome" (Appiah [1992, 36] quoted in Monson [1996, 230]).
3. Correspondence, 14 April 2002.
4. A BBC World News update, televised 26 November 2002, reported Antinori's claim of having two women in his study impregnated with clones. See also *New York Times*, n.a., "Woman to Bear a Clone, Italian Doctor Says," 27 November 2002, A8.
5. McPherson 1999, 35, quoting Woodward.

CHAPTER 1

1. Correspondence, 14 April 2002.
2. Dixon Gottschild 1996, 9: for a fleshed-out discussion of Africanist and Europeanist dance aesthetics from Balanchine and ballet to postmodern and hip hop, see Dixon Gottschild 1996, passim.
3. Gold 1988, 40.
4. Cotter 2001, E28.
5. Whitehead 2001, 25.
6. Kendall 2000, 59.
7. Actually, she said they dance "beautifully because lives are on the line" (Acocella 1999–2000, 141).
8. Conversation with the author, 8 July 2002.

CHAPTER 2

1. For previous discussions of Baker and the primitive trope, see Dixon Gottschild 1996 and 2000.
2. Gladwell 2000, 91.
3. Ibid., 92.
4. Correspondence, April 2002.

LOCATION: WHO'S THERE?

1. Mason 1991, 396.

LATITUDE II

1. According to Lawrence Newman, DPM (Temple University School of Podiatric Medicine), unarched or arched feet can be flexible or inflexible, with many variable in between. Terms like "flat feet" or "military spine" are no longer used because of their medical imprecision and social stigma. Conversation with author, 20 January 2003.
2. Lipsitz 1998, 131, paraphrasing Charles Joyner.
3. Vaughan 1988, 27.
4. Thomas 1991, 8.
5. Johnson 2001, A44.
6. White and White 1998, 47, 55–56.

CHAPTER 3

1. Emery 1988, 186, 188.
2. Le Roc quoted in Ryle 2000, 7.
3. Lott 1993, 112–13.
4. Winter 1978, 40.
5. Stearns and Stearns 1979, 28, quoting Lisa Lekis.
6. Southern 1971, 168.
7. Winter 1978, 39.
8. All quoted in Winter 1978, 50.
9. Ibid., 48.
10. Ibid., 47.
11. Stearns and Stearns 1979, 45.
12. Reproduced in Winter 1978, 43; Lott 1993, 114; and Emery 1988, 187.
13. Strother 1999, 4.
14. Emery 1988, 205.
15. Paraphrasing Gregory Hines in Glover 2000, 6.
16. n.a., Goings On about Town: Dance, New Yorker, 9 July 1990, 6.
17. Glover 2000, 31.
18. Ibid., 35.
19. Ibid., 54.
20. Ibid., 42–43.
21. Ibid., 14.
22. Ernie Smith presentation, Temple University, fall 1987.
23. Winter 1978, 48.
24. Glover 2000, 65.
25. Ibid., 63.
26. Ibid., 6.
27. White and White 1998, 64.
28. Ibid., 64.
29. Gwaltney 1980, 89.
30. Russell, Wilson, and Hall 1992, 5.
31. Sulcas 2001, 11.
32. As discussed in depth in Dixon Gottschild 1996, chapter 5.
33. Correspondence, May 2001.

CHAPTER 4

1. Henning 1995, 54.
2. Ibid., 53.
3. Dixon Gottschild 1996, 8.
4. McMains 2001–2002, 64.
5. Ibid., 65.
6. The Cowardly Lion in the film *The Wizard of Oz*. Quoted in Strother, 1.
7. Strother 1999, 2–3. Strother's and Gilman's research are principal sources consulted for this section.
8. Gilman 1985, 223.
9. Ibid., 232, 235.
10. Strother 1999, 23.
11. Ibid., 4.
12. Ibid.
13. Quoted in Strother 1999, 52, 32, 27.
14. Cuvier quoted in Strother 1999, 35.
15. Swarns 2002, A3.
16. Hammond and O'Connor 1988, 118; Wood 2000, 177–78.
17. Simenon quoted in J. C. Baker and Chase 1993, 154.
18. Ibid., 474.
19. Wood 2000, 9.
20. Rose 1989, 32–33.
21. Wood 2000, 111.
22. Levinson 1927, 291.
23. Flanner 1972, 72–73.
24. J. Baker and Bouillon 1977, 57.
25. Ibid., 58.
26. Ibid., 53.
27. Archer-Straw 2000, 37.
28. Flanner 1972, xx; Rose 1989, 20–21.
29. Jefferson 2000, E2.
30. Wood 2000, 93.
31. Ibid., 82–83; J.C. Baker and Chase 1993, 5–6; Rose 1989, 20–21.
32. Quoted in J.C. Baker and Chase 1993, 6.
33. Rose 1989, 22.
34. In *L'Art Vivant*, quoted in J.C. Baker and Chase 1993, 7.
35. Levinson 1927 291–92.
36. Including J.C. Baker and Chase 1993, 135; Wood 2000, 9; Rose 1989, 97; and Hammond and O'Connor 1988, 41.
37. Wood 2000, 9.
38. Rose 1989, 97.
39. Hammond and O'Connor 1988, 41.
40. J.C. Baker and Chase 1993, 135.
41. Wood 2000, 9.
42. Rose 1989, 81.
43. Kessler quoted in J.C. Baker and Chase 1993, 127.
44. Rose 1989, 87.

45. Quoted in J.C. Baker and Chase 1993, 61.
46. Ibid., 183.
47. Colette quoted in Hammond and O'Connor 1988, 143.
48. Simenon quoted in J.C. Baker and Chase 1993, 154.
49. Irigaray 1985, 76: Thanks to dance scholar Laurel George for directing me to this source years ago. (correspondence 1 November 1989).
50. Baker quoted in Muller 1985, 22.
51. Butler 1975, 182.
52. Stearns and Stearns 1979, 110, 111.
53. Ibid., 24, 111.
54. Telephone conversation, 19 March 2002.
55. From the Yaneff International website, 2001.

CHAPTER 5

1. Gates 1996, 66–81.
2. Orlandersmith quoted in Van Dongen 2002, 3.
3. "Tufts University Study," *Black Issues in Higher Education*, 23 May 2002, 16.
4. For example see Russell et al. 1992 and Dixon Gottschild 2000, chapter 5.
5. Pierpont 1997, 82. According to Deirdre Mullane, editor of *Crossing the Danger Water; Three Hundred Years of African-American Writing,* "*Clotel* is considered the first novel written by an African American author, though Harriet Wilson's *Our Nig,* printed in 1859, is the first such work originally published in the United States" (1993, 168).
6. Pierpont 1997, 84.
7. Russell et al., 1992, 31, 57, 66.
8. Quoted in Gwaltney 1980, 80.
9. Dyer 1997, 64.
10. Quoted in Gwaltney 1980, 85.
11. Russell et al., 1992, 71.
12. Ibid., 78, quoting Love.
13. Stearns and Stearns 1979, 256.
14. Lacey and Zucker 2001 (video).
15. Philp 1999, 7.
16. De Lavallade 2000.
17. Jones 1995, 33.
18. Dyer 1997, 82–144.
19. Ibid., 97, 89.
20. Ibid., 90.
21. Koegler 1977, 221.
22. White and White 1998, 47.
23. Browne quoted in Jackson 2000, 183.
24. Russell et al., 1992, 47–48.
25. Jackson 2000, 184.
26. Russell et al., 1992, 55.
27. Gamble 2001, 62.
28. See Jackson 2000, 185.

LOCATION: TO BE OR NOT . . .

1. Brook quoted in Croydon 2001, 72.

2. "Twain on Race: It's a State of Mind," *American Theatre* 2001, 58.

LATITUDE III

1. Quoted in Allen, Moore, and Nash 1988, 5. Von Grona was a German performer who founded and directed the short-lived American Negro Ballet (1937). Faced with negative reviews, the company lasted barely one season.
2. Quoted in Pence 2001, 25. Lee is a Chicago-based poet.
3. For detailed explanation and sources, see Dixon Gottschild 1996, 11–19; and 2000, 11–16.
4. Schwartz 2001, 2.
5. Walker quoted in O'Meally, July 2001, 2.

CHAPTER 6

1. From his memoir, *Last Night on Earth*, 74.
2. "Duke Researchers Link Racism to Stress," *Black Issues in Higher Education*, 8 August 1996, 28.
3. Mosley 2000, 13.
4. hooks 1992, 158.
5. White and White 1998, 124, 122.
6. Davis 1998, 27.
7. Definition for "topography" (Anat.) — *Oxford Dictionary and Thesaurus* (1996, 1611).
8. Levinson 1927, 284.
9. Glover 2000, 10.
10. Ibid., 14.
11. Thompson 1974.
12. White and White 1998, 80, quoting Kofsky.
13. Ibid., 81, quoting Lomax.
14. Entry dated 16–23 July 1998.
15. All in Dixon Gottschild, August 2000, 55.
16. Marsalis 2001, 3, emphasis mine.
17. Barlow 1989, 171.
18. Bayles 2001, 27.
19. David L. Greenwood, *New Yorker*, 10 March 1997, 6.
20. Malcomson 2000, 232.
21. Ellison quoted in O'Meally, May 2001, 25, emphasis mine.
22. Correspondence 10 June 2002.
23. Jones 1995, 140–141.
24. Perron 2002, 6.
25. Quoted in Camhi 2001, 8.
26. Dale 1999, 35.
27. Garcia Lorca 1980, 43–44.
28. Amin, Willetts, and Eames 1987, n.p.
29. Ellison quoted in O'Meally, May 2001, 25.
30. Pallabi Chakravorti, correspondence 6 June 2002.
31. Ibid.
32. *Pather Panchali* (Song of the Little Road), 1955; *Aparajito* (The Unvanquished), 1956; and *Apur Sansar* (The World of Apu), 1959.
33. Cooper 2000, 17.

34. Chakravorti, correspondence.
35. See Mudimbe 1988 for discussion and references.
36. Cooper 2000, 16–17.
37. Jonas 1992, 58.
38. Cooper 2000, 17–18.
39. Ibid., 18.
40. Quoted in Cooper 2000, 16.
41. Jonas 1992, 67.

CHAPTER 7

1. Choreographer and erstwhile Ailey dancer. Quoted in Gold, December 1988, 43.
2. Kisselgoff 1981, 18.
3. My comments are based on live and video observation of the 2000 and 2001 perform-ances by Philadanco in Philadelphia. I also viewed a "preview" videotape housed in the Lincoln Center Dance Collection of a *Gate Keepers* performance by Danco, 11 June 1998, at New York's Joyce Theater before a live audience. In the 1998 video and in a performance I attended at the Damrosch Park Bandshell (Lincoln Center Out of Doors Festival), August 2002, the dancers wore black leotards and tights.
4. Telephone conversations with Brown and Davis, 14 June 2002.
5. Correspondence 22 June 2002.
6. Hull 2001, 182.
7. At the Lincoln Center Dance Collection I viewed a 1972 video of Jamison per-forming the dance. Her interpretation is quite lyrical; Manning's is more angular, sharp-edged. There are even some minor changes in the choreography. With the two versions for comparison I felt I was able to separate the dancer from the dance. Both are utterly compelling. As Jamison states in the Grimm video, the choreography endures and allows each soloist to fill it with her particular persona.
8. White Dixon 2000, 8.
9. White, quoted in Dunning 1998, 6.
10. Brown, quoted in Dunning 1998, 6.
11. White Dixon 2000, 8.
12. Art Sanctuary, 21 April 2001.
13. Fellers 1995.
14. Historical information given here is excerpted from the slide lecture presented by Laurie Summers (Valdosta State University, African American studies depart-ment) that preceded the McIntosh County Shouters' performance at Valdosta, 3 February 2000.
15. Stearns and Stearns 1979, 104–107.
16. Ibid., 98, 107.
17. Ibid., 26–27.
18. Gladstone 2002, 24.
19. Telephone conversation, 10 June 2002.

POSITION: FROM COON TO COOL

1. For a full treatment of the complex relationship existing between blacks and whites with regard to the black dancing body in the minstrel era, see Dixon Gottschild 1996, chapter 6.
2. Helfenstein and Kurzmeyer 1999, 8.

3. Ellison quoted in O'Meally, May 2001, 20.
4. Olmas quoted in Steinberg 2002, 38.
5. Jones 1995, 272.
6. Malcomson 2000, 230.
7. Since I began attending Pennsylvania Ballet performances in the mid-1980s there have been, at different times, two other African American males in the ensemble. One remained for about three seasons, the other left after one season. There was one African American female principal (Debra Austin) who stayed on for many years but eventually left. Currently there are two black female corps members. The full company is composed of roughly 40 dancers.
8. Jones 1995, 85.
9. Ellison quoted in Staples 1996, 6.
10. Malcomson 2000, 504.
11. Seabrook 2001, 58.
12. Holmes 2001, 5.
13. Ibid.
14. Wade 2001, 1. As of 2003 the estimate was reduced from 30,000 to about 22,000.
15. Lindquist 2000, back cover.

BIBLIOGRAPHY

Acocella, Joan. "The Brains at The Top." *New Yorker,* 27 December 1999 – 3 January 2000, 138–141.

———. "Stagestruck." *New Yorker,* 15 May 2000, 98–101.

Allen, Zita. "The Great American 'Black Dance' Mystery." *Freedomways* 20, no. 4 (1980): 283–290.

Allen, Zita, William Moore, and Joe Nash. "The Black Tradition in American Modern Dance." Unpublished booklet, 1988.

Amin, Mohamed, Duncan Willetts, and John Eames. *The Last of the Maasai.* London: Bodley Head, 1987.

Anbinder, Tyler. *Five Points.* New York: Free Press, 2001.

Anderson, Janet. "Jeffrey Gribler's Highs & Lows." *Philadelphia City Paper,* 31 May–7 June 2001, 20.

Appiah, Kwame Anthony. *In My Father's House.* New York: Oxford University Press, 1992.

Archer-Straw, Petrine. "A Double-Edged Infatuation." *Guardian Weekend* (London), 23 September 2000, 26–28, 30, 33, 35, 37.

Baker, Jean-Claude, and Chris Chase. *Josephine.* Holbrook, Mass.: Adams Media, 1993.

Baker, Josephine, and Jo Bouillon. *Josephine.* New York: Harper and Row, 1977.

Barlow, William. *Looking UP at DOWN.* Philadelphia: Temple University Press, 1989.

Bayles, Martha. "Gospel Speaks a Language Germans Understand." *New York Times,* 21 October 2001, sec. 2, 27, 34.

Blake, Dick. *Disco Dances Choreographed by Dick Blake.* Cleveland Heights, Ohio: YOU, 1974.

Borshuk, Michael. "An Intelligence of the Body." In *EmBODYing Liberation,* edited by Dorothea Fischer-Hornung and Alison Goeller, 41–57. Hamburg: Lit Verlag, 2001.

Butler, Albert. *Encyclopedia of Social Dance.* New York: Albert Butler Ballroom Dance Service. Clothbound typescript, 1975.

Camhi, Leslie. "Courting Death with the Roma." *New York Times,* 26 August 2001, sec. 2, 8.

Chakravorti, Pallabi. "Dance, Pleasure, and Indian Women as Multisensorial Subjects." Unpublished ms., 2002.

Chaplin, Julia. "New Club Dance Craze: Rear-Ending." *New York Times,* 31 December 2000, Styles section, 2.

Cooper, Darius. "Rasa Theory: An Overview." In *The Cinema of Satyajit Ray,* New York: Cambridge University Press, 2000, 15–24.

Cotter, Holland. "Treasures of Far Places and Unfamiliar Peoples." *New York Times,* 25 May 2001, E28.

Croyden, Margaret. "A Certain Path." *American Theatre,* May-June 2001, 18–20, 72–73.

Dale, Madeleine L. "Carmen Linares." *Attitude,* spring 1999, 34–35.

Davis, Thulani. "A Graceful Dancer in My Living Room." *Dance/USA Journal,* summer 1998, 23–27.

de Lavallade, Carmen. Lecture presentation, The Painted Bride. Philadelphia, 29. October 2000.

Dixon, Brenda. "Black Dance and Dancers and the White Public." *Black American Literature Forum,* spring 1990, 117–123.

Dixon Gottschild, Brenda. *Digging the Africanist Presence in American Performance.* Westport, Conn.: Greenwood, 1996.

———. "James Brown: Godfather of Dance." *Dance Magazine,* August 2000, 54–55.

———. *Waltzing in the Dark.* New York: St. Martin's, 2000.

Dunning, Jennifer. "The Dance Life: How Chaos Eventually Makes Order." *New York Times,* 23 October 1998, E1, 6.

Dyer, Richard. *White.* London: Routledge, 1997.

Emery, Lynn Fauley. *Black Dance from 1619 To Today.* [1972]. Princeton, N.J.: Princeton Book, 1988.

Entine, John. *Taboo.* New York: Public Affairs, 2000.

Fellers, Tracie. "Company Shows Depth, Brilliance." *Herald-Sun* (Durham, N.C.), 21 June 1995.

Fernandes, George. "The Year of the Butt." *Rolling Stone,* 1998 Rock & Roll Yearbook, 24 December 1998–7 January 1999, 66.

Flanner, Janet. *Paris Was Yesterday.* New York: Viking, 1972.

Fraleigh, Sondra. *Dance and the Lived Body.* Pittsburgh, Pa.: University of Pittsburgh Press, 1987.

Frank, Rusty. *Tap!* New York: William Morrow, 1990.

Gamble, Althia. Review of *Tenderheaded. Black Issues Book Review,* March-April. 2001, 62.

García Lorca, Federico. "Play and Theory of the Duende." In *Deep Song and Other Prose,* edited and translated by Christopher Maurer, 42–53. New York: New Directions, 1980.

Gates, Henry Louis. "White Like Me." *New Yorker,* 17 June 1996, 66–81.

Gilman, Sander. "Black Bodies, White Bodies." In *Race, Writing and Difference,* editedby Henry Louis Gates, Jr., 223–261. Chicago: University of Chicago Press, 1985.

Gilroy, Paul. *Against Race.* Cambridge, Mass.: Belknap Press of Harvard University Press, 2000.

Gladstone, Valerie. "Stepping and Stomping in an Old-Time Gospel Mood." *New York Times,* 2 June 2002, sec. 2, 24, 36.

Gladwell, Malcolm. "The Art of Failure." *New Yorker,* 21–28 August 2000, 84–85, 88–92.

Glover, Savion. *My Life in Tap.* New York: William Morrow, 2000.

Goings On about Town: Dance. *New Yorker,* 9 July 1990, 6.

Goings On about Town: Dance. *New Yorker,* 2 September 1991, 8.

Gold, Sylviane. "Thirty Years with Alvin Ailey." *Dance Magazine,* December 1988, 40–43.

Gwaltney, John Langston. *Drylongso.* New York: Random House, 1980.

"Hairmaster Casts Out Beast in Wild Dos." *New York Times,* 20 May 2001, Styles section, 6.

Hammond, Brian, and Patrick O'Connor. *Josephine Baker.* London: Jonathan Cape, 1988.

Helfenstein, Josef, and Roman Kurzmeyer, editors. *Deep Blues.* New Haven, Conn.: Yale University Press, 1999.

Henning, Jean-Luc. *The Rear View.* Translated by Margaret Crosland and Elfreda Powell. London: Souvenir, 1995.

Himes, Chester. *The Quality of Hurt.* Garden City, N.Y.: Doubleday, 1972.

Holloway, Joseph. *Africanisms in American Culture.* Bloomington: Indiana University Press, 1990.

Holmes, Steven. "The Confusion Over Who We Are." *New York Times,* 3 June 2001, sec. 4, 1, 5.

hooks, bell. *Black Looks.* Boston, Mas: South End, 1992.

Hull, Akasha Gloria. *Soul Talk.* Rochester, Vt.: Inner Traditions, 2001.

Ignatiev, Noel. *How the Irish Became White*. New York: Routledge, 1995.

Irigaray, Luce. *This Sex Which Is Not One*. Ithaca, N.Y.: Cornell University Press, 1985.

Jackson, Kennell. "What Is *Really* Happening Here?" In *Hair in African Art and Culture*, edited by Roy Sieber and Frank Herreman, 175–185. New York: Museum for African Art and Prestel, 2000.

Jefferson, Margo. "When Black America Triumphed in France." *New York Times*, 3 October 2000, E1, E2.

Johnson, Kirk. "New Yorkers Lose Their Inner Rand McNally." New York Times, 11 November 2001, A39, A44.

Jonas, Gerald. *Dancing*. New York: Harry N. Abrams, 1992.

Jones, Bill T. *Last Night on Earth*. New York: Pantheon, 1995.

Jowitt, Deborah. "Bebe Miller Company." *Village Voice*, 1–7 May 1996.

Keali'inohomoku, Joann. "An Anthropologist Looks at Ballet as a Form of Ethnic Dance." [1969–70]. In *What Is Dance?*, edited by Roger Copeland and Marshall Cohen, 533–549. New York: Oxford University Press, 1983.

Kendall, Elizabeth. "Trisha Brown—And All That Jazz." *Dance Magazine*, February 2000, 58–60.

Kisselgoff, Anna. "Ailey's Fusion of Jazz, Modern and Ballet." *New York Times*, 13 December 1981, sec. 2, 18.

———. "The Year in review: Dance." *New York Times*, 30 December 2001, sec. 2, 28.

Koegler, Horst. *The Concise Oxford Dictionary of Ballet*. London: Oxford University Press, 1977.

Kunitz, Stanley. *The Collected Poems*. New York: W. W. Norton, 2000.

Lemon, Ralph. *Geography*. Hanover, N.H.: Wesleyan University Press/University Press of New England, 2000.

Levinson, André. "The Negro Dance under European Eyes." *Theatre Arts*, April 1927, 282–293.

Lindquist, Susan. "Strong Unity, Rich Diversity: The Human Genome." *Black Issues in Higher Education*, 21 December 2000, back cover.

Lipsitz, George. *The Possessive Investment in Whiteness*. Philadelphia: Temple University Press, 1998.

Lott, Eric. *Love and Theft*. New York: Oxford University Press, 1993.

Malcomson, Scott L. *One Drop of Blood*. New York: Farrar, Straus, and Giroux, 2000.

Marsalis, Wynton. "Education at Jazz at Lincoln Center." *New York Times*, 31 July 2001, special advertising section, 3.

Martin, Wendy. "Remembering the Jungle." In *Prehistories of the Future*, edited by Elazar Barkan and Ronald Bush, 310–325. Stanford, Calif.: Stanford University Press, 1995.

Mason, Francis. *I Remember Balanchine*. New York: Doubleday, 1991.

McMains, Juliet. "Brownface: Representations of Latin-ness in Dancesport." *Dance Research Journal* 33, no. 2 (winter 2001–2002): 54–71.

McPherson, James. "History: It's Still about Stories." *New York Times Book Review*, 19 September 1999, 35.

Monson, Ingrid. *Saying Something*. Chicago: University of Chicago Press, 1996.

Morrison, Toni. *Playing in the Dark*. Cambridge, Mass.: Harvard University Press, 1992.

Mosley, Walter. *Workin' on the Chain Gang*. New York: Ballantine, 2000.

Mudimbe, V. Y. *The Invention of Africa*. Bloomington: Indiana University Press, 1988.

Mullane, Deirdre, editor. *Crossing the Danger Water*. New York: Doubleday, 1993.

Muller, Hedwig. "Parlez-Moi d'Amour." *Ballet International*, April 1985, 20–25.

Nenno, Nancy. "Femininity, the Primitive, and Modern Urban Space." In *Women in the Metropolis*, edited by Katharina Von Ankum, 145–161. Berkeley: University of California Press, 1997.

O'Meally, Robert. "He Inspired Jazz in the Concert Hall." *New York Times*, 27 May 2001, sec. 2, 20, 25.

———. "Kings of Rhythm Headline Harlem Jazz and Music Festival." *New York Times*, 31 July 2001, special advertising section, 2.

Pence, Amy. "Poems from God." *Poets & Writers*, November-December 2001, 22–27.

Perron, Wendy. "Bill T. Jones Searches for Beauty and a New Home." *New York Times*, 27 January 2002, sec. 2, 6.

Philp, Richard. "Instant." *Dance Magazine*, November 1999, 7.

Pierpont, Claudia Roth. "A Society of One." *New Yorker*, 17 February 1997, 80–86, 88–91.

Reardon, Christopher. "What Is Black Dance? A Cultural Melting Pot." *New York Times*, 4 February 2001, sec. 2, 4, 6.

Rose, Phyllis. *Jazz Cleopatra*. New York: Doubleday, 1989.

Russell, Kathy, Midge Wilson, and Ronald Hall. *The Color Complex*. New York: Harcourt, Brace, and Jovanovich, 1992.

Ryle, Sarah. "MP Tops Poll for Sex Appeal." *Observer* (London), 27 February 2000, 7.

Schwartz, John. "Efforts to Calm the Nation's Fears Spin Out of Control." *New York Times*, 28 October 2001, sec. 4, 1–2.

Seabrook, John. "The Tree of Me." *New Yorker*, 26 March 2001, 58–64, 66–71.

Southern, Eileen. *The Music of Black Americans*. New York: W. W. Norton, 1971.

Staples, Brent. "Indivisible Man." *New York Times Book Review*, 12 May 1996, 6.

Stearns, Marshall and Jean Stearns. *Jazz Dance*. [1968]. New York: Schirmer, 1979.

Steinberg, Jacques. "Along with Best Wishes, 9/11 Is a Familiar Graduation Theme." *New York Times*, 2 June 2002, Metro section, 38.

Strother, Z. S. "Display of the Body Hottentot." In *Africans on Stage*, edited by Bernth Lindfors, 1–61. Bloomington: Indiana University Press, 1999.

Sulcas, Roslyn. "Using Forms Ingrained in Ballet to Help the Body Move beyond It." *New York Times*, 9 December 2001, sec. 2, 11, 42.

Swarns, Rachel. "Mocked in Europe of Old, African Is Embraced at Home at Last." *New York Times*, 4 May 2002, A3.

Szwed, John. "Race and the Embodiment of Culture." In *The Body as a Medium of Expression*, edited by J. Benthall and T. R. Polhemus, 253–270. New York: Dutton, 1975.

Talk of the Town. *New Yorker*, 28 December 1987, 36.

Thompson, Robert Farris. *African Art in Motion*. Berkeley: University of California Press, 1974.

"Tufts University Study Links Racial Bias, Prejudice to Skin Tone." *Black Issues in Higher Education*, 23 May 2002, 16.

"Twain on Race: It's a State of Mind." *American Theatre*, October 2001, 58.

Van Dongen, Susan. "Exposing the Rift." *Time Off* (Princeton, N.J.), 4 January 2002, 3.

Vaughan, David. "About Ballet, in Black and White." *New York Times*, 23 January 1988, 27.

Wade, Nicholas. "Genome Analysis Shows Humans Survive on Low Number of Genes." *New York Times*, 11 February 2001, sec. 1, 1, 42.

White, Melanye. "Marion Cuyjet: Visionary of Dance Education in Black Philadelphia." Doctoral diss., Temple University, 1987.

White Dixon, Melanye. "Telling Stories, Keepin' It Real." *Attitude*, spring 2000, 6–11.

White, Shane, and Graham White. *Stylin'*. Ithaca, N.Y.: Cornell University Press, 1998.

Whitehead, Jaan. "To Have and Have Not." *American Theatre*, March 2001, 25–26, 68–70.

Willis, Deborah, and Carla Williams. *The Black Female Body*. Philadelphia: Temple University Press, 2002.

Winter, Marian Hannah. "Juba and American Minstrelsy." In *Chronicles of the American Dance*, edited by Paul Magriel, 38–63. [1948]. New York: Da Capo, 1978.

Wood, Ean. *The Josephine Baker Story*. London: Sanctuary, 2000.

FILMS/VIDEOS

Allégret, Marc (director). *Zou Zou*. 1934.

Allen, Debbie (director). *Kirk Franklin and the Nu Nation Project*. 1999.

Boyd, Julianne (director). *Eubie!* (choreographer: Henry Le Tang) 1978.

Brown, James. *Where the Action Is*. (vintage ABC-TV footage) 14 October 1966.

———. *James Brown in Boston*. (filmed concert) 5 April 1968.

———. *James Brown in London*. 1985. Sony concert videotape 1986.

Brown, Ronald (choreographer). *Gate Keepers*. (Robert Shepard, videographer) 1998; (Carmella Vassor, videographer) 2000.

Castle, Nick (director). *Tap*. (choreographer: Henry Le Tang) 1989.

De Baroncelli, J. (director). *The French Way*. 1940.

Gable, Jim (director). *Savion Glover's Nu York*. ABC-TV 1997.

Goodwin, Archer, et al. *Georgia Sea Island Singers*. Indiana University Instructional Support Center. 1963.

Greville, Edmond (director). *Princesse Tam Tam*. 1935.

Grimm, Thomas (director). *Four by Ailey*. 1986.

Lacey, Madison Davis, and Adam Zucker (directors). *Free to Dance*. 2001.

Lee, Spike (director). *School Daze*. 1988.

———. *Bamboozled*. 2000.

Losey, Joseph (director). *Mr. Klein*. 1977.

Massiah, Louis (director). *W. E. B. Du Bois–A Biography in Four Voices*. 1997.

McIntosh County Shouters (archival video. Odum Library Collection, Valdosta State University, Ga.) 2000.

Minnelli, Vincente (director). *An American in Paris*. (choreographer: Gene Kelly) 1951.

Peterzell, Marcus (director). *James Brown—A & E Biography*. 1996.

Segovia, Claudio, and Hector Orezzeli (directors). *Black and Blue*. (choreographers: Henry Le Tang et al.) 1988. Recorded at Minskoff Theater for the New York Public Library for the Performing Arts at Lincoln Center, 14 June 1989.

Selby, Margaret (director). *Everybody Dance, Now*. 1991.

Sir Mix-A-Lot (composer/performer). *Baby Got Back*. Def-Jam. 1992.

Sisqo (composer/performer). *The Thong Song*. V–12 Films. 2000.

Tosoni, Joan (director). *Painting with Words and Music*. 2001.

Vassor, Carmella (director). *Standing at the Edge, We Dance*. 2001.

Wolfe, George (director). *Bring in Da Noise, Bring in Da Funk*. (choreographer: Savion Glover) 1995. Recorded at the Ambassador Theater for the New York Public Library for the Performing Arts at Lincoln Center, 22 June 1996.

Zollar, Jawole Willa Jo (choreographer). *Batty Moves*. (videographer: Dennis Diamond) 1998.

———. *Hairstories*. (videographer: Carmella Vassor) 2001.

INDEX

CPSIA information can be obtained at www.ICGtesting.com
260879BV00001B/143/P